D1610769

PHILOSOPHY AND THE VISUAL ARTS

ROYAL INSTITUTE OF PHILOSOPHY CONFERENCES

VOLUME 1985

PHILOSOPHY AND THE VISUAL ARTS

Seeing and Abstracting

Edited by

ANDREW HARRISON

D. REIDEL PUBLISHING COMPANY

A MEMBER OF THE KLUWER ACADEMIC PUBLISHERS GROUP

DORDRECHT / BOSTON / LANCASTER / TOKYO

Library of Congress Cataloging-in-Publication Data

Philosophy and the visual arts: seeing and abstracting / edited by Andrew Harrison.
 p. cm.(Royal Institute of Philosophy Conferences; v. 1985)
 Bibliography: p.
 Includes index.
 ISBN 90–277–2468–7
 1. Art—Philosophy. 2. Art, Abstract. 3. Color in art. 4. Visual
perception. I. Harrison, Andrew. II. Series.
N70.P475 1987 87—28442
701 — dc 19 CIP

Published by D. Reidel Publishing Company,
P.O. Box 17, 3300 AA Dordrecht, Holland.

Sold and distributed in the U.S.A. and Canada
by Kluwer Academic Publishers,
101 Philip Drive, Norwell, MA 02061, U.S.A.

In all other countries, sold and distributed
by Kluwer Academic Publishers Group,
P.O. Box 322, 3300 AH Dordrecht, Holland

Printed in The Netherlands

TABLE OF CONTENTS

PART I
ABSTRACTING AND DEPICTING

PART II
DEPICTING COLOURS

PART III
THE LIMITS OF DEPICTION

EDITORIAL PREFACE

This volume consists of papers given to the Royal Institute of Philosophy Conference on 'Philosophy and the Visual Arts: Seeing and Abstracting' given at the University of Bristol in September 1985. The contributors here come about equally from the disciplines of Philosophy and Art History and for that reason the Conference was hosted jointly by the Bristol University Departments of Philosophy and History of Art. Other conferences sponsored by the Royal Institute of Philosophy have been concerned with links between Philosophy and related disciplines, but here, with the generous support of South West Arts and with the enthusiastic co-operation of the staff of the Arnolfini Gallery in Bristol we were able to attempt even more in the way of bridge building; not only were we able to hold some of our meetings in the Gallery, thus making them as accessible as possible to the general public, but we were also privileged in having our discussions supported by two exhibitions of contemporary painting that together presented contrasting aspects of the abstracting enterprise. One, featuring works by Ian McKeever, and drawings and painting by Frank Auerbach, some of which are discussed and illustrated in the present volume, was about the painterly exploration of 'abstracting from' images in nature and in painting itself. The other, curated by Waldemar Januszczak, while showing some figurative works, was concerned with the 'pure' power of colour perceived 'abstractly, in its own right.[1] This backdrop of real art thus presented two central aspects of the nature of abstraction in art, tensions between which provided much of the intellectual and imaginative dynamic with which the papers in this volume are concerned. Moreover, the extended venue of our deliberations provided a meeting place for a wide variety of people ranging from painters and students and teachers of painting to the most 'detached' scholars and theorists who found, sometimes to their surprise, the extent to which they were exercised by common problems. A major debt of gratitude is due to Mr. Jeremy Rees and his gallery staff at Arnolfini for adding these further dimensions to an academic conference.

An important item in the Conference, which does not reappear here

Andrew Harrison (ed.), Philosophy and the Visual Arts, vii—x.
© 1987 *by D. Reidel Publishing Company.*

since it was a talk/performance rather than a submitted paper, was the contribution of Sarah Rubidge of the Ballet Rambert, on 'Expression and Abstraction in Modern Dance'. All those present would wish me to record our gratitude here for her outstanding contribution to the Arnolfini event.

Nonetheless the questions which these papers address turn on a straightforward, and in many ways traditional, philosophical issue. It is this. In the history of modern painting we find ourselves faced with an apparently simple, actually very tricky, contrast between painting (and, of course, other sorts of art too) which is representational, or 'figurative' as opposed to being 'non-figurative' and thus 'abstract'. But what, really, do we mean by this? To the self-consciously uninformed outsider who is a peculiarly central figure in the history of twentieth century art, this contrast may seem easy to express: some paintings are, reassuringly, recognisable as pictures of things we see and care about, others, disturbingly, are not. But nothing, whether in everyday life or in art is ever *just* seen. There is always, as Professor Ziff reminds us in this volume, "more to seeing than meets the eye". Seeing, whether the visual recognition of things or of pictures of things, or the visual experience of colour and of colour's emotional power over us (with which the middle section of this volume is concerned) inevitably involves the selection, discrimination, the active shaping of attention that permits us to "make something of what we see". This active abstracting in experience is both the core topic of any serious philosophical enquiry into the nature of understanding and is also what prompts the motivating curiosity at the heart of the enterprise of painting. One of the aims of this volume is to look behind the (often very useful) generalities of philosophical aesthetics to some of the detailed exploration of abstraction in the visual arts, since it is in these details that most of what is philosophically illuminating can be found. It is fashionable to suppose that as we enter a period of 'post-modernism' in contemporary painting artists should leave an interest in abstraction behind them. But serious work cannot be like that: it always learns and reincorporates; what emerges in the discussions here is that the puzzle and explorations of philosophers and art historians are aspects of the concerns of painters themselves, continuous in turn with the difficult questions self-consciously uninformed laymen ask.

The collection is organised into three sections. The first set of papers centres mainly on the issues of abstraction and representation, with

what abstraction is and its relation to the making of drawings and paintings at any time. The middle section is concerned with colour, with how far our experience of colour, as well as its emotional impact on us, is tied to more or less fixed points in judgment, language and the ways in which our various technologies present colour to us. Notoriously, our colour predicates have a highly ordered and subtly complex structure: must our experience of colour be similarly or inescapably, ordered? Just as colour harmonies and dissonances are the perennial concern of painters, these questions are part of a perennial philosophical interest. The final section is, on the face of it, concerned with more traditional topics in the visual arts, with the nature of representation and depiction and with the rôle of the use of perspective in conveying meaning that transcends mere visual replication, but, as the reader will see, the uniting theme is that of painting's pushing against the 'limits' of such procedures, an issue central to the problems of abstraction. As is proper, none of these compartments are watertight.

All the papers here, except one, are published for the first time in this volume. Professor Bernard Harrison's paper is published by kind permission of Nicholas Rescher, Editor, *The American Philosophical Quarterly*.

Organising the Bristol Conference and preparing the present volume would not have been possible without the constant help and support of every one of the contributors here. I must, however, particularly thank Michael Podro for his tireless enthusiasm, practical help and guidance, and Adam Morton for his enthusiastic co-operation in what must have seemed a virtually endless task within the Bristol Department of Philosophy. Pat Panton's work at the conference stage and Carolyn Wilde's ready assistance added immeasurably to the enjoyment of the project. Above all I must thank Mo Harrison both for putting up with me and also for her seemingly endless labours on the preparation of the typescripts and proofs and Yvonne Kaye for putting up with my incessant demands for letter writing, typing and re-typing, organising and remembering what a job of this sort entails. Only they can know how inadequate my thanks to them are.

A. H.

NOTE

[1] *Borderlines: Abstracting from Art and Nature* Paintings by Frank Auerbach and Ian McKeever at the Arnolfini Gallery, Narrow Quay, Bristol BS1 4QA from 31 August — 6 October 1985

and

Who's Afraid of Red, Yellow & Blue? Works by Zadok Ben-David, Anthony Caro, Alan Green, Anish Kapoor, Gerhard Merz, Piet Mondrian, John Murphy and Julian Schnabel, at the Arnolfini Gallery, Narrow Quay, Bristol BS1 4QA from 31 August — 6 October 1985

LIST OF ILLUSTRATIONS IN
ALPHABETICAL ORDER

PHOTOGRAPHS © MARTIN KEMP (pp. 269—276)

PART I

ABSTRACTING AND DEPICTING

MICHAEL PODRO

DEPICTION AND THE GOLDEN CALF

Painting's own momentum in representing its subject, its control over
the aspects of the world which it abstracts and combines — and which it
transforms through its own procedures — has been the recurrent theme
of critical commentary from Alberti and Vasari[1] to the present. What
has varied is the way in which this momentum and transformation has
been felt to demand commentary. Among the several ways Alberti
conceived this transformation was on analogy with the co-ordination of
parts within the structure of a sentence. And this is similar to Vasari's
sense of *disegno*, the mind's grasp of things realized in the fluent
delineation of them. It is that grasp of things, that continuity and
assurance of thought that we find for instance in a drawing by Raphael
where the spiralling rhythm registers and connects the complex forms
of the Virgin's turning body, her foreshortened arm, the articulation of
her wrist, and the torsion of the reaching child, and it does all this
without loss of its own graphic impulse [PL. 2]. That sustained impulse
in the drawing implies that all these details have been held in mind and
the drawing has subsumed them within its own continuous movement.
The thought in drawing and painting may not always be manifested by
fluency: it may involve an accumulation of adjustments, self-monitoring,
self-revising. Either way the subject is absorbed within the thought of
the drawing — not the thought *about* the drawing, but the thought
within the drawing. This point has been put forcefully by Andrew
Harrison:

How the maker of the picture made his picture becomes a way of seeing how he
attended. . . . [H]ow the materials were put together — partially re-enacts the pattern of
his attention, and the attention to a possible, imagined, seen object he invites from us.
He is at the same time depicting an object and his attention to how the unorganized
units of his attention could be seen to be related. . . . In so far as we can regard the
construction of a pattern or organization of material as a testimony to the exercise of
the thought of a maker, the expression of his thought in making, we are thus led to see
the depicted objects in terms of that expression of practical thought with materials.[2]

This paper is concerned with a sense of abstraction, both in contem-
porary and earlier painting — the sense in which the painting selects

3

Andrew Harrison (ed.), Philosophy and the Visual Arts, 3—22.

from, connects and reconstructs the subject in the medium and proce-
dures of painting; and, because these things are indissolubly connected,
it is concerned with the way that the drawing or painting directs itself to
the mind of the perceiver, who sees the subject remade within it, sees a
new world which exists only in painting and can be seen only by the
spectator who attends to the procedures of painting.

This sense of abstraction has had to maintain itself in constantly
altering philosophic and other circumstances, just as painting itself has
constantly to reconstitute itself under changing pressures and possi-
bilities of pictorial imagining.

In the theoretical literature on depiction during the last twenty five
years — since the publication of Gombrich's *Art and Illusion* [3] — there
have been two questions which have been paramount: how is it that we
can convincingly show the look of the three dimensional moving world
on what we are aware of as a still two dimensional surface; and —
secondly — how does the presence of the surface and the facture of the
paint enter our awareness of the subject depicted upon it. The argu-
ments on the first issue have, I shall argue, been misleading and have
confused attempts to answer the second.

What has characterized these arguments is that the two questions
have been treated separately. I shall go along with this and suggest how
we *can* answer the questions separately, but to answer the two ques-
tions separately is not to answer the question: '*what is the painter
doing?*'. The first two questions are about the conditions which make
depiction possible, the critical question — critical in the sense of
interpretative and in the sense of crucial — is how those conditions are
utilized by the painter. The crucial question becomes the interpretative
one immediately we are concerned with the art of painting; and not just
some epistemological or phenomenological questions to which painting
may give rise. I shall come to the critical questions only in sections
III—V.

I. HOW EARTH COLOURS REPRESENT GOLD AND FLAT STILL
PICTURES THREE DIMENSIONAL OBJECTS

Let me start with the question of how we can see the three dimensional
moving world convincingly depicted on a still two dimensional surface.
There is the argument which starts off by saying that a flat canvas does
not look like people dancing round the golden calf so that representa-

tion of the scene cannot be a matter of picture and scene looking like each other *campagna*. And anyhow, even if two things do look like each other, it does not follow, just because of that, that one represents the other; the chairs we are sitting on are very alike but one does not represent the other. For one thing to represent another it must be intended to do so, and intended to be seen doing so, and this involves some social convention.

How then does likeness or resemblance enter an account of pictorial representation and what is conventional about it? The simple answer to this is that it is a matter of convention that we look at the surface of a painting to see what is represented on it. It is a matter of convention that we use flat surfaces to represent things by showing the look of those things. (The limiting case would be one surface showing the look of another with edges coinciding and similarly figured, coloured and textured.) There are other ways of representing than by showing the look of things but that is one way of doing so, and it is a matter of convention that it is so. What is *not* a matter of convention is that we are *able* to do this. We are able to do this because we can exercise our ordinary capacities for recognition through difference and this is not a convention but the very substrate of our mental life. So our question becomes: how are we to give an account of the way we exercise the capacity for recognition in paintings without being deluded by them?

Let us look at Poussin's *Worship of the Golden Calf* [PL. 12]. To start with, consider the Golden Calf itself. The flat lustreless patch of painted canvas is unlike a gleaming three dimensional piece of golden sculpture. So what kind of adjustment do we make in order to see the golden calf in the picture? First, let us observe, as Alberti would have done, that Poussin has not represented gold with gold.[4] He has not used gold leaf in representing the Golden Calf but dabs of ochre and umber paint.

This rather simple fact is exemplary of the way depiction works in two closely connected ways. First, by not representing the Golden Calf by gold, Poussin has restricted the extent to which the depiction can afford us experiences which the object itself would have afforded. For instance, we cannot experience the change of highlights as we change position in relation to the painting. This is something which a real shiny surface would provide. In looking at the painting we make a negative adjustment, restricting the kind of expectation we have of what will appear.

By not representing gold by gold, he has not *isolated* one property of the idol or scene at the expense of the other properties like the modelling of the calf, or its position within the surrounding space, or its brightness relative to other features within that space. So we have, on the one side, a loss of completeness with respect to one property — the goldenness — and on the other a gain in the extensiveness and cohesion with other properties can be shown. In depiction the degree of completeness with which any factor or feature can be represented is constrained by what other factors or features you want to represent. Short of constructing a simulacrum of your subject you have to make an interlocking set of sacrifices.

The adjustment which we make in looking at the golden calf in the depiction may serve as a useful parallel to the adjustment we make when considering the *spatial* relations within the depiction.

It has been a recurrent observation in a criticism of the last hundred years that a painting which appears to be flat yields not only the likeness of objects occupying a three dimensional space, but even clarifies our sense of volume and spatial relations. There is nothing paradoxical about this. Just as we did not seek a complete experience of the golden surface of the calf at the expense of the idol's other properties, so when looking at a painting we do not seek, in isolation, the look of the gap left by one thing being further back than another.

When an array of objects is depicted, and one characteristic of the array is that some objects are further back from the viewing position than others as Moses is further back than the dancing figures, those spatial relations of *in front* and *behind* are not given or sought in isolation from other properties. They come together with properties of shape and colour, of relative clarity and size, of the general look of what is going on. To make spatial relations in a painting recognisable and convincing does not require the presentation of actual gaps, any more than the application of gold was required to give the effect of goldenness to the idol. What gives spatial relations in a painting their conviction are changes of scale, the interruption of one form by another, degrees of clarity, the sense that one figure is looking or moving toward another.

These give determination to the spatial look of the array. They do not, of course, *cause* a two dimensional surface to look three dimensional, for observation of these features in this way already presupposes that they are being scrutinised to show us the look of — to give determinacy to the look of — a three dimensional array.

What, then, makes spatial depiction possible is that we scan the surface of the painting to show us how something looks. To do this we follow the convention of making the marked surface the privileged object of our attention, and we adjust our attention to recognise the look of things that the marked surface can yield, accepting the limits to the similarity between the experiences yielded by the surface and by the object itself.

The adjustments we make are a matter of avoiding certain kinds of questioning to which the painting could not respond, restricting our search for experiences of the subject which it was not within the scope of pictorial representation to provide. But our adjustments are not only negative, but also positive. We seek to *use* features of the marked surface in order to resolve the subject.

Thus the figures in the distance on the left of the picture form a series in which each echoes and varies the others, their echoing and turning link the foreground dancing group with Moses. Our sense of the spatial as well as the dramatic relations within the picture is enforced and clarified by such positive relating and not only by avoiding inappropriate questioning.

Let us then take the dancing figures: seeing them in movement does not only require us to *avoid* trying to see the surface as in movement or the figures changing position in relation to each other, it involves our catching a sense of movement by attending to the way one figure echoes another, the posture of one intimating what the posture of another will become, and allowing the visual confusion of legs to suggest the perceptual uncertainties of looking at figures in movement. Even our perception of the golden calf itself does not require negative adaptation only, we have to look hard to catch the sense of gold. It does not shimmer at all obviously.

But our sense of positive adaption may be given a wider application. We have observed how a sequence set out in space may be seen as a sequence in time. We may enlarge upon this sense of adaption by considering the structure of Poussin's composition as a whole. There is an implicit movement which may be seen to run from upper right to the foreground and then back toward Moses in the distance. The propensity to see this movement is enhanced when we connect the composition with Titian's *Bacchus and Ariadne* [PL. 5]. (This was at the time in the Villa Ludovisi, where Poussin certainly knew it. He used features from it in other paintings and drawings. The milieu of Cassiano del Pozzo, in which Poussin worked, was deeply involved in archaeol-

ogy and comparative religion as well as painting. There, not only would the visual relation to the painting by Titian have been clear, but almost certainly the connection between Bacchus and Apis the bull god of the Egyptians would have been perceived. The fullest account of the episode of the Golden Calf relating it to Apis was in Philo Judaeus's *On Drunkenness*, and that was certainly an available text. We are thus not being capricious in reading the *Golden Calf* in the light of *Bacchus and Ariadne*.)[5] In Titian's painting the movement sweeps down from Bacchus's train on our right and forward to the leaping Bacchus himself, then to Ariadne as she turns from looking out to sea at the departing sail of Theseus. We surely have, and are meant to recognise, the echo of Ariadne in Poussin's blue clad dancer, and of the figure with snakes in the dancing man. But I am concerned here only to suggest that we are required to perceive, in both paintings, a sense of movement through the static disposition of forms, and in doing so we draw not merely on general experience of the visible world, but on our familiarity with painting procedures and with other paintings.

II. HOW WE SEE THE PAINTING PROCEDURE IN THE SUBJECT AS WELL AS THE SUBJECT IN THE PAINTING PROCEDURE

We do not look at the painting just to see the look of what is represented on it, but to observe the feat of painting, the way, for instance, the drapery of the girl dancing in the center has a complex articulation of curves and straight-edged planes, or the way the overall sense of the surface has a leanness in the handling of paint, with little differentiation of paint surface or distinction made between the textures of objects. How are we to describe the interpenetration of our sense of the marked surface and the subject?

Talk of the surface may here seem problematic. Is the surface not taken for granted as we look for the depicted appearances? To talk of our sense of the surface may appear to be returning to the notion that attention to surface and attention to the represented subject compete or are reciprocally independent, while in our account we assume the opposite. So how do we understand the relation of our perception of the painting's surface to the recognition of what is represented upon it?

We need to conceive of the painted surface in two rather different ways. First we can think of it as a material precondition of depiction; we scrutinise the surface to recognise the look of trees, figures, or

whatever the subject may be. But secondly we need to conceive of the surface as itself having an appearance — an appearance which inter-penetrates or interplays with the look of the depicted subject. But how, we may ask, is that possible? How could the appearance of the surface be connected with the look of the subject?

Let us first of all take a drawing by Poussin: the look of the figures is — in the sense we have been using — incomplete: we have to adapt, negatively, in recognising the figures in the drawing. We recognise the figures in the alternating light and dark patches. These, in turn, also have a presence and rhythm of their own. But the presence and rhythm of the paper left bare and the shadows of ink do not simply co-exist unrelated to the look of the figures. The situation here is just like that in, say, Raphael's drawing of the Madonna with a book [PL. 2], where the rhythms of drawing interpenetrated the figures. In such cases we want to say not only that we see the figures in the pen or brush marks, but that we see the pen or brush marks, or the intervals shadow and light, in the figures. There is, we want to say a *symmetrical relation* between medium and subject.

But is it not perverse to say that seeing the look of figures in the shaded and black areas is symmetrical with seeing the shaded and blank areas in the figures? To start with, those shaded and blank areas are really there and the figures are not. But from this the relevant asym-metry is not shown. It is not shown because we are not talking about figures and patches of light and dark, but about the *look* of figures seen in the picture, and the *look* of the array of light and dark patches.

But this, it may be argued, it still not enough to establish relevant symmetry, because in recognising the figures in the picture we recognise through difference, and what we recognise are figures in certain limited respects. But the light and dark areas of the paper are not recognised in certain respects only. They are recognised *tout court*. To this we reply that nothing is recognised except under a description — nothing is recognised unless it is recognised as something of a certain kind. Now, the description or kind under which the light and dark patches of Poussin's drawing are recognised is that of being a drawing procedure or a depicting procedure. We see the drawing presenting us with a marked surface of the kind we scan for depictions and scan in a particular way. The overall look of the drawing procedure is a look that is not ex-hausted or saturated by the recognition of the figures we see in it.

We want to say that the drawing is perceived by us as having a

procedure which could revise itself to show different figures or figures in different positions: we recognise in the drawing procedure a consistency in its relation to the visible world, so that we conceive it as able to pick out different situations in that world.

Just as in our perceptions of the visible world we are aware of a penumbra of features we do not make focal, and a sense of the alterations an object would reveal if seen in different perspectives, so in looking at a drawing we are aware of the procedure which could have other realisations. That is not to say it could have other realisations by our changing our relation to it: but that *it* could have *had* other realisations had it been aligned to an altered world or aligned to the world differently.

This perception of the drawing procedure is something to which we can direct our attention in looking at the figure which it represents to us. We can look at the drawing procedure in the delineated figure. It is for this reason that it seems appropriate to say: there is a symmetry between seeing the figures in the patches and spaces and lines of the drawing procedure and seeing the drawing procedure in the figures which are represented by it.

III. HOW THE CONDITIONS OF DEPICTION ARE USED BY THE
PAINTER. POUSSIN AND ALBERTI

If we have, at least in a schematic way, outlined answers to the questions how we can have convincing two-dimensional representations of three-dimensional objects, and how the surface can make itself present in the depiction, we now have to face the third question: how do we, the spectators, *use*, or how does the painter use, the interpenetration of the painting's real presence and the projected or imagined world?

Now we cannot regard these two factors as providing two distinct kinds of interest, linked only by their being causally interdependent. They form, in any painting that will concern us, part of a single interest, which we may term the painting's way of holding the subject in mind. We might put it in a slightly exaggerated way by saying that the subject becomes directed to us and we to it by both of us participating in a new kind of world, a world in which the relation between the spectator and subject is mediated by the art and procedure of painting; it requires a

particular kind of attentiveness on our part and reveals the subject as it can be seen only in painting.

This may occur in very diverse forms: we see it in the way Poussin, for instance, in the *Sacrament of the Eucharist* [PL. 3] leads us to see the lean procedure of painting as distancing the subject from us, as diminishing our sense of its corporeal presence, so that is appears in shadow, intimating its historical remoteness through the way it evades a sense of material tangibility.

In the *Golden Calf* [PL. 12] itself we have a remarkable play upon the feat of painting within the content of the painting itself. Earlier in this paper I commented upon the way Poussin had not only *not* represented the gold by gold but had underplayed the sense of lustre. It has been an underlying feature of Alberti's prescriptions for the painter in the fifteenth century (of which we may assume Poussin to have been fully aware) that he must not allow detail to disrupt the coherence of the whole. The painter must not indulge in effects which would disturb the overall dramatic coherence, or deploy colours which, while matching their objects, would not conduce to the harmony of the whole:

Even in representing snow-white clothing you should stop well on the side of the brightest white. For the painter has no other means than white to express the brightest gleams of the most polished surfaces. . . .[6]

Now, in the *Golden Calf*, Aaron's robe is surely snow-white, but it is not depicted with the brightest white, and this fact is actually demonstrated within the painting. The overall Albertain harmony of the picture is emphasised by the woman in the foreground whose skirt is, as it were, lit by the brightest white in contrast to Aaron's robe which harmonizes as her skirt does not, with the rest of the scene. She is a kind of choric figure looking back at the golden calf and possibly beyond. In one sense she is outside the picture as a whole and enforces the sense of the events being one stage removed from us, a sense which requires our recognition of the painting procedure.

But the mode of imaginative conviction produced by the interplay of subject on the one hand, and painting procedure on the other, may be very different. We have only to think of the way in which Rembrandt and his followers may depict something wrapped in shadow, so that the procedure of seeing the objects in the picture (making the transition from objects in the real world including the canvas to the objects depicted on the canvas) is itself like the procedure of discerning objects

in real shadow. Our sense of the painting procedure becomes itself an analogue of the efforts of perception in obscure circumstances: seeking the subject in the picture is rehearsed by seeking the subject in the shadows that surround it. (And on occasion Rembrandt will even point this up as when in one etching Jupiter gazes into the shadow that lies across the body of Antiope or leaves us, as in *The Holy Family* now in Amsterdam, puzzling over who is figured in the great cast shadow.) Rembrandt, like Caravaggio, makes the very procedure of adjustment — of seeking the subject in the light and dark patches of the surface — take on a representational force; we can imaginatively use it to represent to ourselves the puzzlement of engaging with the obscure material world. In contrast to this, the mode of imaginative conviction achieved by Poussin in the *Sacrament of the Eucharist*, or even the *Golden Calf*, was of being removed, distanced from the graspable material present.

IV. AUERBACH'S VARIATION ON TITIAN'S "BACCHUS AND ARIADNE" [PL. 6, & 7—11]

Finally, let us turn to a contemporary way in which the interpenetration of the subject and painting procedure occurs, and with it another kind of pictorial conviction, that in the painting of Frank Auerbach.

There has been a deeply consistent feature of his painting throughout the last thirty years: he has worked continuously on his subject to produce not a view, but a summation of many perceptions. By the sixties the procedure had established itself of working over the canvas a hundred times or more, as well as doing innumerable drawings, scraping the canvas down more or less fully each time, and starting again, until in one final stage he could hold the whole thing in mind in one continuous, sustained argument.[7] Let me take one example in which the complexity of the subject and the sustained continuity of the final painting are clear. It is a portrait of a regular sitter, J.Y.M. [PL. 1] of 1972. The wide sweep which rises from her neck, through — or rather under — the line of the jaw, re-emerges at the side of the nose. It then bifurcates and defines the deep eye sockets, the edge of the paint catching the edge of the skull's cavity. Our sense of the brush's movement is informed by the volumes and movements of the head — which carry with it a sense of the movement of the whole body — and the head is grasped through following the continuities of the painting.

In some of his first work he had allowed the image to accrete: earlier

stages were incorporated in later stages. And in a group of screen prints of the nineteen sixties he sought to preserve an earlier stage and also recast the subject in a dark drawing across it. These are various modes in which he seems to have aimed at the summation of perceptions. The process of constant revision and then a final comprehensive formulation takes a striking form in his variation on Titian's *Bacchus and Ariadne* [PL. 6], painted in 1972 as a commission for David Wilkie.

A series of drawings [PL. 7—11] has been, in this case, preserved, which must have run concurrently although in no simple relation to development of the final painting. The sense of summation, of gradual stripping down, of changing the factors which become focal and their reconstruction into a work with its own driving movements can be followed through the drawings. It might be thought, of the painting itself, that it has so insisted on its own procedure as to remove the *subject* of the painting from us, in contrast, say, to the head of J.Y.M. But this would be to misperceive the painting. Rather, we might say that structures within Titian's painting have been excavated, drawn out and made palpable. For the subject of the new painting is not the subject of Titian's painting, but Titian's painting itself, Auerbach once referred to it as a portrait of Titian's painting. With Titian's painting in our mind we catch the twist on the body of Ariadne and the thrust that runs from the snake-man through to the erotic leap of Bacchus which dissolves in an ungraspable flash of movement.

There is a sense in which Auerbach's relation to Titian's painting is not unlike that of Poussin in relation to it, previous works are themselves constitutive of later works previous perceptions and previous depictions are caught in the immediacy of the new performance.

V. MODERN ABSTRACTION AND OLD REPRESENTATION

But here someone might want to say that there is a gap between this twentieth century painting and that of the tradition of painting with which I have assumed that it is continuous. It might be felt that I have sustained the sense of continuity between earlier representational painting and that of, in this instance, Auerbach by maintaining a very narrow focus — on the interpenetration of the procedure of depiction and the subject depicted. And, so the criticism might run, that in maintaining this focus I have allowed fundamental changes in the appeal and interest of painting to go unremarked. And it might reasonably be

asked: is it possible, within the focus that I have maintained, to analyse what has altered, most obviously, the 'more abstract' quality of the later painting in contrast to the earlier?

The view that this paper has so far assumed is that the exertions demanded by major twentieth century painting are not that much greater or less than those demanded by real attention to great seventeenth or sixteenth century or other painting. The gap may appear very great, however, for those who are less interested in how painting's transformation relates us, the spectators, to the subject in a new way. For those whose interest in paintings is in looking through them for confirmation and even celebration of what they already know and value, including what they know and value in painting of the past, the gap may seem enormous. It may even seem emphasised by critical talk about painting in the twentieth century making a virtue of flatness as opposed to illusion, as if Poussin had not made a virtue of flatness — made the painted surface as surface into a potent psychological factor in establishing imaginative distance. The sense of a great divide between twentieth century painting and earlier painting might be enforced by a sense that twentieth century painting, in its demands upon us, no longer involves our social and religious or scientific life. That it has become, if not just mere paint, then mere painting. I do not propose to engage with this problem of the shifting relation of painting to other involvements in this century, but I do feel committed to enlarging on the phenomenological character of painting in a way which may help to chart its diversities — including its diversities in this century — and to do so in a way which will preserve the sense of the continuity of earlier and later procedures.

The content of our perception of, say, a tree, involves not only a view or projection of it from a given position, it includes in its character for us (its *Sinn* in Husserl's terminology) a sense of the other views it would yield from other positions. It also includes a sense of other possible aspects we could fixate, other features we could make focal. These are parts of what Husserl termed a horizon of possibilities which an object of experience could yield, and the indeterminate sense of those possibilities is governed, for each of us, by our own general sense of how the world is; for instance, our sense of how objects are set and perceived within the spatio-temporal, causally ordered world, or our sense of the modifications a person's face or body may be expected to undergo as circumstances alter. (See particularly Edmund Husserl, *Ideas*, paragraphs 44—45).

Now, by contrast, let us turn to the perception of the drawing or painting of an object. What we perceive is not the object drawn but the drawing, and what we perceive *in* the drawing is a characterization or look of the object drawn and the 'horizon' of that includes the belief or awareness that it could be used to show other objects, or other views of the same object or other features of the same view as salient.

The sense of the look of the depicted object does not saturate the 'look' of the drawing for us (we always see it as a drawing), any more than a particular prospect of an object saturates our sense of the object. In this way the perception of the drawing has a horizon of possibility that the object itself cannot have, and the contrary is also true. So, to put it summarily, the object (considered independently of the drawing) has as part of its character or *Sinn* one horizon of possibilities, and the drawing has another.

But not only do the drawing and the object have *different* horizons, but there is a clear sense in which neither can absorb totally the horizon of the other. Yet there also seems a sense in which the look of the object in a drawing, since it is the look of that object, must carry within it implications of what the object itself is like. To be a depicted head is not to be a diminished head. If we see it as a head in the depiction, it is seen as having sides that are hidden from us, textures we cannot discriminate, moves it would make if circumstances changed. That is simply a truth about being someone's live head, actual or depicted.

In our ordinary perception of objects, however, we are *free* to alter focus, to make now one aspect, now another salient — even to change position and catch another facet of the object. On the other hand, when we look at an object in a drawing, although we may alter our fixations on the *drawing*, we cannot alter our fixations on the object, because it is not really there. Only the drawing is there. In the case, then, of perceiving the real object there is, in principle, no restriction on how we alter our attention, how we realize other possibilities within the object's "horizon", in the case of the object in the drawing, there is, and it is a central aspect of the painter's control to elucidate aspects for us, to make then determinate forms.

The perception of a head in a drawing or painting is unlike our non-pictorial perception, not only because we are much less independent as to what aspects of the subject we make determinate, but because we are engaged in looking at something which is meant to be resolved in some particular way, while there is no special way the things themselves are meant to look.[8]

These are *conditions* of the painter's enterprise. And one part of his response to them may be to exercise potentialities of his depicting procedure in such a way that the image of the subject may resolve in a multiplicity of ways. They may be more or less disjoined, fuse more or less into one cohesive appearance, the cohesion may be more or less consistent in a literal sense, and it may elicit more or less ready recognition. At one — usually boring — extreme there is the visual pun, but more centrally and seriously the delineation may sustain a whole range of interpenetrating, reciprocally illuminating or disturbing aspects. A painting or drawing is for our perception an object in its own right. We explore *its* many facets for ways in which they may be revelatory of its subject and of its own internal organization which combines these facets.

VI. REMARKS ON TWO CURRENT ARGUMENTS

Finally I turn to two accounts of depiction to which I have throughout been indebted and which I have also been concerned to resist. I shall argue that they are accounts not of the art of painting but of the preconditions of that art coming into being.

When Richard Wollheim, in a supplementary essay in the second edition of *Art and its Objects*,[9] distinguished what he termed "seeing as" from "seeing in", he was distinguishing between the perception of an object's real properties and the perception of what we saw it representing, and this distinction he described as involving two different projects in which our perception may be engaged: scrutinising what was present and looking at what was present in order to perceive what is represented or suggested.

Wollheim in this paper treated the perception of things represented in painting as a species of the genus 'representational seeing'. Included in the genus representational seeing would be such feats as seeing a landscape in the stains of a damp stone wall. And further, he distinguished the two projects, the objective scrutiny and representational seeing, or seeing in, so that one excluded the other except in marginal cases. It must be emphasised here that he distinguished the two *projects*, making one project exclude the other: he did not, as Gombrich had done earlier, assume that there was a psychological incompatibility between seeing the actual surface and seeing the scene depicted on it. For Wollheim the incompatibility between seeing *in* and seeing *as* was

between two purposes. In discussing seeing in, or representational seeing Wollheim writes:

Now in the grip of such experiences, the spectator enjoys a rather special indifference or indetermination. On the one hand he is free, if he wishes, to overlook all but the most general features of the things present. On the other hand, there is nothing to prevent him from attending to any of its features he selects: he may not give them full attention, but certainly he can give them peripheral attention. The source of this indifference . . . lies in the fact that his essential concern is with further visual experience, with seeing the battle scenes in the landscape, discrete from visual awareness of the wall or the stones. [p. 208]

Now he does not think that this 'essential concern' with seeing the battle scenes in the landscape, and 'indifference' to the wall as such, adequately describes our perception of painting. For in our perception of painting we attend, in his account, to both the represented subject and the material which sustains it:

Twofoldness becomes a requirement upon the seeing appropriate to representations but it only becomes a requirement as it acquires a rationale. For, if the spectator does honour the requirement, the artist can now reciprocate by undertaking to establish increasingly complex correspondences and analogies between features of the thing present and features of that which is seen in the thing present. These are the delights of representation. [p. 219]

In Wollheim's account what distinguishes pictorial representation from our projection of landscapes and battles onto the stains on damp walls are two things. First there is a criterion of correctness, we try to see what was intended to be shown. Secondly, after the stage at which we leave the real nature of the surface or object a matter of indifference, as an added premium, we then follow the artist "return one experience to the other. Indeed he constantly seeks an ever more intimate *rapport* between the two experiences. . . ." [p. 224]

But this implies that the indifference to the real properties of the object is part of following the fiction, of looking for what is represented. This would contradict what we might term the *disegno* thesis — the thesis that we follow the formulating as a way of perceiving what is represented. Wollheim's account of the feat of representation by the painter, which is responded to in the representational seeing of the spectator, gives a logically secondary place to observing the material procedure of painting, and that procedure's relation to the depicted subject. It is as if this were a second project, which might follow upon the project of representational seeing.

It is *possible* that we may look at some surface to catch, or read off or register, the look of something not really present. In such cases we might, in Wollheim's sense, hold ourselves indifferent to the medium. But this is not a posture we adopt to depictions. For example, does recognising bodily movement of the figure of the Virgin require or even allow us to be indifferent to the sweep of Raphael's line? To insist that it does would seem intelligible only if the line were thought of as a mere material mark rather than being perceived as the material in use within the representational procedure. We look at the painting as a depiction we resolve, not as a surface in which we catch likenesses.

If we start our consideration of paintings from the question 'how does the brute material world yield depiction' we might answer, because in that brute matter we catch likenesses of things not present, and this might lead us to posit Wollheim's state of indifference toward the material substrate of the picture. (It is as if we were asking the question 'what is the origin of painting?' rather than the question 'how do we look at paintings?') But once we admit the notion of painting or depictions into our ontology and history, recognition would not imply a moment or mental purpose which was medium-indifferent, because in looking at a painting we would not look at it as a piece of brute matter but as the product of the procedure conducted to show the look of things. We should not have to disregard the material to see the depicted subject in it, for we should be seeing the material as a representational medium, under the concept of depiction.

It might be argued that although perceiving a landscape in a depiction is unlike seeing one in the stains of a damp wall, even when we examine a depiction the subject must still be seen and conceived as seen as distinct from the medium in which it is represented, unless we suffer delusion. But why must it? While aptly perceiving a depiction involves recognition — seeing similarity through difference — the difference is not a screen which we have to penetrate in order to grasp the similarity. We do not have to extract the common factor, for instance, when we see the look of the father in the face of the son. Although the epistemological ground of recognition is similarity, and this must exclude what is not similar, it does not follow that recognition itself involves such an abstraction or indifference to what lies outside the limits of similarity.

We might rather conceive of recognition, with Merleau-Ponty, as the initial sense of familiarity which leads us to attend to the object before

us in a certain way to fill out the sense of the objects upon which the familiarity was based. Similarity serves as the causal basis, but we look at the new object not at that basis.

In depiction, the features of the new object will not correspond in any simple one way with features of the old, but, like the sweep of the pen in Raphael's drawing, or the movement of the brush within the paint in Auerbach's portrait, have aspects which evoke the original in various ways: the pen stroke delineates the outline of the figure but also the sense of movement of the body, while the outline of the body did not itself carry the sense of the body's movement. We discriminate the pen mark to use it in two different ways, it makes two connections with the subject, or evokes two different aspects of the subject by what we may term two different routes. Our capacity to do this, to allow aspects of the subject to emerge from the painting or drawing procedure in these diverse ways would seem to show how a sense of the procedure is pivotal and integral to our recognition. I am not offering this as a *proof* that medium indifference is impossible, but as *evidence* that it is alien to the phenomenology of depiction.

Kendall Walton's paper 'Picture and Make Believe'[10] raises the problem in a rather different way. He took up the theme of Gombrich's paper of 1951, 'Meditations on a Hobby Horse',[11] which had made the basis of representation the use of surrogate objects. Walton's paper insists on the project which depiction serves: to provide an object in relation to which we can conduct games of make believe. These are distinguished from mere imaginative projections because they both depend on objective properties and have rules for what can count as a substitute for what. Walton's argument approaches the problem by distinguishing between literary and pictorial representation:

A too easy explanation is that paintings or parts of them, look like or resemble what they picture — 'Haymaking' looks like fields, peasants at work, haystacks and so forth . . . [But] the resemblance between 'Haymaking' and any ordinary peasants, fields and haystacks turns out on second thoughts to be exceedingly remote: the painting is a mere piece of canvas covered with paint, and that is what it looks like. . . . I shall propose a theory of depiction which does not itself postulate any resemblance between pictures and what they depict and so escape the objections to theories which do.

Walton's theory does not go to the length of holding that resemblance plays no role in the games of make believe that constitute the art of painting. For instance he writes: "What novel characters lack, if they do not happen to be pictured in illustration, is the possibility of being

objects of make believe visual actions". (p. 303) We must therefore
assume that recognising peasants in canvases, smiles on faces in pic-
tures and so on are, for Walton, conducted *within* a rule of a game of
make believe. To revert to the example Walton used in that paper, such
recognition must go beyond intitial stipulations like pebbles in globs of
mud stand for currants in a children's game of mud pies. What Walton
has insisted upon, is that our perception of the subject in painting is
governed by a 'convention' of what we are about; furthermore, that
convention relies on the notion of resemblance enabling things to serve
as surrogates for make believe activities. But what this leaves out is any
role for the procedure, and the perception of the procedure of painting.

One feels the difficulty in Kendall Walton's earlier paper "Categories
of Art",[12] where he introduces the interesting concept of standard as
opposed to variable properties of a given category or genre of art. The
flatness of a Rembrandt portrait is something we take for granted, and
does not therefore disturb our seeing the likeness of the three dimen-
sional head in the painting. And Walton goes on to consider qualities
which are standard in given styles:

> A cubist work might look like a person with a cubical head to someone not familiar
> with the cubist style. But the standardness of such cubical shapes for people who see it
> as a cubist work prevents them from making this comparison. (p. 345)

But surely the sense of the sharp planes of a cubist head, while not
looking to us like the depiction of someone with an oddly shaped head,
are not just taken for granted but enter into our sense of the depicted
and transformed head, as the dabs of paint on Rembrandt's canvas
enter there into our sense of the head. Walton allows that standard
properties may be aesthetically relevant but, with respect to visual
representation, appears to allow them only to be transparent or instru-
mental.

Whereas Wollheim makes the interest of the procedure of painting
distinct but considers the need to relate it to what is represented,
Walton leaves out of account how the use of the medium figures within
our grasp of the subject depicted, and the way the interest of depicting
enters into the project of make believe, the imaginative game which
focuses upon a picture.

Walton, in his paper in this volume 'Looking at Pictures and Looking
at Things' says: "We see more clearly now how serious a mistake it is to
regard Cubism, for instance, as just a *different* system from others, one

with different conventions we must get used to. It is a system which affects substantially the nature of the visual games in which the works function as props, quite apart from our familiarity with it. The difference I have described bears out the familiar characterization of Cubism as a more intellectual, less visual pictorial style, compared to earlier ones". I want to say all pictorial styles involve their own distinctive visual games and these involve the kind of the relation which we imagine ourselves as having to the subject of depiction by responding to the possibilities of the medium. What may be distinctive about Cubism are, first, that our synoptic view of the depiction may not be a make-believe synoptic view of the subject; second, that it makes our perceptual adjusting a comprehensive theme wii ر. ; the painting.

University of Essex

NOTES

[1] For Aristotle see particularly *Poetics*, 1451b; for Alberti, *On Painting and the Sculpture*, ed. and trans. C. Grayson, (London: Phaidon Press, 1971), 'On Painting' Bk. II and Michael Baxandall, *Giotto and the Orators*, (Oxford: Oxford Warburg Studies, Oxford University Press, 1971), pp. 121—139; for Vasari, see particularly *Lives*, Preface to Pt. III, and *On Technique*, paragraphs 74—76.

[2] Andrew Harrison, *Making and Thinking: A Study of Intelligent Activities*, (Sussex: Harvester Press, 1978), p. 184f.

[3] E. H. Gombrich, *Art and Illusion, A Study in the Psychology of Pictorial Representation*, 2nd ed., (London: Phaidon Press, 1962).

[4] See Alberti, 'On Painting', ed. cit. p. 93.

[5] *On the Adoration of the Golden Calf*, see A. Blunt, *The Paintings of Nicolas Poussin, a Critical Catalogue*, (London 1969) No. 26. On Poussin's relations to Cassiano del Pozzo, see A. Blunt, *Nicolas Poussin*, (London and New York: Phaidon Press, 1967), pp. 100ff, and Francis Haskell, *Patrons and Painters*, (London: Chatto and Windus, 1963), pp. 99—114. For Poussin's drawing from Titian's *Bacchus and Ariadne*, see Blunt, *Nicolas Poussin*, p. 59, and Blunt, *The Drawings of Poussin*, (New Haven and London: Yale University Press, 1979), plate 115, for an adaptation of the movement of Titian's painting.

[6] Alberti, *On Painting, ed. cit.*, p. 91. I am indebted here to an analysis of Poussin's thoughts on colour and of his drawings by Oskar Bätschmann in his *Dialektik der Malerei von Nicolas Poussin*, Schweizerisches Institut für Kunstwissenschaft, Zurich and Munich, 1982.

[7] For the clearest account of Auerbach's own views on this, see C. Lampert, *Frank Auerbach*, Arts Council Exhibition Catalogue, (London, Hayward Gallery, and Edin-

burgh, Fruitmarket Gallery, 1978), pp. 10—23, and M. Podro, 'Auerbach as Print-maker' in *Print Quarterly*, **II**(4), (December 1985), pp. 283—298.

[8] This I take to be the real issue of the distinction marked by the title of Kendall Walton's paper 'Looking at Pictures and Looking at Things' in this volume.

[9] Richard Wollheim, *Art and its Objects*, 2nd ed., (Cambridge: Cambridge University Press, 1980), pp. 205—226. I have discussed this further, *Burlington Magazine*, **CXXIV**(947), (February 1982), pp. 100—102, and 'Fiction and Reality in Painting', *'Funktionen des Fiktiven, Poetik und Hermeneutik*, Vol. X, (Munich: Wilhelm Fink Verlag, 1983), pp. 225—237. A response to this paper by Max Imdahl, '"Kreide und Seide" zur Vorlage "Fiction and Reality in Painting"' appears in the same volume, pp. 359—363. This prompted the argument in section II of the present paper. The notion of a symmetrical relation between medium and subject is one called for by Imdahl's criticism.

[10] Kendall Walton, 'Pictures and Make Believe', *Philosophical Review*, **82**, 1973, pp. 283—319.

[11] Reprinted in E. H. Gombrich, *Meditations on a Hobby Horse and other Essays on the Theory of Art*, (London: Phaidon Press, 1964).

[12] Kendall Walton, 'Categories of Art', *Philosophical Review*, **79**, 1971, pp. 334—376.

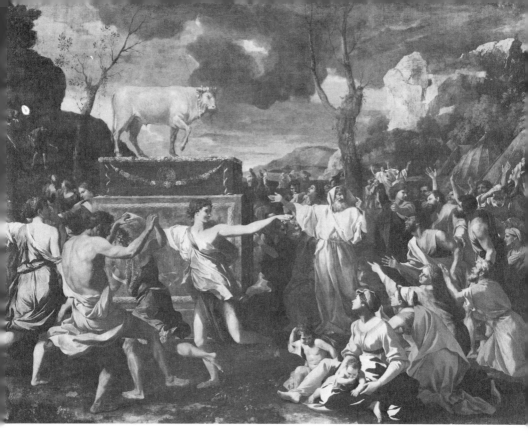

Plate 1. POUSSIN, Nicholas. *The Worship of the Golden Calf.* Oil on canvas.
154 × 214 cm. The National Gallery.
Reproduced by kind permission of the Trustees.

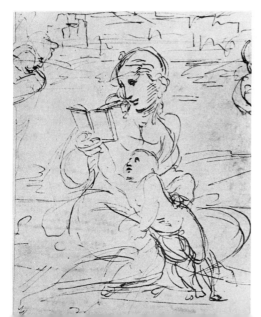

Plate 2. RAPHAEL
Madonna and Child with Book
Pen 19.3 × 15.2 cm.
Albertina Collection,
Vienna, Austria.

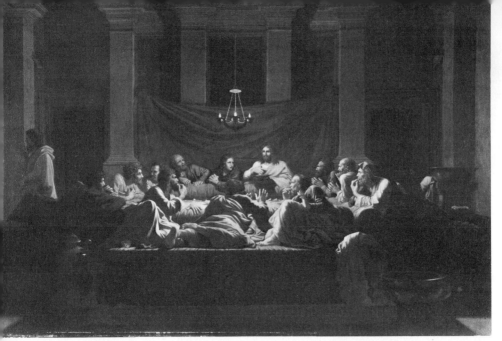

Plate 3. POUSSIN, Nicholas. *Origin of the Sacrament of the Eucharist.* Oil on canvas 117 × 178 cm. National Gallery of Scotland. Sutherland Collection. Reproduced by kind permission of the Trustees of the National Gallery of Scotland.

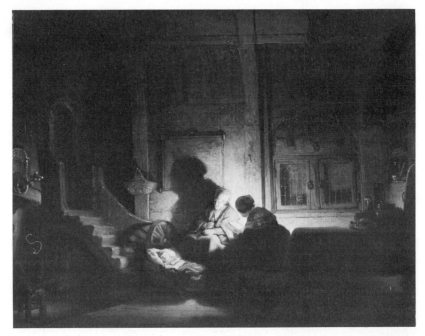

Plate 4. REMBRANDT van Rijn. *Holy Family.* Oil on panel 66.5 × 78 cm. Reproduced by permission of Rijksmuseum Stichting, Amsterdam.

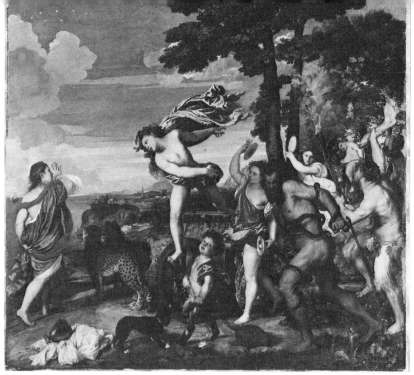

Plate 5. TITIAN. *Bacchus and Ariadne*. Oil on canvas 175 × 190 cm. The National Gallery. Reproduced by kind permission of the Trustees.

Plate 6. AUERBACH, Frank (b. 1931). *Bacchus and Ariadne*, 1972. Oil on board 101 × 127 cm (private collection). Photo © Marlborough Fine Art (London) Ltd.

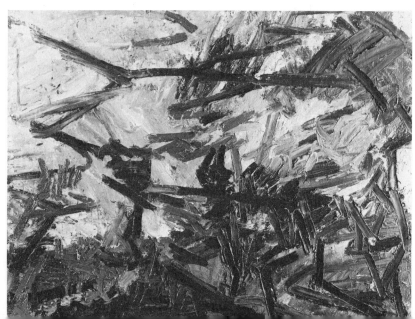

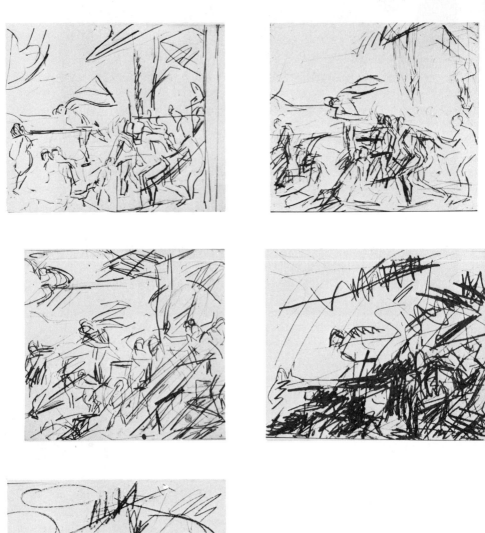

Plates 7—11. AUERBACH, Frank
5 studies in pencil for
Bacchus and Ariadne PL. 6
(private collection)

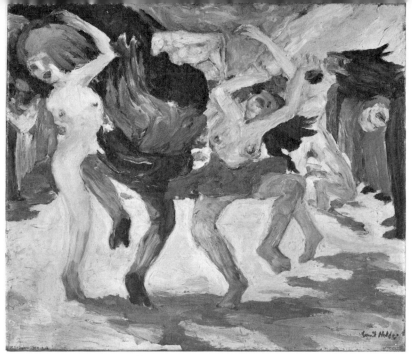

Plate 13. NOLDE, Emile. *Dance Around the Golden Calf.*
Bayerische Staatsgemäldesammlung, Munich, W. Germany
© Nolde-Stiftung Seebüll.

Plate 14. MATISSE, Henri. *Dance* (first version) (1909 early). Oil on canvas 259.7 ×
390.1 cm. Museum of Modern Art, New York.
© DACS

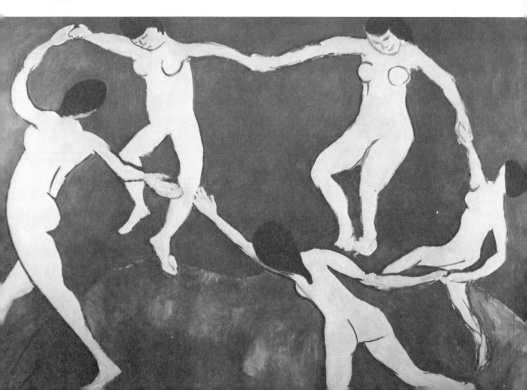

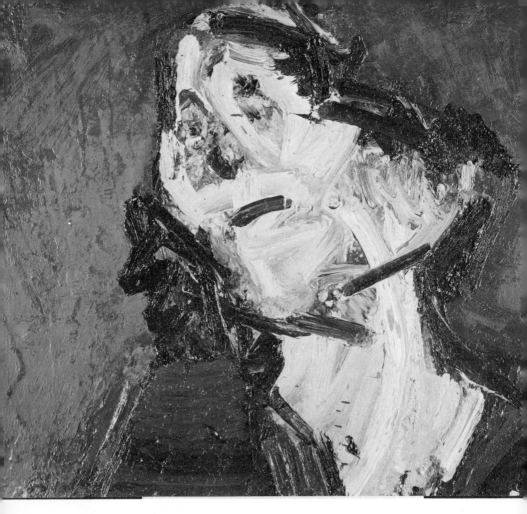

Plate 12. AUERBACH, Frank (b. 1931). *Head of J.Y.M.* Oil on board 71.1 × 61 cm (private collection). Photo © Marlborough Fine Art (London) Ltd.

CAROLYN WILDE

PAINTING, EXPRESSION, ABSTRACTION

> When spiritual, material or immaterial events come
> into my life, I can only fix them by way of painting. It
> is not the subject which matters but the translation of
> the subject into the abstraction of the surface by
> means of painting.
>
> Max Beckman, 1938 [1]

In Max Beckman's first sentence here, he underlines a popular idea
about modern art. The idea that a painting somehow fixes the artist's
own experience, the events of his mental life, in visual form. Fixing
something is a way of re-ordering it which holds it together and makes
it more permanent. This is one of the ways in which art has traditionally
acquired value, for it connects with the ultimately Platonic idea that
that which is most permanent is most real. When this is married to a
common assumption stemming from Romantic art theory, that the artist
is one who sees and feels more deeply and intensely than others, then
works which seem to fix the events of his internal life become especially
significant. The events which Max Beckman speaks of are not just the
external events of public life, but those 'immaterial' events of his own
thoughts, feelings, memories and responses. But he speaks also of
'spiritual' events, those which seem to illuminate deeper or more
general human or even cosmic concerns. In this first remark, then, there
is a personal statement about the relationship between painting and the
artist's subjectivities and an implicit claim about the deeper significance
or value of art. Since Beckman spoke these words however, many of
the assumptions and implications involved in such ideas have been
widely challenged, both within art theory and in the practice of painting
itself.

However, in Max Beckman's second sentence above, he offers a
more illuminating way of approaching the traditional issues about
feeling and expression in modern painting. In the fixing of the events,
he tells us, the important matter is their transformation into art. Yet
what is that? Clearly he is not here speaking of some elevated sphere of

29

Andrew Harrison (ed.), Philosophy and the Visual Arts, 29—50.
© 1987 *by D. Reidel Publishing Company.*

culture, but of something more material and specific, namely, the *processes* of painting. That complex series of judgements and discriminations ordering colour and form on a flat surface with paint. Beckman's remark helps us to see that in giving any account of the way in which a painting is expressive of feeling, it is the principles and constraints determining this ordering which need elucidation. Such principles as come both from life and, crucially, from art. It is essential that these principles have to be quite specific in order to differentiate the production of one painting from any other. For, as is often observed, a work of art is a unique focus of experience. Any account of it, therefore, must ultimately be able to show how particular responses to it are possible.

What is disturbing about the use of the term 'Neo-Expressionism' to speak collectively about some prominent contemporary painters in the international art market, such as Julian Schnabel, Clemente, Baselitz or A. R. Penck, is the fact that it hinders rather than helps the possibility of response to the particularities of different works. It also involves a misleading conception of the painterly process. The term 'Expressionism' has come to be used to identify works together merely on the basis of superficially similar stylistic features, the assumption of common concerns, and on the basis of the crude generalisation that in these works the artist is expressing his feelings. But the mere use of raw and direct brushwork does not itself ensure any expressive content to a painting, no more than the use of the iconography of political and existential concerns ensures that these actually are the concerns of the work. The new application of the term 'Expressionism' may not only seduce us into ignoring crucial differences between works of very different periods, but may also lead us to forget that changes in the content of paintings arose in the past from the need to distinguish and identify new sensibilities from outside of art.

For example, painters of the German Die Brücke group early in this century painted with heightened colour, a simplication of form and fierce and crude brushwork. Largely on the basis of these features, their work became linked with that of others such as Van Gogh or Soutine. There certainly are similarities of style, but the sources of this style and the choice of subject matter to which it was applied are significantly different. The idea that what links these artists is some heroic and uninhibited ability to express their feelings in paint obscures very different concerns and stances towards the society in which they painted.

The style of any work — its use of perspective, its brushwork, its particular simplification or exaggeration of form and colour — is a principle of organisation, a particular way of making the content coherent. Coherent not only to sight, but to other interests and values, moral or political. Classical perspective orders the seen world according to principles which are abstract and rational. The break with these conventions, (ironically, to become an 'abstract' painter), is to break with this order and viewpoint and implicitly to question its source of authority. A Cubist work does this, but the viewpoint remains anonymous and ambiguous. With an Expressionist work we are given the idea that the distortions of perspective present us with the intentional, personal and subjective responses of the painter. In some cases, for example in some paintings of Edvard Münch, the painting is intended to show what he feels, the inclusion of the image of his own head in the corner of a picture is one prosaic way of saying so. But in others, the abstractions of style do not direct us back towards the artist, but show us how something is to be seen. The painting, and the ways in which it breaks with previous conventions and style, can demand that the viewer re-orders their experience and expectations. A painting can therefore provide for different possibilities of response to the social or natural phenomena of the world. In any figurative painting the choice of subject matter itself shows something that is thought worthy of attention and changes in what is regarded as a fit subject for art are themselves part of wider changes in the concerns in society.

In his early peasant paintings for example, Van Gogh chose to bring the lives of certain people into focus for others to see. Peasant subjects were not new at that time of course, but Van Gogh's way of painting them was. Van Gogh himself wrote that the thing represented must be in agreement with the manner of representing it, and he claimed that he wanted to use the crude earth colours and to emphasise the visibility of his brushwork in order to express something of the conditions of life and work of the people he painted. I shall have more to say soon about the difficult relationships between what a painter says and what he does, and in this case it could be argued that Van Gogh's brushwork is not so much symbolic as an attempt to touch, substantiate and move his images. Whichever account is nearer however, the fact remains that his abstractions of style establish a certain intimacy with his subject. (Which is equally true of his landscapes and other portraits.) We may now, some hundred years later, when we have lost touch with that

which enabled Van Gogh to perceive Millet as providing an adequate vision of the framework of peasant life, think that Van Gogh's portrayal of peasants is in some cases sentimental or paternalistic. Nevertheless, his paintings contrast forcefully with many other Salon peasant paintings of the time, paintings whose less obvious abstractions of style put the subject at an almost totally obscuring distance.[2]

The superficially similar aspects of style of Kirchner's painting however, do not bring us closer to the subject. There is no sense that what we see is to be integrated within our social concerns. Rather, the use of what are still revealingly described as 'primitive' sources, serves to separate us from the established order of conventional society. One of the effects of this art was that it became popular to believe that works of this style stood for the subversive presence of the artist within the established order of society. Thus, after the war, painters such as Georg Grosz could use some of these techniques of abstraction to authorise and make vivid a far more specifically political vision. The application of the term 'Expressionism' to recent paintings valorises these works through indiscriminate connotation with such others in 'the tradition' of Modern Expressionist painting. But although the crude and violent surfaces of Julian Schnabel's paintings of the early 1980's may be complicit with the imagery of the 'primitive' graffitti which subverts the ordered surfaces of urban life, it is the differences between these works and others described as Expressionist which are eventually more important than the similarities. Schnabel's paintings and their allusions to 'humanity' interject within the social order of High Culture of the 1980's in ways which are not only more rhetorical, but also more cynically exploitative of the subversive elements of urban society. The notions that an Expressionist painter is in some way directly in touch with more primitive or elemental human feelings draws upon some ultimately empty idea of universal human feeling. Similarly in emphasising his 'Expressionism', Clemente's crude and violent images of sexuality and death lose the specificity of our engagement with these forces in life, fantasy and imagination.

In these ways and many others, then, the use of the term 'Expressionism' obscures differences and specificities in the name of a practice of art which is supposed vaguely to give expression to some more generalised forms of human feeling and experience. My concern here, however, is not the critical or art historical one of offering an account within which a more particular understanding of these new works is

possible. Rather, I am interested to outline some of the theoretical assumptions involved in a popular expressive account of painting and to review some of the familiar objections to them, in order to give some alternative accounts of Expressionist painting, accounts which put more emphasis on what Beckman described as "the translation of the subject into the abstraction of the surface by means of painting".

In order to make some of the popular theoretical assumptions of an Expressionist view of art more explicit, and to illustrate its currency, I want to mention two recent writings on Expressionism. The first is from a book on Expressionism by Roger Cardinal published in 1984.[3] The Foreward to the book begins with the remark that "it is a fundamental tenet of Expressionism that the true creative impulse springs from a source deep within the individual, at a primal level of emotional life untouched by knowledge of academic art, art history and indeed history at large". In Chapter 1 the author says that what we see as being expressed in an Expressionist work is "necessarily something invisible, an inner meaning", and he later speaks of "a primary emotion" which is translated into secondary expression. The work, he says, transmits the emotion of the artist to the viewer. Elsewhere in the book parallels are drawn between dance and expressionist works, and between abstract art and music. On this basis different works are collected together; "If we are to define (the expressionist impulse) in terms of foregrounded emotion, the term 'expressionist' can be readily applied to the widest range of works, from the leaping bison at Altimira to the frenetic drippings of Jackson Pollock, from the tortured limbs of Grünewald's *Crucifixion* to the ravaged face of Picasso's *Weeping Woman.*" The author does say that this idea of 'a creativity as pure transcription of feelings, a raw feeling which is already articulated and formed before it is given material expression in the work, is in many ways a suspect notion'. He admits that many would see it as faulty and idealistic. Yet nevertheless he allows it to underpin his uncritical acceptance of a painter's own writings as a means of informing their work.

A second example is to be found in the article *Expressionism* by Norbert Lynton, who begins his account with a general definition of what makes a painting expressionist.[4] He says that although all art is expressive, a work is expressionist if, "it is intended to move us through visual gestures that transmit, and perhaps give release to, emotions and emotionally charged messages". It is clear that he takes the emotions involved to be those of the artist, for he goes on to say that, "since the

Renaissance art has been able to function more openly as a means of self revelation". However the interest of the works is wider than the merely autobiographical in so far as, "the artist is able to channel the anxieties of their time into the work". He then develops these points in relation to abstract, non-figurative works and says that, "the only true innovation that modern Expressionism can show was the discovery that abstract compositions could serve at least as effectively as subject pictures. The subject, having served as the vehicle for expressive gestures (to some extent as the acceptable sugar coating around the pill of meaning), could, it was found, be abandoned entirely. The expressive power of shapes, of brushstrokes and textures, of size and scale was shown to be sufficient". At this point he makes the analogy common to such ideas, between the directly effecting power of such works and that of music. Like music, he says, expressionist abstract art offers a form of creativity without benefit of narrative or description. "Ut musica pictura".

Both of these accounts are written from a vantage point which attempts to generalise over a wide range of work on the basis of the single term 'Expressionism'. The fact that this term has a complex genesis and history, entering into different discourses and polemics, tends therefore to get ignored in favour of the assumption that there is within art, independently of the facts of its construction in history, some single phenomenon to be described. This is one indication that the inspiration of these accounts is not so much the observation of connections between works, connections which might illuminate their significance; rather, they seem to be accounts which bring previously existing quasi-philosophical assumptions to bear on what is to be described. These assumptions are about the nature of the relationship between the artist's subjectivities and his or her work, and, more generally, about the nature of emotion and feeling. I'd like to make these assumptions more explicit in order to offer some more critical thoughts about expression in painting.

Both accounts use the metaphor of transmission. The painting is merely the vehicle which carries the feelings of the artist to the viewer. As Cardinal admits, the objections to this crudely idealist picture are familiar. The metaphor invites us to regard the question of what is expressed in the works primarily as a question about its emotive causes.[5] It betrays the assumption, first of all, that the feelings expressed

in the work must necessarily be attributable to the artist in some way independently of the work. Secondly, that the process of the feeling's transmission through the medium of art does not significantly alter it — as with the transmission of a message in radio or semaphor, the feeling is supposedly identifiable independently of the process of its transmission. And thirdly that the viewer is caused to feel exactly the same feeling on gazing at the painting. These assumptions, however tempting, are false. And furthermore they mystify the project of understanding works of art.

A painting is not merely the outpouring of the artist's emotional state. Whatever state the artist is in, in so far as it is directed towards what he or she is doing, then any feelings or perceptions are structured through a method of art. The feelings expressed in the work must, in some crucial sense, be immanent in the work itself. They cannot be regarded as somehow identifiable independently of it, and attributable, via some process of inference, to the person who produced it.

Identifying the artist as the source or locus of the feelings expressed, is of course one of the main factors influencing the emphasis put on biography and on the artist's writings in modern art history and theory. Attention to the work itself, as something which stands before us, the result of a process with its own painterly constraints and determinations, is uncritically redirected towards theoretical texts which accumulate around it. The relationships between the texts surrounding an artist's work, particularly his other own writings, and the paintings themselves, is of course complex. However, one element in this relationship is crucial. The writings are governed by different principles of organisation and order than those which have governed the production of the paintings[7]. For one thing, the former are in language, whereas the principles governing the painted mark are essentially to do with the sensuous organisation of colour, form and spatial allusion. The theoretical ideas which some painters bring to their work have determinations which are often at odds with those of the paintings themselves. The relationship between the writings and the paintings of Kandinsky are an obvious example. Although at a certain stage his paintings lost all vestiges of earlier representational elements, his writings introduce various symbolic representations to take their place. But the symbolic order of his writings is informed by quite anachronistic theological and quasi-philosophical ideas. If these ideas are imposed

between us and the paintings themselves, then the contemporary social and painterly demands to which his formal innovations are a response, are obliterated.

The fact that we can distinguish, both in others and in ourselves, cases where what is being expressed is not actually what is being felt, can misleadingly conjure up the picture of an emotion as something essentially 'inner', to use Cardinal's word, and separable from any of the ways in which it can be given expression. Yet it is also this same fact which makes possible the metaphorical attribution of feeling to inanimate objects and works of art.

But this is not just a matter of recognising a feeling in a gesture or posture or arrangement of facial features. For a feeling which has the structure of an emotion also involves cognitive and moral ways in which certain things are understood and some sort of disposition to act. The implications of these commonly discussed elements of emotion for painting are significant. For the painter's task is not one best couched in terms of how best the painter can express his or her feelings about something, but how best, within the historically located problematics of art, and in the terms the medium sets, to make something fully apparent. So that its meaning and significance and pleasures are openly and adequately disclosed.[8]

Consider an example mentioned by Cardinal, Picasso's *Weeping Woman* from the Tate collection. [PL. 25] There is no reason of course to suppose that Picasso himself must have felt this particular feeling of grievious anguish at any time in order to portray it. Neither of course do we have to feel it ourselves in order to recognise it. We do not even need to imagine a context to the suffering in order to recognise its expression. This is a modern piece, it eschews narrative and does not even allude to an anecdotal. imagination. (As does, for example the ubiquituous popular print of the crying child). Instead, we are shown, as it were, the mere physiology and facial distortions of grief. How does the painting achieve its expressive power? The painting employs various techniques of abstraction derived from Cubism. Cubism itself is not an obviously expressive style of vision. Although both objects and human subjects are destroyed and reconstructed, the principles of Cubist re-ordering are almost exclusively those of sight alone, detached from other concerns. But it is a very radical break with the conventions of the perceptual orders of art. And so in the case of this painting, when we are invited to bring with our gaze a more affective concern

with the subject, then the rending of the conventions of painterly perception are also a tearing of the features of the face. In this painting the feelings are given expression through the abstractions of art. This does not mean, however, that the feelings are expressed through formal means alone, as though the face of the woman is a dispensable vehicle. What the formalist asserts, namely that the expressive power of a work is carried by the formal means of art, even when a work is figurative, is true. But what he denies, that the recognition of this power need involve no experience from outside of art is not. The figure of Mary in Cranach's diptych of *Mary and Christ* in Vienna has no pretentions to modern abstraction of course. Yet the jagged lines of the folds of her green garment as they fall across her stomach have allusions of a torn and empty womb. Similarly, the Cubistic elements of Picasso's painting make certain aspects of suffering present to our sight through metaphor and simile. The tears gouge the cheek, the features become jagged like glass. To recognise the force of these formal or abstract elements of art we have to bring to the work experience of things from life. Not our own experience of grief necessarily, but of things broken and rent apart, and other things so commonplace as to be unremarkable. This painting, then, through its painterly abstractions, show us something particular about the form of anguish, something hard, tearing and cruel.

These features of the painting however, not only present something to sight in a very particular way, they also thereby shape the possibility of a certain response. It is not a painting which primarily engages a sense of compassion. The style of the work sets up a ruthless distance between the viewer and what is perceived. The fact that emotions involve dispositions and inclinations to act is connected with the sorts of distance set up by art. However, I believe that it is deeply erroneous to think of this distance as always functioning in one way, as one producing complete moral disengagement. As I mentioned previously, in the case of Van Gogh's peasant paintings, his style invites a certain recognition of these people. As such it involves political and moral concerns. But the painting is not a political act. It is a painting done within the institutions of art by someone who identifies himself as an artist. Nevertheless the political and religious framework of his concerns are there for us to see and respond to in the very ways in which his images present themselves to us. It is not of course appropriate to respond to the images of art as we might do to other images in life which demand moral or political recognition. But it does not follow

from this that the responses of art have nothing to do with the moral or political realm, as though the aesthetic were a completely separable order from the ethical, (or as identified together within a transcendental realm of complete detachment). For a painting can present before us the possibility of a certain attitude[9]. This is the way in which the dynamic aspect of emotion, its connection with appropriate and responsible action, is engaged in art. The ruthless distance of Picasso's painting could lead us to attribute to Picasso himself a destructive ambivalence to women conceived as objects of vulnerability and beauty. Just as very different sorts of engagement with the woman are presented through the more tactile and oral abstractions of De Kooning's *Women* series, where the paint is smeared, licked and swiped over and into her body. But here we are using what is in the work as a basis of speculation about the men who painted them, and so leaving the work itself behind. The *paintings themselves* show us ways in which women can be perceived.

Norbert Lynton spoke of the feelings being transmitted through visual *gesture*. The free unmasked brushstroke is offered as the directly visible record of the painter's impassioned bodily gesture independently of any use it may have to delineate the image of any object. The picture we are given is that of the simple release of the energies of any feeling. Even without reference to art, this is of course a severely limited idea of the bodily expression of feeling and of the many different relationships there are between a gesture and what is perceived, felt or intended. Although there are natural or unlearned gestures of the human body, most of the expressive activity of the body is of course structured through conventions of ritual and social habituation and intelligible only within specifiable contexts. The idea of a more 'primitive', 'elemental' gesture which the expressionist painter is supposed to be able to give release to, not only ignores the ways in which human gesture has significance, subtlety or power, but also ignores the fact that these gestures are made within the context of art. Where the immediate context of the gesture is art, when it is a mark on a painting, then its significance and power has much to do with the historical conventions of painting. In a painting the physical presence of the artist is of course absent. But in the sorts of account I am here criticising we are given the idea that in seeing the body's traces we are in some privileged position to witness some direct outpouring of feeling. The grip of these

ideas is sometimes tightened by analogy with dance. For of course, the body is the medium of dance.[10] This analogy is itself based on a mistaken idea of dance. Dance is not a means whereby the dancer or even the choreographer uses the body and some supposedly natural repertoire of gestures to express their feelings, to externalise their inner state. Dance, like any other art form, has a history, its forms are structured and conventional. The dancer works not from some force of feeling working up inside but from a keen awareness of kinaesthetic sensation, sensations of balance, support, transition of movement, weight, extension etc. Many contemporary choreographers claim emphatically that their work is non-expressive. But in so far as the movements of the dance are intended or seen as expressive, the particular formal conventions of the dance have to be understood and the movements have to be made specific through the context of props, costumes and even narratives. In so far as the gesture is not supported by these constraints on medium, only the most obvious or extreme states of emotion, in the simplest or even banal form have expression.

Consider two strikingly different expressive paintings of dance from the early modern period, Matisse's *Dance* of 1909 [PL. 14] and Nolde's *Dance Around the Golden Calf* of 1910 [PL. 13.]. In Matisse's painting there is a flowing rhythm, the dance is joyful and elated. Whereas Nolde has painted a dance vividly expressive of a more violent and insistent rhythm. Both are expressive in the virtue of the fact that the formal elements of the painting reveal the energies of the dance. The differences in what is expressed however is not brought about merely by the postures and relationships between the figures. Nor is the difference merely a matter of the way in which the paint is applied. For each exploit different uses of essentially spatial conventions of painting. It is within this context that the gestures of Nolde's work are more expressively violent. The surface on which Matisse's figures dance is ambiguous between ground and background, so that any distinction between the space or ground beneath the feet, and the space behind the figures is lost, consequently, the figures seem to be in some non-defined space of air. (This is a slightly different application of the familiar formal point that Matisse has a masterly sensitivity to the tensions and ambiguities between the flat surface of the painting and the surfaces of things within the painting.) Nolde in contrast, provides an illusion of recession and distance beneath the dancer's feet. The figures seem

therefore to make more emphatic contact with the enclosed area of the earth.

The gestural marks on an Expressionist painting, then, are first and foremost, marks on a painting. This truism is significant. For although it is true that certain ways of making marks, such as those in a doodle, can have expressive characteristics of their own, can be described as frenzied, agitated, timid or whatever[11], a mark on a painting has around it in addition the aura of all the different marks to be found on other paintings. The artist is not simply doodling and betraying a state of being, is not simply giving vent to feelings with a swipe of paint, but is applying it with some awareness of many other ways of marking a painted surface. A mark of paint can evoke, and not just represent, textures and surfaces of things in life, things which are peeling, stained, slimy, scratched, glacial, rough etc., and so be expressive without any reference to action. The application of paint has its own formal and conventional rhetoric. Barnet Newman spoke of the even and disguised brushstroke of traditional paintings as an 'established rhetoric of beauty'. By this I think he alludes to the fact that the surface of such a painting is a sensuously beautiful finished object. However horrendous the scene depicted we are sensuously seduced to gaze upon it. Thus the subject is elevated through beauty. Emile Nolde speaks of his experience of rubbing and scratching at the surface of his work in the attempt to reach something deeper. These two remarks indicate to me not the attempt to use the brushmark to produce some more direct or spontaneous expression of feeling, a feeling which would otherwise somehow remain obscured behind a more finished surface, but a dissatisfaction with the inherited conventions of painting. The polished surface of concealed brushwork puts things at a distance, renders them untouchable. Certain conventions of applying paint, as in dance certain conventions of movement, make certain experiences not only impossible, but more significantly, inconceivable.

It may be thought that these remarks about gestural expression have glaringly overlooked the example of Abstract Expressionism. The immediate artistic background to those paintings of the late 1940's and the 1950's was, after all, the Surrealist enterprise of 'automatic writing', where marks and images were supposedly poured onto the canvas as though directly from the artist's psyche without any artistic mediation or intention. Surely Jackson Pollock's paintings offer us major examples of the expression theory of painterly gesture? Well, I think not. I do not

even think that these works are primarily expressive. And this is not merely because nothing is expressed, for I do admit that a mark can have an expressive quality without there having to be any object or situation towards which feelings are expressed.

Reports of the stated aims of those who became the leading painters of the New York School often mention the urge to break away from the traditions of European painting. In a courageously direct sense, Jackson Pollock's paintings are without tradition. The marks are made within a vacuum which has displaced the tradition of the images of European art. With these paintings the traffic between art and life seems finally to have ceased, and the processes of applying paint to a flat surface have unequivocally detached themselves from the uneasy relationship which they had to the spaces and surfaces of everything which engages us outside of art. It is in this context that Rauschenberg's wish to 'bridge the gap between art and life' becomes intelligible and the constraints on the ways in which it was open to him to do so become clear. As the critic Harold Rosenberg put it, "the apples have finally been brushed off the table . . . so that nothing would get in the way of the act of painting". But although this way of putting it does portray the decisiveness of the project in a particularly vivid way, it can be misleading. For it might seem to suggest some single sort of activity common to all traditions of painting, which can be detached from each of them. This idea of a pure act of painting can be tied to a vague concoction of ideas stemming from nineteenth century Romantic theory in such a way that we are presented with the idea that these Abstract Expressionist works have achieved an expression of the pure creative act, as though the artist was a mere channel for the creative will itself. Such claims are a mystification. There is no pure act of painting which can be detached from the changing principles which govern its process at different times. These principles are tied to different interests and concerns from outside of art, both technical and ideological. But more significantly for the case of Jackson Pollock's work, these principles are also tied to different ideas about the processes of unification within a painting, and to ideas about the spatial properties of marks, whether or not these are put to the service of figuration. Secondly, and relatedly, the notion that with Abstract Expressionism we are somehow involved more directly in a pure act of painting returns us again to the claim that we are now in touch more directly with the artist's self. He is supposedly expressing himself in a way unmediated by the history of the conventions of art.

(Cf. Cardinal's fundamental tenet of Expressionism; "the true creative impulse springs from a source . . . untouched by knowledge of academic art, art history and indeed history at large.") This self which is being expressed can be none other than that spurious idea of will or assertion which arises when the freedom of the individual is sought for in isolation from those historical and social determinations in terms of which anyone presents to themselves the issues of choice, responsibility and liberation. Thus these works seemed to some to be a supreme manifestation in art of the Existentialist pure act of assertion. In these terms it is obvious why Abstract Expressionism has been a target within polemics about American liberal theory and policy during the Cold War period.[12] (In 1944 the painter Robert Motherwell said, "Modern art is related to the problem of the modern individual's freedom. For this reason the history of modern art tends at certain moments to become the history of modern freedom." I draw attention to the fact that this was said, about these works which defiantly abstract themselves from more concrete issues of freedom, in 1944.)[13]

If our response to Pollock's paintings, then, is mediated through some of the ideas in the contemporary critical writings which brought them to prominence, it seems that we can see them as little more than arenas for empty and meaningless action. However, if we explore the complex surfaces of the paintings themselves, and bring with our gaze not so much the words of the texts which surround them, but our experience of other paintings, then we no longer need search for the self of some vanished presence. These paintings yield up a single-minded engagement with a very specific sort of sensual fascination and pleasure. The historically specific pleasure of the extensive accentuation and modification of a painted surface. The constraints which structure this pleasure are not essentially private to the painter. They are constraints subverting many of the previous assumptions about pictorial unity and about the spatial coherence of painted marks. These paintings are active both within and against traditions in which the process of painting consists of the application of marks of various tones, colours, opacities, size, texture and direction in order to organise a certain unity within which allusions are made to background and foreground, solidity, depth and distance. Even in cases of previous works which are abstract, the painted marks are subject to such conventions inherited from a figurative tradition. A painting by Pollock, such as *Autumn*

Rhythm [*PL. 16*] singlemindedly rejects and fights against these conventions. It is this, above all, which distinguishes his paintings from that of many others which are often aligned with them, such as those of Georges Mathieu, whose paintings remain, ultimately, decorative. The energy and freedom of Pollock's works is not, then, the expression of a free individual abstracted from history. Certainly they have immense vitality and energy, but for all that, I do not think that they are primarily expressive. They are the result of a skilfully sophisticated *cognitive* form of attention to more formal aspects of the process of painting. Precisely, however, because they do subvert existing practices, they seem, at first glance, to be works which blatantly eschew all skill, so giving rise to the idea that they are, for that reason, the more primitively expressive.

I now turn more explicitly to that part of Norbert Lynton's remarks in which he speaks of the discovery that purely abstract composition, devoid of all figurative content, is sufficient for expressive power. I want to link this idea with some of the more ambitiously spiritual claims that have been made on behalf of Expressionist painting. The idea which Norbert Lynton speaks of is of course one of the cornerstones of Modernist art theory. I suggest that it is an idea, which, in radically separating the moral from the aesthetic order, leads to the necessity of locating the deeper significance of art in some purely theoretical realm. We are familiar with ideas expressed at the beginning of this century by writers such as Roger Fry and Clive Bell, to the effect that the emotions that were finally able to be expressed through the purely formal features of art were not the baser emotions of our daily lives, but something far rarer. Art assumes powers of transcendence beyond the material world. Paradoxically, art, gloriously founded in the sensuous, is offered as means of the liberation of spirit from matter and of ourselves from history.[14] In contrast to these views, I believe that where feelings are abstracted from the context of our lives, they become merely abstractions of feeling.

Wassily Kandinsky has probably been the most theoretically ambitious and the most influential writer about these ideas of an art which is a means to the most pure and deeply spiritual of emotions.[15] He claimed that the pure abstract forms of painting can liberate us from our responses to colour and form which are fixed to the leaden and glutinous things of the world. His writings are notoriously a melange of

ideas taken indiscriminately from German Romantic philosophy transformed through Rudolf Steiner and Madame Blavatsky.[16] (I am not
going to try to deny that there is some substance to the idea of a
harmony of experience which can elevate us from the weight of desire
and illusion, but I do not think that the sort of spiritual discipline which
is required can be achieved in the ways indicated in Kandinsky's writings. Whatever art's relationship to the spirit is, it is surely something
which shines its light onto the things of this world, not beyond them). It
is his more prosaic ideas about the nature of emotions and their transmission through art that I shall here take issue with. Kandinsky presents
an emotion as some purely internal event identifiable only by an awareness of its formal dynamic direction. It is a short but backwards step
from this idea of an emotion which is abstracted from its connections
with judgement, perception and action, to the idea of the purely
abstract forms of painting detached from their specific and non-generalisable connections with things which have form and colour.

Although it is true that colours and shapes have conventional and
even perhaps natural associations with certain feelings, and can seem
to have their own internal dynamic relations, the sort of analysis which
Kandinsky offers cannot begin to do justice to the complexities of the
matter. The sorts of feelings involved in such generalisations about
colour which he and others make so easily are most often both vague
and obvious. Gaiety, tranquillity, dominance, aggression, bleakness, are
some of the associations which may easily be made with certain configurations of colours or shapes, but there is little possibility for subtlety
even within these. Feelings essentially connected with human vice and
virtue, such as generosity, humour, pride and many of the others which
give art its moral depth and complexity, are not obviously within the
range of purely abstract form. I suggest that colours are, in general,
more evocative of sensations than emotions. Consider some of the
adjectives descriptive of colour. Many are taken directly from characteristic colours of things in the world, natural or artificial. Thus to
describe white we speak of snow, milk, steel, bone, and as such these
descriptions have all the associations with and resonances of these
things themselves. Other adjectives, such as *acid* green, *delicate* pink,
velvety brown, *cool* blue, *muddy* purple, *lurid* orange, *silky* beige pick
up more directly from our sensuous relationships to the things and
surfaces of the world. It is perhaps a third group, those adjectives which
pick up from the saturation of the colours themselves and their quality

of light, which are least grounded in our concerns with things and their surfaces. Adjectives such as translucent, cloudy, sombre, radiant, glowing, which speak of a quality of light or of darkness. Colours with these features have associations with all that the role of light and its absence, in all its various natural and artificial conditions and qualities, plays in our lives. Dawn, gloom, sunlight, night, storm, interrogation. Here perhaps, are the resonances of death and beatitude. The different expressive power of the different colours surrounding the images of the lamps in Van Gogh's *Potato Eaters* and his *Night Cafe* are resonant with many of these features. As is, I believe, the deeply moving power of Rothko's painting.

In various infinitely complex ways, then, the expressive qualities of colour are tied to the material conditions of our lives. If this is correct, then there can be no theory of colour which captures the complex ways in which the emotive significance of colour is woven into our life. The ineffability or indefinability of the emotions supposedly expressed by purely abstract form is, I suggest, a quality of unresolvable ambiguity, of elusive suggestion. These are not insignificant features, but they are more meaningfully qualities of mood and sensuous pleasure than self-sufficient pointers to some transcendent realm. For the same reasons, I do not think that there can be any formal structural system of colour for the artist, of the sort sought by Peter Lloyd Jones in his contribution to this volume. There are, as he says, many interlocking orders in the expressive and significant features of colour in art, and he has well indicated some of these. But I think it is mistaken to believe that expressive abstraction in colour requires or can have any general or systematic elucidation or purely formal analysis.

Kandinsky and others, as we saw earlier, made much of the analogy between abstract form in painting, and music. Although this is an analogy certainly worth investigating, I believe that it nevertheless falls seriously short at the most crucial points. For music has a dimension of time and development, an essential use of silence, and an extremely complex set of structures which may have loose analogies, but which have no direct parallel in colour and shape. We may well have a vague synaesthetic sense about which colour is associated with which instrument or even maybe with which chord, or even further, which range of colours with which key. But tonal music has rules of modulation through keys, rules which have no strict analogy with the modulation and transformation of colours through the colour circle. It is these

complex structures of music, as they modulate through time, so creating a sense of narrative and a possibility for internal reference, which enables it to express a more subtle and penetrating range of feeling. Music also has a basis in the voice and all that can mimic it. So it can be as evocative as the wordless voice or the tonalities of a conversation in a language which one does not understand. Although shape may have echoes in the posture of the body and in its weight and vulnerability, (a fact which impressed Roger Fry and which is fully exploited in cartoons), there is again no parallel with the rules providing for the richness and complexity of aural elements in music. No, it is only when shape and colour are allowed their allusion to the surfaces of things in the lived world and to the space wherein we can move with others that they achieve anything like the same subtlety of expression. Colour and tone are what produce our sense of substance. Plato was right — painting deals with the corporeal. It is a way of bringing the body into form.

In 1948 Barnet Newman wrote a well known paper in which he connected his painting with the idea of the sublime.[17] In it he proclaimed, "We are re-asserting man's natural desire for the exalted, for a concern with our relationship to the absolute emotions." The 'we' here are the artists. For the original act of man, he says, is the artistic act. The act of calling upon and addressing the Unknowable. Barnet Newman's metaphysical ambitions for painting reach an end point in the modern project of exalting the abstract as a means of expression of the most profound emotions. What does he mean by the 'absolute' emotions? From the immediate context within his paper, he means emotions which are not located within the finite, quotidean, forked experience of our own personal and social histories. Emotions which arise from a confrontation with the Unknowable, the grounds and incomprehensible limits of experience. How can art be an expression of these things? By clearing the field of awareness of all the allusions to natural and social phenomenon, of all anecdotal and personal traces. But these are negative prescriptions. What would a contemporary image of sublimity be?

In an illuminating paper Paul Crowther shows how Barnet Newman's paintings use a non-representational symbolism in order to express humanity's relationship with the Unknown.[18] Newman's painting *Onement III* of 1948, [PL. 19] consists of a single coloured inverted rectangle of a slightly differentiated dark brownish red intersected with

a rough thin line of paler red. Paul Crowther argues that if this image is put alongside Barnet Newman's writings, then there is an implied analogy between the two. Just as the stripe, or 'zip' is properly defined and comprehensible only through its opposition to the colour field, so humankind can only define and express its own finite rational nature in opposition to the infinite and unknown. As Paul Crowther goes on to say, despite Barnet Newman's claims that he was creating images whose reality was self evident, this awesomely ambitious idea is far from evident merely by gazing at the paintings. The deeper significance of the painting is only revealed in the context of the words. One effect of this is that Newman's paintings have been all but severed from his esoteric writings and have been absorbed within latterday Modernism as primary examples of colour field painting. But more devastatingly, Paul Crowther points out how Barnet Newman effectively reduced the expression of the transcendent sublime to a mere visual formula. A formula which lost all ability to generate new forms or to renew any experiental engagement with its repeated applications. Could this have been avoided?

Barnet Newman's painting stands in need of its ambitious theoretical support because of the private and singular nature of the symbolism. He does not draw upon, indeed he explicitly eschews, any of the more public symbols or images which have given expression to our sense of the unknown, of the ultimately mysterious, the tragic, the inexplicable, of good and evil. For all such images are fixed to their time and culture, they localise the understanding. He thereby endorses Kandinsky's proclamation: only through complete abstraction can such limitations be transcended. I believe that this heroic conclusion of Modernism however, is poignantly false. The conclusion is, rather, that the shifting and relative images of transcendence which we create for ourselves cannot be surpassed and given expression in images denuded from the forms of our own historical self understanding. Furthermore, many of the attempts to do so are vulnerable, as symptoms of defence and retreat. In many religious traditions, there are the well known restrictions on representing or uttering the image or the name of the divine. Barnet Newman's work possibly has sources arising from a respect for this idea. But another source of the notion of the sublime is to be found in the Classical writings on rhetoric [18]. There is a sublimity of thought sometimes recognisable in speech at the point where the orator reaches and holds a silence. I think there are two significant features about this

idea in its Classical context relevant to Barnet Newman's work. First, the orator has some 'nobility of character' some authority to be heard. Secondly, the moment of silence gets its significance and solemnity from what is said around it. I use these points to suggest that there is a significant difference between the silence of Barnet Newman's canvases and that within the religious context. For the silence within the context of religious ritual gets its significance from its place within the practices of some collective faith. The context in which the presence of these works is interposed however, is that of art and its institutions, and the questionable role of these within society more widely. Therefore the silence of such paintings has no such public authority or eloquence.

Contemporary 'Neo-Expressionist' painters are now realising a new vision through figuration. Some of them attempt to retrieve the mythological images of the past in order to give expression to concerns of sexuality, death, or time. But these dead images become merely rhetorical hostages to reaction in the context of the contemporary world. In the attempt to reintegrate art within the rest of our life any figurative image has to take its place within the rest of the public and media imagery with which we surround ourselves. Imagery which reduces the tragic to spectacle and the mysterious to banal fantasy and to the demonic. The contexts and juxtapositions in which such images are placed and the interests which they serve make any adequate human response almost impossible. In this context the task of any contemporary figurative imagery of art which claims to be expressive of human concerns must be to *locate a context and style* for the image in which, in Max Beckman's words, to 'fix' it, so that its meaning and significance is most adequately revealed.

University of London

NOTES

[1] Quotation from the translation of Max Beckman's lecture *Meine Theorie in der Malerie* given at the New Burlington Gallery, London in 1938, taken from H. B. Chipp, *Theories of Modern Art*, (Berkeley: University of California Press, 1968), p. 188.

[2] This point was discussed more fully in the television programme, 'Rooted in the Soil' made by Fred Orton and Griselda Pollock for the Open University course *Modern Art and Modernism*. Notes for the programme printed as part of the Modern Art and Modernism course, Open University Press, 1980.

[3] Roger Cardinal, *Expressionism*, (London: Paladin Books, 1984). Compare also the remarks made about the 'Neo-Expressionist' painters in the catalogue to the Tate exhibition *New Art*. (Michael Compton, *New Art*, London: Tate Gallery Publications, 1983, p. 24—33).

[4] Norbert Lynton, 'Expressionism', in *Concepts of Modern Art*, ed. Nikos Standos (London: Thames and Hudson, 1981), p. 30.

[5] For a qualified defence of a causal account see 'Art and Language; "Abstract Expression"', in C. Harrison and F. Orton (eds.), *Modernism, Criticism, Realism*, (London: Harper and Row, 1984).

[6] Cf., Andrew Harrison's discussion of 'occurrence detachment' in this volume.

[7] For a much fuller discussion of this point see Marcelin Pleynet, *Painting and System*, translated S. M. Godfrey, Chicago: University of Chicago Press, 1984).

[8] These points about the relevance of the medium and the procedures of painting to any adequate understanding of the significance of what is represented are examined from a different direction in the contribution to this volume by Michael Podro.

[9] See also Paul Crowther's discussion of the relations between art and morality in his contribution to this volume.

[10] During the conference which occasioned these papers, the dancer Sarah Rubidge gave an informal talk and demonstration on 'Expression and Abstraction in Dance' which made the points discussed here clear for those fortunate enough to be present, in a way which perhaps is not possible in print.

[11] There is a fuller discussion of points about gesture and painting in Andrew Harrison's contribution to this volume.

[12] See, for example, Serge Guilbaut, *How New York Sold the Idea of Modern Art; Abstract Expressionism, Freedom and the Cold War* translated A. Goldhammer, (Chicago: University of Chicago Press, 1983).

[13] Robert Motherwell, 'The Modern Painter's World', Dyn VI, 1944, quoted in F. Frascina, (ed.), *Pollock and After*, (London: Harper and Row, 1985), p. 111.

[14] The remark here is a paraphrase of a similar point made by Susan Sontag in her essay, 'The Aesthetics of Silence', 1967, reprinted in *A Susan Sontag Reader*, introduced by E. Hardwick, Penguin 1983, p. 192. Her essay also informs my discussion of Barnet Newman's work.

[15] Wassily Kandinsky, *Concerning the Spiritual in Art*, 1912, translated M. T. H. Sadler (New York: Dover Publications, Inc.), 1977.

[16] There is of course an important place in art history for the study of the sources of artist's writings. In his contribution to this volume John Gage marshalls the materials for such a study, but unfortunately he takes the ideas at their face value and uncritically assumes that they can inform us about the expressive qualities of colour in some general way.

[17] Barnet Newman, 'The Sublime is Now', *Tigers Eye*, No. 1, October 1947, p. 551. Quoted in H. B. Chipp, opus cited.

[18] Paul Crowther, 'Barnet Newman and the Sublime', in the *Oxford Art Journal*, **7**(2), 1985.

[19] See the reference to Longinus' text on the sublime in J.-F. Lyotard, 'The Sublime and the Avant-Garde', *Art Forum*, April 1984.

ANDREW HARRISON

DIMENSIONS OF MEANING

> Whilst a man is free — cried the Corporal, giving a
> flourish with his stick thus —

> A thousand of my father's most subtle syllogisms
> could not have said more for celibacy.
>
> Sterne, *Tristram Shandy* Vol. IX, Chap. IV.

1. INTRODUCTION

This is in many ways a highly schematic paper, more strategy than
tactics. In what follows I shall try to explore those senses of 'abstract'
and 'abstraction' that overlap and interact with each other across a far
wider field than that of 'abstract art'. My claim is that abstraction in art
does have a definite location within that field and that how to place it
can take us a long way towards understanding what abstraction in art is.

My most contentious subsidiary claim is that just as the very idea of
abstraction in other areas tends to get entangled with notions of mean-
ing so it *should* do even in the area of the visual arts. The underlying
issues are the same throughout. In arguing for this I shall make use of
two somewhat technical notions. The first is that the primary condition
of meaning, in however wide a sense we choose, is the possibility of
that sort of fictional pretence that permits the possibility of acting as an

Andrew Harrison (ed.), Philosophy and the Visual Arts, 51—76.
© 1987 *by D. Reidel Publishing Company.*

actor may perform. The second is that we should consider any mean-
ingful object, be it a picture or an utterance, as kind of locatable solid
within a 'space' of quite different sorts of intersecting 'dimensions' of
significance and in particular that to ascribe significance to the visual
arts is to locate their products properly within that 'space'.

2. MEANING AND ABSTRACTION

It might seem that the very idea of abstract art should rule out con-
siderations of meaning. For as far as the visual arts are concerned
'abstraction' has come to be used as a shorthand for what is non-figura-
tive, non-representational. Since any core concept of 'meaning' essen-
tially requires some concept of reference, of being 'about' something, it
might seem to follow that an art form that has as its essential charac-
teristic a lack of 'aboutness' cannot legitimately be approached in terms
of meaning, that to just the extent that a work *is* abstract an interest in
its 'meaning' is rather obviously wrong-headed. My question is whether
what seems so obvious really is right.

Slogans come readily to mind. "Don't obsessively ask 'what does the
thing mean?' Pay attention to the thing in its own right, not to some-
thing outside and beyond it." Thus the propaganda of art shifts from a
concern with what is non-figurative to an insistence on the value of the
purely formal. (And, correspondingly, as the pendulum of art, and art-
school, fashions swings back it can seem that a return to the figurative
must be to avoid the sterilities of a 'meaningless' abstractionism. If only
things were ever that easy, that simple!) There is no doubt, of course,
that an obsessive search for meaning can often be a fatal barrier to
understanding in the arts. A new sort of dance, a new sort of music,
a strange kind of picture, even a new sort of story, all need to be
responded to in other ways than by a senseless search for sense. Yet
to say all this can also be oppressive and mystifying. It leaves the
bewildered bafflingly unaware of just what *is* to be expected of them if
they are not to be consigned to the outer darkness reserved for the
philistines.

We need to make common cause with the bewildered. That is, after
all, the *first* business of philosophy, even if philosophy should never
rest there. But more specifically, about the only thing that is clear about
the slogans of the above paragraph is that virtually all of the key terms
are either obscure or question-begging. Worse still, practically none of

them can be avoided when we try to talk sense about the arts. To advocate silence, as certain practitioners do (and *can* do in good faith just so long as they *are* absorbed in the practice of their art) is no help either. For we are still faced with the question what *kind* of silence to advocate: good ways of attending, of responding to, of grasping what a work sets before one are not the product of the mind's absence, but of its presence; they are cognitively rich. We cannot deny that richness. The problem is how to honour it. A large part of that problem is how to find the right analogies. This precedes the right analysis.

So far the principle terms are 'abstraction' and 'meaning'. Something should immediately surprise us about this. This is that while, on the face of it, at least, in the context of visual art these two ideas seem to pull away from one another, in other contexts, especially those most familiar to philosophers, they seem inexorably to pull together. For in familiar philosophical contexts theories of abstraction tend to *be* theories of meaning. One reaction to this could be simply to note that issues in different areas naturally are different and to set up warnings against an obsessive search for general unity. But that would be an idle response. Philosophers of art would do well to note that these concepts of meaning *are* the stock in trade of *any* philosophical enquiry, no less puzzling outside the context of art than within it; that the visual arts are not composed of words does not make problems of 'meaning and abstraction' essentially more recalcitrant than elsewhere, even if it may make for different *sorts* of difficulties. The most general problems set by the philosophy of art are no different from those set by the philosophy of anything else.

The term 'abstract' seems to indicate two quite different ideas.[2] Firstly, there is the idea of considering something 'in the abstract', that is to say for itself apart from any context of further use, meaning, or origin. Often enough this has behind it some definitely present, if distinctly vague, sense of condemnation. Thinking about things 'in the abstract' is what sensible people know that academics do, and we all know what the common sense of a 'purely academic question' is. But on this side the positives are familiar enough too. One might in this way consider the wave-formed pattern of the sand on a beach for *itself* without thought of how it came about, what further phenomena it might illuminate, just as a lovely thing in its own right. To many this sort of attention has something centrally to do with the very idea of 'aesthetic' response since there is a powerful and influential philosophical tradi-

tion that has it that the very idea of an aesthetic judgment just *is* that of one divorced from such extraneous considerations. I could make no attempt to defend that tradition[3], which seems to me to be essentially wrong-headed, but what sustains it are some very deeply held, essentially moral, attitudes about the value of how we act and react to the world. It matters that this sense of 'abstract', of 'abstracting', does mark the battleground of what look to be deeply divergent, highly antagonistic ideologies — even if the struggling protagonists are vague and unformed monsters of prejudice. But if we link this thought with that of a work being abstract insofar as it is *not* 'figurative', not a depiction, not having a significance outside itself, it is clear that these thoughts together can give rise to a powerful, and manifestly troublesome, doctrine which has it that most of what we have traditionally cared about in the arts should become aesthetically irrelevant.

The aesthetic value of what is in some sense or another non-referential implies, of course, nothing of the kind and only a silly sort of search for the wrong sort of generality would lead us to suppose otherwise. One way of seeing this can be to note that this idea of 'pure' abstraction can be opposed to, but also goes along with, a second idea of abstraction, namely that of abstracting *from* something *towards* something else. If the first of these concepts of abstraction has us thinking of the 'abstract' object in itself, isolated from process and becoming, this second concept has essentially *to do with process*, normally something that marks a stage within, or towards the end of, a mental, or interpretative, process. This is why in its most familiar contexts it is bound up with the idea of *meaning* and with the matter of *making* meaning.

The process may result in the construction, or the evolution of (none of these semi-metaphorical expressions ever seem quite right) 'abstract' concepts, ideas, 'objects' and so on that can be themselves considered 'in the abstract' in the former of these two senses. Tensions between these two conceptions cause difficulty in theories of the 'abstract sciences' that have to do, for instance, with the idea of 'pure' mathematics — tensions that it is familiar to find illuminating. They may be similarly illuminating in the context of the arts. For what seems to be involved in all these cases is a difficulty about how to capture the right account of the processes of development in our own awareness itself.

Thus a picture whose content has been abstracted *from* some source in the second of these two conceptions of abstraction may always be regarded in itself, abstractly. This is central to the problem of under-

standing works of art; that they are both the outcome of a process of making (of being 'worked') and also objects in their own right that can be set *free* from that process. But the same thing may be said of non-art objects too, for example of a theory, or a system of ideas. The point is not well made by saying that such made things are in some sense 'concrete' objects as opposed to 'abstract' ones. It is, rather, that these artefacts of the *intelligent* process of their making (whether works of art or other sorts of works of the understanding) derive their life from a constant interplay between these two sorts of abstraction.

3. A TRADITIONAL ACCOUNT OF ABSTRACTION

For most philosophy students the familiar starting point for the exploration of the nature of abstract*ing* kicks off from Locke's account of the origin of 'abstract general ideas' — sometimes from Berkeley's apparent rebuttal. The account is of a process, the rebuttal considers the end product. But a more illuminating sample may be Frege, who, while in the tradition of Locke's narrative, is more simple and more direct. His starting point is simply the matter of detaching aspects of our attention to a complex experience.

> ... We attend less to a property and it disappears. By making one characteristic after another disappear we get more and more abstract concepts. Inattention is a most efficacious logical concept ... Suppose there are a black and a white cat sitting side by side before us. We stop attending to their colour, and they become colourless, but they are still sitting side by side. ... We stop attending to position; they cease to have place, but still remain different. In this way, perhaps, we obtain from each of them a general concept of Cat. By continual application of this procedure, we obtain a more and more bloodless phantom ... bringing an object under a concept is just recognition of a relation that was already there; here objects are essentially altered by abstraction, so that objects brought under one concept become more alike. (Translations from the *Writings of Gottlob Frege*, P. Geach & M. Black, p. 84)

Abstraction, in other words, is *ex*traction. For all that he refers to 'bloodless phantoms', there is no reason why this account *needs* to be of something that points towards the abstractions of mathematics or towards 'idealised' or exact, highly formal concepts. The process *need* not have lead towards the 'bloodless phantom' abstract general idea of 'Cat', or of 'discriminable object': a very similar process might have lead to that peculiar black fuzziness, or that peculiar quality of white, exhibited, brought to our attention, by the two cats. Or, *extracting* our

attention to the cats *from* the complex of attention possibilities we might *abstract to* such products of creative inattention as colour relations or adjacent masses, as such.

The account is so general, in other words, that it could as well be offered as a story of a painter's controlled process of aspect discrimination, as of a thinker's construction of concepts. It is a seductive story. What is most seductive about it is that it has to do with a hugely general account of the making of meaning and, seductively, it beckons us further. For the story it tells is how by such inattention to what ties the content of our experience to particular occurrences, by generalisation *itself*, we can detach the content of our thought from the *occurrence* of our original attention. For meaning depends on that detachment. Meanings are *portable*, can be carried away from particular incidents of awareness: an animal that can 'understand' its experience to any degree (*whatever* this means) is thereby able to escape the grip of the passing moment, and thereby able to make sense of it. This tells us next to nothing about meaning, but not *quite* nothing. It gives us the first minimum.

But we only have to try to tell the story in the context of making a drawing of a pair of cats to see how tiny that minimal illumination is. Inattention *could* not be the whole of the story, could not even be its first episode. The process, if it is to work at all, must require that meaning (even in this most generous of senses) must also be *marked*. If words are our medium they must work as words, must have semantic and syntactic interconnections with one another that take us far beyond the mere residue of inattention. If the process is to be marked by paint or pencil that must somehow be put onto the surface in a definite way (if the expression were not so outworn, we might say a 'style'). If what is extracted is to be marked, the marks must have their *own* vitality. If we are to mark, learn, what we see, whether we read it or not, our ability to inwardly digest it requires that a mark is *made. That* colour, *that* texture, however it has its origin in selective attention to the cats, *can* only be carried in terms of the colour or the texture of pencil, ink or paint, or of whatever else we may have to hand or call to mind. If abstraction-by-impoverishment is to be achieved at all it can only be in terms of the corresponding enrichment of whatever medium it is that conveys the process. By itself, mere inattention achieves nothing. The original sin of empiricism is to overlook this.

What has all this got to do with the visual arts? In saying all of the

above I have been going on as if the obvious differences between picture making and talking and writing were not there at all, as if I have naively assumed that thought that can be located in language use must have core features in common with thought involved in the use of paint, paper and pencil, that the use of paper and paint and pencil is to express thought in whatever way the use of words and sentences is to express and exercise thought. Much has recently been said about, and much more against, the idea that there is some parallel to be drawn between the cognitive process and problems of language and the cognitive processes and problems of art-works, as if the issue was whether ways of drawing or painting were a sort of language (or whether there is a 'language of music').[4] I certainly know of no serious thinker who has wanted to maintain that understanding a work of art is *just like* understanding a language. For one thing it is quite unclear what we could even be asked to *imagine* as an analogue to grammars or dictionaries for painting (whatever iconography is or could be it isn't *that*). What can tantalise, however, and not irresponsibly, is the thought that some parallel must be illuminating. If it is to be illuminating it will be so only if we can find some deeper source for the parallel than language's distinction between syntax and semantics. Such a thought is not irresponsible even when, especially when, it hasn't yet emerged in the form of a clear question. I suggest that the true parallel is that to make something that enables us to break away from the grip of the passing moment of attention *is* to make something which we can stand back from as an object of significance *in its own right*, and that this is why to be puzzled by abstracting is to be puzzled by meaning — the two concepts pursue one another.

4. MEANING: DETACHMENT AND THE POSSIBILITY OF FICTION

Not everything that is open to intelligent understanding and interpretation is a matter of meaning. It need not be even where what is open to such understanding is essentially the production of some mind, produced, that is, by an agency whose psychological characteristics *have* to be taken account of in any understanding of what it has made or done. For in some general sense of 'communicate', which means more or less how one of us may come to understand the state of mind of another, a great deal of our communication is not mediated via *any* system of meaning. For instance, blushing, tumescence, pupil enlargement and so

on can give a pretty fair indication of another's psychological state, and
all together such symptoms would give very precise indications. None
of them, despite certain modish talk about 'body language', are part of
any system of communication that could be called a system of *meaning*,
One reason for this is that such systems are non-intentional: so they
can't be faked non-misleadingly, fictionally, can't be *acted* — or at least
not well enough. It is not just for social reasons that one cannot have a
polite erection. In the same way, while one may readily enough grasp
what the psychological state of a dog is from its behaviour, from its tail
wagging, quality of barking or whining, that too is not even *analogous*
to a canine language. For gesture to be at all like something that means,
that expresses a psychological state even in terms of an *analogy* with
language, however loose, it must be voluntary and fakeable, actable, as
an *actor* can act.

I often suspect that my dog can fake cheerfulness, can wag her tail
on purpose (if not *for* a purpose) so that I think she is happier than she
is: thereby she placates me, reassures me or could another dog. Of
course I don't *know* this and good hard-headed theorists may tell me
that I am being absurdly anthropomorphic. This fear leaves me virtually
unmoved, but not quite, for what even I am not prepared to suppose is
that she can show me how *another* dog *could* feel, or how she might at
other possible times — "like *that*, you see!" The first analogy with
language must be that the components of any candidate for a 'system of
meaning' should be capable of being *detached* from their utterance
occurrence 'into' a system. If understanding another's state of mind is to
be (even in the most loose sense) to do with 'meanings' or is via a
system of meaning it is necessary to be able to say what the com-
ponents of such a system mean independently of whether or not on any
particular occasion of their being produced their producer is in the
appropriate state, but more importantly, this should be capable of
occurring *without deceit*. There is a Wittgensteinian scruple about
whether a dog can lie. This misses the point. The real issue is whether a
dog could produce fiction.

(There are difficult cases here even with dogs: the doggish game of
mouth wrestling, mock fighting that may scare onlookers but never
scares the dogs, is not unlike the standard case of fictional pretence,
playing bears: what anyone who wishes to elevate doggy psychology
towards our own will have to ask about this is whether this could in any
way be interpreted as a primitive or elementary form of conceptualisa-

tion of the making of violent gestures. I personally suspect not, but this may simply be over-caution). The essential point is that for any analogy with meaning to be able to establish itself what is to be understood as having a meaning must be *abstracted from* its occurrence — detachable into a system of some sort. For an action, such as a gesture to be even *like* that its connection with the psychological or mental state of its producer needs to lack that interpretative transparency that does obtain with such evidencing states a pupil enlargement. Meaning is in this sense referentially opaque to the maker's mind.

This is obviously true of words and sentences in English or any other natural language. "I have a headache" means what it does whether at the point of writing this I have a headache or not. I could be lying, telling the truth or merely using a philosophical example. Related to this is a second condition for the analogy of meaning. This is that any system of meaning must be a system of loose-equivalent conditions, such that understanding their sense involves having at one and the same time a grasp of meaning-equivalence within the system and of *how loosely* that understanding can be applied. No two words in English ever mean precisely the same, and no two thoughts (however accurately communicated between two people) can ever be quite alike, if only because the teller's state of mind will be different from that of the told. Yet for all that to understand English is to be able to follow instructions to put what someone else has said "in your own words", to be able to report gists and piths, to be able to translate (however indeterminate the translation) what is said in English into French or German. Indeterminacy of translation, looseness or synonymy, is no more a weakness of language than that it is a weakness of walking that it is controlled falling. Portability of sense depends on such 'weakness'. Understanding the understanding of meanings, then, is coming to understand how we can detach meanings from occasions of their specific use, find equivalence patterns between them, have an adequate grasp of the appropriate looseness of such equivalence such that in putting all that together we can see how meanings can be generated. This is why the pursuit of the understanding of meaning has to be in terms of the pursuit of varieties of abstraction. Why also, the pursuit of analogies with meaning must also be the exploration of varieties of abstraction.

The question is whether the minimal virtues of meaning (which I have tried to sketch in without mentioning the linguistic technical bugbears, 'grammar', 'syntax', 'semantics' and so on, could in principle

be shared by other things than language, notably by pictorial systems, or by the other intelligible aspects of the visual arts. The question is about a search for a useful set of *analogies*: nobody doubts that to come to terms with a painting with full intellectual attention, with as much understanding as one can muster, is not to read a piece of linguistic prose or poetry and it is folly to attack folly that no serious thinker engages in (whatever loose talk may occur from time to time). What is not folly is the thought that some analogies keep pressing their demands on us in this area. It does matter what those demands are.

They have, I will suggest, to do with two thoughts — unclear, perhaps, nagging nonetheless — the thought that thought can be exercised in painting, can be embodied, expressed, in other media than words, and the thought that ways of doing so may be both radically different from the ways of words and at the same time different from one another. The first of these thoughts does not concern the need, whatever it may be, for painters to express *themselves*, but that what they make can, at the end, stand apart from them, can at the outcome of their process of making be at one and the same time 'the expression' of that process and stand as 'an expression' in its own right. Subjectively, to the maker, the joy of completion is of being freed from that intimacy with the materials of the making by something's being able to stand, because any further move would spoil it, *in its own right*. In the sense of 'mean' that means intention (but note the intimate connection between the two senses) successful expression is to be able to say of what is made, or is said or done, '*that* is what I meant': *then* that refers to the object, not an inner state. There is no need to conclude from any of this that something mysteriously internal has been made external, only that what is done can now be in the public domain, freed for others. The publicity of art shares just this with the publicity of language — any language — *however* we may try to extend and loosen that concept.

5. DIMENSIONS OF MEANING

The second thought is different, that there may be different, radically different, ways of achieving this, ways that serve each other, but never *reduce* to each other. This is what I mean by dimensions of meaning.

Different dimensions cannot be reduced to each other, not in the sense that they run parallel and never meet but in the quite contrary sense that they intersect at right angles to each other so that anything

located in their 'space' must have features belonging to each dimension such that changes in one sort of feature never *imply* changes in other sorts. Let's try to flesh out that highly schematic idea with reference to understanding paintings. The idea is to think of a painting as a solid as occupying a position in a space of interpretative possibility.

Consider a picture, not at all 'an abstraction', fully figurative in familiar — if massively complex — ways. It might be a Poussin or a Titian. [PL. 5] We need not be very elaborately educated to recognise that it demands response in a quite distinct variety of ways — as it were in several dimensions at once. The picture depicts people in a landscape who seem to be engaged in rather odd and mysterious activities. The way in which the depicted people and their environment are depicted, are painted, are clearly, if intelligibly enough, different from how other painters might have painted them. The paint itself, the disposition of the colours, the composition, all have forms and features that demand our attention — even if only in being lovely to look at and excitingly handled. We need to know, and to respond to, what is supposed to be happening in the picture, what it is about, what the story is that it tells, the general significance of what is happening to the protagonists and of what they are doing. We are led by the picture into a world of depicted (we ought to say 'illustrated' were the word not so degraded in our time) story. But that narrative world, or world-fragment, is shown to us by the picture's representing human bodies, trees, landscape in its own representational style — and to do that the painter has had to handle materials, to exercise touch and control, gestural rhythm, all of which *contributes* to the picturing, none of which is *in itself* a form of depiction, of figuration. These are logical distinctions. The sense in which the events of a story can be depicted by a painting's being in the representation of such things as make up the furniture or the protagonists of the story *cannot* be the sense in which *they* are depicted. Story-telling and picturing are different sorts of things to do, which is why the latter can be a *means to* the former, but not a *case of* the former. Similarly the control and pattern of putting on paint — its visual gesture — can be an essential means to picturing because it is itself not figurative. These aspects can be orchestrated together in our understanding of the work just insofar as we can distinguish them. The work is, as it were a solid located within three dimensions of our understanding. It should be a further consequence of this metaphor's making sense that the concept of 'style' in the visual arts

should become otiose. Whether this delightful result can be achieved I should not, perhaps, dare to hope.

It is not, I suggest, an outrageous simplification to see the development of recent visual art towards and away from 'abstraction' as emerging from a struggle to recover this fact for us by another sort of abstracting, that of the 'peeling off' of the paradigms of narrative, the paradigms of 'pure' pictorial depiction, and the paradigms of painterly touch and gesture from what we might otherwise see as a too-naturally integrated whole. (It would, however, be better to see the process as radically shifting works within the available 'intelligibility space'.) This has often been accompanied by an obsession with the nature of 'pure' painting 'as such' which can sometimes seem to be neurotic. Why should it have mattered for painters to want to exclude the 'irrelevantly literary' from their art, or to pursue the 'pure' art of putting on paint? What, after all, is wrong with opera? The answer must, I think, be seen in terms of a need to pursue an understanding of the business of the production of visual art itself, which might be called philosophical were it not that in general philosophers showed no interest in the issue and were it not that the idea of being 'philosophical' was felt as an insult by those painters who wished only to stick to their lasts. It is as if a process of analysis had to be undertaken by the institutions of art themselves, for lack of the tasks being performed by anyone else.

6. PICTURES AND STORIES:
TWO OF THE 'DIMENSIONS OF MEANING'

Yet philosophers *were* pursuing parallel thoughts. Ironically, at the time it was most fashionable to insist on the exclusion of 'literary' elements from the pure pictorial exercise in painting, Wittgenstein's pictorial paradigm for meaning in general, for 'how language hooks on to the world', was being developed for and in the *Tractatus*. But what is significant is the huge restriction on what can be said in a language imposed by that model. In effect that restriction excludes the core of what we most often associate with the literary. There is no accident in this. The rather obvious point that any 'picture theory of meaning' is also a 'meaning theory of pictures' is frequently overlooked, but in essence there can be found here a powerful, and essentially very simple, account. This is that a picture — any picture, one of the familiar sort such as a painting or drawing, a map, a diagrammatic 'model' or linguistic

analogues to these things — represents what it does by presenting, via a structural analogue between the picture and its topic, a projective model of the state of affairs it depicts. This means that unit objects in the picture can be unambiguously identified with unit objects in the state of affairs it represents: pictures are homomorphs. It would be a bizarre misreading of such an account to suppose that a successful picture has to have *the* complexity of its topic, such that every unit item in the 'world' must have a corresponding unit item in the 'picture' (such a situation would be like Lewis Carroll's absurd map that mapped everything so that the map of England had to be as big as England itself) pictures provide ways of imposing simplicity in multiplicity. They are how we do come to recognise unit objects, and thus how we do come to recognise relations between them. Realism might suggest that the world as such is bound to be more complex than any picture or model of it, and thus that whole ranges of validly simplified structural 'abstractions' can both legitimately differ from one another and at the same time be capable of 'truly' representing situations in the world as they are, or if imaginary, might be. Another way of putting very much the same point can be that the core 'grammar' of picturing lies in our ability to recognise the different rôles played by pictorial signs for relata from signs for relations: the radical linguistic mistake of supposing that a sentence of the form 'a R b' represents a three-object situation, rather than a two-object one is then exactly the *same* kind of mistake as it would be to confuse the lines in a drawing that indicate the direction of a plane with marks that stand for related objects. Thus when the young Laurie Lee in *Cider with Rosie*, told to 'sit there for the present' waited all his first day at school to be given something, the form of his misunderstanding would have been just the same as if he had seen a steel engraving of his mother as a picture of a lady with lines, a net, all over her face. The analogy between pictures and languages here is that at this point the 'deep grammatical' constraints on understanding are the same. These are the conditions of pictorial fact and fiction.

The first thing to stress about this highly 'abstract' and general theory is that it implies absolutely *nothing* either way about 'conventionalism' or linguistic, or pictorial 'relativism', whatever those doctrines or their opponents really amount to. For it is compatible with it to suppose that any structural analogue could be construed by us, learnt by a convention's being learnt, to 'look the way' things do in the world around us, and it is equally permitted to suppose that we, and the real world are

such that there are tight 'naturally given' limits to this. For the account says, and can say, nothing about our psychology or about the world's causal order. The bite, the sting, of the interpretation of language as pictures lies elsewhere: it is that we seem to be able to do less with language, to say less, than we might have thought we could.

There is a logical gap between picturing and the resources of verbal language that any attempt to use picturing as a model for all sorts of language either overlooks or, more boldly, must deny with catastrophic metaphysical consequences. A picture of a man standing above another bearing a knife may be a picture of a man stabbing another, but the very same picture — the same pictorially interpretable array of line and colour — may equally well be a picture of him removing the blade. This is not just because the picture is still. A film — that is to say a merely moving picture, for films as an art form are *essentially* more than that — while it may show events in sequence, cannot, unless we also have a narrative in mind as we watch it, show why what happens in sequence happens as it does. A film of Charlie Chaplin eating spaghetti may show the stuff disappearing into his mouth: run backwards it will show a different state of affairs, that of the stuff emerging on to the plate. Neither will show whether the agent of these absurd processes was the spaghetti or Chaplin; we have to assume that from what we know of the world of food and people, or gather from what we hear *said* to us on the sound track or in the titles. Cause and consequence, intention and accident are not pictorial matters. Neither are values or selves.

Pictures, in themselves, cannot represent general laws. They may *illustrate* such things and indeed in many contexts of use (in scientific illustration for example) that is their primary function. But then they need for our understanding law-like assumptions on our part; then they may depict samples and examples of what conforms to a general law and thus provide essential aids to our ability to grasp the sense of laws at all. But that is all. This may seem paradoxical in view of the funda-mentally explanatory nature of models, which on this account are embraced by the concept of picture. But models are about structure. Our use of them may claim that such structures instance fundamental laws, but by themselves models, maps and pictures don't make that claim. Most crucially of all, perhaps, from the point of view of the analogy of the metaphysics of meaning with the problems of art, a pictured scene, while it may show what was, or might have been seen, from a point of view, by a conscious self, cannot at the same time

picture that self. To use the diagram re-used by the author of the *Tractatus*[5] the content of the visual field is 'not like this'

5.632 The subject does not belong to the world: rather, it is a limit of the world.
5.633 Where *in* the world is a metaphysical subject to be found?
 You will say that this is exactly like the case of the eye and the visual field.
 But really you do *not* see the eye.
 And nothing *in the visual field* allows you to infer that it is seen by an eye.
5.6331 For the form of the visual field is surely not like this

The conception of the eye-point, the point *form* which what is seen is seen, as standing for the self as subject of experience, that 'I think' of which, in Kant's phrase "it must be possible to accompany all my representations"[6] goes back further, I suspect, than the Schopenhauerian source from which Wittgenstein derived it. In so far as Kant is talking about the transcendental unity of apperception, that conception of the Cartesian self which, being its subject, gives unity to experience without being a part of the experience, this diagram could well have served Kant's purpose. But its implications are present in the very project itself of depicting people who are themselves subjects to experience.

Selves, for example the woman reading a letter in Vermeer's painting [PL. 42], a letter *we* cannot see but know that she can, are capable of being presented to us as eye-points in a perspective field. One of the ways, I would suggest, in which Vermeer's women remain intensely themselves is in our being shown how they can see what we cannot. If we construe the fiction of Vermeer's painting as Walton suggests in this volume we must *also* construe the further experience of those depicted in it. As Svetlana Alpers says of Vermeer's women[7] he "recognises the world present in these women as something other than himself and with a kind of passionate detachment lets it, through them, be." The detachment consists in making no attempt at trying to paint what is 'transcendental' to the depicted scene's 'unity'. To parody Wittgenstein, it is as if "what we cannot see we should not attempt to force into paint". Tact about the reach of an art may lead to its greatest power.

Wittgenstein as the author of the *Tractatus* has to make cause, intention, purpose, value, the self, transcendental to what can be pic-

tured — to what, if we accept the picture paradigm of meaning, can be *said*. Hume equally, whose conception of what is given in perception seems to have been, tacitly, very much that of what could be 'objectively' drawn (or could be photographed) makes very much the same range of concepts lie beyond what could in principle be given to us in experience. The reason has not, I would argue, to do with the material resources of familiar picturing, with light and colour and shape, but with how picturing can cope with the logic of possibility. I may show by a drawing not only that it is possible to draw something, but that in so far as that drawing can be construed as of an imaginary object — and *only* in so far as that is so — that it is possible. Dragons may not be actually possible for there are problems about their genetics and their peculiar chemistry, but if we disregard *all that* as we must if we just look at a painting of a dragon located in the space of a meadow, then that painting, while it does not show them to be real, does show them to be *possible to that extent*. Pictorial imagination, like any other sorts of imagination, like fictional story telling, tests *circumscribed* possibility — not real possibility certainly, but possibility *up to the point that the process of imagining is carried out*. But what we cannot paint, is what *can* make the substance of a narrative: that if that were to be possible, other things must be, might be, could be considered to be. Pictures, we might say, have no internal modal brackets.

The narrative resources of language are, by contrast, rich in just that kind of complexity, the complexity of obligation, of cause, and of course values of responsibility, and of that 'given' that obsessed Descartes; the certainty that we are ourselves, distinct from the world we experience and distinct from others. All these have to do with what must be, might be, ought to be, and so on. To these 'pure' picturing is positivistically blind, all transcend strict pictorial sense.

In the Notebooks that preceded the *Tractatus* in 1914[8] Wittgenstein tells us that to the eye of the artist all things are of equal value, that a stovepipe is of equal value to anything else, except, like anything else, of supreme value as he concentrates on painting it. Compare this to Cézanne insisting that getting the shirt front right was as important as the face of the portrait, or telling his wife to sit like an apple. This is the painting of the metaphysics of extreme empiricism that makes a virtue of the limitations of the pictorial exercise itself, peeled off from the 'literary' — from the topics of talk. The result, for art, is in terms of my metaphor, that painting is understood only in, at best, two dimensions of understanding. The other, yet to be discussed, is to do with 'touch'.

There are two senses in which we may refer to a painting, or a tradition of painting as 'narrational'. Some sorts of painting, history painting, religious painting, the painting of moral narrative (whether we are talking of the *Sistine Ceiling* or the *Rake's Progress* makes little difference) in which the paintings require of us that we assume or construe *specific* stories, narratives or the like. Other painting clearly does not demand this. But in a more general sense no painting can be narrational, or to put the matter positively, *any* painting may require of us that we, assisted but not instructed by, the picture, find ways of transcending the essential limitations of the forms of depiction. This is the heart of the problem of 'pure' pictorial realism. We do an injustice to this when we subscribe to the purist snobbery that reserves the concept of 'illustration' to a certain (low, common and impure) sort of figurative art. For so long as what is depicted is recognisably something that we can care about, whether it be a person, an apple or a mountain, we are challenged by the depiction to reach beyond the boundaries of the *abstraction of being pictured*: the most figurative of art needs to be, demands to be, *de*abstracted by us. These demands constitute the content of that sort of visual art's community of understanding.

7. A THIRD DIMENSION OF "MEANING": 'GESTURE', 'TOUCH', CALLIGRAPHY

But that is so far only to refer to two dimensions of meaning, of understanding. What of the other?

The story has it that the counter example that successfully challenged Wittgenstein's early pictorial paradigm was not a narrative, but a gesture. We don't know *what* significant gesture, but only that it was meaningful, expressive enough and that the challenge was to find the logical (i.e. pictorial) form of *that*. But *could* gesture, as such, have 'meaning' in any useful sense?

In painting the idea of gesture may seem to be an odd one, but I can think of no other general concept that quite as well captures the matter of the handling of paint and materials that is sometimes called 'touch'. Just as playing a musical instrument is more than a matter of sound, but of touch and movement of fingers, lips, or whatever part of the body the instrument may require, so, too, painting cannot ever be merely a matter of sight. It is not a mere accident of the production process that this should be so; the experience of the handling of materials is as essentially a part of the making of an image as is their look, for the

complex processes of attention and choice, hesitation and concentration, deliberation and production, that constitute the intensely absorbed process of painting or drawing must involve concentration on, the exercise of thought *in*, how they can be handled, brought to lie and behave on their seen surfaces. Painting is a manually expressive act in much the same way handwriting is — normally more intensively. [Cf. esp. PLs I—II] We might say that the invention of printing removed calligraphy from the realm of writing as photography can remove handling from the realm of picture making. Perhaps as Walton[9] and Scruton[10] have suggested the latter removal is more radical. Poetry did not die from the loss of the hand and eye, can even survive well the loss of voice and sound (though these things must be put back by the reader) but we might well not think this if we had quite recently been deprived, say, of a tradition of poetry that was fully calligraphic, as Chinese poetry may be. Perhaps, indeed, a better word then gesture for the significant touch and handling of paint or pencil would be calligraphy: it would be if this had not such strong associations with the production of words.

A handwriting expert — and to some extent a non-expert too — can tell much about the mood, the attitude, even the health and personality, of a letter writer from the letter's handwriting — in the case of bad typists even from that too. But this is not calligraphy in any full sense for much the same reason as blushing or tumescence is not gesture. In most cases our handwriting exhibits what clues it can to the writer's psychological state in an unintentional, uncontrolled manner, rarely with the writer's attention to the implications of what he is doing. Such attention rarely in our culture goes beyond the need on occasion to attempt one's very best handwriting, or to the less self-conscious friendly casualness of a scrawled postscript. But these cases themselves may serve to show how gesture may begin to take off as a minimal primitive, system of meaning.

The very idea of a 'meaning analogy' for gesture needs to get two examples out of the way first. Rabelais has a famous incident[11] in which two philosophers debate at length solely in gesture, most of which are inevitably splendidly obscene, none of which give us the faintest idea what the debate is about. Neither it seems, have they. Yet it can seem as if we ought to, as if the meaning were just around the corner. It is the reverse of when you have a word on the tip of your tongue and can't say it. Music can strike one the same way: the horns reply to the strings,

argue even, though there is no way of telling what they are arguing about. But that gives us no reason for referring to unspoken meanings and Rabelais' story could be taken as showing this. On the other hand, he might have had his philosophers talk in deaf and dumb. But this would not have done either, for such signing systems are (more or less) perfectly proper natural languages (like English or Welsh) whose morphemes just happen to be hand signals rather than sounds. (And they are languages in their own right, not encoded morphic alternatives such as Morse Code.) Neither example captures the point of even seeking for an analogy, for in diametrically opposite ways they seek an equivalence for speech, not an illuminating analogue. So what, from this point of view, is gesture as such? If we exclude on the one hand nonvoluntary indications of psychological states, and on the other such formal gestural signs that could be replaced by, or translated into, words (nodding, hand-shaking and the like) what are we left with?

The short answer is that we are left with what an actor can perform. Because we do have natural and characteristic ways of behaving when in certain states of mind and mood, they can be imitated, heightened, elaborated and *detached from* such natural occurrence situations. Thus an actor can act at a given moment a gesture that is sad, happy, sullen, bewildered, just as easily as he can speak hopeful lines. And it does not follow that he is happy, sad, resentful and so on. Thus the gesture can be detached: it can have its 'own sense' independent of the matching mood of its maker. So we can, as dogs cannot, report states of mind gesturally. We could speculate on two reasons for this ability of ours that dogs lack. It seems tempting to suppose that this has centrally to do with the animal's lack of a sense of its self, as opposed to, or like, other selves, of its situation as opposed to or like other real or possible ones, and thus of our ability to make abstracted artefacts out of the features of occurrence behaviour.

For once this first move has been achieved, actors, especially stage actors, are not limited to reproducing just how 'natural' gestures may be. It matters that they are not. The abstractive process is not simply *ex*tractive. To be seen from a distance, gestural patterns may need to be amplified, modified, stylised in all sorts of ways. They can become 'artificial'. Along these lines if music has human meaning it is not as language does, not as deaf and dumb is a language of gesture but as such signing may still be performed sadly, hesitantly, sullenly and so on. If the patterns of music can be referred to as sad, cheerful, mournful, it

is *in their own right* that they are so — but this is also because the *route from which* this recognisable abstraction of significance has come has its origin, not in *reference to* such moods, but in their expression in a natural context. But the route can have been a long one with much artifice along the way, an artifice in which different cultures have come to form, to formulate their everyday gestures by convention, courtesy and artifice. We should expect this to be so, for only if such things are possible at all can gesture get its own significance, its publicity which makes it *language-like*, if not language identical.

To repeat my central claim about 'language-likeness': what I call 'occurrence detachment', that something of significance can be pretended in a non-deceitful way, the way in which an actor can pretend, fictionally, is the root condition of meaningfulness in the most general sense. It is fiction, not truth or falsity which is the most fundamental underlying concept for 'language likeness' we can have.[12]

The price worth paying for language-like publicity is an opacity to the gesture's psychological cause: the *gesture* that someone makes is kindly, sad, morose itself. These terms do not in themselves refer to the corresponding inner states of their makers: hence we can say that *honest* people do have such corresponding states of mind. It is not a necessary truth that honest people are honest in their gestures and manners. A dog is honest in much the same way as a camera cannot lie, unvirtuously, automatically, but if Iago had been honest his virtue would have been unautomatic. For he *could have been* as the 'real' Iago *was*.

Much the same can be said of calligraphic qualities. A line, just like a body, can dance, can move sweetly, quickly, sadly, over the paper, be hesitant, firm and tentative, because that is how *we* can behave. But it is the line *itself* that has these qualities because (while the easiest way to produce such lines may be in fact to *be* in such moods) linearities can achieve the intentional opacity of abstraction from such occurrence: such qualities are part of a public sense. Such publicity depends on the possibility of a certain sort of hypocrisy: it is *not* metaphorical to ascribe such qualities to line and form. They have them because we have relinquished our dog-like innocence with respect to them. Expressive linearity does not have to express us, ourselves.

And this is why if you set yourself the task of abstracting the elements of touch and handling from the painterly complex to do so you must concentrate on the line, the paint, the materials, the materials

moved and placed, scraped and laid down, *not* on your mood, not on a psychological inner state. For only that way *will* these lines and forms come to have those very 'psychological' attributes, those qualities that reek of the human in *their own right* as *artefacts*.[13] [Cf. PL. 7—11] Such artefacts can only mean moods, be redolent of human qualities, so long as they *can* be abstracted from the casual snap-shot of the passing mood of their maker.

Elsewhere[14] I have argued that the thought present in painting is the maker's thought, not *about*, but *in* the process of his making. I take none of this back. What I am arguing here is that what can lend any credence to an analogy with meaning in what has to be understood, responded to, in art is that such thought-in-making must be in an important way non-introspective: it must be to the artefact *not* to the artist's soul. The abstractive process involved in this cannot, any more than any other abstractive process, Frege notwithstanding, be merely extractive: touch and line, texture and the rhythm of handling, can convey the human, can convey the hesitancy, vigour, sweetness, indolence, nervousness not by a reduction downwards to some minimal core of our behavioural movements when we are in such states of mind or mood, but by the artifice and enrichment of abstraction. For what the maker of such things makes is what *can* achieve publicity of understanding. It is not simply that the *institutions* of art, of buying and selling, of exhibition and viewing demand this of art. This is demanded by the cognitive process of investing an artifact with the significance it demands: significance cannot be private however secretive artists may try to be, however coy their exhibitors.

So far this may indicate how an analogy of meaning in this area might run. But so far all this says little about my three dimensions of meaning. Let me repeat the hypothesis. It is that just as a model of meaning *fails* that is based solely on picturing, though this may capture some essential aspect of meaning, but not the power of narrative, these two models equally need to be reinforced by another, that of 'gesture'. But my metaphor of 'dimensions' takes me further than that. It is that the resources of one sort of significance can never be solely *reduced* to those of another, and more fully, that forms of communication should best be thought of as solids located in a three dimensional space of kinds of significance.

As far as gesture, calligraphy, rhythym, stress and so on, in concerned, how can I convince a linguistically literal sceptic of my anti-

Rabelaisian case? This is that gestures can be seen abstracted into their own artifical forms, but that they remain significant *sui-generis*. There seems to be a dilemma here: either we can 'translate' (fairly indeterminately) such 'expressions' into words or we cannot. If we can (and isn't the very fact that I have used words to indicate the features, of the 'psychological' qualities of what I have in mind evidence of this?) then we have no *separate dimension*. If we cannot do this are we not left with the mystical, the inexpressible? Wittgenstein in the grip of his pictorial positivism, said of what we cannot speak we must remain silent. Ramsey, knowing his Wittgenstein better than he was understood by the author of the *Tractatus*, added "and you can't whistle it either". What he knew Wittgenstein wanted to say I wish to assert. Moreover I want to say that there is more than something in the view that what you can whistle you can (calligraphically) draw. This was, I take it, the view of Paul Klee.[15] In defence of such a view I can only offer a tentative suggestion. It is this. We can certainly say of lines, paint, rhythms of sound that they are hesitant, sad, sullen, etc. I think we can even say much the same thing about certain colours.[16] But the force of the words, such as there may be, follows the force of the recognition: no amount of talk can talk someone into understanding what it can be to say this to someone, who, as Locke nearly said of the taste 'of that excellent fruit the pine-apple', understood it not before. In the same way essentially pictorial qualities, the recession of a plane, the modulation of linearity into volume, can be *given* words but the force of the words, why they are right, when they are misplaced, *follows* the understanding of the projective power of drawing, can never replace it. To an audience unlearned in the task of seeing those communicative artefacts we call pictures the language of the 'description' of art can seem to make no sense at all. It is as if someone educated solely in the task of 'objectively drawing' apples were to be faced with a discussion of the political background to questions of the morality of apple scrumping; the thought belongs in another dimension.

But can we whistle what we can (calligraphically) draw? I don't know. I think so. For the qualities that we can apply to line are often the qualities that we can and do apply to rhythm in poetry and music, the abstracted qualities of dance when a dance does *not illustrate* a story. Why this should be so would take me far beyond the possible scope of this paper. Again I can only indicate a direction. It is this.

Dimensions of meaning correspond, so I would speculate, to really

quite distinct sorts of cognitive states, states of mind which in real life we learn to orchestrate much as we learn to orchestrate the aspects of a Titian or Poussin. Let me point the way, only. Much has been said in recent philosophy about the cognitive structures of emotion. What is sought is, among other things perhaps, what components of thought go towards *constituting* such states as emotions, feelings, moods and so on. Thus the cognitive structure of fear is that it takes an intentional object, what one is afraid of, say a bull, a mouse, or the continuing political career of the American President. Then fear is irrational if such objects do not have reason to threaten. Mice can, surely, do little to harm one in fact, Reagan clearly can . . . and so on. This is to say that an emotion such as fear is essentially *narrational* with its objects, *what* is feared, as characters in stories of what might well be. Its cognitive structure is that we tell ourselves stories of what might happen if — in the case of fear horribly, in the case of hope splendidly. But not all 'emotional' states are like this. To feel depressed is not to fear or blame anyone, not to tell a story about the world and what it might do. To feel happily erotic on waking is not to believe that some story of what might be is possible or likely, not to hope, but to feel hopeful, at best. We say we are not depressed *about* anything in particular, just depressed. It is as if we are in a state to see the world patterned in a certain way, overall, as a general patterned whole, a general, delightful or horrible structure. As one pictorial style may represent what it does by making much of an overall pattern of interconnections. The structure of such 'emotional' states as those often called moods (our standard labels are not precise) stands to the structure of pictures as that of emotions such as fear stands to that of stories, to narratives. Significantly, we are far more ready to say that a certain picture conveys a mood, such as cheerfulness or unease, than that it conveys an emotion such as fear or resentment. The latter seems, explicably, to belong to the resources of narrative art alone.

But the very hunt for these cognitive structures can leave one feeling that something is left out: specifically it can leave one feeling that it becomes somehow inexplicable that the mere belief that something is dangerous, and that it would be better if it were not so, is so obviously *different* from the emotion of fear. Somehow the search for 'cognitive' patterns here (thus conceived) leaves us without bodies, without the pretty brute fact that moods and emotions are essentially bound up with our bodily states[17] and our awareness of ourselves as selves among

74 ANDREW HARRISON

others with similarly sentient bodies. And I want to say that if there is a
'dimension' of 'gestural meaning' it is with this fact that it has to do. For,
however abstracted from that origin, gesture has to do with how we
think, feel, respond with our bodies, with our experience as material
bodies dealing with other materials. The landscape of gesture, of calli-
graphy, of touch, is the landscape of bodily sentience.[18]

There are certainly forms of non-figurative abstraction in art that are
not derived from this form of experience and its artefacts, which have
to do with 'cool' formal exploration of shape and proportion, with
balance and counter balance of areas of colour and texture far removed
from the insistence on the touch and feel of the materials' handling. I
have little to say, here, about these, not because I reject their value but
because it is here that analogies with meaning do, I suspect, essentially
fail[19] for in such cases we have to do with the proper demands of things
to be seen in their own right, without reference beyond themselves, and
with the just discipline our attention to such things imposes on us. The
sort of non-figurative visual art and non-figurative aspects of art that
puzzles more is that which does make such demands beyond itself,
often, and bafflingly, in ways that reek of the human, but which neither
tell a story about humans, nor portray them. For such paintings and
drawings draw on what we have learnt to see as an essential component
of great art at all times, something non-formal. It is this which my
attempt at meaning's third dimension has been trying to locate within
the patterns of our general understanding of ourselves and others.

Peter Fuller has recently said[20] of certain sorts of abstraction done
well, that they represent the sublime in art in its highest state: of the
sublime Kant said that whereas a failure to respond to the beautiful
showed a want of taste, a failure to respond to the sublime showed a
want of feeling.[21] My third dimension of meaning is an attempt to hint
at what the abstracting demands of feeling, in this sense, are. They are
that we are sentient bodies among other bodies.

University of Bristol

NOTES

[1] Laurence Sterne, *The Life and Opinions of Tristram Shandy, Gentleman*, ed. Ian
Campbell Ross, (Oxford: Clarendon Press, 1983), illustration reproduced by permis-
sion of the Clarendon Press.

[2] Cf. Dieter Peetz's paper in this volume.

[3] This tradition which runs familiarly from Kant through Schopenhauer to twentieth century formalists such as Bell and Fry could obviously not have survived had it not been able to incorporate within itself far more subtle insights than my sweepingly dismissive comments here indicate. This is often the way with such general philosophical doctrines when they provide the vehicle for a different kind of interpretative thought.

[4] Cf. for example, Scruton's attack on this idea in *The Aesthetic Understanding*, (Manchester: Carcanet Press, 1983), which seems to miss the point, especially pp. 59—61.

[5] See Ludwig Wittgenstein, *Tractatus, Logico-Philosophicus* (trans. Pears and McGuinness) (London: Routledge and Kegan Paul, 1961).

[6] See Immanuel Kant, *Critique of Pure Reason* (trans. Kemp Smith) (London: Macmillan, 1961).

[7] See Svetlana Alpers, *The Art of Describing: Dutch Art in the Seventeenth Century*, (London: John Murray, in association with the University of Chicago Press, 1983). Also my review of Alper's book in *Art International*, **XXVII**(1), (Jan-Mar, 1984), pp. 52—55 and in this connection also see Michael Baxandall's discussion of Chardin, *Patterns of Intention: on the historical explanation of pictures*, (New Haven and London: Yale University Press, 1985). His account of Chardin is that his pictures are 'Lockean', that such "pictures represent, in the guise of sensation, perception or complex ideas of substance, not substance itself". They present, in other words, what was to become for Kant the manifold of perception as given to the apperception of a particular perceiving subject — in effect they present how we experience others who are perceivers too and this project for us "a re-enactment of bafflement by the elusiveness and sheer separateness" of the person depicted, in his case, p. 103, *The Woman Taking Tea*.

[8] L. Wittgenstein, *Notebooks 1914—1916*, (C. H. von Wright & G. E. M. Anscombe eds., translated Anscombe) (Oxford: Basil Blackwell, 1961), p. 83e, dated 8.10.16, I read this entry as continuing the thought of 7.10.16.

[9] Cf. K. Walton, 'Transparent Pictures: on the Nature of Photographic Realism', *Critical Inquiry*, 1984.

[10] Cf. R. Scruton, *The Aesthetic Understanding, ibid*, pp. 102—136.

[11] Rabelais, *Gargantua and Pantagruel*, Bk. II, Chap. 19 'How Panurge confounded the Englishman who argued by Signs'. (Harmondsworth: Penguin, 1955).

[12] Cf. K. Walton in this volume. For me, fiction's possibility is a quite general condition of meaning ranging far wider than for pictorial understanding only. This does not conflict with Walton's view that it is also specifically important for pictures: what *is* suggested by this is, however, that we should be careful of the *variety* of ways in which fiction's possibility can be exercised. Almost, one would like to say, taking such care is what constitutes any *general* theory of significance.

[13] As with Auerbach's drawings it may be hard to find the right words: the point remains that whatever the words are that fit the linearities fit the linearities of the drawings *themselves*.

[14] See Andrew Harrison, *Making and Thinking*, (Sussex: Harvester Press, 1978).

[15] See Paul Klee, *The Thinking Eye* (trans. Ralph Manheim) (London: Percy Lund, Humphries & Co. Ltd, 1961), esp. pp. 271ff.

[16] See Peter Lloyd Jones' contribution to this volume. A way of regarding his project there from my point of view would be to ask whether, if successful, colour could be construed as a further dimension of meaning. For that to be so would depend crucially on (a) whether the condition can be, since colour effects on mood *seems* too directly causal for that. Carolyn Wilde, in this volume, gives reasons for doubting the second, in that colour's effect on our emotions may be *essentially* tied to associations with other aspects of experience. However, I would still like, after reading Lloyd Jones' paper, to be hopefully agnostic about this: it would be exciting to believe that conditions (a) and (b) could succeed for colour.

[17] Adam Morton has questioned whether moods must be tied to bodily experience. "Could we not", he has asked me, "imagine a worried wraith?". Well, I can, but *then* what I imagine becomes inextricably tied up with a thought about the sort of worry I would feel *as a wraith*, which is still (an embarrassing) sort of bodily experience, I suppose.

[18] See Paul Crowther's discussion of Merleau Ponty in this volume. The relevance of Merleau-Ponty's philosophy to what I have to say is far greater than I have acknowledged in the text. But even Descartes seems to have seen embodiment as an essential condition of experience, especially the experience of emotion. cf the letter to Princess Elizabeth, Descartes, *Philosophical Writings*, trans/ed. Anscombe and Geach, (Edinburgh: Nelson, 1954), pp. 275—276.

[19] They do not fail if some of the hopes reported by John Gage and by others in this volume could be fulfilled.

[20] Peter Fuller, *The Naked Artist*, London, Writers and Readers Cooperative, 1983, p. 189.

[21] Immanuel Kant, *Critique of Judgement*, trans. J. C. Meredith, (Oxford: Oxford University Press, 1952), p. 116. Kant's normal reference is, of course, to what he calls 'moral' feeling. I suspect that any serious revival of the concept of the sublime for twentieth century art of this sort would have to turn largely on how far we might wish to extend this idea of 'moral' feeling quite as much as on the idea of feeling as such, problematic in this context as that is.

ROGER L. TAYLOR

CUBISM — ABSTRACT OR REALIST?

Is Cubist art abstract or realist? I suspect most would say that it is abstract, although not wholly, and certainly not realist. This judgment may be determined in part by the dominance of theory and by Modernist theory in particular. Early Cubist theory saw Cubism as realist; the dominance of Modernist theory has obscured this. I shall argue that the application of Modernist theory to Cubism yields an inadequate interpretation of Cubism in its original, historical setting. To be more precise my argument will be less general than I have indicated as its central contentions bear only on the Analytic Cubism of Braque and Picasso. My positive argument, as it concerns the Analytic Cubism of Braque and Picasso in its origins, will be for a realist Cubism. However, this argument will not be that of early Cubist theories nor that of Hintikka in his more recent essay.[1] Despite what I have said, my object is not to arrive at the definitive interpretation of some aspects of Cubism. Looking at paintings is as open an activity as making paintings has come to be. What I have to recommend is a possible way of looking at some Cubist paintings and one which, it is plausible to maintain, Braque and Picasso invented in making the paintings of Analytic Cubism. The suggestion that these works are realist paintings is not meant in any technical sense that would imply more than grammatical differences between the words 'realist' and 'realism'. 'Realist', in this context, contrasts with the paintings being formal arrangements (the latter being the main meaning of 'abstract' in this essay) and implies representations of particular things or experiences as they sometimes are, and not as they might be imagined (fantastically). What is interesting in this whole project is both the critique of Modernism and the exploration of the way in which philosophical ideas can be of assistance in the act of perceiving paintings.

To present the formalist (Modernist) understanding of Cubist painting I quote from a book by R. H. Wilenski.[2]

It is held as a first principle that the artist must be free, as the architect is free, to introduce representational details in his work or not; that representational details are no more a necessary part of a picture or a piece of sculpture than they are a necessary part of a cathedral.

77

Andrew Harrison (ed.), Philosophy and the Visual Arts, 77–95.
© 1987 *by D. Reidel Publishing Company.*

Talking of the artist Wilenski says,

... eventually he (the artist) has in mind a series of symbolic fragments which he fits
together like a jigsaw puzzle to create a single symbol for his general perception of
formal relations which is the subject of his picture.

And when talking about Seurat and Cézanne, Wilenski says,

Both Seurat and Cézanne attempted and achieved what might then have been thought
the impossible; they continued to retain representational elements in pictures the
subjects of which are as formal as the Parthenon.

Approaching the Cubists, Wilenski summarises their intentions as
follows,

I must approach my problem like an architect. The architect achieves formal harmony
without representing physical objects and concrete things, I must do the same. I must
make pictures which shall be frankly symbols on a flat surface for formal proportions,
harmonies, recessions and so on

The achievement of Cubism is presented in the following words,

With great efforts they had themselves succeeded in creating architectural pictures by
eliminating representation altogether.

Wilenski's book came out in 1927 but much of the subsequent treat-
ment of Cubism in art history is very much along the same lines. For
instance, Meirlys Lewis argues[3] that the Cubists,

... assert that the bare fact of painting consists in dividing the surface on the canvas
and investing each part with a quality which must be excluded by the whole.
 It is in this context that we are to understand the Cubist preoccupation with the
surface from which the painting springs. It is a preoccupation with the lateral plane
surface of the painting, with the purely pictorial elements of line, colour and texture
parallel to, and by implication imposed on the two-dimensional truth of the canvas.

In terms of this kind of analysis the appreciation of Cubist paintings
involves the treatment of them as essays in pure pictorial form. If there
is an historical or social or ideological or intellectual perspective which
is relevant, this only involves how it was that artists were able, at a
particular time, to arrive at a clear understanding that, as artists, their
task was no more and no less than the creation of form, or in the
language of Clive Bell 'significant form'.
 How does this approach match up to the reality of Cubist painting?
To begin with Cubism is not popular art. Even in circles where people
have some interest in the fine-arts Cubism is not popular art. If a

middle-class lounge sports a Picasso reproduction, and it might well do so, it is unlikely to be a Cubist picture like Picasso's *Portrait of Kahnweiler.* [PL. 21] Even for the art historian or critic, Cubism seems more interesting as a bridge between Cézanne and modern art than as something to look at for itself. In fact, if you are inclined to want to look at paintings in a purely painterly and formal way, e.g. admiring the lemon-yellow in a Vermeer or the excitement of line in a Jackson Pollock, it is far from obvious that Cubist paintings provide this sort of satisfaction. However, it was the intention of some early Cubist painters to reach the masses with their art. This is the claim made by Gleizes and Metzinger in their 1912 essay on Cubism.[4] Are we missing something then? Is it possible that the theoretical orthodoxies of Modernism obscure from us the possible meaning of Cubist painting? One consequence of the orthodoxy is that it tends to deflect attention away from the specific social milieu out of which Cubism grew. From the Modernist angle we simply have to stand before the paintings and open our sensibilities to them as examples of universal form. As Clive Bell put it,

To appreciate a work of art we need bring with us nothing but a sense of form and colour and a knowledge of three-dimensional space.[5]

But if the paintings do not confront us with the so-called delights of form, what are they about? In much of the early writing on Cubism the writers make use of the history of philosophy to offset the difficulties experienced by the uninitiated with Cubist pictures. This is not to say that these early writers engage in philosophical aesthetics as Bell did. The early writings on Cubism connect up Cubist paintings with central areas of philosophy, like ontology, epistemology and metaphysics. It is in this way that the paintings are supposed to be explained and made intelligible. If philosophy is the key to the cipher then the problem of access may be the more general problem of the esoteric nature of philosophy. It is surprising to discover that the main thrust of the early criticism was to argue for the realism of Cubism. The negative side of this claim was to denounce the realism of Impressionism. So one thing to bear in mind is the fact that Cubism rather than identifying itself with a modern movement starting with the Impressionists and leading through the Post-Impressionists to itself, instead posited itself as remedying certain deficiencies in Impressionist paintings, or, at least, this was the point made by the early criticism. A brief consideration of

some of the criticism brings out something of the intricacies of the argument as applied to the history of painting. A good source book for this is Lynn Gamwell's *Cubist Criticism*.[6]

For instance, there was the art critic Maurice Raynal who was based in Paris and a friend of Picasso and many other artists. There are several writings by him from 1912 onwards on Cubism, particularly an article called 'Conception and Vision'.[7] In this article he distinguished between painting in accordance with what one knows and painting in accordance with what one sees, i.e. the possible difference between conception and vision. It was Raynal's claim that a painter like Giotto painted in accordance with his conception of the word rather than in accordance with what was given to his eye: conception prevailed over vision. When Giotto painted the *Madonna and Child* he made them much larger than the saints, angels and persons surrounding their throne. Giotto, Raynal pointed out, was using pictorial conventions in order to convey things he thought he knew about the universe. Raynal claimed that Cubism was a revival of this tradition; in some way or other it gave us deep and profound truth about the nature of the world.

A similar theme was broached by Metzinger, Gleizes and Apollinaire. They constructed a realist tradition in what was for them recent French painting, out of which Cubism was held to have grown. The forerunners of the Cubists in this tradition were said to be Courbet and Cézanne. Courbet was seen as concerning himself with the solid, physical character of the world (this was contrasted with the intentions of the Impressionists) and with life as it is. For example, in Courbet's famous painting *The Atelier* we get the reality of the painter's studio, with the model waiting to be painted, rather than the perfect world and classical nudes of Ingres' *Turkish Bath*. Cézanne was seen as going one better by plunging into "profound reality", by which was meant that his paintings, like Courbet's and unlike the Impressionists', were concerned with the permanent side of reality, but that he did this, unlike Courbet, through the exposed flatness of the picture plane and thus without attempted illusion. The profound truth of the world as it is and the painting as something in the world but about it, was arrived at (this was the claim) by giving equal value to the mind and the eye.

In this exposition the theorists were dealing with an array of difficult and slippery concepts. For instance, 'conception', 'vision', 'the mind', 'the eye', 'reality'. In order to shore up the abstract nature of what they were saying they dipped into the philosophers' more thoroughgoing

treatment of these ideas. In doing this they rather assumed that they had the weight of philosophy behind them and they thought that Impressionism lacked philosophical clout. However, this was not fair to Impressionism. I can better bring out the philosophical ideas associated with Cubism by first introducing the philosophical ideas associated with Impressionism.

It is a tenet of Empiricism that all we ever encounter directly are experiences rather than the things we say the experiences are of, and so the claim is that genuine knowledge cannot transcend experience. It is a short step from admitting that all we ever encounter directly are experiences to admitting that Monet's painting *Rouen Cathedral Sunset* [PL. 20] is an approximate record of an experience, namely, a particular visual sensation, possibly myopic. This conclusion might seem reinforced by noting that Monet would change the canvas as the light (or, in Empiricist jargon, the visual sensation) changed. Here, on the philosophical side we are looking at a concrete, French, intellectual tradition going back to the Enlightenment and Condillac, and which was itself derived from the British Empiricist tradition and particularly Locke. In terms of Empiricism it might seem that Impressionist painting was convincing realism.

Another philosophical argument for the realism of Impressionist painting is the 'innocent eye' argument (this argument is well-documented and explained in Gombrich's *Art and Illusion*[8]). This argument is Kantian in form and so it anticipates ideas which have been used in connection with Cubism, although ultimately it is illiterate in Kantian terms. If you look at a pylon which stands against a stock pile of coal what you see is dependent on concepts which you bring with you. This is to say, if you did not know what pylons and coal are, and this is possible as you might come from an environment where there was neither, then you would be unable to identify what you see as pylons and coal. More deeply the identification of what you see involves the ability to use concepts of three-dimensions and of singularity and quantity (e.g. a pylon, some coal). These considerations might persuade you to believe that there is seeing and making judgments about seeing, and that the latter is dependent on the mind possessing concepts. To believe this can lead to believing that the closest one comes to an objective order independent of consciousness (e.g. the closest one comes to an orange which is not heavily mind dependent) is in the seeing which is prior to judging, what is seen. The exhortation to the

artist has taken the form of saying something like 'if only one could record the mere seeing that would be reality, or as close to it as one is likely to get'. Monet's paintings have been seen as such a record. If this theory is coherent and the paintings record mere seeing then realism might seem the appropriate descriptive concept. This position takes up at least the from of the argument in Kant's *Critique of Pure Reason*. Kant requires judgments to be compounded out of experience and concept. This is to say that a judgment is supposed to come about as a result of something that comes from outside ourselves and something which we ourselves provide (i.e. material from the senses and the inbuilt structure of the mind's logical ordering apparatus). However, it is unKantian to suppose we could have any knowledge of the experience without the concept. The Kantian dictum is that concepts without experiences are blind but experiences without concepts are, from the point of view of the knowing subject, nothing at all. From the Kantian viewpoint there is no possibility of the 'innocent eye'; even seeing coloured patches, which one might feel is primarily what an Impressionist painting confronts us with, is conceptualised seeing. We might say that to see is to be able to some extent to describe what one sees and that describing what one sees must be bringing what one sees under concepts. There are arguments against this and one such (the views of Bergson) I will come to in due course.

The early proponents of Cubism objected to Impressionist painting on the ground that it was not realist. Metzinger and Gleizes wrote of Impressionism as being "superficial realism". What might be the theoretical justification for such a view? Well, from a realist angle one might object to paintings based on an Empiricist credo because their only certainties would be subjective and insular. For example, an objection to Monet could be that all he gives us is the pattern of light on his retina, or his own peculiar sensation. The objection here, which is an objection to Empiricism itself, is that such painting leads to solipsism. On the other hand, Kant might seem to offer more. Raynal and Kahnweiler (Picasso's dealer) certainly thought so. Kant distinguishes not only between concept and experience but also between what he calls the noumenal and phenomenal worlds, i.e. between things as they are in themselves and things as they appear to us. Of course for Kant we can never be acquainted with things as they really are, although we can know the bare fact that they exist. Phenomena, though, are the appearances of things and with these appearances we are

acquainted. In some of the early Cubist criticism the suggestion is that Cubism gives us the noumenal order (again an unKantian thought) whereas Impressionism only gives us the phenomenal order, and so the inference is that Cubism confronts us with reality when Impressionism only appears to do so. Not only does the early criticism suggest this but we find also, statements from some of the artists involved suggesting the same. For instance, Braque was quoted as saying in 1908, "I want to expose the Absolute, and not merely the factitious woman". Such a comment is not that of a purely practical and manual intelligence (one commonly received view about Braque) but indicates a degree of theoretical sophistication.

If we turn from the theory to the paintings and peruse a range of Cubist paintings by Braque and Picasso, stretching from 1908—11, to what extent does the theory account for the paintings and the practice of painting them? Not surprisingly, considering the metaphysical nature of the theory, it proves inadequate. Thus, what could convince us that these Cubist paintings are representations of ultimate reality? More-over, it is strange that the pictures of 1908—9 differ in style from those of 1910—11. Are we to suppose that the noumenal order underwent a change in the space of a year? More conclusively, why did the artists, having at last found the way to represent the Absolute, desert it so quickly as though it was a passing fashion, e.g. Cubism is simply a phase through which Picasso goes. In real terms it hardly seems that the claim that the paintings are representations of a noumenal order makes them more intelligible or realistic.

Of course, for Kant there was no possibility of representing or knowing the noumenal order: we could know of its existence but nothing of its nature and to think otherwise was the mistake made by speculative metaphysics. The early writers on Cubism were not so ill-informed about Kant to be cut off from this fact about his system, but Kant wrote in the 18th century and much post-Kantian, German philosophy (e.g. Hegel and Schopenhauer) had continued to pursue the Absolute. However, though the accounts of Cubism slipped in the Absolutist implication, other more orthodox aspects of Kant's theory were used to explain what was going on in the paintings. The main suggestion was that the paintings were produced in accordance with Kant's account of how knowledge was possible. Here we are back with vision and conception. Material comes to us shaped by the senses (according to Kant the senses themselves organise the material spatially

and temporally) and this shaped material is synthesised into judgments in accordance with rules and categories which the human mind cannot transcend and must impose. Kant's overall objectives were three-fold, 1. to reject scepticism, 2. to erect an insurmountable barrier to speculative enquiry and 3. to establish as a necessity, for the human mind, a Newtonian and Euclidean universe, i.e. a universe where space was conceived of through Euclidean geometry and where what happened in this space obeyed the laws of physics as conceived by Newton. Incidentally, so much for those who happily assimilate alternative geometries with Kantian Cubism. If a Cubist painting is supposed to be like a judgment arrived at by the efficient Kantian mind, its realism should be Newtonian and Euclidean, but the paintings are hardly clear models of such a reality. A similar point is made in Hintikka's essay,

... the representational freedom which the cubists asserted goes much beyond the innate forms of sense-perception which Kant emphasized and which are grounded not in artistic choice but in immutable human nature.

Kant was tying to shore up a conventional reality against Empiricist doubt, whereas Cubist criticism sees Cubist painting as attempting to rupture the smooth appearance of a conventional reality.

So far, then, in following through connections made between Cubism and the history of philosophy we encounter muddle. Either we have muddled exposition of Kant, or theory that sounds impressive but fails to fit the paintings. We also encounter a serious under-estimation of the possibilities of providing some philosophical backing for the realism of Impressionist paintings. It is within this area of theoretical confusion that a theory, like the formalist theory, might gain credence as something straightforward and clarifying.

A contemporary attempt to clarify the notion of a realist Cubism using the history of philosophy in order to do so is that by Hintikka. In fact his starting point seems very similar to my own. Thus, he claims to be confining his attention to the "original cubism of Picasso and Braque", he rejects Harold Rosenberg's view that Cubism is abstract art (finding it "seriously incomplete") and he sets up the main problem for his article as follows,

Cubists were realists in some sense, but in what sense?

Hintikka thinks that this question can be answered by drawing analogies between "what we can find in modern art and what we can find in modern philosophy". This is not to say that he argues for any

influence of one on the other. The historical side to this seems to be the idea that similar things happen in different areas not because of mutual influence but as a result of cultural development. In my view Hintikka's essay would be more informative if it was argued explicitly in terms of its general title (i.e. 'Concept as Vision: On the problem of Representation in Modern Art and in Modern Philosophy'), rather than in terms of the more specific problem of the possible realism of the original Cubism of Braque and Picasso. Much of what Hintikka has to say applies to a lot of modern art rather than to Cubism in particular, and, moreover, Hintikka is not careful in directing his analysis to the original Cubism, tending, instead, to consider the case of Picasso in general. But what light do his analogies throw on the realism of Cubism?

The main argument concerns and analogy between Husserl and Cubist painting. Hintikka introduces Husserl's distinction between 'noemata' and 'objects' (roughly Frege's 'sense' and 'reference'). 'Noemata' are meanings and 'objects' are things meant. Husserl saw phenomenology as being the study of 'noemata'. Raynal's early distinction between conception and vision is presented by Hintikka as being analogous to Husserl's distinction, and Hintikka sees Picasso picking up the same distinction when telling Gertrude Stein that he painted things the way he knew them to be rather than how they looked. So Hintikka concludes,

In the same way as phenomenology is supposed to be a philosophical study of noemata, cubism is the art of the noemata.

At first sight this analogy appears mishandled. 'Objects' are not equivalent to 'vision' (unless both are to be understood as sense-data). The concept of 'objects' suggests things in the world to which our concepts ('noemata') refer, whereas the distinction between conception and vision, particularly in the context of Picasso's remark to Stein, suggests the difference between reality and appearance, i.e. how things are and how they appear to be. On this interpretation 'noemata' are more like appearances, and 'objects' are more like the reality, in which case Cubism would be the opposite of phenomenology. However, if the idea of 'how things appear to be' is a way of referring to subjective experience then Hintikka denies that the study of 'noemata' is the study of subjective experience. It take this to mean that Husserl saw phenomenology as the study of socially shared concepts and conceptual systems, i.e. things which have an objective existence in their own right. More than this though, Hintikka tells us that for Husserl the study of

'noemata' was supposed to elucidate "the real things", which seems to mean that through an investigation of our conceptual system we can come to know the 'objects' (this might be compared to Strawson's interpretation of Kant). If Cubism pursued either objective it is doubtful that we learn anything as a result. For instance, what do we learn of our concept of a person or violin or musician or female nude from the Cubist paintings of Braque and Picasso? Or, to take the more direct case, what do we learn of persons, violins, musicians or female nudes from these paintings? The answer must be not much, perhaps phenomenology has fared better. If the question is one of what we learn then Hintikka goes on to point out that Cubism encourages a degree of self-consciousness about what is involved in using pictorial representation, thus drawing attention to second-order facts about pictorial schemata (e.g. pointing out that perspective in representation only presents an object from one point of view, that representational systems are languages and that there is the possibility of many languages all having the same references). Hintikka connects up these alleged, second-order facts with various philosophical ideas associated with Husserl and 'possible-worlds semantics'.

It is true that the original Cubist paintings drew attention to the fact that perspective in representation fails to present us with three-dimensional objects, but instead presents us with representations of objects looking three-dimensional. This is really just the simple fact that pictorial representations are two-dimensional surfaces and so cannot be the three-dimensional objects they represent. Cubist painting indicates this through the pictorial fragmentation of the object, presenting bits of the front, sides and back of the object simultaneously to the point of view of the onlooker. However, the realism of Cubism is not demonstrated in this way. The Cubist painting no more gives us the three-dimensional object than does a representation using perspective. It is not possible to deconstruct a Cubist painting into four representations of an object in perspective, i.e. front, back and two sides. The fragments work as reminders that representations in perspective are not the objects themselves, and so, despite representation, the objects themselves slip from our grasp.

Perhaps though, the attack on perspective in Cubist painting points to realism in another way. Hintikka brings into focus the idea that the lack of perspective and consistent lighting in the paintings shows a disregard for what philosophers have called 'secondary qualities', so

that Cubist paintings might be though of as realistic representations of objects, representing what they really are, namely, their 'primary qualities'. This though is difficult to accept. To begin with, there is the possible incoherence of supposing that there could be representations of 'primary qualities'. Those who make the distinction between 'primary' and 'secondary qualities' maintain standardly that 'primary qualities' cannot be represented because they are necessarily imperceptible. More down to earth though, the crucial question must concern what information about shape, size, spatial location, velocity and degree of hardness one can derive from the paintings. This question is straightforwardly factual and surely it is the case that even Impressionist painting provides more information of this kind than Cubist painting does. What Cubist painting does, is to remind us of certain second-order facts about the perception of these qualities (or any qualities for that matter) and the possibility of their representation: in doing this a certain kind of scepticism is encountered and the possible meaning of this I will try to detail in due course.

The final analogy I shall consider, to which Hintikka directs attention, is that between what Hintikka calls the "logic as calculus" view, and what is seen as Cubism's rejection of naturalistic representation. The "logic as calculus" view, Hintikka characterises as one which says that "the representational relationship between language and reality" can be freely varied. This point transposed to cover Cubist painting indicates "the most important feature of the Cubist revolution" according to Hintikka.

It is not that these pictures do not represent. Rather they represent their objects by means of conventions, by means of a *language* which the spectator has not yet learned. Once one realizes this *key*, one finds much more method in the apparent madness of cubist paintings.

The implication seems to be that in this way Cubist paintings fulfil the realist claims made for them despite their not being, what Hintikka calls, "naturalistic" or "illusionistic". Such a view is reminiscent of Rudolf Arnheim's claim made in 1954,

Probably only a further shift of the artistic reality level is needed to make the Picassos, the Braques or the Klees look exactly like the things they represent.[9]

Again the question is straightforwardly factual. I cannot see that any such shift has occurred since 1954, or that there is a Cubist language which is learnable. The situation is not like deciphering the allegorical

meanings of a painting by Poussin, or learning to read the hieroglyphics in Egyptian painting. The informational content of a Cubist painting, in terms of the objects represented, never becomes fuller than the rather unspecific second-order facts referred to by Hintikka. Certainly there is no possibility of suddenly discovering a startingly realistic likeness to some object depicted in a Cubist painting, as though the situation was like seeing suddenly that one could switch from seeing the duck/rabbit drawing as duck to seeing it as rabbit. The difficulty experienced in looking at Cubist paintings has remained, and I shall argue it is not necessary to dispel it in order to justify the possible realism of the paintings. If not mad, Hamlet intended his behaviour to be seen as madness. What sense then can be made of this madness without it evaporating altogether?

Clearly enough the Cubists were not avid students of philosophy. For instance, Picasso rarely read anything. Despite this the Cubists were active members of a bohemian society where theoretical discussion was commonplace. The prevailing atmosphere was one scornful of conventional society, but rather than the theoretical alternatives to it being political they grew out of escapist desires for a more mysterious, exotic and spiritual reality. A comparison between Paris street scenes and the paintings made in Paris at the time (not just Cubist ones) makes the point (e.g. the illustrations in Nigel Gosling's *Paris 1900—14*[10]). Very few paintings give concrete information about the congestion, anonymity and modernity of the streets. In this particular, intellectual environment, theories (philosophical and scientific) were bandied about and would have been available, although often in a misreported form, to those with half an ear for theoretical ideas. If Francoise Gilot's book[11] is good evidence Picasso was capable to propounding Hegel merely on the basis of conversations with Kahnweiler. Henri Bergson, the philosopher who worked mainly in Paris and who was mentioned by many people at the time in connection with Cubism, seems to me to be a philosophical thread to be woven into Cubism to give it some substance. Bergson was very popular in intellectual circles at the time and so it seems very likely that his ideas would have been available to Braque and Picasso, even if they had not known they were his ideas.

Bergson, like Hegel, emphasises the mutable, temporal character of reality. Everything is changing, so reality is process. This ever-changing reality is something with which we try to cope by the use of conceptual systems, but the real (i.e. the multiplicity of interconnected processes)

eludes formalisation through conceptual thinking. For instance, we say that a thing is the same thing from one moment to the next (Picasso's *Portrait of Kahnweiler* is today the same thing as when he painted it) yet because like anything else it changes all of the time it must be different. Here there is an apparent conceptual impasse in so far as it seems unacceptable to say that something which is the same from one moment to the next is, also, different from one moment to the next. So it might seem that our concepts of identity and difference try to encompass the reality but cannot do so (traditionally philosophy has made the unsatisfactory distinction between substratum and attributes to cope with this problem). For Bergson the Kantian categories (i.e. the rules in accordance with which we organise reality) are not timeless verities but conveniences which have arisen in evolution as ways of managing the flux of living experience. His view is, though, that they are inadequate for authentic understanding. Even in this very bare form Bergson's theory can be seen to be open to different emphases. One can concentrate on the reality of experience or on the reality to be experienced. In the first case, Bergson points towards the tension between the flux of reality and our standard ways of making sense of it, in the second, he points towards the possibility of an intuitive grasp of a becoming, rather than a given, reality.

It is not far-fetched to read Braque and Picasso's range of Cubist paintings from 1908—11 as a progression towards understanding Bergson's thesis about epistemological difficulty (i.e. the first case above). Psychologically this difficulty involves an insecurity about the world; conventional concepts do not fit. There is a passage in Bergson's *Creative Evolution* (of 1907) which is particularly relevant in this context (perhaps it started Cubism!) In this passage Bergson talks of what might be involved in trying to copy a canvas painted by a 'genius', but the real subject of the passage is reality and our attempts to make sense of it.

An artist of genius has painted a figure on his canvas. We can imitate his picture with many-coloured squares of mosaic. And we shall reproduce the curves and shades of the model so much better as our squares are smaller, more numerous and more varied in tone. But an infinity of elements infinitely small, presenting an infinity of shades, would be necessary to obtain the exact equivalent of the figure that the artist has conceived as a simple thing, which he has wished to transport as a whole to the canvas, and which is the more complete the more it strikes us as the projection of an indivisible intuition. Now, suppose our eyes are so made that they cannot help seeing in the work of the master a mosaic effect. Or suppose our intellect so made that it cannot explain the

appearance of the figure on the canvas except as a work of mosaic. We should then be able to speak simply of a collection of little squares, and we should be under the mechanistic hypothesis. We might add that, beside the materiality of the collection, there must be a plan on which the artist worked: and then we should be expressing ourselves as finalists. But in neither case should we have got at the real process for there are no squares brought together. It is the picture, i.e. the simple act, projected on the canvas, which, by the mere fact of entering into our perception, is decomposed before our eyes into thousands and thousands of little squares which present, as recomposed, a wonderful arrangement.[12]

One might compare this with the gradual dissolution of Roquentin's capacity to understand in Sartre's novel *Nausea*. The objects of his world dissolve gradually into the unknown as he fails to extend securely his array of conventional concepts so as to accommodate them.

I looked at as many as I could, pavements, houses, gas lamps; my eyes went rapidly from one to the other to catch them out and stop them in the middle of their metamorphosis.

And,

Things have broken free from their names. They are there, grotesque, stubborn, gigantic, and it seems ridiculous to call them seats or say anything at all about them: I am in the midst of things, which cannot be given names.[13]

In paintings like Braque's *Road new l'Estaque* [PL.23] or Picasso's *Three Women* [PL. 24] the painters find ways of drawing attention to the fact that painting is a construct and not a mirror. In the process they loosen their grip on the subject of the picture, e.g. the three women. To this extent what is going on accords with formalism. But paintings like Braque's *Man with a Guitar* [PL. 22] or Picasso's *Portrait of Kahnweiler* [PL. 21] go further than this. The focus in these paintings is not on an already constructed subject becoming a self-conscious construct (i.e. a picture drawing attention to itself as picture). Rather the focus is on the appearance of an unconstructed subject beginning to undergo and, at the same time, slip away from conceptualisation (starting to apply the mosaic but realising its inadequacy). In these later paintings the highly geometrised, pictorial surface is not functioning as to undermine the illusion of the subject, but so as to create the illusion of unspecified, i.e. not precisely conceptualised volumes. Viewing these paintings is like coming across a submerged wreck in murky waters; every so often one comes across a figurative element or an isolated volume which can be identified, but the principle experience is the difficulty of identification.

This is the very experience which the so-called 'philistine' has. On this basis the paintings are dismissed as nonsense, but this nonsense (or 'madness') can be seen as central to what the paintings are about.

Picasso spoke of the creation of these pictures as first involving the making of the ground and then, at the end, the addition of what he called "attributes". He spoke also of confronting the public with a fog and, within this fog, something they know, so that they have something to cling to as they thrust into the unknown. These paintings can be seen as two-dimensional analogues for Bergson's linear, epistemological argument. The world is an undifferentiated flux, which we try inadequately to understand by the imposition of rigid classification. These Cubist paintings are realist paintings in the sense that they convey the reality of knowing, a reality concealed from us without something like exposure to the arguments of Bergson. Although these paintings are not representations or coded depictions of a noumenal order or of the world of Kantian judgments, one can see how Kant crept into the discussion, because he highlights the distinction between the real and the conceived, even though, for Kant, there is no epistemological hesitation about the application of concepts. For Kant, Cubist painting could not have represented the reality of knowing. The fact that the paintings can be seen as communicating a philosophical idea fits in with the anonymity and similarity of Braque and Picasso's paintings at this time. For a while they are collaborative, philosophical converts and not egocentric artists. Despite this submission, they subject their mode of communication to the philosophical ideas it is used to convey (their development of Cubism beyond 1911—12 might be seen as a further elaboration of this, e.g. the use of wax cloth to represent caning instead of painting doing the representing, in Picasso's *Still Life with Cane Chair*) and so in challenging pictorial conventions are much bolder than Sartre in *Nausea*, where disturbing philosophical ideas are presented by means of undisturbed narrative techniques. Moreover, these paintings are possibly the philosophical high-point of Cubism. Gleizes and Metzinger wrote theory but they fail to produce appropriate or exact analogues. Gleizes *Harvest Threshing* and Metzinger's *Cafe Dancer* [PL. 17] are mainly decoration. These paintings do not work as an encounter between the inadequately equipped and the unknown, nor, despite their rather active titles, do they express anything like Bergson's positive thesis about the intuitive grasp of mutable process. So Cubism, as it concerns Braque and Picasso at a particular time, can be seen as visual

art illustrating Bergson' thesis of decomposition. This is not to say that
the appearances of the paintings come about as some automatic transla-
tion of Bergson into a pictorial form. Clearly, the specific appearances
owe as much to the history of the medium in which Braque and Picasso
work as to any extra-pictorial ideas they came across. For the formalist,
like Bell, if the paintings are to be interpreted through their exploration
of philosophical themes then they do not count as Art. What Bell says
of Futurism would apply equally to Cubism.

Futurist pictures are descriptive because they aim at presenting in line and colour the
chaos of the mind at a particular moment; their forms are not intended to promote
aesthetic emotion but to convey information. ... A good Futurist picture would
succeed as a good piece of psychology succeeds; it would reveal, through line and
colour, the complexities of an interesting state of mind. If Futurist pictures seem to fail,
we must seek an explanation, not in a lack of artistic qualities that they were never
intended to possess, but rather in the minds, the states of which they are intended to
reveal.

The realism of original Cubism is a psychological realism. It illus-
trates not what the 'innocent eye' is supposed to see, but rather the
seeing done by a corrupt, self-conscious eye. The state of mind repre-
sented is philosophical, it may be also pathological, but this leads into
larger questions concerning the health of our intellectual culture. At this
point the original question seems answered:— there is a way of seeing
the original Cubism as realist rather than abstract, and there is some
historical grounding for a realist interpretation but very little for an
abstract one. However, certain additional thoughts intrude.
 To begin with, the idea of overcoming the mystification of Modern-
ism suggests that there are Cubist paintings which have definite mean-
ings and that if we are careful enough in our archaeology these truths
will be uncovered and will constitute timeless, definitive interpretation
of the objects involved. But objects like concepts (and it is strange the
reminder should go this way round) are subject to use and use brings
about changes, which can be creative and destructive (e.g. an old
railway sleeper can become a weapon or firewood etc.). It does not
follow from the fact that x meant y originally that y is *the* meaning of x.
Cubist paintings cannot be sealed off in their original social and intel-
lectual milieu. They are real objects in a real world and as such must
take their chances. If Modernism wishes to detach objects from their
relations we must not think we have corrected this by mapping out a
sub-class of these relations. If some Cubist paintings ever did live

socially as Bergsonian analogues I doubt they will ever have this significance again. In fact, like Aboriginal dance, we may be unable with real certainty to reconstruct the original meanings, but this still leaves us with the handiman's opportunity of producing something useful from the scrap-yard.

Finally though, the problem of this essay comes full circle and in the process increases in difficulty. In my book *Beyond Art* there occurs the following passage about music,

One thing which needs stressing and which certainly deserves greater exploration is the indefinite quality of the drama which music is. It is a drama without precisely specifiable characters and events (at the dramatic level, that is). The character and events one can supply for oneself, although there will be some offers which are inappropriate, but the important thing is that one can listen to it as drama without doing this. One listens to it as if there were precisely specifiable 'as if' beings and events to witness, or rather it is that the music puts one into this attitude.[14]

This gives rise to some notion of abstract, representational perception. One listens to the music as if it was a drama but one is unaware of any concrete determination or identification for the elements of the drama. The drama is abstract, but the music is representational because it is not the physical properties of different sounds which attract our interest. What attracts our interest is the way the sounds concoct a sense of drama. A simple indicator of this is the use of music as a background to film drama. The same piece of music can have many functions, can be associated with many different concrete elements. Now, the arguments for abstract, visual art have often tried to ease people into it by means of pointing to the abstraction of music, e.g. Sheldon Cheney *Expressionism in Art*.[15] Music and visual art have been presented as analogous, although the analogy is usually at the expense of representation. However, if there is some plausibility in conjoining the notions of abstraction and representation with reference to hearing and listening, what can be said of seeing and looking? Perhaps I begin to touch on themes to which other papers at the conference have given their full attention, but as I am at the end of my paper I must simplify in order to deal with them.

The concept of 'abstract' must be open and complex. Its main meaning in this essay has been equated to the handy notion of 'formal', where this notion is in opposition to 'figurative'. However, abstract seeing is fairly commonplace. A person's perceptions are called abstract when they lack concreteness, i.e. when the identifications that a person

can provide are so hopelessly general that within a shared context they are uninformative (of course, some shared contexts are abstract, in which abstract insight is informative). For instance, in a gardening context one might be able to make some general distinction between the vegetation and inorganic objects but be unable to provide names for any of the plants, nor recognise any of the differences between the plants. The failure of memory in the early stages of senile dementia may bring one to such abstract experience. One might compare this to using binoculars focused and unfocused, although for the person the problem is not optical. The more the particular and the concrete recede the more abstract the seeing, but the problem is also one of generality, because form is particular and concrete yet to be aware only of form is to be utterly general and so abstract.

I have argued that the realism of the original Cubism is a psychological realism; the Cubist painting represents a philosophical state of mind, or better, a perception contaminated by certain forms of philosophical reflection. The perception in question is one where there is unease about the concrete determination of objects when based on the usage of the conventional, conceptual system, but perception where concrete determination is difficult and where almost all that is left is some sense of form undergoing unsatisfactory synthesis is a form of abstract seeing. So in the original Cubist paintings we have the possibility of the realism of a representation of abstract seeing. More generally, one might say that the move towards abstraction in modern painting grows out of a withdrawal of the concepts for concrete determination, in which case Impressionism is also part of the abstract movement (this throws some light on dating the origins of the abstract movement). However, the concepts 'realist', 'abstract' and 'representational' do not necessarily exclude each other. Therefore, "Is Cubist art abstract or realist?" Both.

Sussex University

NOTES

[1] J. Hintikka, *The Intentions of Intentionality and Other New Models for Modalities*, (Dordrecht, Reidel, 1975).

[2] R. H. Wilenski, *The Modern Movement in Art*, (London: Faber, 1927).

[3] M. Lewis, 'Hintikka on Cubism', *British Journal of Aesthetics*, 1980.

[4] A. Gleizes and J. Metzinger, 'Cubism' in *Modern Artists on Art*, R. L. Herbert (ed.), (New Jersey: Prentis Hall, 1965).

[5] C. Bell, *Art*, London, 1914.

[6] L. Gamwell, *Cubist Criticism*, (Ann Arbor: UMI Research Press, 1980).

[7] M. Raynal, 'Conception et Vision' in *Gil Blas*, 1912.

[8] E. Gombrich, *Art and Illusion*, (New York: 1960).

[9] R. Arnheim, *Art and Visual Perception*, (Los Angeles: Faber, 1966).

[10] N. Gosling, *Paris 1900—14: The Miraculous Years*, (London: Weidenfeld, 1978).

[11] F. Gilot and C. Lake, *Life with Picasso*, (London: Nelson, 1965).

[12] H. Bergson, *Creative Evolution*, (London: Macmillan, 1960).

[13] J. P. Sartre, *Nausea*, (London: Penguin, 1965).

[14] R. L. Taylor, *Beyond Art*, (Sussex: Harvester Press, 1981).

[15] S. Cheney, *Expressionism in Art*, (New York: Tudor, 1934).

PETER HOBBIS

REPRESENTING AND ABSTRACTING

I

Western painting seems to have changed more radically this century than at any other time during its history and this is due in considerable measure to the development of abstraction. For the essence of truly abstract art appears to be its use of the pure elements of the medium — line, shape and colour — for purposes which have nothing to do with representation. In this respect abstract art seems to stand in marked contrast to figurative depiction and the creation of an illusion of objects in three-dimensional space which are virtually defining characteristics of pre-20th century art.

This contrast is my starting point. For although this polarizing way of referring to abstract and figurative art is still common, it does scant justice to the complex relations between the two. In this paper I want to explore these relations. I shall suggest that the difference between pre-modernist art and what follows it is not that the latter uses abstraction while the former does not. It is that the latter makes use of abstraction in a quite different way from the former. In developing this idea I shall argue that, although spatial illusion is central to figuration but not to abstraction, we should not suppose that spatial relations have no role in abstract art.

Why should anyone assume that true abstraction is to be understood as the reduction of painting to line, shape and colour? Here is one way of arriving at that conclusion. In depicting an object a painter abstracts certain features from the object he is picturing and sets down on his canvas a configuration which — in ways to be explored later — cor-responds to these features. Such depictive abstraction is a matter of degree and the more we abstract from the features of particular material objects the more general those features become. Among the most general are shape, colour and line (the last often as contour). Hence abstraction in one of its extreme forms will certainly end up with just these elements. This alone does not show that concentration on these elements is the sole form of abstraction but it is easy to see why

97

Andrew Harrison (ed.), Philosophy and the Visual Arts, 97—120.
© 1987 *by D. Reidel Publishing Company.*

it should quickly come to be thought of as the dominant form. For creating art by such means is bound to lead to much fuller awareness of and much greater respect for the literal materiality of the medium, for the work of art as object. Once this has been achieved a radical change has taken place in our conception of art relative to the conception which underlies figurative art (this being the idea that art is illusionistic). Hence any reversion to the former would appear retrograde and a rejection of the truth to materials seeming to mark much of the development of abstraction. Abstraction's claim to be identified with the use of pure line, shape and colour will have been established.

Given the recent history of art this conception of abstraction has its attractions, even if it does not tell the whole story. Hence our account of abstraction needs to take seriously the connection made between abstract art and aesthetic responses attending to the picture's physical qualities. So in developing the idea that there are continuities between figurative and abstract art, we must still recognise the need to take account of a picture's materiality in these two very different ways.

II

It would, of course, be very misleading if the differences between premodernist and later art were to be presented simply as the respective absence and presence of abstraction. For the response to abstract elements has always been part of an understanding of art. Indeed, our capacity for this sort of response is shown by architecture and non-vocal music, both of which are entirely abstract. In fact we often need to read figurative art in terms of its geometrically abstract qualities as well as naturalistically. When this happens depicted objects are stripped of their concrete particularity and they, or aspects of them, become forms, shapes and lines constituting an ·aesthetic organisation not reducible to the merely representational features of the work.

Consider a typical formalistic analysis of Van de Weyden's *Descent from the Cross*. [PL. 15] This painting is characterised by a complex interplay between lines of force which is not reducible to the relative placing, posture and movement of individual figures and objects. We note, for example, the complementary enclosing curves formed by the outer contours of the extreme left and right figures; also the striking parallels both between the lines formed by the body of Christ and by the Virgin's body and between the tilt of the heads and the disposition

of the arms of the two figures supporting Christ and the Virgin. At the same time we note complexities which serve to counteract the leftward movement produced by these parallels — a strong, stabilising vertical axis created by the cross, the ladder and the two central figures; the antithesis between St. John on the left and the figure of Christ; more subtly, the interplay between Joseph's hand passing across the body of Christ and the supporting hand which passes behind the Virgin's arm. It is quite evident that these formal relations are not simply attributes of the depicted items since they are not identical with relations of a narrative or psychological sort between the depicted participants. For example: with respect to the latter the figures of Christ and St. John seem unconnected even though formally they are obviously interdependent.

There are clear implications of being able to describe paintings in this sort of way. Their nature is indicated by the fact that Roger Fry is both the critic with whom we most readily associate analyses of plastic formal relations and also among those critics most notable for directing attention away from the narrative and psychological aspects of art.[1] For his position implies the possibility of confining attention to certain aspects of the depicted objects and of abstracting from those objects whatever is necessary to apprehend formal organisation. What this suggests is that the beholder is frequently called on to recognise highly abstract relations in paintings and in doing so can dispense with, for example, the humanness of depicted people, the physical reality of depicted landscapes and the functional utility of what is seen in a still-life. If so we seem to have at least the starting point for a continuity with abstraction in 20th century art. For we might think that the latter simply discovered the possibility of creating abstract relations without depending at all on figurative depiction. In claiming this we do not commit ourselves to the belief that abstract art is an aesthetic purification of figurative art as well as a logical development of it. We commit ourselves only to the belief that such abstraction is one possible development, one which needs to make no use of figurative depiction. Hence we do not invoke criticisms like those levelled by Schapiro against Barr[2] for failing to recognise the possibility of sociological or ideological explanations of this development.

In fact we do not have to make even this relatively short step from figurative depiction to see a continuity with 20th century abstract art. For, as I have already implied, the capacity to respond to abstraction is

a condition of pictorial representation as well. We get a hint of the
reason for this if we consider an important element in our responses to
purely abstract arts. Consider, for example, that simple kind of repre-
sentation in music conceded even by Hanslick in his critique of expres-
sive accounts of music.[3] When we hear a musical quality such as the
driving energy in, for example, the first subject of the Finale of Mozart's
39th symphony we do not seem to hear the activities of some particular
being who displays this driving energy. We hear this quality only, as
we say, in the music, meaning that the quality of driving energy is
abstracted from all particular instances and appears as a quality merely
of the sequence of sounds. (Schopenhauer makes this point when he
says that music does not express particular feelings but the feelings "in
themselves, to a certain extent in the abstract, their quintessential
nature, without accessories".[4]) Similarly, when Wölfflin speaks of the
agitated features in the windows of Michelangelo's Palazzo Farnese[5],
the agitation he means us to see is not the manner of someone's
behaviour but abstracted from such behaviour and located in abstracted
form in the arrangement of base-line, jambs, pediment and so forth. It is
in this sense that abstraction is always present in figurative representa-
tion, a sense which I will now explain in some detail.

 An analysis of figurative representation has to account for two
things. Firstly there is the fact that when looking at a picture of some-
thing, what we appear to see goes well beyond what is strictly given in
the representational configuration. For example, we see in Titian's
Bacchus and Ariadne, [PL. 5] not coloured patches on a canvas, but
Ariadne pointing into the distance. Secondly, recognising a depicted
object *is* a matter of *seeing* something. It is not a purely cognitive
activity, a matter merely of making a judgment about what is seen,
independently of the experience of seeing it. This is the point of saying
that if pictures were signs they would have to be iconic ones. A picture
alludes to what is depicted because of what we see it as, not merely
through some more strictly linguistic process of denotation.

 Accounts of representation have tended to fall foul of the need to
reconcile these two facts since the temptation is to do so by making
pictures into forms of illusion in far too strong a sense. Generally
pictures are not illusions in the sense that they might be mistaken for
what they are pictures of (unlike optical illusions). However, we can
accommodate both requirements if we can locate a perceptual experi-
ence of pictures which is not excessively illusory; and we can do that if

we accept the beholder's capacity to embody certain modes of thinking and conceptualisation in a configuration whose actual features do not exhaust them and which, thereby, become, as it were, their perceptual bearer. In the example above the qualities thought by the beholder to be those of a woman's form are neither a deceptive illusion created by the configuration nor reducible to the signification of its lines and colours. Instead they are embodied in the configuration. Very roughly, we see the configuration as what we recognise it to picture. In this way an area of pinkish pigment takes on the qualities of the surface of the sort of pliable but dense stuff that a human hand is.

What this phenomenon depends on is the possibility of seeing a configuration as something which it is not, but only to an extent compatible with our knowledge that what we are looking at is (in this example) just a pigment-covered canvas. This in turn depends on our capacity for what we can call perceptual abstraction. This is not merely a capacity for *thinking* about the properties of things in a general way without reference to particular instances. It is the ability to see things in this abstracted way. It is as though we can bring to bear on the configuration as much of our knowledge of the human body — or whatever — as is necessary to transform the configuration into a female form as an object of perception: but we do not bring to bear so much that we disturb our belief that what we look at is not really such a form.

This capacity for perceptual abstraction may well be peculiar to aesthetic phenomena. If so, it is an irreducible one in the sense that the discovery of pictorial representation was not the discovery that some more basic ability has this particular application. In discovering that pictures could be made mankind discovered this capability: just as it did in discovering that the facade of a building could be seen in the way described by Wölfflin and that music could be heard as possessing even the limited expressive qualities conceded by Hanslick.

So it is not only in the recognition of formal qualities that the abstractive faculty is at work in responses to figurative art. It is also a necessary condition of our being able to read a configuration as depictive at all. What we do is, so to speak, to supplement the configuration until it becomes a perceptual equivalent, though an abstract one, of the depicted object. So it is only because it is possible for us to experience abstracted versions of depicted objects that seeing these equivalents can take place. If we think of this supplementing as an activity of the imagination we can say that imagination partly traverses the gap

between the bare configuration and a real instance of what is depicted, taking us to a point somewhere between where the abstracted object resides.

This gap is of variable width. To put the point less metaphorically; abstraction of the sort necessary for representation is a matter of degree. It ranges from the photographic illusions of hyper-realism to the extreme abstraction of Miro's indeterminate creatures and Picasso's grotesque post-cubist reductions of the human form. All involve a process of abstraction since in all cases the beholder endows the configuration with qualities which discernibly transform it into something more than is strictly given but without conflict with our beliefs about what is really seen. The differences are a matter of detail and degrees of coherence with the expectations entertained in corresponding real situations. If this is right then the abstract art of the 20th century does not depend on newly discovered ways of looking at pictures since it makes use of ways constantly at work for hundreds of years. Hence, in drawing attention to these general features of representation we appear, again, to have provided ourselves with an easy way of making the transition from figurative representation to abstract art. For we could now regard the latter as a more extreme version of what is found in all figuration; the increased abstraction being a matter of confining attention to the most general features of the objects depicted, such as the geometrical properties of material objects and volumes.

Consider, for example, Malevich's *Suprematist Painting* [PL. 18] of 1915. Bachelard described Malevich as "the poet of the ether" who advocated secession from "the ring of the horizon" and whose indeterminate space with its weightless, gliding geometrical shapes, conveys a sense of liberation and unbounded freedom[6]. Looking at this picture it is easy to see why. It is not a picture of objects of specific kinds, such as birds or gliding aircraft. But it does seem to present a limitless, recessive space in which geometrical objects float motionlessly. So, although nothing is depicted as a three-dimensional volume, we do have a sense of slightly titled planes seen head on and gliding towards us or sharply angled and receding into the pictorial space (like a highly abstracted version of a steeply raked, bitumened roof-top). The abstractness of the painting is a matter of it presenting us with abstractions from material reality, just as figurative art does, though at a different and much higher level of generality.

III

So far, then, I have identified two kinds of abstraction: the kind which is essential to any sort of figurative representation and the kind which is present in formal qualities. Do we now have a basis for establishing continuities between abstract and figurative art? There are objections to the belief that we do, and they come from two directions; the first appearing to show that figurative representation cannot provide a basis, the second that neither representational nor formal qualities can. The first objection rests on the claim that it is wrong to explain figurative representation in terms of seeing-as. The second objection rests on the claim that, in any case, both the interpretations of abstraction which I have offered are too tightly wedded to the illusionistic conception of space which is fundamental to figurative art. I will consider each of these objections in turn. I think only the second damaging enough to lead us to look further for the basis of the continuities.

Arguments against regarding representational seeing as a form of seeing-as have been advanced by Richard Wollheim.[7] He claims that we should instead consider representation as resting on the phenomenon of seeing-in. Wollheim adduces three considerations in support of this view. Firstly he claims that a configuration is a particular and it is possible to see that particular only as another particular: whereas what is represented is often a state of affairs, and this is something which we *can* see *in* a configuration. Secondly, seeing-as requires localisation in the sense that, in seeing a configuration as a particular thing, it must be possible to specify which parts of the configuration are so seen. This requirement does not hold of seeing-in since it is possible to see in a configuration depictions which are only very imprecisely connected with the configuration's parts. The final and perhaps most important considerations is that seeing-as does not permit unlimited simultaneous attention to the features of the configuration. This is for the reasons intimated earlier: that it is not possible to attend simultaneously to the supporting features of a configuration and to the aspect they support. However simultaneous attention to both depicted object and the depicting medium is possible when the former is merely seen in the latter. Indeed the possibility of being able to divide attention in this manner is a condition of response to representational art, a key component of which is our admiration for the ways artists exploit their medium to create analogies between it and what is represented.

Wollheim's arguments are not completely convincing, I think, though I shall not consider them in detail. But even if the considerations Wollheim adduces are sound, they could not be used to show that representation must be understood exclusively in terms of seeing-in other than by an act of arbitrary stipulation. For, as Wollheim is ready to admit, it is quite wrong to suppose that seeing-as has no place in our response to art. What Wollheim seems to have done is in effect to distinguish between two kinds of response to figurative art, one of which is more illusionistic than the other. That seems especially to be implied by the sort of attention to art which leads to Wollheim's third consideration. It is indeed correct to say that a major element in our responses to figurative art is attention to the way the medium is employed for representational ends: and that attention does not seem consistent with too exclusive an attention to what is depicted — to the content of the illusionistic realm. But that fact does not altogether preclude a more exclusive attention to what is represented which, indeed, seems an equally important element. Its importance is not merely a consequence of our wanting to engage imaginatively with the artist's subject-matter, to enter the depicted world as it were. For it also seems a requirement of the way we attend to formal qualities.

This is clearly illustrated by Fry's discussion of Rubens's *Martyrdom of St. Ursula*, of which he writes:

And notice how perfectly all these forms fit into the turbulent rush of the rhythm, how definitely that rhythm is one of sequences of planes and not of lines, and how the diagonal movement into the depth of the picture space allows room for all this huddled confusion and gives a harmonious unity. Note, too, the dramatic value given to the figure of St. Ursula and the executioner who is on the point of cutting her down by making this a nodal point in the rhythmic theme, for here the main diagonal movement is sharply countered by St. Ursula's gesture as she is dragged down by the executioner to the left.[8]

The organisational features attributed to the picture by Fry are based partly on the distribution of items within an illusionistic depth and partly on the conflicting movements of depicted figures. These are the bases of the rhythmic features, for it is in terms of the relations between them that the rhythms are defined. Awareness of the rhythms is therefore dependent on taking as given items *within* the picture — overlapping figures which define the planes, dynamically opposed bodies — and seeing them as so related. Thus the rhythms take the illusionistic representation as a starting point, so that the effect would be lost were

we to be concerned, while attending to the formal features, with seeing the products of the illusion — the depicted figures — *in* the configuration in a way which permits simultaneous attention to them and the configuration itself.

Fry's analysis does indeed include attention to the medium of precisely the sort Wollheim draws attention to and of a kind which does require simultaneous attention. He comments, for example, that the

unifying colour of light becomes as it were the dominant key of the colour scheme, and he suggests local colours by very slight variations from that. This key is so strictly felt underlying a whole passage that it is surprising what brilliance of local colour can be suggested by tints actually very far from bright.[9]

Local colour matters, of course, because it contributes to representation. So here Fry draws attention to features which rest on the beholder's ability to give simultaneous attention. But this serves only to show that our response to a picture may involve a complex interplay between features generated by the representational illusion and features of the configuration itself: between seeing-in and seeing-as. There does not, therefore, seem to be any good reason for insisting that representation should be associated exclusively with the former.

Indeed, there is some reason to suppose that seeing-in depends on seeing-as. For even if we grant that the subject-matter of a painting needs to be seen in the configuration the subject-matter still has to be identified. As I stressed earlier this is the result not of an independent act of judgment about the configuration but of the way it is seen. But given the relative dissociation between the configuration and what is seen in it, it is not clear how, initially, this could occur unless it is a matter of the configuration itself already suggesting how it is to be seen: and that seems very much like claiming that the depiction which a configuration suggests is whatever we are able to see the configuration as. That is to say, even if seeing-in is an important part of our responses and provides the rationale for exploring correspondences and analogies between configuration and what is represented, we must start with some idea of *what* the correspondences and analogies are between. By far the most natural way of explaining this seems to be by appeal to an initial act of seeing-as, though without the implication that this exhausts our possible responses to the configuration. If that is true then we could concede the substance of Wollheim's first two considerations. For if what the configuration can be seen *as* is only part of the total represen-

tational content it will not matter that this content is not exhaustively accounted for by the phenomenon of seeing-as.

I take it, then, that the place of seeing-as in representation is not decisively challenged. Let us turn now to the thought that my attempts to establish continuities between figurative and abstract art still leave the latter too tightly bound to illusionistic representation. The strength of this objection depends on the fact that these attempts seem to commit us to locating the pictorial elements of abstract art within an indeterminate space as though they were schematic versions of three-dimensional objects. I have argued above that it is possible for non-depictive painting to retain a clear form of spatial illusionism, and illustrated this with Malevich's *Suprematist Painting* of 1915. This illusionistic quality is no reason for denigrating Malevich's contribution to the development of abstraction. Indeed, such abstraction was no doubt an essential stage in the progression from figurative to non-illusionistic painting. Nonetheless, from one point of view this kind of abstraction represents not so much the beginning of a new era as the culmination of an old; the limiting case of the sort of perceptual abstraction found in hundreds of years of figurative art.

A related point is made about Kandinski by Michael Fried. He speaks of a kind of painting, including not only Kandinski's abstract works but all so-called abstract art before Pollock, which he describes as figurative but not representational. In such painting

one senses throughout the canvas how the line has been abstracted from various natural objects; and to the degree that one feels this, the line either possesses a residual but irreducible quality as contour, so that one reads it as having an inside and an outside — as the last trace of a natural object that has been dissolved away by the forces at work in the pictorial field — or else it possesses the quality of an object in its own right: not merely as line but as a kind of thing, like a branch or bolt of lightning, seen in a more or less illusionistic space.[10]

Such a conception of abstraction (and this is part of Fried's argument) seems seriously incomplete in failing to show how the basic elements of the medium, such as line and colour, can function within a painting quite autonomously and not in the service of even residual illusionism. But since it appears to be the conception which was employed earlier to make abstract art continuous with figurative art the continuity seems more tenuous than it needs to be.

Further, we can now see that the point holds equally for continuities based on formal features. For as my defence of seeing-as has brought

out, the formal qualities Fry was preoccupied with cannot be separated from illusionistic depiction. In recognising formal dispositions we cannot abandon our sense of flexible volumes and their containing space. Figuration and form are not independent of each other: the latter is as much a way of reading depicted elements as the former is a way of reading the configuration.

We see, then, that neither perceptual abstraction nor formal qualities provide a wholly adequate way of establishing continuities between figurative art and the most thorough-going abstract art. For both rest on notions of abstraction too firmly rooted in the kind of three-dimensional spatial depiction generally associated with illusionistic representation. This means that both lean too heavily on the illusionistic conception of the art object, requiring us to go on regarding the picture surface as something through which we look into a distinctive pictorial space.

Should we suppose, then, that genuine abstraction is total reduction to the physical qualities of the picture, apprehended with literal truth? I think that this is to move too far in the opposite direction. For if we did we would be unable to account for a great deal of abstract art which seems to invite a very different kind of response. The attempt to articulate the picture's surface in ways which at least echo spatial relations is a constant theme of 20th century art. If we abandon illusionistic depiction, even of the most abstract sort, we do not immediately lose a sense of the picture surface as indeterminate ground or spatial arena within which elements of design can be located. It is certainly wrong to pretend that abstract art merely continues to create an illusion of space in which radically abstracted objects are located, just as happens within the mainstream of European figurative art. But it is another question as to whether the perspective adopted by the beholder in recognising these illusions plays no part in his response to abstract art. What we need to do, then, is consider whether or not there is a form of abstraction which neither reduces to line, colour and shape nor implicitly reverts to illusionistic spatiality. In order to do so we need to look again at the general notion of representation.

IV

I return to the view that seeing a picture involves seeing one thing in terms of another in a sense derived from Wittgenstein's conception of seeing-as[11] (i.e. the kind of seeing-as which is *not* implied by standard

veridical perception). We need, in particular, to note three aspects of this phenomenon. The first is that, because representation involves seeing the configuration as the depicted object, it also involves what I shall call referentiality. By this I mean that the beholder is caused to make some association with what is not strictly present and it is this which in some broad sense the depictive configuration refers or alludes to or signifies. However, such reference, even when made by an object we see, is not necessarily part of the act of perceiving it. For example, what is referred to may be merely symbolised and enter awareness purely cognitively, as I have already intimated — as happens when we interpret the symbols in a railway timetable. That is why a depictive configuration's referentiality depends on how it is seen — what is referred to becomes an object of perception. What is referred to is what the configuration can be seen as. This is the second feature of representation which we should note.

However, not every case of seeing one thing as another is a case of seeing a depicted item, even when that response is intended. Looking up at the rib vaulting in Amiens cathedral we shall be inclined to see the ribs as springing effortlessly from the capitals at the tops of the shafts and soaring gracefully up towards each other. To see them like that is to think of them as paths traced by the winged movement of some living being. But clearly they do not depict the movement of such a thing. Here the discerned aspect falls far short of figuration.

To take this into account a third feature needs to be added to the referentiality and the perceptual experience of representation. This I shall refer to as its illusive nature. I mean by it the sense of being in the presence of some immediately perceived particular object and thus the sense of having just the sort of perceptual experience we would have were we looking at a real instance of a thing of that kind. We are, I think, inclined to regard this as the most puzzling feature of representation. What is responsible for it is the illusion of three-dimensional space in which depicted objects are located. It is clear that this is an illusion since it requires the beholder to treat the picture's surface as something to be looked through into a space not continuous with real space. How is it possible for this illusion to occur?

I suggest that the key element in illusiveness is an analogy between what the beholder takes to be the causal interchanges occurring in the perception of, respectively, actual and pictured objects. Consider first what happens when we see real objects. Very roughly, it is a condition

of our seeing something that it should be causally necessary and sufficient for the perceptual experience. That is to say, if a beholder with relevant sensory and conceptual abilities is to see a given object, generally it is necessary for there to be an object of the appropriate sort standing in appropriate relations to the beholder: and generally, if there is such an object standing in those relations, then such a beholder will see it. Of course it is possible to imagine both circumstances when the perceptual experience is induced by something other than the object and also circumstances which prevent the otherwise standard causal interchange. But for present purposes such cases do not matter. Seeing pictured objects rests on a sensed analogy with seeing real things and not, of course, on the logically strict satisfaction of causal conditions. I contend that this analogy is between the causal origins of our experience when looking at pictured things and the causal origins of real sightings of them.

It is plausible to suppose there is such an analogy. Just as a suitably endowed perceiver, confronted with a real object of a certain kind, will see it in certain ways and would not unless confronted with it, so a suitably endowed perceiver, confronted with a depictive configuration, will as a result have perceptual experiences he would not have in its absence. 'Suitably endowed' must be taken, here, to imply 'recognises that a representational configuration is being looked at', if only to accommodate the intentional nature of depiction. (Though it would be a mistake to suppose that this is always a judgment made by the beholder quite independently of his inclination to see the configuration as a pictured object. For sometimes the fact that inclination is prompted is a ground for responding in that way.)

There is, however, more to it than this general causal parallel. We can see what more by examining an apparent disanalogy between the case of a real object standing in space and the case of an object depicted as standing in space. In the first case the space in which the object is located does not seem to be part of the cause. In the second case just because that part of a configuration which is identified as empty space is part of the configuration, it *is* part of the cause. Indeed, if we could not identify part of the configuration as the space in which the object stands it would be impossible to interpret the whole as illusively depictive in that way. If that is so the assumption about what causes the perception threatens to drop out of the explanation altogether. For it seems as though it is only if we have already

recognised the configuration as depicting objects in space that we could identify parts of the configuration as causes analogous to material objects and distinguish them from the space in which they are located.

This difficulty is not hard to overcome. It is only real things which have to exist before they can make us see them. Depicted ones need only create the impression that they do while we are looking at them. They are able to do so for two reasons. One, as I have suggested, is the real causal transaction which takes place between the configuration and the beholder's response to it. The second has to do with the specific features of the configuration: what is in the picture will appear to us as material things capable of making us see them. Typically this will be because the depicted objects seem to be disposed within the configuration as a whole as they would were we to be looking at real counterparts which make us see them in ways consistent with what are taken to be standard optical laws. For example: distant objects will appear smaller and be less visible; as objects recede in space our view of them will alter in predictable ways; nearer objects will obscure more distant ones standing in line with them; how a surface appears will depend on its position in relation to the beholder and to the depicted light source; and so on. So there are two elements in the sensed causal transaction between the beholder and what he sees: the real causal properties of the configuration and the illusory properties of the objects, apparent once the configuration is interpreted as illusively depictive. In reality we would assume that the first are identical with the second in a depictive illusion we know that they are not. But this does not matter since in the pictorial case our sense of the real causes and our inclination to perceive the apparent causes combine to create an experience closely analogous to looking at what is real.

This brings out something important. It shows an intimate connection between our sense of objective causal properties in representations and the kind of coherence possessed by the representational configuration. Because this sense is part of the illusiveness of depiction, that provides a reason for thinking that a certain sort of coherence is a condition of spatial illusionism. It is not that parts of the configuration appear in accordance with the appropriate causal constraints. It is that the configuration as a whole gives the impression that they do — Merleau-Ponty says

Space is not the setting (real or logical) in which things are arranged, but the means whereby positing things becomes possible. This means that instead of imagining it as a

sort of ether in which all things float, or conceiving it abstractly as a characteristic that they have in common, we must think of it as the universal power enabling them to be connected.[12]

That is very close to the principle underlying our response to illusionistic spatiality.

That, then, is how I account for the third, illusive element in figurative depiction. It needs to be stressed, though, that this and the other two elements — referentiality and seeing-as — do not stand independently in representation. Instead there is a interaction between them. As soon as we are able to read a configuration in terms of objects in space we are also able to see it as making reference to them. Once this happens the association which goes with the reference will reinforce the illusionistic reading and hence the inclination to see what is depicted as having a certain causal power. Having seen part of Titian's *Bacchus and Ariadne* as a female form in a particular stance, we reinforce this with our belief that limbs so disposed must reach into the space behind her; which in turn leads us to see one part of the configuration as foreshortening of the figure's right arm, produced by our spatial relation to it. Reference to material objects in illusionistic art is important at least in part because the references reinforce a particular conception of what causes us to see things as we do. So figurative depiction, we may say, is a peculiar combination of the three elements I have distinguished: referentiality, perceptual experience and illusiveness. Greenberg makes (what I take to be) much the same point when he identifies as central elements in representation both the "spatial rights" enjoyed by images and their "conceptual meaning".[13]

We can now return to the point with which I ended the last section. For once we have distinguished the three elements which go to make up illusionistic depiction we seem to have the basis for a mode of abstraction which is neither wholly reductive nor dependent on residual illusionistic space. For we open up the possibility of such a form of abstraction if we show that there can be paintings incorporating the first two features but not the third. Such paintings would make reference to spatially related items and be capable of being seen in terms of those relations: but they would not thereby regenerate an illusion of space of the standard figurative kind. For they would not possess the sort of coherence which generates that sense of causes for our perceptions on which illusionistic figuration depends. To that extent the art-object would no longer need to be illusionistic even though it is being seen in

terms of more than is strictly given. But the more in question would not be so much more as to rule out proper respect for the picture surface.

I shall now look at some particular cases to see how far we can get with this idea. If we are successful we shall have revealed something important about the differences between this sort of abstraction and figurative painting: namely that it does not hang in any important way on abstraction as such. What it will hang on is the way abstraction is connected with referentiality and a sense of our experience's causal origins.

<div align="center">V</div>

The transition- from the three-dimensional space of such painters as Raphael, Claude, Vermeer and Constable to non-illusionistic spatial organisation was inevitably a gradual one. The work of both the impressionists and Cézanne were instrumental in its development. There is evidence of this in the way the apologists of American formalism, like Greenberg, tend to see Cézanne primarily as a precursor of Cubism and as an intermediary between Impressionism's tacit acknowledgement of the picture plane as a fundamental point of structural reference and the new structural devices and modes of representing space developed by Picasso and Braque in their cubist work. This is, of course, an incomplete view which misrepresents Cézanne's uniqueness and peculiar expressive concerns. Kramer notes[14] that Greenberg's seminal essay on Cézanne makes no mention of the artist's portraits, which seems significant and certainly suggestive of relative unconcern for Cézanne's expressive power.

However, there is no doubt that this expressive power is intimately tied up with a peculiar quality of harmonious, poised stability, often within designs of great complexity: and this is turn rests on Cézanne's handling of spatial depth in relation to colour and plastic form. I think the key element is persistence of traditional illusionistic three-dimensionality, and hence of perspective, but without a clear sense that the picture frame opens onto an indeterminate spatial container. In this respect the notorious perspectival inconsistencies seem very important (and certainly not to be dismissed as merely the result of Cézanne's closeness to his subject). They temper the illusion since they are at odds with the beholder's impression that he is looking at material objects familiarly related within the three-dimensional space which contains

them. This is often reinforced by backgrounds which are indeterminate and geometrically articulated in ways that echo the canvas's literal shape. The effect is to make the picture's actual flatness part of the representation and the result a tension between the rhythms of surface pattern — now much more obvious — and the plastic relations between three-dimensional forms. This tension accounts for our sense of a tilted central plane with middle-ground objects brought oddly forward. A lot of Cézanne's achievement lies in his skill at handling the tension and using it to generate a highly dynamic stability. What is important is the extent to which it rests on the emergence of new spatial relations. Illusionistic space no longer reigns supreme since the configuration can no longer be coherently read in those terms. Even so, there very clearly. is a picture space. Because it no longer adheres so closely in structure to real space it in effect presents the beholder with a highly abstracted version of space unsupported by the usual illusionistic cues.

However, it is with Cubism that we see most clearly the disintegration of the old indices of illusionistic space. Cubism dispenses both with a coherent sense of material objects as determinants of our experience and with references to reality of the kind needed to reinforce an illusionistic reading.

Consider Picasso's *Portrait of Kahnweiler*. [PL. 21] Certainly there are residual allusions to the depicted object, with recognisable if rudimentary representations of hair, eyes, watch-chain and hands. Also evident is the use of line to delimit objective elements within space by establishing contours and edges. And the subject is located in the centre of the picture area, as a unified entity if not as a coherent volume. On the other hand there is nothing else to shore up the sense of illusionistic space. Pictorial depth relies on planar contours which require and therefore generate only a very shallow space. We are aware of the edges only as the extremities of planes which have no depth. Because the assumed space needs to be only very rudimentary to sustain these relations it remains very schematic. Further, the subject's form is presented only as a complex of interrelated surfaces. Certainly these are not located in just one plane, so the picture does have depth. But the planes do not define a coherent, integrated three-dimensional solid. They are merely a series of reflectors for various intensities of light, as would be the different parts of a body's surface.

These features — the kind of space created and the way the subject is presented — reinforce each other. Because the body's volumetric

coherence has been abandoned pictorial depth no longer needs to be construed as an indeterminate spatial container. Contrariwise, because the picture's depth depends largely on the relations of overlapping and adjacent planes, more or less parallel with the picture plane, the central figure emerges not as mass but as visible surface.

This is a clear example of art in which the referential and the illusive have parted company. There is no sustained correspondence between what seems to produce the beholder's perceptions and what the painting alludes to. This is generally true of analytic cubism and it shows that cubism develops abstraction primarily by abandoning the causal coherence of appearances. It is therefore not a development of abstraction by itself but a modification of the way space is depicted with the result that spatial relations become less illusive. Greenberg sums up the main thrust and its outcome when he says that what results is "an illusion of depth and of relief so general and so abstracted as to exclude the representation of individual objects".[15]

Cubism's exploration of new modes of spatial abstraction has an important outcome. It shows the need to acknowledge in painting an intermediate state between illusions of 3-dimensional space and actual 2-dimensional space. The former is the mainstay of traditional figurative art, the latter what we end up with given unqualified respect for the literal flatness of the canvas surface. Total acceptance of flatness presumably confines the artist to surface decoration and to articulating it in ways restricting attention to the picture plane. There are certainly elements of that in the work of later abstractionists like Joseph Albers and Elsworth Kelly and even in the figurative painting of Gauguin and Matisse, and, more recently, Tom Wesselmann and Allen Jones. However, it is a serious oversimplification to suppose that abandoning illusionistic spatiality leads in one step to exhaustive reduction of the painting's salient features to surface properties. For that fails to take into account the way surface articulation can generate an intermediate, highly abstract but non-illusionistic sense of space.

Two considerations bring this out. Firstly, even a two dimensional space allows of figure-ground relations. Hence it can be used to give identity to elements within an otherwise empty and indeterminate area: and these elements can, within that area, be more or less attracted to each other, combine or resist combination into clusters, fill the area in more or less balanced ways and so on. Lines can also be seen as tracing paths through that area and as moving in various ways within it.

Secondly, if colour is introduced into this supposedly two dimensional space its tonal values are likely to recreate precisely those effects to which colour contributes in illusionistic spatiality. Effects of spatial depth, for example, often depend on the difference between the tonal values of nearer and further objects: the simplest case being when a dark object will stand out against — that is, stand forward from — a lighter background simply because darker — it produces the effect of a silhouette. Now it is perfectly clear that figure-ground relations, graphic line and colour can all appear in wholly non-figurative, non-illusionistic art. However, when they do — and this is what cubism shows — they are likely to recreate a sense of depth, however abstract and however perspectivally inconsistent. The *purely* flat plane will begin to disintegrate even if not to the extent that it becomes a window opening onto an illusionistic space.

Prefigured in cubism, this is an important element in 20th century abstract painting generally. It is not always obvious because figure-ground relations do not always appear quite so explicitly as in Miro's and Kandinski's abstract painting. Sometimes this is because unfilled space is excluded altogether by making figure cover ground completely. In other cases ground is retained but its emptiness negated. The former is illustrated by some of Ben Nicholson's work in which, although nothing is identifiable as ground, the dynamic play between the elements depends on their having separate identities, defined both by lines which act as contours and by colour values. Mondrian's classic grids illustrate the latter. The black horizontals and verticals have a complex function in these paintings. They obviously contribute to articulating the independent counterposed elements as well as conferring great stability on the whole. But they also prevent the lower-value areas from degenerating into mere background since these areas too are independently articulated and thus put on a par with the more prominent areas of the picture plane. In this way incipient recessiveness and an allusion to indeterminate space are checked.

So even though illusiveness has now disappeared completely, a kind of spatiality persists. Such devices as figure-ground relations mean that the configuration can still be seen as alluding to relations akin to those between material objects and the space they are located in. Of course these perceived relations are exceedingly schematic, but given the disappearance of illusiveness, that is what we would expect.

This idea is particularly apparent in the preoccupations of post-war

formalist criticism, especially in the kind of attention given by critics like Greenberg and Fried to abstract expressionism and post-painterly abstraction. Earlier I noted a distinction drawn by Fried between representational and non-representational figuration. Fried does not see this distinction as adequate to deal with all 20th century abstraction since it will not cover spatiality which is not at least residually illusionistic. He is thus led to postulate an illusion of space which is rendered wholly optically; a kind of pictorial field and a way of articulating the picture plane which, while not a mere reduction to shape and colour, addresses itself, as Fried puts it, to eye-sight alone without any tactile implications at all. He argues that a problem attaches to this kind of pictorial field since it is very difficult to reconcile with figuration. Pollock is held to have solved this problem only once, in *Out of the Web* — "one of the finest paintings Pollock ever produced".[16]

We may well demur and not simply on the grounds that *Out of the Web* does not merit such distinction in relation to Pollock's work as a whole. For the theoretical distinctions drawn by Fried in discussing pictorial space seem not strong enough or clear enough to support marked qualitative difference between such paintings as *Out of the Web, Autumn Rhythm* and *Lavender Mist Number 1*. I shall not pursue the details of Fried's attempt to explicate his ideas. For as I think the examples already discussed show, even if we abandon what Fried seems really to be reacting against — illusionistic spatiality — we do not need a completely new conception of space or of the function of line within void. Non-illusionistic forms of spatial relations leave open a wide variety of alternatives for analysing the work of Pollock, Newman and others.

Fried gives the clue himself when he says that in Pollock's paintings:

line . ∴. is entirely transparent both to the non-illusionistic space it inhabits but does not structure and to the pulses of something like pure, disembodied energy that seems to move without resistance through them. Pollock's line bounds and delimits nothing — except, in a sense, eyesight. We tend not to look beyond it and the raw canvas is wholly surrogate to the paint itself.[17]

Now it is certainly true that in, e.g., *Autumn Rhythm* [PL. 16] both the spots of paint and the larger areas of colour — which are not always opaque — are so much part of the picture surface and so enmeshed in the skein of lines as to prevent our seeing the canvas as any sort of illusionistic space. And the general randomness of line and the elusiveness of the coloured areas undermines any sense of edge and bounding

contour. At the same time, as Fried admits, there *is* a space the line inhabits and through which we sense it moving with extraordinary flexibility and freedom. Of course the relation between the path traced by entirely disembodied motion and the void it moves through is abstracted to an extreme degree: to the extent that we are able to identify it only very locally, using such expressions as 'the movement traced by the line *here*, through this space *here*'. Space is not articulated systematically enough to permit us to do more. Nonetheless the spatial relations are present.

Much the same goes for a lot of Frank Stella's work, even though his early stripe paintings, such as *Tampa*, seem to depend exclusively on surface decoration and to exclude spatial relations more than anything so far considered. Certainly the so-called deductive structure of these works is a strong disincentive against seeing the configurations in terms of figure-ground relations. Because the picture surface is composed of linear elements which run strictly parallel with the edges of the canvas support every part seems equally important with every other part so none invites the viewer to see it as indeterminate ground. Even so it is very hard to see the stripes as mere marks on the picture surface. Greenberg's often-quoted remark that the first mark on a surface destroys its flatness has as much application here as anywhere. The fine lines are seen as delimiting edges of broader bands which entirely fill the picture space and are made to converge or change direction or run away from each other. They thus take on a role which is relatively independent of the framing shape. Of course the deductive structure continues to assert itself and often the result is notable tension between the overall shape and the autonomous elements bounded by it. In the absence of this tension — as for example in *Delaware Crossing* — the paintings are lifeless and do indeed seem little more than marks on the canvas surface. What is significant is that the tension depends on our seeing the stripes as relatively autonomous. This embodies a highly abstracted conception of the spatial relations between the individual stripes and between the stripes and the picture as a whole, resting only on a sense of distinctly articulated coloured elements without any idea that they might be particular sorts of abstractly depicted item (such as strips of painted wood). For the configuration incorporates too little to create any sense of three-dimensional objects causing such perceptions. Nonetheless these extremely abstract relations are still essential to the dynamic of the works.

Stella's polygonal paintings of 1966 incorporate a comparable tension but handled differently. These paintings depend on ambiguous ways of seeing the depicted shapes, for example as rhombuses and trapezia, or as receding rectangles. Adopting the latter perspective, the beholder harks back to a more illusionistic conception of spatial relations. There is, of course, still no possibility of organising the configuration into a logically coherent space, for this is ruled out by the way Stella connects shape and surface design to stress the materiality of the canvas. The level of abstraction is so high that if there is anything recessive in what we see it is recession as such, not receding things. This is why it is of no importance just what the edges of the quasi-depicted shapes are edges of. Hence there is no incoherence in their coinciding with, indeed their *being* the physical edges of the canvas support itself. Here the abstraction is so extreme that we are able to combine spatial, though non-illusionistic ways of seeing with complete respect for the literal materiality of the art object.

VI

We see, then, that 20th century abstraction does not always present highly abstracted versions of objects located in illusionistic space. At the same time we see that it is still possible to see a configuration in spatial terms and therefore not to rest at the level of the figurating object's literal materiality. This results from the difference between two sorts of configuration: those which invite the beholder to respond to them as engendering perceptual experiences akin to the ones he would have if looking at material particulars located in a three-dimensional space, and those whose elements can still be seen as spatially related even though the beholder is unable to organise them coherently into such a space. The first sort incorporates all three features of representation earlier identified, the second sort only the first two features.

I will return briefly to the polarization of the abstract and the figurative with which I began. I have argued that the development of abstract art as such does not constitute a radical break. For there is at least one kind of abstract art which is clearly continuous with figurative art. The significant break occurs when depiction ceases to be concerned with illusionistic causal coherence. Again, though, the break is not due to the appearance of abstraction exclusively concerned with the basic elements, line, shape and colour. For continuity is still preserved in that

we go on seeing the configuration in ways alluding to more than is strictly given and particularly in terms of spatial relations. Indeed, exploration of possible ways of doing this is one important strand in the history of twentieth century art. Nonetheless the break is significant. For while abstract illusionism is distinctively different from figurative representation it retains essential elements of it — a perspectival stance akin to the traditional one and a persisting sense that, so far as perceptible character goes, the depicted world is essentially the same as the real one. Both are abandoned when art foregoes illusiveness. The fact remains, though, that it is on *that* change that we must rest our understanding of the distinctiveness of twentieth century art. Abstraction, as such, will not provide the key.

University of East Anglia

NOTES

[1] See, for example, his account of Raphael's *Transfiguration, Vision and Design* (Harmondworth: Penguin Books, 1961), pp. 232—233.

[2] Alfred J. Barr Jr., *Cubism and Abstract Art* (New York: Museum of Modern Art, 1936). Meyer Schapiro's discussion is in the essay 'The Nature of Abstract Art' in his *Modern Art* (New York: George Braziller, 1978).

[3] E. Hanslick, *The Beautiful in Music*, (trans. G. Cohen) (New York: Liberal Arts Press, 1957).

[4] F. Schopenhauer, *The World as Will and Idea*, (trans. R. B. Haldane and J. Kemp) (London: Kegan Paul, Trench, Traubner, 1907), Vol. 1, p. 338.

[5] H. Wölfflin, *Renaissance and Baroque*, (trans. K. Simon) (London: Fontana Library, 1964), p. 69.

[6] Quoted in T. Anderson, *Malevich* (Amsterdam: Stedelijk Museum, 1970), p. 28.

[7] R. Wollheim, *Art and Its Objects* (Cambridge: Cambridge University Press, 1980), p. 205.

[8] Roger Fry, *Flemish Art* (London: Chatto and Windus, 1927), p. 44.

[9] *Ibid.*, p. 45.

[10] Michael Fried, *Three American Painters* (Harvard: Harvard University Press, 1965), p. 15.

[11] L. Wittgenstein, *Philosophical Investigations* (Oxford: Blackwell, 1952), Part II, section xi.

[12] M. Merleau-Ponty, *Phenomenology of Perception*, (trans. Colin Smith) (London: Routledge, 1962), p. 243.

[13] Clement Greenberg, *Art and Culture* (Boston Massachusetts, Beacon, 1961), pp. 134—136.

[14] Hilton Kramer, *The Art of the Avant-Garde* (London: Secker, 1956), p. 505. Greenberg, *op. cit.*

[15] *Op. cit.*, p. 77.

[16] *Op. cit.*, p. 18.

[17] *ibid.*, p. 14.

PAUL CROWTHER

ALIENATION AND DISALIENATION IN ABSTRACT ART

INTRODUCTION

To be alienated is to be estranged from something. In the case of abstract art, its critics have held that such works are alienated in the sense of embodying a flight from reality into a vacuous realm of theory, which renders them unintelligible to the majority of people. In this paper, I shall argue that the former claim is true only in a restricted sense, and that if freed from this restriction, the latter claim need not apply. To show this, I shall, in Part 1, outline a theory of alienation inspired by Schiller but derived substantially from Merleau-Ponty and Hegel, with some nods towards Marx and Heidegger.[1] In Part 2, I will relate this to the theoretical justifications offered by some abstract artists for their work, and will suggest that whilst such theories do indeed involve an element of alienation, this is irrelevant from an aesthetic point of view. In Part 3, I will argue further that, grounded in terms of a complex notion of aesthetic experience, abstract artworks actually turn out to be disalienating in both ontological and political terms.

1

Merleau-Ponty has argued very plausibly that the fundamental condition of human being-in-the-world is embodiment. If we were not mobile and embodied — creaturely things of feeling and sensibility amongst other things in a shared sensuous world, we would not be able to conceptualise reality in the way we do; but reciprocally, if our bodily activities were not guided by such rational comprehension, we would relapse into the status of mere things, and would be unable to sustain our embodied existence. One might say, then, that through embodiment, the rational and sensuous aspects of our being are in a state of ontological reciprocity. We only achieve full definition as human if these aspects are integrated in a thoroughgoing unity. Now there are many occasions in ordinary life, when the interests of reason, and the

121

Andrew Harrison (ed.), Philosophy and the Visual Arts, 121–133.

interests of sense are played off against one another for practical reasons, e.g. the deferring of some immediate sensuous gratification, on the ground that such deferment will lead to greater gratification at a later date. However, under certain socio-historical conditions, this pragmatic division of the rational and the sensuous is absolutised, and passed off as embodying the true and natural order of things. The human condition is characterised in terms of a disequilibrium wherein our rational being is construed as being fundamentally opposed to, and thence alienated from, our sensible being (or vice-versa). This aliena-tion takes two forms. At the level of understanding we have ideology, and at the level of practice, we have alienated labour. Let me briefly outline these in turn. First, ideology. The classical examples of this mode of alienation are religious belief and idealist philosophy, wherein our rational capacities are seen as attributes of the soul, or of a pure thinking subject. In such systems of belief, the senses, indeed the sensuous world in general, are seen as sources of sin, or as features which impair our grasp of truth. On these terms, we are fully human only when we negate our particularity and sensuousness, and aspire towards universal truth and rational comprehension. At the other extreme, some philosophies — such as utilitarianism, degrade the universal, and see our rational capacities as significant, only insofar as they are a means to the realisation of certain sensuous states, e.g. happiness. Having, then, outlined aspects of ideology, I shall now consider the notion of alienated labour. This arises through that divi-sion of labour which is required in order to maximise efficiency and profits in the industrial economy. The worker's rational activity is rewarded with wages with which he or she obtains the means of bodily subsistence. Instead of labour satisfying the whole human being, ra-tional activity becomes a mere means to the survival of our sensuous being. The worker sees the end product of labour as a mere alien force. Indeed, with unskilled labour, the worker's very relation to the object produced is in a sense, contingent, insofar as the individual's personal skills or interests have no bearing on the process of production, or on the end product's function. This amplifies out into the way experience itself is organised generally. The world becomes a network of means and ends, of things to be done, objects to be appropriated — in return for enjoyment and the means of subsistence. Nature is a mere fund of resources. We lose our sense of community. — Other persons and institutions (apart from friends and family) are seen stereotypically as

features of the total productive system, of significance only insofar as they regulate or inhibit our own function within the system. All in all, the divisions between rational and sensuous being are writ large. Nature and other people do not form a sensuous domain of existents continuous with, and akin to ourselves, but an anonymous Other to be appropriated or resisted through rational activity as a means to perpetuating our own sensuous existence.

2

How, then, is ideology and alienated labour manifested in abstract art? I shall consider this, first, in relation to the theoretical justification for their work, offered by Mondrian and Malevich, respectively. For example, Mondrian observes that

We find that in nature all relations are dominated by a single primordial relation, which is defined by the opposition of two extremes. Abstract plasticism represents this primordial relation in a precise manner by means of the two positions which form the right angle.[2]

Hence

Through the exact reconstruction of cosmic relations it is a direct expression of the universal; by its rhythm, by the material reality of its plastic form, it expresses the artist's individual subjectivity.[3]

Here, then, the justification for Mondrian's abstraction, is that it gives expression to a kind of Platonism of relations — a pure Ideal essence of visual reality beyond sensuous particularity. It is by mediating this essence through the handling of the medium that the artist achieves self-expression. However, the problem here is that the artist is very much the slave of spiritual reality. His or her painting is an attempt to recuperate a wholly external rational truth by (as Mondrian also puts it) "a logical and gradual progress toward ever more abstract form and colour".[4] But if this is the case, whilst the artist must indeed handle and shape sensible material, it is difficult to see how this counts as anything more than a formal condition. The operative imperative is, rather, that in order to express pure plastic relations the artist must actively suppress any individuality of style. The sensible particularity of his or her handling of the medium, in other words, must be recognised as a mere means to spiritual truth — as something to be transcended. This means, in effect, that not only is Mondrian's theory ideological in its spiritual

orientation, but that it also entails a dimension of alienated labour. Let me now consider Malevich's approach. We are told that

Everything which determined the objective-ideal structure of life and of "art" — ideas, concepts, and images — all this the artist has cast aside in order to heed pure feeling.[5]

And

To the Suprematist the visual phenomena of the objective world are, in themselves, meaningless; the significant thing is feeling, as such, quite apart from the environment in which it is called forth.[6]

Here we have the opposite extreme to Mondrian, but a similar theoretical mix of ideology and alienated labour. — Any sense of rationality or objective structure in the world is merely significant insofar as it gives rise to a specific sensuous state of 'pure feeling'. The world is simply a meaningless Otherness, significant only as a stimulus to the artist's feeling. Now it is interesting that — as the modern epistemological emphasis in theory of the emotions has shown[7] — there is no pure feeling. Emotions are only characterisable (even in terms of such debatable categories as 'pure' or 'plastic' or whatever) insofar as they can be differentiated from other emotions on the basis of the different cognitive objects they are directed towards. To talk of some 'pure' state of feeling apart from a causal- evaluative link to some object of cognition, is ridiculous. By focussing on subjectivity and the artist's particular feeling so exclusively, in other words, Malevich empties it of any meaningful content. Indeed, if pure feeling is a state of absolute and self-validating inspiration, then the artist's rational artifice is at best a mere translation of this state, or a means for communicating the fact that it exists. In either case, rational being is alienated from reciprocity with the sensuous.

Now whilst the writings of Mondrian and Malevich mark out the two extremes of alienation, we find similar tendencies in the theoretical justifications offered by many other abstract artists for their work. The Surrealists, and some of the Abstract Expressionists (such as Jackson Pollock) for example, degrade rational comprehension and objective knowledge in favour of the unconscious repressed desires of our sensuous being. On the other hand, Duchamp, the Dadaists, certain Pop Artists (such as Jasper Johns), and the Minimalists, degrade or parody the sensuous and expressive features of their media in favour of making statements about the status of art objects. Thus we are led towards the

all important notion of conceptual art. In the most extreme forms of this tendency — such as the work of the Art Language Group in the late 1960s and early 1970s, the distinctively visual mode of art is transcended in favour of the universality of the written word. This, however, results in a distortion of both elements. On the one hand, by setting themselves apart from the handling of sensuous media, the 'artists' neatly avoid conventional modes of art criticism; on the other hand by linking their conceptual work to the gallery system and visual artworld, they obviate having their theories evaluated in philosophical terms. Now it might be argued that this mystifying surge towards conceptual art is demanded in order to sustain artistic creativity. But since its implied imperative is that in the final analysis, art is whatever the artist designates as embodying an idea about art, this renders creativity into a merely formal, negative notion[8] — a case of simply producing something different. What has really happened here, I would suggest, is that in order for the market to maximise profits and critics to maximise careers, a fundamental division of labour has been brought about. Originality is identified with the theoretical dimension of abstraction, and is split off from the handling of materials (which gives it substance) in order to be exploited more efficiently) That this should ultimately happen was implied at the very outset in the misadventures of Cubism. Rather than regard Cubism in strictly phenomenological terms, critics and some of the artists themselves (such as Gleizes and Metzinger)[9] attempted to justify it as a vehicle for obscure theories of idealist philosophy and worse. It is this aura of theory which ultimately makes the careers of critics and gives abstraction whatever alienating tendencies it has.

I shall now summarise my main points of argument, then effect a qualification and make a transition. First, I suggested that alienation is a mode of disequilibrium between the rational and sensuous aspects of the embodied subject, and is brought about by ideology and the division of labour. I further showed how these alienating forces might be said to be at work in the theoretical justifications offered for a great deal of abstract art. Now this being said, there are clearly some such justifications (— notably those of Klee and some Constructivists such as Gabo[10]) which are much less flawed and which point in the direction of some of the disalienating features which I will outline in Part 3. However, this, in a sense, is irrelevant. For so far I have been talking about alienation purely in terms of the theories which (presumably) underlie

the causal production of certain forms of abstraction. But if we bring our philosophical perspective to bear on this *strictly* historical level of understanding, such modes of abstraction keep rather interesting company. The whole Classical and neo-Classical tradition of visual representation, is founded on a broadly Platonist Idealism; the Romantics shift the emphasis to the unique intuitions of the pure creative subject; Symbolism celebrates a whole host of spurious transcendentalisms. In short Ideology abounds. Now faced with this point, we are surely led to the conclusion that whilst the causal forces which underpin the production of such works may be alienated, this is relevant mainly to our historical or broader cultural understanding of them. If such works engage us aesthetically, however, the dimension of alienation is transcended. Can we not, therefore, take such a view in relation to abstract art. Indeed is this not the approach of those critics (once called Formalists nowadays called Modernists) such as Fry, Bell, and Greenberg? The answer to both questions is, of course, yes. The problem is, however, that the notions of aesthetic experience they have operated with, have been unworkably narrow, with the emphasis upon its sheer unanalysable intuitive or transporting nature. What has been lacking is the kind of phenomenological investigation hinted at by Marcuse[11] amongst others, which would clarify the complex and disalienating aspects of the aesthetic domain. It is the outline of a theory of this sort which I shall now undertake in Part 3.

3

There are three[12] salient ways in which abstract art can give rise to what might broadly be termed aesthetic experiences. Let me outline these in turn. First, following Kant, I would claim that the experience of form is a source of the aesthetic. Normally we take a pleasure in judging that some object possesses quality x, because x is of some practical or theoretical significance to us. However, to take a pleasure in an object possessing formal unity in its phenomenal structure, presupposes no such practical or theoretical context. Rather formal unity is enjoyed for its own sake. But why is this so? Why should we find it more exhilarating and worthwhile than other non-instrumental activities — such as playing Patience? Kant's indirect answer to such questions is that in the apprehension of formal qualities, the two elements in our faculty of cognition (— namely imagination and understanding) are in a

playful and harmonious relation that issues in, and is recognised through a feeling of pleasure. However, if we strip away the Transcendental Idealist notion of distinct cognitive faculties a somewhat more fundamental significance to this explanation emerges. For whilst, in the apprehension of formal configurations our capacity for conceptualising is engaged in a complex and heightened way, it does not denude or dismiss the sensuous particularity of the object — in the way that judging it in terms of some practical or scientific interest might require. Rather the zestful intensity of our conceptualising is made possible by, and indeed involves a recognition of the phenomenal richness and diversity of the sensuous world. Freed by formal qualities from the vicissitudes of everyday life and its interests, in other words, our rational being and the sensuous world are in a state of harmonious, disalienating, reciprocity. It is this, I would suggest which is the ground of our aesthetic pleasure in form.

Let me now consider a second aspect of aesthetic experience which abstract works can embody, namely expression. In this respect, it frequently happens that we further characterise formal structures and their parts metaphorically in terms of emotional qualities.[13] We say that such and such a work looks joyous, serene, sad, tragic, or whatever. Now why should our metaphorical encounter with such emotions be any different from our experience of them in real life. Sometimes, of course, it won't be. We may simply say 'that's a miserable looking thing' or 'this painting makes me feel sad' and leave it at that. However, there are occasions when our experience of some emotion metaphorically expressed, has a different effect from the one we would expect. When, say, a joyful configuration, is experienced with a feeling of serenity, or, tragic-looking forms with a feeling of awe and elation. It is on these occasions that our experience of emotion metaphorically expressed takes on an aesthetic, and ultimately disalienating character. I would explain the complex factors involved here, as follows. First, to experience emotion metaphorically expressed, is to encounter that emotion at a distance. There are two aspects to this. First, because the emotion is expressed in a sensuous medium, it is a property of a thing not a person. Second, since this sensuous mode of embodiment means that the metaphorically expressed emotion is detached (or in principle detachable) from the causal circumstances that governed its production, we do not know[14] whether its creator did or did not experience an emotion of the type expressed. Given these two features, one might say

that metaphorical expression distances emotion from the particular stresses and involvements of everyday life. There is no pressure to identify directly with the emotion expressed; no guilt in turning away from it; and no need to control it. We recognise, rather, a possibility of feeling which facilitates a more reflective attitude on our part. We understand that the emotion is more than our own or the artist's experience of it; that it is, in fact, universal — a permanent possibility of experience for any human being. Now if this distancing of emotion from our ordinary experience of it were *just* a distancing, there would be no reason why we should value it any more than a statement such as 'there is sadness'. To understand the full significance of distancing in metaphorical expression, we must link it to another feature. In this respect it is useful to ·consider our rather stereotyped understanding of emotion in everyday life. It is all too easy for example to identify emotion, with some simple feeling-state in the subject, or to construe it on the stimulus-response reflex model. The truth, of course, is more difficult. Even the simplest emotion involves a complex not only of physiological and behavioural aspects, but of cognitive appraisal — wherein the emotive situation is assessed against a background of the individual's other beliefs, attitudes, and values. Hence to recognise an emotion in ourselves or others, is to recognise only the salient contours of a complex network of relations. Its roots remain submerged. Now in the case of metaphorical expression we do not simply 'read off' the emotion. Rather we characterise it as such and such an emotion on the basis of our scrutiny of the complex interplay of formal relationships in the work as a whole. It becomes visible from this background. We are thus led to a contrast. On the one hand, in ordinary life, we read the surfaces of expressed emotions and have only a precarious sense of the complex relations which subtend them and made them possible. On the other hand, with emotion expressed metaphorically, the emotion emerges from a visible complex of relations. The conditions of its possibility are themselves made manifest. In the case of the latter, therefore, we have an analogue which expresses the nature of emotion more lucidly than the real thing. It is this in combination with distancing, I would suggest, which accounts for the fact that the experience of an emotion expressed metaphorically can differ profoundly from that of a similar emotion in ordinary life. Through the sensuous complexity of the formal configuration, our rational comprehension of the emotion expressed, is both deepened and transformed. We experience a disalienating reciprocity.

Now these two disalienating modes of aesthetic experience which I have just described are both disinterested, insofar as our pleasure in them presupposes neither a practical or theoretical context of application, (a point made earlier in relation to form) nor an interest in the 'real existence' of the object. By this latter point I mean that our aesthetic appreciation of form and emotion does not have as its ground any reference to what kind of thing the object which sustains the qualities is; or any reference to those dispositional properties or the absence thereof which would establish it as real or illusory respectively. We are dealing with the pleasures of phenomenal surfaces and their emergent qualities alone. However, there is a third mode of aesthetic experience which whilst counting as disinterested in the first sense, is not so in relation to the question of 'real existence'. It is that mode of experience which arises when our appreciation of form or emotion is modified by the knowledge that the object which sustains these qualities is the product of human artifice. I refer, of course, to the notion of empathy. To establish its aesthetic basis, I shall follow a line of argument that broadly parallels the one adopted in relation to metaphorical expression.[15] First, we know that as embodied beings, no matter how common a language or culture we share, we each retain a unique perspective on the world. To others this uniqueness is manifest primarily in our personal style — our way of speaking, gesturing, the choices we make, the company we keep, etc. It is this particular perspective which we seek to empathise with. Now in the course of ordinary life, there are three sorts of restriction placed upon our empathy with a particular person's style. First, the physical presence of the person who sustains it. may inhibit us from, as it were, 'going over' i.e. the fact that we encounter the style in the person of its bearer stamps it too manifestly as theirs. Second, the person concerned may be so close and dear to us, that we are totally engaged by the particularity of their existence. Their human proximity to, and significance for us, demands so intense an involvement that we do not identify with the other as an equal, but are, rather, obsessively absorbed into their concerns. Third (and finally) as with emotion, a personal style is something of great complexity — a web of behavioural traits, personal beliefs, attitudes and values. In the situations of everyday life, however, we tend to read style as a surface feature i.e. in terms of its most salient aspects and contours. Now if an artwork is original enough to manifest a style, then a crucial dimension of distancing and lucidity is intro-

duced. The work itself is not a person, but neither is it simply a mundane description of style. Rather, through the articulation of form, the choice and juxtaposition of colours, the selection of materials, etc., it exemplifies the artist's aesthetic style — his or her way of reacting to, and forming the sensuous world. This, I would suggest, has a further crucial symbolic significance as an analogue of the artist's personal perspective on the world, as such. The reason for this is that style in an art work is not read off in terms of any one, or group of salient features, but from the total interplay of the different visual elements and relations. Whereas in life, the roots which make style, are hidden; in the artwork, in contrast, they are made lucidly visible. Given this dimension of distance and lucidity, therefore, our experience of empathy through artistic style, will be phenomenologically different from empathy ordinarily experienced. There is more scope for free imaginative identity with the artist — for taking the work's stylistic clues and attempting, say, to share the cool, refining values of Mondrian, or the stark tragedy of Rothko's condition. Indeed, one can learn through the artist's style, truths about oneself. For example, the tension between spontaneity and 'finish' in a Jackson Pollock drip-painting, may make us aware of a similar tension between the yearning for spontaneity and the yearning for order in our own lives. Here our identification with the artist is not an imaginative 'attempt', it is a recognition of both problems and solutions shared. All in all, one might say, then, that when stylised sensuous form is at a premium, we achieve a deepened comprehension of the artist's uniqueness and of our shared humanity with him or her. Again we have a disalienating reciprocity.

I shall conclude with an observation, and a more lengthy discussion of a putative objection to the approach taken in this paper. The observation is simply this. The aesthetic effects I have ascribed to abstract art have by no means a special relationship to it. Aesthetic pleasure in form and emotion can arise from nature, and both these modes of experience and that of aesthetic empathy can arise from representational art. The tendency to abstraction, in other words, is nothing special or esoteric. It only looks that way when viewed through the mist of alienating theories which have informed the production and critical reception of certain works. If abstract art is set free from such mystifications, and the emphasis placed on it as an embodiment of pleasurable formal configurations, then it becomes correspondingly more intelligible to the non-specialist audience. However, by construing

abstraction's fundamental significance in terms of aesthetic experience, I lay myself open to the following objection. To ground abstraction on aesthetic experience is politically alienating. Aesthetic experience is a category of pleasure that reflects the interests of a privileged ruling elite in a western culture. It is a fetishised form of value, that is historically specific, and therefore liable to be transcended through a revolutionary transformation of society. There are several responses one might make to this. First, it is true that the forms of aesthetic experience I have outlined, have only been theoretically articulated by a specific class, at a specific stage in world history i.e. the cultural middle-class intelligentsia in Europe, since about 1710. However, the fact that these experiences have been theorised in this historically specific way, does not entail that the complex experiences themselves are merely historically specific. Indeed, if my characterisation of them is correct, they are in principle, available to all persons at all times, insofar as they involve the harmonious interaction of our embodied being's two definitive aspects — rationality and sensuousness. Embodiment, of course, cannot be transcended. A second response to the objection, would be that (again) if my analysis is correct, aesthetic experiences arising from whatever source, are not mysterious, ineffable, or other worldly i.e. fetishised, rather the opposite is true. They reconcile the ontological disequilibria wrought upon our being by high industrial society, and the division of labour. Indeed, insofar as through the creation and reception of aesthetic objects the artist and his or her audience respectively achieve self-recognition, such artifacts are to be regarded as paradigms of unalienated labour and culture. It might, nevertheless, still be objected that the time is not yet ripe for pure aesthetic objects and experiences, in that they distract us from the struggle for a liberated society (a view held, in effect, by Lenin[16]). However, to this it can be retorted that aesthetic experience and the art forms founded upon it, have both an internal and external dynamic which points in the direction of political change. The internal dynamic consists not only in the fact that the aesthetic domain anticipates a society of unalienated labour, but, indeed, the demand for change is actually built into it. We do not take aesthetic pleasure in a formal configuration if it simply reproduces existing categories of form. We demand originality, and this entails both an acute awareness of the medium's history and an openness to revolutionary transformations. Our sensibility is thus directly prepared for cultural politics, and indirectly, for political activity. A similar moral

can be drawn from the external dynamic of aesthetic experience. Despite his strategic doubts, even Lenin allowed that aesthetic experience in itself is exhilarating and desirable. However, we know that there is inequality of access to such experiences. We know that aesthetic sensibility is stifled by the ideology and rubbish of mass culture. The need for revolutionary social change, in other words, is acutely implied by aesthetic experience's relation to the broader context.

I would claim finally, then, that if (as it should be) abstract art is grounded in aesthetic experience, and, if also, we understand aesthetic experience correctly, then the tendency to abstraction can be seen to be disalienating in both ontological and political senses.

University of St. Andrews

NOTES

[1] Specifically, I would cite the following texts: Maurice Merleau-Ponty, *The Phenomenology of Perception*, (trans. Colin Smith) (London: Routlege and Kegan Paul, 1974), see especially Part Two, Section Three. G. W. F. Hegel, *The Phenomenology of Spirit*, (trans. A. V. Miller) (Oxford: Clarendon Press, 1979), especially Part B, sub-section B entitled 'Freedom of self-consciousness'. Karl Marx, *Early Texts*, (trans. and ed. David McClellan) (Oxford: Basil Blackwell, 1972). See especially the extracts from the 'Economical and Philosophical Manuscripts' — notably the section entitled 'Alienated Labour'. Finally, I would mention Martin Heidegger, *Being and Time*, (trans. John Macquarrie and Edward Robinson) (Oxford: Basil Blackwell, 1967), See especially 'chapters' 15 & 16 (included in Part One).

Of crucial significance for the methodology of this paper as a whole are Merleau-Ponty's essay 'Eye and Mind' included in *The Primacy of Perception*, (ed. James Edie) (Evanston: Northwestern University Press, 1964), and G. W. F. Hegel's *Aesthetics*, (trans. T. M. Knox) (Oxford: Clarendon Press, 1975), especially the Introduction.

[2] Piet Mondrian, 'Natural Reality and Abstract Reality', (1919), included in Chipp Herschell, (ed.), *Theories of Modern Art*, (London: University of California Press, 1968), pp. 321—323. This reference p. 323.

[3] Mondrian, in Chipp, *ibid.*, p. 323.

[4] Mondrian, in Chipp, *ibid.*, p. 322.

[5] Kasimir Malevich, 'Suprematism', included in Chipp, *ibid.*, pp. 341—346. This reference p. 342.

[6] Malevich, in Chipp, *ibid.*, p. 341.

[7] See for example, William Lyons's thorough study *Emotion*, (Cambridge: Cambridge University Press, 1980), especially Chapter three.

[8] For a critical discussion of Dickie's attempt to justify this through the 'Institutional' definition of art, see Part One of my 'Art and Autonomy', *British Journal of Aesthetics*, **21** (Winter 1981). It should be noted that I have modified the views on abstraction presented in Part Two of that paper.

[9] See for example, Gleizes and Metzinger's 'On Cubism', included in Robert L. Herbert (ed.), *Modern Artists on Art*, (New Jersey: Prentice-Hall Inc., 1964), pp. 1—18.

[10] For a particularly sensible, though far from unambiguous statement on abstraction, see Naum Gabo, 'Sculpture: Carving and construction in space', (1937), included in Chipp, *ibid.*, pp. 330—337.

[11] In for example, his *The Aesthetic Dimension*, (London: Macmillan Press, 1979).

[12] There are several more. For a discussion of one of these — 'aletheic experience' see Part Two of my 'The Experience of Art: Some Problems and Possibilities of Hermeneutic Analysis', *Philosophy and Phenomenological Research*, **XLIII** (March 1983), pp. 347—362. Whilst in that paper I reserve the term 'aesthetic' for the experience of form alone, I now feel that this serves no useful purpose — insofar as a number of experiences share (in varying degrees) a disinterested character.

For a discussion of the relation between colour field abstraction and the aesthetics of the sublime, see my 'Barnett Newman and the Sublime' in the *Oxford Art Journal*, **7**(2) (1985), pp. 52—58.

[13] For a rather different treatment of metaphor and expression, see Nelson Goodman, *Languages of Art*, (Indianapolis: Hackett Publishing Co, 1976), especially Part Two section 9.

[14] Unless there is a strong accompanying documentary evidence of course.

[15] Different and highly illuminating approaches to the problems of empathy and emotion in art generally, are to be found in R. K. Elliot, 'Aesthetic Theory and the Experience of Art', included in Harold Osborne (ed.), *Aesthetics*, (Oxford: Oxford University Press, 1972), pp. 145—157. And in chapters four and five of R. W. Hepburn, *Wonder: And Other Essays*, (Edinburgh: Edinburgh University Press, 1984).

[16] As recorded in Gorky's anecdote quoted at the start of Frederic Jameson's essay 'Pleasure: A Political Issue', included in *Formations of Pleasure*, (London: Routledge and Kegan Paul, 1983), pp. 1—14.

DIETER PEETZ

ON ATTEMPTING TO DEFINE ABSTRACT ART

Definition has been unpopular amongst philosophers since Wittgenstein's *Philosophical Investigations*. His invitation, to bring back words and concepts from their philosophical to their everyday use, his cautionary maxims against the danger of hasty generalisation, in which the human mind so effortlessly indulges, tended to be strictures on defining, certainly, but also on theorising as well. But ordinary language is *not* perfectly in order as it is. There is a genuine need, not only in science, for stipulative definitions, a need which Wittgenstein acknowledged and philosophers have long turned their backs on in linguistic philosophy. Theorising is once more the order of the day. There is a saying that if you can't define *x* in a single sentence, then use as many sentences as you need and then you have a theory, rather than a definition, of *x*. Theorising in philosophy tends to mean books, not articles. If we turn, for example, to two areas of current philosophical endeavour, Philosophical Logic/Philosophy of Language and Philosophy of Mind, we can see how true this is. In both fields, books and more books, theory upon theory, engulf the philosopher in ever-increasing tides. Where, for example, in Philosophical Logic, Russell's Theory of Definite Descriptions held sway for nearly half-a-century, theories of meaning and reference now supercede one another within a few years. The same is true of the Philosophy of Mind. So how is it possible for Richard Rorty[1] for example, to pronounce upon the approaching demise of the analytical tradition in philosophy within the English-speaking world? Instead, we appear to be living in one of that tradition's Golden Ages.

The ever-swelling tides in theorising in these areas of philosophy have had their predictable effects in philosophical aesthetics. On the one hand we have Richard Wollheim declaring that we must abjure the mistaken quest for a definition of art and its concepts and, instead, concern ourselves with the mental activities of the practioner or creator, so that philosophical aesthetics may be subsumed under the philosophy of mind. He declared:

For decades . . . Aesthetics and the Philosophy of Art seemed to bifurcate into these two enterprises, the definition of art on the one hand and the analysis of the aesthetic judgment on the other . . . And one of the reasons why so little was written is precisely

135

Andrew Harrison (ed.), Philosophy and the Visual Arts, 135—145.

that people felt that the programme to which they would have had to conform was so peculiarly unpromising.[2]

Unpromising, because

a definition clearly cannot be anything long. And yet it seems unlikely that we could come up with anything of this sort giving the nature of art. On the contrary, if we are to do justice to the nature of art, it looks as though what we have to do is to take account of a very large number of activities, which go on, which are connected in various kinds of ways, and which all add up to the phenomenon of art we have in our society.[3]

In short, what Wollheim is here proposing, is that, instead of engaging in the search for a simple definition of art, we should more fruitfully engage in the examination of the related activities which constitute artistic endeavour. I may be wrong about this, but there is little or nothing in Wollheim's published work which fits his manifesto. The same charge may be levelled against Roger Scruton who in the opening sentence of his book, i.e. the preface to his seminal work, *Art and Imagination*, makes a similar claim as follows:

My intention in this book is to show that it is possible to give a systematic account of aesthetic experience in terms of an empiricist philosophy of mind.

His intention is not realised. It is one thing to examine the traditional concepts and topics in the light of current philosophising, but that does not make these concepts empirical, nor does such piece-meal examination of such concepts as 'expression', 'representation', 'symbolism' etc. add up to a "systematic account of aesthetic experience". All we have from Roger Scruton is the application of current philosophising — as it was prior to 1974 — to a list of traditional topics in philosophical aesthetics; excellent in its way, but not systematic and all-embracing.

It is Nicholas Wolterstorff's *Works and Worlds of Art* which more nearly than either Wollheim or Scruton in their works carries out their expressed, but unrealised, intentions. It is, I think, probably the most tough-minded book ever written in philosophical aesthetics. Although limiting himself to the analysis of the concept of representation, his work spills over into most of the nooks, crannies and quagmires of traditional aesthetics. With an imaginative boldness and superb analytical gifts, he, unlike Wollheim and Scruton, carries out a programme which would subsume philosophical aesthetics, not under an empiricist philosophy of mind, but its near relation, the philosophy of language. In his Preface, he correctly declares his intention, since he carries it out:

My project is to construct a theory concerning the nature of *mimesis* in art. Two ideas lie at the heart of my suggestion. Representation is commonly understood to be a relation between symbols of a certain sort and that which they symbolize. I suggest, instead, that at its root representation is an *action* performed by human beings. Thus my theory stands more in line of contemporary theory of symbols. Secondly, the heart of representation, no matter in which of the arts it occurs, lies not in composing a copy of the actual world distinct from our actual world. Representation, or *mimesis*, is world projection. An implication of this approach is that art is seen more from the side of the artist than from the side of the spectator.

I have serious misgivings with Wolterstorff's analysis and theory of representation, which lies within the limitations of the speech-acts school of philosophy of J. L. Austin and John Searle. Does language picture in a strictly analogous way to the way pictures picture? I don't think so and here is an example taken from his book:

What I have said about asserting something by producing a picture applies, *mutatis mutandis* to issuing commands, to asking questions, to making promises. By producing a picture of a closed door I can command that my study door be closed, or ask whether it is closed, or promise that it will be closed. Likewise by producing a picture of a closed door I can invite others to take up a fictive stance toward the state of affairs of my study door being closed. Is this not how the illustrations accompanying some work of novelistic fiction are to be taken? The illustrator is not asserting, commanding, asking and promising. He is inviting us to take up a fictional attitude toward certain states of affairs. He is doing so by producing a picture rather than a sentence. And to a considerable extent the states of affairs that he presents for our consideration are the very same as those the novelist presents. The point is too obvious to labour: by producing a picture one can perform a mood-action.[4]

Again:

Specifically, in picturing a man on a horse one introduces the state of affairs of there being *a man on a horse*. And likewise, in picturing a unicorn one introduces the state of affairs of there being a unicorn. Unicorns have never existed. Nonetheless there is a state of affairs, or proposition that there is a unicorn — this proposition is false. And so at once we see how a *de dicto* theory of p-representation can handle, with ease, those special cases of 'representations of what has never existed' in which 'the thing represented is impossible of existing'. Though there cannot be such buildings as Escher represents, nonetheless, there is the proposition that there is a building of such-and-such impossible sort. It just happens to be a necessarily false proposition[5]

As I have already replied elsewhere:

Wolterstorff's 'ease' in handling such self-contradictory propositions is only sham. For on his *de dicto* theory of representation it is possible to conceive of the inconceivable. And since propositions for this are on all fours with the pictorial analogue 'design' or

picture, on his theory it must be possible to imagine and picture a self-contradictory falsehood.[6]

Although this is a seriously flawed consequence of his theory, it does not detract from my overall view that Wolterstorff has written a philosophical classic, and, if he is wrong-headed, which I believe he is, he is brilliantly and absorbingly wrong-headed. What more, may I ask, can be expected of any philosopher?

Enough has been said, I think, to illuminate the general point I wish to make. Alternatives, like Wollheim's have been suggested to the seemingly fruitless quest for a definition or for a unified theory, which does justice to the monstrous, hydra-headed, general concept 'art'. But these alternatives have either not been pursued, merely announced, or, when carried out, they raise more difficulties than they are trying to avoid. And, I have a strong suspicion, for which I hope to give philosophically respectable grounds later in this paper, that these so-called alternatives turn out to be simply tributaries that eventually, when the going gets sufficiently tough, end in the old, traditional mainstream.

What is specifically wrong with the attempt to encapsulate the concept of art within a definition or theory? Wollheim supplies an engaging answer:

'What is art?' 'Art is the sum or totality of works of art.' 'What is a work of art?' 'A work of art is a poem, a painting, a piece of music, a sculpture, a novel . . .' 'What is a poem? a painting? a piece of music? a sculpture? a novel? '. . .' A poem is . . . , a painting is . . . , a piece of music is . . . , a sculpture is . . . , a novel is . . .'[7]

Wollheim continues:

It would be natural to assume that, if only we could fill in the gaps in the last line of this dialogue, we should have an answer to one of the most elusive of the traditional problems of human culture: the nature of art. The assumption here is, of course, that the dialogue, as we have it above, is consequential . . .[8]

And again:

It might, however be objected that, even if we could succeed in filling in the gaps on which this dialogue ends, we should still not have an answer to the traditional question, at any rate as this has traditionally been intended. For that question has always been a demand for a unitary answer, an answer of the form 'Art is . . .', whereas the best we could now hope for is a plurality of answers, as many indeed as the media or arts that we initially distinguish . . .[9]

Wollheim goes on to suggest that it may be, even given the plurality and distinctiveness of different media, that they all nevertheless share a certain overlap in their characteristic properties, which would then provide us, despite plurality, with a unitary answer, but it is clear that Wollheim does not think that such an overlap is at all likely — an overlap, that is, which is neither too bland nor too trivial in its generality. So it is the ever-increasing multitude of media and their new branches which makes the task of finding a unitary definition of art not only hopeless but futile. Is art then an open concept? Professor Sibley[10] has given his reasons for thinking that there are arguments against each of the main considerations, for example those advanced by Morris Weitz[11], of those who wish to answer this question in the affirmative: (1) New works of art are always being produced, there is no closed set, but is there not the possibility at least in theory, that the new works of art will be aesthetically praiseworthy in virtue of the same general properties as the existing ones. (2) Are there not always new art forms? Yes, but why cannot the new forms be admitted by the traditionalists, judging by the old and established criteria. (3) Are there not sub-concepts, e.g. the novel, which are open? If the sub-concept is open, then the general concept 'art' must also be open. But, considers Sibley, such terms as 'novel', 'painting' etc. are neutral. They are not typically used in the prescriptive or evaluative sense in which the term 'art' is. Finally, Sibley considers whether a novel or a new work of art is so by virtue of possessing new aesthetic properties, which so far have escaped human sensibility, or, a work of art is new because it makes us regard as aesthetically pleasing, properties which were hitherto regarded as neutral or descriptive. The second alternative is rightly ruled out by Sibley for its implausibility. If by 'new', however, we mean the former, i.e. a new work has new aesthetic properties, then perhaps it is more likely that we mean by that, contends Sibley, by way of counter-argument, that the work has the established aesthetic properties, but displays them in new ways.

At first sight it appears fortunate for my purpose that I need not bother whether the generic term 'art' comprises an open or a closed concept. For, as was originally stated under consideration (3) above by Weitz before being countered by Sibley, that if a species or sub-concept, say novels, is thought to be open, then it follows logically that the genus term 'art' is also open. The two most general species terms

relating to pictorial art are representational art and abstract art. There are many theories and definitions of representational art, which suggests to me that it is likely to be a closed, unitary and essentialist concept, or at least, that there are good reasons on that score for thinking *prima facie* that it might be. I have already explored the validity of the most potent of esssentialist theories of pictorial representation elsewhere [12].

Let us now look at the second species or sub-concept of pictorial art, abstract art. The organisers of this conference are to be congratulated in that they have forced at least the philosophers amongst us here to have a good look at that monumentally difficult item. The greatest aesthetic philosopher, in my opinion, was and still is Immanuel Kant, greater by far than the much more influential Hegel. Bertrand Russell, in his amusing *History of Western Philosophy*, makes a typically Puckish, but profoundly Russellian observation with reference to Leibniz. "The real importance of a philosopher is often in inverse ratio to his popular influence". Kant has a secure place among professional philosophers, but his influence among the *literati* was always much less than that of Hegel, who spawned every 'ism' from Marxism, existentialism, structuralism, to fascism, although he himself was none of these. I think that Kant's Third Critique to be the only classic work yet written in philosophical aesthetics. Kant is, I think, the greatest aesthetic philosopher, but typically *qua* philosopher, he was not well-endowed with aesthetic sensibility. For example, he says some really crass things about the aesthetic merit of primary and mixed colours. By and large this is true of empiricist philosophers nowadays who are mostly self-confessed philistines, with a few outstanding exceptions. I personally am no exception especially when it comes to abstract art. So producing this paper was an unequal challenge for me.

There are no theories of abstract art as yet, which are in any way accepted or challenged among professional philosophers. There is Harold Osborne's encyclopaedic *Abstraction and Artifice in Twentieth Century Art* and there are brief references to abstract art in recent introductions and surveys of the subject. There are also two books just published, which do discuss the relevant topics: one is B. R. Tilghman's *But Is It Art?*, 1984, and a very distinguished fellow contributor to this conference, Paul Ziff, has also published an engaging shocker, entitled *Antiaesthetics: An Appreciation of the Cow with the Subtile Nose*, 1984, which puts all its readers on the spot.

A good way to discuss, or begin to discuss, a difficult concept is to say what it is definitely not. Here one would like to say that art which is abstract is not representational; that the two predicates are logically independent of one another. But is it true of the converse case? Is it true that representational art is not abstract art. Anyone who has read Sir Ernst Gombrich's *Art and Illusion* and has taken on board its most valuable points, which in my humble opinion have little to do with illusion in art, but everything to do with modes and manner of pictorial representation from the ages of the Pharaohs and ancient Athens on and the role which projection, ocular or mental projection plays in them. Now Gombrich is at pains to point out that, be a picture as true a likeness of a landscape or a horse-race (say Frith's *Derby Day*) as it may, it will still necessarily be an abstraction of the totality of the phenomenal items there to be seen. No artist, be he Jan Van Eyck say, depicting his *Musical Angel,* can render on canvas everything out there before the organ in the room which is literally there to be depicted. The artist must select items and provide merely visual cues, which, if sufficiently skilful and adequate, will allow the spectator to project from what is hinted at on the canvas, to complete the picture in all its detail, or rather the details hinted at in his mind by projecting onto the canvas what is not literally there but only hinted at. If Gombrich is right on this, as I think he is, then no pictorial art is non-abstract. So the distinction, if absolutely made, between abstract and representational art is one of degree and not of kind, i.e. they are not logically independent predicates.

Our observations so far on abstract art tend to be in line with one main meaning of the participle and adjective 'abstract'. Here, in philosophical as in popular usage it means 'withdrawn or separated' in particular 'withdrawn in attention from something, or from some aspect or particular thing'. 'Abstract thinking' is thinking in terms of general ideas or concepts, which bring together a number of particular things or qualities in virtue of the features they have in common, by disregarding, or abstracting attention from, the features in which they differ. But, as Harold Osborne interestingly points out at the beginning of his book on abstraction already mentioned,[13] this is only one meaning of 'abstract' when that adjective is applied to art. The other meaning, as when we describe pictures as abstract, has little in common with the other, but means that the picture is not a picture *of* anything at all. This second meaning has little or nothing in common with the former and is linguis-

tically far more arbitrary. Constant misunderstandings and confusions occur, even among artists themselves, owing to the failure to grasp the difference between the two uses of the term 'abstract'.

So 'abstract' in this sense is naturally at least logically independent of 'representational' when both are applied to 'pictures', whereas in the former sense they are mutually dependent, the difference between them being one of degree rather than of logically independent kinds.

The ways in which something is put down on canvas, where 'something' is used in an abstract sense, must be infinite. A picture can be abstract in the sense of not representing anything at all in an infinite number of ways. Hence 'abstract art' in this second sense must be an open concept. So recapitulating we have: Genus: Art. Species: Pictorial Art, Sub-species: Representational Art (probably a closed concept), another sub-species Abstract Art, where 'abstract is used in the former sense, in which it is possible for it to overlap with the Species Representational Art, probably also a closed concept and finally, amongst many others, the sub-species Abstract Art, logically independent of the species, Representational Art', which I shall call 'abstract-two-art' and which must be an open concept, which is not what I had blithely assumed at the outset.

If all this is acceptable, what can be said about the open concept 'abstract-two-art'? Not very much more I suspect, but I have a suggestion to make. The analogy is with logical fallacies. Just as there are infinitely many ways of committing logical howlers, most of which ways are totally without interest, there are, however, noteworthy ways in which one can commit certain kinds of them, which it has been found worthwhile to label: there are the informal fallacies arising out of the use of language such as equivocation, the *argumentum ad hominem* etc. etc. and there are the formal logical fallacies like the *illicit major* and *minor*, the undistributed middle etc. etc. There are something like fifty interesting kinds of ways in which one might reason invalidly, and these, because they are of interest, have been listed and named. I have an ambition to get myself elected to Parliament, so that I could get up during the Prime Minister's question-time and, should the occasion arise, shout out in ever-increasingly accusatory and menacing tones: "Is the Prime Minister aware that she has just committed the fallacy of *illicit major*?", i.e. *the illicit process of the major term*. The fallacy is easy to commit and difficult to spot. Here is an example of it:

Fools rush in where angels fear to tread,
Prime Ministers are no fools,
Therefore,
Prime Ministers do not rush in where angels fear to tread.

Now, just as it is neither necessary nor useful to list the myriad ways in which we might go wrong when we attempt to reason, but only some kinds of these ways are found to be sufficiently interesting to be labelled and characterised, so *mutatis mutandis*, (since there are likewise an infinite number of ways in which we can paint abstractly, since 'abstract-two-art' is an open concept), there will only be a finite number of listable ways in which what results will be of aesthetic interest. Certain categories suggest themselves from Harold Osborne's book: (a) semantic and non-iconic abstraction, (b) expression abstraction, (c) abstract expressionism, (d) cubism, (e) constructivism, (f) concrete art etc., etc. So the name a few which have en-compassed kinds, or movements, in pictorial art.

I think this is as far as a philistine like me, with some philosophical training, dares to go in the presence of practitioners of art and art historians. They can do the job of listing kinds of non-representational art much better than I could do. So, although the paper is woefully brief, I think it would be silly to extend it, except to perform one more task, which I promised to do in the lengthy introduction.

As I said before, I am one of the Colonel Blimps in the world of philosophers, who thinks that the attempt to define is not a futile one and that we sometimes, for want of anything better, learn even from a hasty generalisation. Only by taking seriously for a time such slogans as 'Art is the expression of emotion', 'Art is significant form', 'Art is illusion', 'Art is the decrease in psychical distance without its disappearance', 'Art is empathy' and other such block-busting blanket definitions, can we learn anything at all about the kaleidoscopic nature of the most general of aesthetic concepts, i.e. 'art', and only by examining the arguments which are proffered in support of these arrogant, essentialist slogans, can we learn anything of the quagmires of aesthetics.

Now, if we take Wollheim's manifesto seriously and eschew definitions of 'art' and instead study and examine the myriad activities, both mental and physical, which go on in all the varied media when their practitioners are at work and so produce a philosophy of artistic action

or practice, then we will come up against the problem of what marks off genuine artistic endeavour from other, non-aesthetic endeavours and straightaway we are confronted with the general problem "What is art?" "What makes a situation aesthetic?" and the like. So Wollheim's declared alternatives to definition turn out to be simply trunk-roads feeding the futile highway of definition. So there!

May I add one small postscript to abstract-one-art, i.e. the sense in which the predicate 'abstract' is not logically-independent of 'representational'. This sense puts me very much in mind of Kant's *aesthetical ideas* (*Critique of Judgment*, Paras. 49ff). An aesthetical idea is one which occasions much thought without, however, any particular thought being adequate to it. Aesthetical ideas go beyond the understanding (egged on by the freed imagination). Hence they can be made to illustrate Gombrich's principle of projection, his ETC. principle, and they allow for, and explain, artistic ambiguities and help to answer the question "Why do we find representational art interesting enough to return and take periodic looks at its better examples?"

University of Nottingham

NOTES

[1] R. Rorty, *The Consequences of Pragmatism*, (Brighton: The Harvester Press, 1984), Ch. 12.

[2] R. A. Wollheim, Talk with Bryan Magee, 'Philosophy and the Arts' in B. Magee (ed.), *Modern British Philosophy*, (London: Secker & Warburg, 1971), Ch. 11.

[3] *Ibid.*

[4] N. Wolterstorff, *Works and Worlds of Art*, (Oxford: The Clarendon Press, 1980), p. 280.

[5] *Ibid.*, p. 282.

[6] D. Peetz, 'Some Current Philosophical Theories of Pictorial Representation', *The British Journal of Aesthetics*, Summer 1987.

[7] R. A. Wollheim, *Art and its Objects*, 2nd Edn, (Cambridge: The University Press, 1980), p. 1.

[8] *Ibid.*

[9] *Ibid.*

[10] F. N. Sibley, 'Is Art an Open Concept? An unsettled question', Proceedings of the IVth International Congress of Aesthetics, Athens, 1960, pp. 545—47.

[11] M. Weitz, 'The Role of Theory in Aesthetics', *Journal of Art and Criticism*, 1956.

[12] *Op. cit.*

[13] H. Osborne, *Abstraction and Artifice in Twentieth Century Art*, (Oxford: The Clarendon Press, 1979), p. 26.

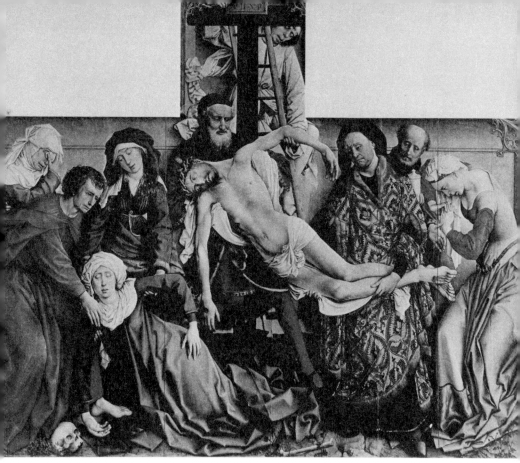

Plate 15. VAN de WEYDEN. *Descent from the Cross.* Oil on panel. Reproduced by kind permission of National Museum of Painting and **Sculpture**, Musae de Prado, Madrid, Spain.

Plate 16. POLLOCK, Jackson. *Autumn Rhythm.* Oil on canvas 105 × 207 in. The Metropolitan Museum of Fine Art, New York. George A. Hearn Fund, 1957. (57.92)

Plate 18. MALEVICH, K. S. *Suprematist Composition*, 1915. Oil on canvas 101 × 62 cm. Stedelijk Museum, Amsterdam.

Plate 17. METZINGER, Jean. *Dancer in Café*, 1912. Oil on canvas 148 × 114 cm. Courtesy of Albright-Knox Gallery, Buffalo, New York.
© ADAGP 1986

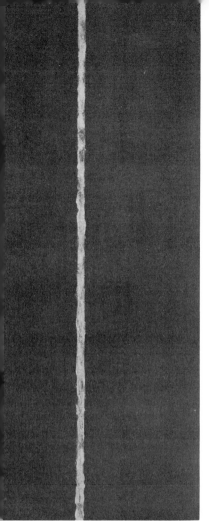

Plate 19. NEWMAN, Barnett. *Onement III*, 1949. Oil on canvas 182.5 × 84.9 cm. Museum of Modern Art, New York.

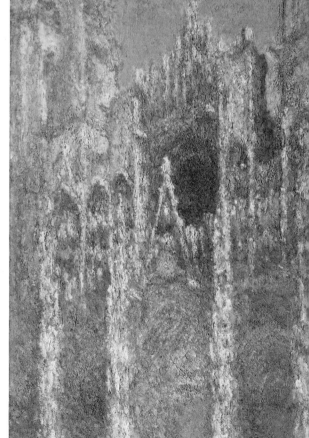

Plate 20. MONET, Claude. *Rouen Cathedral in Full Sunlight.* Oil on canvas 100.5 × 66.2 cm. Courtesy of Museum of Fine Arts, Boston, Juliana Cheny Edwards Collection.

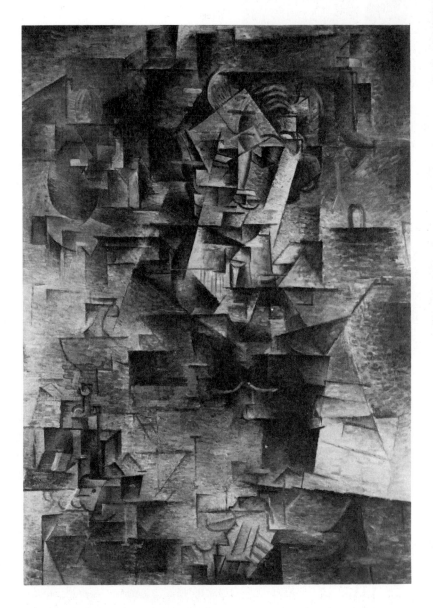

Plate 21. PICASSO, Pablo. *Portrait of Daniel Henry Kahnweiler*, 1910. Oil on canvas 39 1/2 × 28 5/8 in. The Art Institute of Chicago. Gift of Mrs. Gilbert W. Chapman.
© DACS 1986

Plate 23. BRAQUE, Georges. *Road near l'Estaque*, 1908. Oil on canvas 60.3 × 50.2 cm. Collection: Museum of Modern Art, New York. © ADAGP 1986

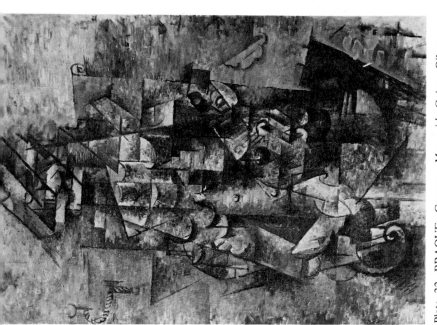

Plate 22. BRAQUE, Georges. *Man with Guitar*. Oil on canvas 116.2 × 80.9 cm. Collection: Museum of Modern Art, New York. The Lillie P. Bliss Bequest. © ADAGP 1986

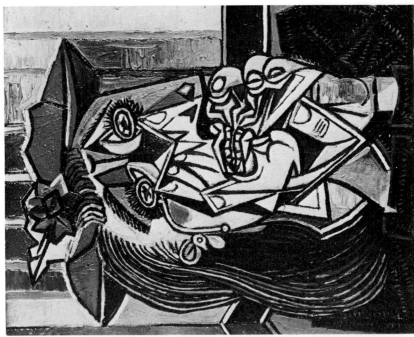

Plate 25. PICASSO, Pablo. *Woman Weeping*, 1937. Oil on canvas. On loan to Tate Gallery, London.
© DACS 1986

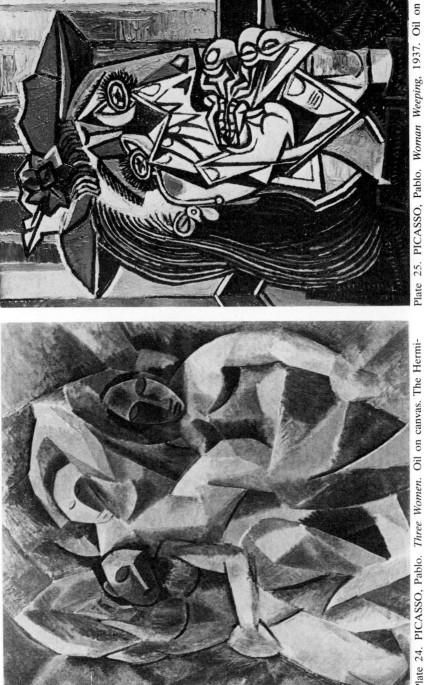

Plate 24. PICASSO, Pablo. *Three Women*. Oil on canvas. The Hermitage, Leningrad.
© DACS 1986

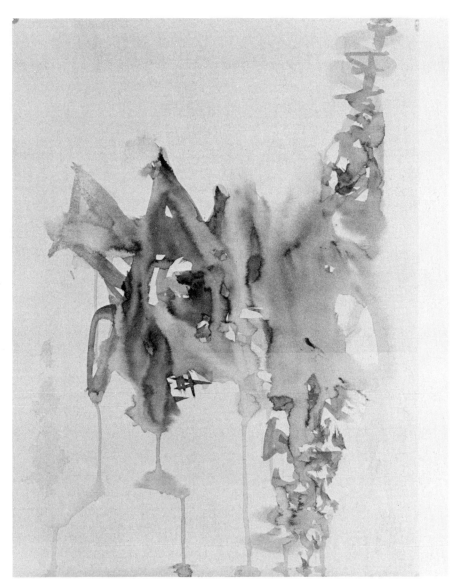

Plate 26. ZIFF, Paul. Untitled print.

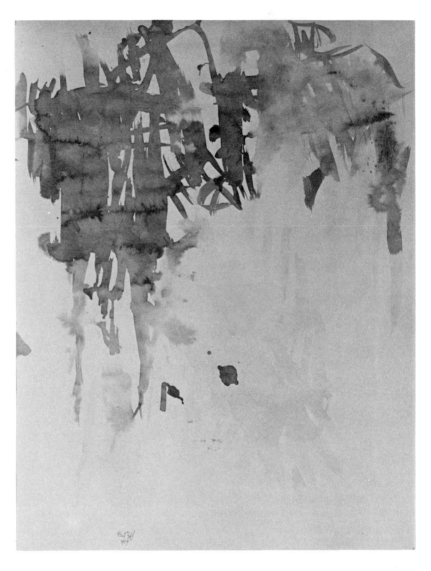

Plate 27. ZIFF, Paul. Untitled print.

PAUL ZIFF

ON BEING AN ABSTRACT ARTIST

I am a painter, an abstract artist. I have been one for forty eight years: I was a painter long before I became a philosopher. I paint in oils and acrylics, watercolours and ink. As a painter, I shall try to say something about abstract art and about being an abstract artist.

When I tell you that I am an abstract painter, what do you learn about my work? I think largely nothing: maybe some negative things, but nothing of any worth: that my works do not resemble traditional academic achievements, that it may be difficult to identify representational features and so on.

What is abstract art? As an artist, I have never before been concerned with such a question. It it not that I think taxonomical investigations are idle; but cladistic claims about the precise place of homo sapiens among the apes may be of interest to a philosopher while an aesthetic ape unsurprisingly turns his attention elsewhere. Philosophical thought has no rôle to play in my artistic activities. When I draw or paint, I do not think as a philosopher thinks. Here, however, as a philosopher, I mean to try. (As an aside, I think I should say that this paper has been peculiarly recalcitrant, almost refusing to be written: there is, I think, a deep conflict between my two personas, artist and philosopher, which surfaces whenever there is a philosophic intrusion into artistic pursuits.)

The term 'abstract art' has not, at least in my personal experience, ever had a clear use. When I began studying art in 1937, my first teacher, Werner Drewes, was a member of a group that called itself 'American Abstract Artists'. Drewes has been a student at the Bauhaus and had studied under Wassily Kandinsky. Drewes' own early work clearly manifested the influence of the later Kandinsky, work that I have always personally characterized as non-objective; work that is not only forthrightly non-representational, that not only does not invite being seen as representational, but work that positively resists being so seen. What I have in mind here is plainly exemplified by such a well-known series of works at Josef Alber's various 'Hommage to the Square's; one of Piet Mondriaan's famous compositions of black lines

155

Andrew Harrison (ed.), Philosophy and the Visual Arts, 155—166.
© 1987 *by D. Reidel Publishing Company.*

and white quadrilaterals would perhaps do as well. But I would not characterize my own works as non-objective; they are better conceived of as 'organic abstractions', or better still, as 'organic art objects', a more felicitous, though hardly attractive, term.

By and large, works by members of the American Abstract Artists group were readily classed either non-objective or abstract; nonetheless, the 1939 catalogued exhibition of the group included some works with unmistakable representational elements. In particular, there was a work, by Hananish Harari, virtually depicting, albeit abstractly, objects and persons at a shooting gallery. In an introduction to the catalogue, one of the editors, G. L. K. Morris, admitted that "All of the painters have not completely lost touch with representational symbols. A few works still betray suggestions of recognizable objects . . .".[1]

My only other teacher was the English artist, J. M. Hanson. Hanson had studied with André Lhôte and Othon Friesz, and then with Fernand Leger and Amédée Ozenfant. Hanson was Ozenfant's assistant from 1927 to 1935. Hanson worked in a cubistic abstract manner, but it was generally altogether clear what his works were abstractions of; in Morris' terms, he, too, had not lost touch with 'representational symbols'. Hanson was a draftsman, a modern abstract incarnation of Ingres.[2]

The morphological construct, 'abstract', is a Latin derivative, formed from the prefix 'abs', from, and from the word 'trahere', to draw; thus to abstract is to separate, to draw away from. 'Abstract' is a verb or a noun or an adjective, and even though it is the adjective that some might be wanting to look at here, both the noun and the verb offer fine perspectives and a nice distinction. An abstract is a summary, an abstracted person is one who is withdrawn or separated, while an abstracted watch is one that has been purloined. An abstract of a document is supposed to convey the substance, the gist, of the document; in consequence, an abstract is not wholly independent of that which it is an abstract of: the character of the abstract is dependent on and determined by that of its original. But if I abstract myself from this company, I turn away from this company: it need no longer enter the purlieus of my concern.

As one looks at the noun and then the verb, it is not difficult to discern the Janus aspect of the adjective 'abstract': one is led to look both to and away from something.

I am an abstract artist: people, other artists, dealers and gallery

owners, have said so for years; I would not deny it, and how could they be wrong? Yet my works are not abstracted from anything; they are not derived from anything; they stand in no relation to anything that I have turned away from. The term is wrong, or if not wrong, it will not do; it is not equal to the matter of creation in art: certainly it is not apt for my efforts. I am inclined to think that it is not the right term for many; I find it implausible to suppose that an Alber's 'Square' is abstracted from, or derived from, or related in any significant way to anything other than the work itself and its own creation.

But works of so-called 'abstract' art are indefinitely varied, both in the character of the artist's creative activity and in the character of the results or products (when there happen to be results or products) of that activity; the subject scarcely admits of any insightful, or even interesting, generalizations. A romantic Germanic preference for the general, however, need not obscure the value of particular truths.

There are, in my paintings, cats and aoudads and animals of many kinds; when one looks at my paintings, one can, almost invariably, find either organic shapes or shapes similar to shapes to be seen elsewhere: I do not deny this. On the contrary, I insist on it. That such similarities are there to be found when a work is completed is not an accident.

Certainly I look about me, but not with a pen or crayon or brush in my hand. Shapes, there to be discerned in my works, are not shapes that are, or were, before my eyes: they are shapes, lines and edges, that appear as I work.

Did they have a prior existence? It is not simply a matter of what one sees, for, as I have elsewhere remarked, there is more to seeing than meets the eye.[3] As I walk a beach, I see ears everywhere as oyster shells take on the aspect of intent listeners; eyes stare out at me from paired snail shells. As ink spreads on my papers, horns appear or cats' claws clutch the brush. Sweat dripping down, staining the dry wooden boards of a sauna, grows miraculous goats. But are these shapes that I discover or, rather, shapes that I create with my eyes? I prefer the latter characterisation, though perhaps there is no fact of the matter. Is discovering a shape like discovering an island? Or is one simply subjecting oneself to a peculiar sort of Rorschach test? One can't discover an island unless it is there to be discovered: is that how it is with shapes? Again, I am more inclined to credit the creativity of an artist's eye.

To begin with, one can distinguish between work as a process and a work as a product. Naiveté, silliness or whatever can lead one to

suppose that, in, or by means of, a product, one can at once, auto-
matically, and with ease, discern the process in matters of art. And
naiveté, silliness or whatever can lead one to suppose that products can
be totally estranged from processes.

The process of abstract art may require the artist to turn his atten-
tion both to what is immediately at hand, perhaps the surface of a
paper, and to the moment of time in which, perhaps, his hand is poised
above that surface, a beginning of some sort; whereas a product of
abstract art may serve to turn an observer's attention either to what is
before one or backward in time, towards the processes that gave rise to
the work, rather than towards the ecosystem, which the work, as
product, may then serve to constitute, and from which it will inevitably
eventually disappear.

Processes and products: these are easy but recondite matters. I think
what I shall say here will not be easy for many to understand. For so
many are accustomed to look at a painting simply as an object whose
provenance is of concern only in so far as it establishes that the object
is indeed an artefact. Sometimes that is a way to look at a work and
sometimes it is not: a lust for generality can and, unfortunately, often
does vitiate much aesthetic research. Here perhaps it would help to
think of a continuum: at one extreme one finds such a work as Leonardo
da Vinci's portrait of Ginevra de'Benci, at the other extreme, a product
of a sort, but merely a record, a memento mori, of what has transpired:
a photograph of Joseph Beuys from the action 'How to Explain Pain-
tings to a Dead Hare', 1965. The portrait of Ginevra is a work of art, a
product; the photograph of Beuys records some work of art, a process.

I shall talk about process first and from a personal point of view.
Yao Tsui (ca. 550) wrote:

When an artist prepares the ink and dips his brush into it, his mind contains nothing
but the thoughts of diligence and reverence; thus facing the objects, although there is a
limitation of form, by responding to that which is beyond the form, he attains the
unlimited.[4]

Though, in painting, I am neither concerned with reverence nor face
objects, I would not disagree with Yao Tsui. To prepare the ink and dip
one's brush and clear the mind is wanted if one is to begin: a beginning
in art is not like a beginning in philosophy; the processes are radically
different.

When I begin a work in philosophy, I welcome thoughts, or at least, I

do not turn away from them. But the process of painting is not, for me, a thoughtful process, which is not to say I do not think. As I paint, I sometimes, not often, but sometimes, think this: There are no moments more significant than these moments, no matter what moments they may be. But that is not a reasoned conclusion; neither do I think that there is anything particularly important in painting when I am painting: it is only that there is then nothing as important. Then, I think, one can, as an artist, attend to these moments: one can arrange what, perhaps, would otherwise remain inchoate, not inarticulate, but unarticulated: the difference is important.

The conception of the artist as one attempting to express himself has always impressed me as ludicrous, as remote and irrelevant. It's a dogma of the day that someday will be dismissed. Possibly some artists are indeed trying to express themselves, display and reveal themselves and the like. But I am not: Being a sufficiently fluent being, I really never feel inarticulate. Possibly I shall when entropy grips me, but, for the time being, some words can still say more than a thousand pictures. No doubt the work one does is apt to be revelatory, but so is just about anything anyone ever does. When I paint, what am I trying to say? What a curious question! I am not trying anything: I am doing something. (But in saying this I am not denying that products of art are often remarkably expressive objects. One might say, if one wished to appear philosophic, that they are so in virtue of their physiognomic characteristics, which may be akin to appealing to the dormative powers of opium. However, I have done all I care to do to clarify the differences between what a sayer means and the meaning of what is said.)

In the 5th century, Hsieh Ho stated the Six Methods: the first is Ch'i Yuen Sheng Tung. 'Sheng-tung' means lively movement. What 'Ch'i Yuen' means is less clear; to quote Dr. Kwo Da-Wei:

Ch'i Yuen ... has been translated by Western scholars as 'rythmic vitality', 'spirit resonance', 'vibration of vitality', 'harmony with the spirit' (Ch'i)- is the paramount element in Chinese art. Stated simply, Ch'i Yuen refers to the spiritual expression of its vital components. With Ch'i Yuen an art work is vibrant; without it, the work is lifeless, stiff.[5]

Dr. Kwo then criticised Hsieh Ho's First Method:

(1) Ch'i Yuen is the lively spirit of a piece of art work. It is a result. NOT a method, and thus should not be included among the methods. It would have been more logical if Hsieh Ho had listed Ch'i Yuen as the first criterion for judging or appreciating art, and had listed the other five as instrumental in achieving Ch'i Yuen.[6]

A more traditional, and, I think, more perceptive, reading of Hsieh Ho's first method is to be found in a work on Chinese painting by Diana Kan:

To transmit this quality of life [of Ch'i] the brush itself must be infused with spirit. . . . Without the quality of Ch'i, without a sense of vitality in handling the brush, the painting will be lifeless, regardless of correct technique.[7]

And this begins to turn one's head in the right direction: Hsieh Ho's first method directs one to the process, not the product. If one can give to the process, the time, of painting the character of Ch'i Yuen Sheng Tung then one is heeding Hsieh Ho.[8]

Painting is a temporal process, but not a simple one: it may be intermittent, discontinuous, randomly segmented. When it begins is difficult to say. One can, clearly, mark the moment when a surface is altered, the first brush stroke or drop of ink. But, for the process, there is often neither a clear inception nor a clear continuation nor a clear termination. Perhaps the process is finished when the artist ceases to attend critically to what has been or is being done. One cannot sensibly suppose that the process logically terminates only when some product is completed; for there need not be any entity, distinct from the process itself, characterizable as the product: one can do paintings with clear water on newsprint, which slowly disappear as the paper dries; or one can paint with droplets of oil in still or slow moving waters. And even when one is working with ordinary media, there need not be anything that constitutes a completion. When is a painting done? Perhaps when I realize that I am about to do too much, or when I realize that it is too late to do anything more (except, possibly, burn the record) or when a look suffices to reveal that it is in fact done. I have no idea how to characterize that look, but, in time, one learns to recognize it.

But to say that is not enough; for the conception of a completion, of an end, is, in painting, of the utmost importance: it is not something given but something that evolves as one proceeds. It can take many years to learn, but, finally, some can learn to see the end in the beginning. Beginners begin but do not know where to or how to end; and what is so odd is that one can find an end almost anywhere, but beginners do not know this, perhaps because, as beginners, they can only focus on one stroke at a time.

Beginnings and endings are both difficult, but the beginning is, for

me, the more esoteric, and almost invariably so. What is requisite is at least a moment's inspiration. 'Inspiration' is, indeed, a good term, for, quite literally, one requires and has recourse to it. In either athletic or artistic matters, inspiration prior to, and exhalation at the moment of, performance can be essential to success. But it is not only an increase of oxygen that is wanted; just as in sport, one must not choke at a crucial moment, so it is in beginning a painting in ink: a commitment is called for and temerity is invariably preferable to timidity.

But do not misunderstand me: temerity is preferable to timidity, not simply because the product of one is apt to be preferable to the product of the other, but in the way that an afternoon gazing at the Bay of Naples was once preferable to a day staring at slag heaps anywhere. Or anyway, in each case it is so for me. The intrinsic value of the process, not of the product, is what is here in question.

Some would say staring, but I say looking, at the blank bare white paper one, or some, can sometimes begin to see shapes staring back, and it may then be in response to these staring shapes that some, or anyway I, begin by putting down either lines, shaping lines, that possibly contour the shapes that are beginning to appear, or, with broader strokes, washes that infuse areas until edges appear. Sometimes, when no shapes appear, an appearance can be forced with only a few almost random brush strokes.

And what are the intentions of the artist? I find it so tiresome to listen to philosophers, to amateurs, talk about the intentions of the artist. I do not know about others, but I, at any rate, have no intentions when I paint. Or, if this jejune conception is, somehow, a source of comfort to some, when I paint I intend to paint, at least in the sense that when there is a brush in my hand, it is no accident that there is a brush in my hand. I attend to what I see, to the shapes that appear at my finger tips; but in doing what I am doing, I am merely time's toy and, if I seem to lend myself to the process, the truth is simply that I do not attempt to refuse.

Painting is a temporal process and, of late, my painting turns and focusses on its temporality: time has always been an obsession with me and my recent works are processes displayed and fixed fast in time, even though I believe that only in the past is anything fixed fast. I think all my works have attended to time, and to space as a temporal display; my thoughts about time constitute a background against which the works can be viewed, or, I suppose, are to be viewed, if they are to be

viewed as I view them. (Should one view them as I view them? That strikes me as a question of ethics, or of prudence, but not of aesthetics.)

I think time is splintered, today anyway, for there is no time now that is shared equally by all; I suppose there never was. (For, of course, it is incredibly silly to speak, as some are wont to speak, of 'the age of reason' or 'the age of enlightenment' and the like: six pedants do not constitute an age.) There is no such thing as 'our time': we each follow separate single spatio-temporal paths that cross and recross not quite but almost at random: transience is the order of the day and nothing stays. If 'brevity is the soul of wit', then the world is becoming wittier for its time is growing shorter under a constant rapacious assault. And how can one close one's eyes to the heraldic emblem of the day: a nuclear maniac rampant in a field of bright green folly? Everything conspires to cut short the time, and it is there that abstract and conceptual art can be a celebration of moments, the moments during which one paints, or, perhaps, moments in which one views what one, or someone, has painted, moments in which one, or some, can arrange a time that is out of joint.

There are, without doubt, too many variables here, for the character of the process does depend on the medium: I will speak primarily of ink, but first I must say something about other media.

One can hardly exaggerate the importance of the medium, but this is hard to describe. Maybe thinking of fiddles or tennis racquets will be suggestive: some will not play, will not cooperate; charcoal, for example, will do nothing for me. I feel about charcoal the way I feel about fuzzy set theory. And then if I were given an air brush, I would throw it away, at once, before it wreaked havoc with my drawing. On the other hand, a Koh-I-Noor Rapidograph pen is wonderful. Whereas on a third hand, I find crayons largely, but not totally, uncooperative. And so it goes.

If one wished a viewer to attend to a product of art simply as a product, a crafty move would be to use either tempera or oil on a brilliant white gypsum ground. With such media, brushes' strokes gladly disappear, as do all signs of the artist's labour, of any temporal process. The object, one's creature, appears whole, intact, without any evidence of, or need for, a creator.

Leonardo's Ginevra de'Benci is a timeless creature. She clings fast to her timeless stance; nothing today can outface her, put her out of countenance, stare her into time's slide. Certainly Ginevra is not im-

pervious to time's attack: nothing is.[9] But Leonardo's technical expertise and curators' constant care have so far combined to preserve her reasonably intact. She is, I think, as immortal as they come. And she was, by Leonardo, carefully crafted to be so. Ginevra has this triple temporal aspect: clearly she took time to be created, and clearly she was created to take time to view, and clearly she was created to endure. This triple temporal aspect is characteristic of all classic western art of the past. It is not characteristic of the art of today.

Tempera and oil are classic media, but today is the day of acrylics. Acrylics are maybe excessively plastic: they allow almost anything except subtle tonal transitions. Oils (and watercolours) are the strings of painting, acrylics, the brass and timpani.

Ink, black ink, is a splendid colour for displaying processes. To infer processes is often, no doubt, difficult: do you count the cows in the pasture by counting legs and dividing by four? Years and years ago it puzzled me that lines in a sketch that expressed extreme vitality and suggested a sudden spontaneous creation could sometimes, on occasion, not always, but, sometimes, be produced, and reproduced, calmly and at leisure. Shapes, lines and edges expressive of violence need not invariably, or inevitably be the products of violent processes. I do not say that they are not, but only that they conceivably need not be. And conversely: being the product of violent processes in no way guarantees being expressive of violence. The latter is, of course, more evident than the former.

A work in ink may display the Eastern Ch'i, 'one-breath', performance: clean washes, pristine surfaces, everything unretouched. Washes on washes are avoided, muddy opacities are anathema: wasn't Plato reluctant to concede a form to mud? And, of course, one can (given considerable talent) execute a composition over and over until the desired one-breath aspect is displayed.

One-breath performance is a perfection of a sort, but there are other forms of perfection. I find nothing wrong with mud and much that is right: for a muddy opacity can mark a change in passage, a new direction, and muddy opacities can serve to highlight contrastive translucencies.

But the issues here are even murkier than I have managed to indicate: the perfection of imperfection is also a perfection of a kind. Just as Ch'i calls for the sureness of one-breath, so one can present the certain and unhesitant rendition of what some would characterize as an

uncertain, hesitant, faltering line, a diffident brush, clumsy fumbling washes, random floods and drops dripping anywhere.

Of course, painters once wished to control, and not be controlled by, stone and ink and brush and paper. That was the way art was supposed to be, wasn't it: skill and the display of skill? And of course today many still strive for that. I. however, prefer to relinquish such control, to let the stone and ink and brush and paper make decisions for me while I remain unencumbered. But there is a play of contraries here that could please both Hegel and Humpty Dumpty; for what appears by chance does not remain by chance: random drops are left by resolve or else turned into washes or just washed away.

One can, in time, reveal and display the flow and spatter of ink in the growth of images and the growth of images in the flow and spatter of ink.

It is time to turn closer to products, for they pose a considerable, and for me, unfortunately, an insurmountable, problem. The problem is that of appreciation: how can one who knows virtually nothing of the process appreciate a product of an abstract art focussed on the process?

To understand what I am saying here, it may help to think of a product, say an ink painting, as an extended entity in a four dimensional space-time manifold: thus think of it as a huge pile of papers, where each separate paper constitutes one temporal slice of the painting and only the surface of the last paper is available for viewing. To say that a work displays the process of which it is the product is to say that the last paper, if not transparent, is, at least, somewhat translucent, for it bears on its surface the marks of temporality. In consequence, it is of little consequence to me that the product is transformed, or even deteriorates, in time; indeed, entropic degradation merely emphasizes any work's temporal character.

Traditional works of western art do not display, indeed even turn away from, the fact that painting is a temporal process. There is no hint of the eastern Ch'i, of 'one-breath' performance, in Leonardo's Ginevra. Perhaps there is no need to say it but, Leonardo's time is past, and though, certainly, he was a very great painter, no painter could paint a Leonardo today, not even Leonardo, were he around to try it. (And if I could paint red plush as Titian could, what could I do with such a skill? Not even make a mockery of it!)

It is not remarkable that products of contemporary art are often

unstable in time, subject to immediate decay; they figure to be only transient records of remarkable events. As emphasis on the process increases, the importance of the products may dwindle. A product may merely confirm what has already been affirmed, which is why one can, snakelike, wriggle out of the product, even slough it off altogether.

The shift of emphasis from product to process is a twentieth century phenomenon, and one cannot understand the art of this century without attending to it. I am a great admirer of Juan Gris, but Gris was truly a great admirer of Chardin; however, unlike the works of Chardin, Gris' oils are cracking badly. Restorers had profited from contemporary artists: most restorations done today are restorations of contemporary works.[10] Was Gris simply inert? I think his attention was elsewhere. Picasso sometimes painted in Duco, and adequate house paint; so did Siqueiros: Rubens, a perfect craftsman, gave his white gypsum grounds a glue sizing, with fine particles of charcoal mixed in to provide a light scumbled gray ground to paint into; he exploited the enamel versatility and permanence of Venice turpentine. One of Joseph Beuy's impressive works is a piece of paper that has a crease in the middle, down which fat, probably pig fat, had been dripped; another is, or more likely was, an old straight backed wooden chair with a huge triangular lump of lard on the seat. I often paint on cheap newsprint: I like the way the paper yellows.

Of course one feels it everywhere: museums to some painters are public marble mausoleums, the resting place of the towering dead. One comes to them, as to cemeteries, on Sundays with hushed voices.

I do not know what the essence of art is, or that it has an essence. But my paintings are abstract and brief chronicles of a time, processes fixed fast in time like glass.[11]

Chapel Hill Center for Philosophic Linguistic Research

NOTES

[1] George L. K. Morris, *American Abstract Artist 1939*.

[2] *Cf.* Paul Ziff, *J. M. Hanson*, (Ithaca: Cornell University Press, 1962), 51 pp. with 33 plates.

[3] *Cf.* Paul Ziff, *Understanding Understanding*, (Ithaca: Cornell University Press, 1972), Chapter VII, 'There's More to Seeing than Meets the Eye', pp. 107—126.

[4] Cf. *Spirit of the Brush*, translated by Shio Sakanishi, (London: John Murray, 1948), p. 62.

[5] Kwo Da-Wei, *Chinese Brushwork*, (Montclair: Allanheld & Schram, 1981; London: George Prior, 1981), p. 74.

[6] *Op. cit.*, p. 75.

[7] Diana Kan, *The HOW and WHY of Chinese Painting*, (New York: Van Nostrand Reinhold Company, 1974), p. 7.

[8] I would guess that Dr. Kwo is not, whereas it is clear that Miss Kan is, a painter in ink.

[9] Time is the enemy of Tintoretto's blues: red bolus grounds are seeping through, saponification of pigment, turning blue cloaks to purple. And a shade is being drawn down from the tops of Whistler's portraits: an excessive use of linseed oil in the area of the faces is transforming the figures to faceless apparitions. But sometimes time is a friend: Van Gogh's garish gaudy sunflowers have gone to gold, benefitting from the instability of his chrome yellows.

[10] *Cf.* an article in *The Wall Street Journal* by Tim Carrington, 'Why Modern Art May Never Become Old Masterpieces', January 19, 1985.

[11] The first phrase is, of course, borrowed from Hamlet, the second from Wallace James Turner.

PART II

DEPICTING COLOURS

BERNARD HARRISON

IDENTITY, PREDICATION AND COLOUR

> Either a thing has properties that nothing else has, in
> which case we can immediately use a description to
> distinguish it from the others and refer to it; or, on
> the other hand, there are several things that have the
> whole set of their properties in common, in which
> case it is quite impossible to indicate one of them.
> For if there is nothing to distinguish a thing, I
> cannot distinguish it, since if I do it will be distin-
> guished after all.
> Ludwig Wittgenstein,
> *Tractatus Logico-Philosophicus*, 2.02331

I*

Suppose (*hypothesis 1*) A sees the same colours that B sees, only
systematically transposed, red for green and blue for yellow, for in-
stance. Or suppose (*hypothesis 2*) A sees a range of visual presentations
which qualitatively resemble nothing seen by B — are not *colours* at all,
in fact — but which are related to one another in exactly the ways in
which the colours B sees are related to one another. Suppose, too, that
A and B are native speakers of the same natural Language L. Would
such discrepancies in their visual experience necessarily make any
difference to what either says in L? Can't we, on the contrary, easily
imagine versions of both hypothesis 1 and hypothesis 2 on which the
envisaged discrepancies *couldn't* make any difference to anything either
A or B might say in L?
 Sceptics answer 'no' to the first of these questions and 'yes' to
the second, thus posing a threat not merely to such elaborated and
defended philosophical positions as physicalism and verificationism, but
also to something more commonplace, more fundamental to our every-
day relationship to others, and thus possibly more in need of defense:
our unphilosophical presumption that conformity of language use in
principle warrants the assumption of conformity of perceptual experi-
ence from speaker to speaker; or to put it crudely, that we can check on
what is seen by appeal to what is said.

Andrew Harrison (ed.), Philosophy and the Visual Arts, 169—189.

One might wonder, of course, whether the epistemological coupling of seeing to saying is not as much threatened by the actual phenomena of colour-blindness as by the sceptic's hypothetical transpositions and substitutions. But clearly it isn't. We learn about colour-blindness, in part, precisely by noting what subjects *say*, in response to the questions put by psychologists applying Ishihara tests, for instance. In any event, it is the epistemological legitimacy of the link between saying and seeing which I propose to defend in what follows.

II

I turn now to some questions about kind-identity, understanding and community of reference.

Categorial colour-names, like 'Red', 'Blue', 'Burgundy', can clearly be taken as designating *kinds* (though to what extent the kinds in question are *natural* kinds is one of the things we shall be discussing here). Saul Kripke[1] and Hilary Putnam[2] are, I think, right to suggest that our use of kind names raises problems about identity and reference which parallel those raised by our use of proper names. And these problems in turn bear on questions about *understanding*: about what account we are to give of the conditions under which a competent speaker can be said to understand kind names in general and names for colour kinds, including the kind *colour*, in particular.

Frege, held, also rightly I think, that to understand a given kind name is, at least, to be in a position to raise, if not necessarily to settle, questions concerning the truth or falsity of assertions employing that name. Frege argued also that if there is no common agreement between speakers as to the identity of the kind designated by a given kind name ('bovine tuberculosis' is the example he chooses) then it will not be possible for them even to dispute about the truth or falsity of such assertions, because 'the presupposition that could alone have made all their activity and talk reasonable would have turned out not to be fulfilled; they would not have been giving the question that they discussed a sense common to all of them.'[3]

If this is correct, then it is a necessary condition for the introduction into a natural language L of a kind name N_k, that speakers of L should be able to identify the kind K which N_k designates. For the purposes of Frege's argument it clearly doesn't matter whether we suppose each speaker to be able just on his own, without consulting other speakers,

to identify K, or whether something like Putnam's 'linguistic division of labour'[4] prevails. The point is that on either hypothesis there must be some way of establishing the identity of K to which all speakers possess common access in principle, even if the actual exercise of that access by a particular speaker in a particular case involves him in consulting experts. Frege's eminently plausible claim, now, is that unless this condition (call it Condition F) is satisfied for a given K, it will not be possible for speakers even to dispute about the truth or falsity of assertions employing N_k, since it will not yet have been made clear what they are disputing about. The difficulty is that as long as condition F remains unsatisfied for K, N_k will as yet have been assigned no determinate sense, and so will not really be a kind name at all: will not have the kind of function in the language that a genuine kind name, like 'tiger' or 'gold', has. So there will be no question of its being *understood* by anyone.

Notice, now, that Condition F requires not just that it should be the case, as a matter of psychological fact, that all speakers of L do associate N_k with the same kind K, but that it should be possible for any speaker actually to ascertain that this is so. For a putative kind name N_k to possess a determinate sense in L, in other words, speakers of L must enjoy common access to an adequate *criterion of identity* for K, by appeal to which they can keep a running check on one another's identifications of K.

It seems easy enough to state, in terms of this Fregean account of the relations between sense, reference, kind-identity and understanding, what the sceptic of Section I is up to. He wishes to show that, although we may imagine ourselves to possess common access to adequate criteria of identity for the kinds designated by colour-kind names like 'Red', 'Purple' or 'Burgundy', we are in fact just mistaken about this. It will clearly only be possible for other speakers to identify the specific colour kind which a speaker associates with a given colour name if it makes a difference to the way one talks or behaves which colour kind one associates with which name. But it is perfectly possible, or so the sceptic wishes to argue, that it might make no difference at all. Two speakers may associate quite different colour kinds with a given colour name without that making any discernable difference to anything they may say to one another (hypothesis 1). And for that matter (hypothesis 2) one speaker may associate a colour kind with a name with which another speaker associates something which is not a *colour* kind at all,

without there being any means, even in principle, by which either could come to know of the existence of the disparity.

Forcing the sceptic to formulate his enterprise in this way reveals a certain lack of internal coherence in the enterprise itself. The sceptic's primary aim is presumably to demonstrate that certain aspects of the world — those picked out by colour predicates — might be perceived in ways differing undiscernably from observer to observer. Call this *Claim 1*. Claim 1 is the important one for our present purposes: the claim whose acceptance entails the denial of the epistemological legitimacy of the passage from what is said by another person to what that person sees.

In order even to formulate Claim 1, now, the sceptic must possess some means of specifying the aspects of the world to which Claim 1 is supposed to apply. Plainly he can specify which aspects he has in mind only if he can rely to some unspecified extent on the referential potency of ordinary colour names.

At the same time, however, his enterprise requires him to cast as much doubt as he can on the notion that such names have any clearly defined reference.

Even to the naked eye there seems something fishy about this. With one hand the sceptic is doing his best to lift himself by bootstraps which he is at the same time doing his best to sever with the knife grasped in the other. The Fregean considerations just outlined suffice, I think, to sharpen these suspicions into certainty. If the sceptic is right and we really have no means of discovering what kind another speaker associates with a given colour kind name, then we lack common access to an adequate criterion of identity for colour kinds, in which case condition F is not satisfied for colour kind names. But from this it follows, by the Fregean arguments adduced above, that colour kind names designate nothing, and are not, properly speaking *names* at all; and hence that ordinary colour language has no referential potency whatsoever and cannot be appealed to by the sceptic in formulating Claim 1.

The sceptic, of course, is left with his detailed arguments unscathed, for the moment at least (we haven't so far considered them). However, it appears that what those arguments support, if anything, is not Claim 1, but the thesis (call it *Claim 2*) that colour names are mere sound and fury, signifying nothing.

Claim 2, although fatally subversive of Claim 1, has no tendency in itself to subvert our ordinary presumption that what is said reveals what

is seen. If colour names designate nothing, no problem can arise over whether what they designate is or is not the same for different observers.

So far as our announced aim goes, then, we might well be content to leave the matter there. But can we allow the sceptic even that much latitude? For one thing, while Claim 1 had a certain specious surface plausibility, Claim 2 is frankly unbelievable. We seem to know perfectly well what kinds we are referring to when we talk about colours. Is it really possible that we lack common access to adequate criteria of identity for the kinds in question? It is time, perhaps, to ask what criteria we actually do have access to, and how they operate.

III

A categorial colour name like 'red' or 'green' does not pick out a single recurrent feature of the world but a category of such features: we discriminate, as we say, many different *shades* of Red. Moreover, such categories have fuzzy boundaries. We can speak of 'a yellowish orange', 'a blueish green', and so on. One way of establishing which colour kind someone associates with a colour name is to notice where he puts the boundaries of the corresponding category of hues: under what circumstances he is inclined to stop speaking, for instance, of 'yellowish oranges' and start speaking of 'orange-y reds', and so on.

Teaching an apprentice speaker the meaning of a categorial colour name will thus involve getting him to see where these admittedly fuzzy boundaries fall. It might seem at first sight possible to do this by ostensively indicating every single discriminable hue which falls within the boundary of the required category. But this is clearly not feasible, not just because the boundary *is* a fuzzy one but because the discriminable items which go to make up the extension of a colour name are just too numerous to be exhaustively ennumerated. There will always be further ways of being red or orange whose credentials as such have not been definitively ratified by ostensive stipulation, either because we simply ran out of colour samples, or because there are hues which no English speakers happen to have seen yet: new dyes under development by organic chemists, for instance. But no competent speaker ever feels the need to enquire of others whether a hue not situated in the fuzzy boundary between the two colours is to be called 'red' or 'orange', and all competent speakers immediately and simultaneously recognise the

organic chemist's new dyestuff as (a previously unencountered shade of) red or orange the moment they are presented with it.

What the apprentice speaker clearly needs, if he is to emulate such feats, is some criterion which will enable him to fix for himself, in a way which will automatically accord with the linguistic judgments of other speakers, the extension of a colour name over the domain of discriminable hues.

It is not hard to see how such a criterion must work. Quine puts it very well:

> One learns by *ostension* what presentations to call yellow; that is, one learns by hearing the word applied to samples. All he has to go on, of course, is the similarity of further cases to the samples. Similarity being a matter of degree, one has to learn by trial and error how reddish or brownish or yellowish a thing can be and still be counted yellow. When he finds he has applied the word too far out, he can use the false cases as samples to the contrary; and then he can proceed to guess whether further cases are yellow or not by considering whether they are more similar to the in-group or the out-group. What one thus uses, even at this primitive stage of learning is a fully functioning sense of similarity, and relative similarity at that: *a* is more similar to *b* than to *c*[5]

The conception of *ostension*, or ostensive definition, working here is far more complex, of course, than the Russellian conception criticised by Wittgenstein at *Investigations* I. 26—29. According to the conception Wittgenstein attacks, the meaning of the name being defined is established merely through the learner's becoming *acquainted*, in something like Russell's sense of the term, with the ostensively indicated sample. On Quine's account, which seems to me to evade Wittgenstein's criticisms at least for the case of colour, the act of ostension merely identifies the sample as a piece of linguistic data which the learner is going to be asked to manipulate in a certain specific way. The meaning of the associated name does not become apparent merely on acquaintance with the sample, but depends, as Wittgenstein himself suggested, and in Wittgenstein's phrase, on what the learner *goes on to do with* the sample.

What he 'goes on to do with' it is, of course, to compare it systematically with other ostended samples under the guidance of a rule: that x is to be called yellow if it is more similar to *a* (ostended as a sample of yellow) than it is similar to *b* (ostended as a sample of red) or to *c* (ostended as a sample of brown), ... , and so on. The meaning of yellow, in the sense of the extension of 'yellow' over the domain of discriminable hues, thus becomes something that the apprentice learns

to establish for himself by applying that rule, or a suitably generalised version of it, to the samples ostensively indicated for him by other, already competent speakers, so that he himself becomes able to generate judgments about what is and what is not yellow which automatically match theirs (because generated by the application of the same rule to the same samples); and for other colour names likewise.

Such an account of the ostensive learning of colour names (an account rich enough, in other words, to evade Wittgenstein's criticisms of acquaintance-based accounts) evidently rests upon the presumption that competent speakers and learners alike have common access to an organised quality-space of colour, in which the location of each hue relative to adjacent hues is uniquely determined by n-adic relations of relative similarity of the kind invoked by Quine. And in fact we do take ourselves to enjoy common access to just such a quality-space, the familiar 'colour solid', often constructed as a double cone, with hues in maximum saturation and spectral order around the equator, degree of saturation diminishing towards the vertical axis, lightness increasing towards one pole and darkness towards the other.

What makes us so confident that the quality space of colour is publicly accessible; as publicly accessible as a table, or the mountains visible through the window? Partly, of course, the fact that different observers assemble physical colour samples in the same way when constructing representations of the colour solid, or two-dimensional colour charts or series derived from the colour solid. But agreement in linguistic performance counts as well. Different speakers, when they have come to grasp the extensions of colour names over the domain of discriminable hues in the manner Quine describes, have no difficulty in assigning colour descriptions to objects ('This book is red', 'That wall is green') in a way which satisfies other competent speakers. Moreover, speakers agree, for the most part, about the intrinsic properties of colours. They agree, for the most part, about what colour samples satisfy identifying descriptions such as 'a dark, purplish red', 'the colour mid way between blue and green', and so on. They agree that the result of mixing white pigment with red is a hue belonging to a distinct colour category, called pink, while the result of mixing white with green is just a pale, whiteish green. They are prepared to give second-order descriptions of what they are doing when they make, or assent to, judgments of the above kinds, using terms such as 'hue', 'saturation', 'tonality', 'belongs' ('this sample belongs between that one and that one') 'becom-

ing' ('that series of blues is becoming more greenish') and so on, in senses which can be given no propositional elucidation, but which can be elucidated to everyone's satisfaction by appeal to the actual phenomenal constitution of colour charts and colour solids. Only by appeal to the demonstrable qualitative character of colour, as presented in charts and samples, can we teach or explain our use of colour language; but just because of this, the fact that we are successful in using and teaching colour language underpins our belief in the publicity of colour. In *On Certainty* Wittgenstein says,

Giving grounds, however, justifying the evidence comes to an end; — but the end is not certain propositions' striking us immediately as true, i.e. it is not a kind of *seeing* on our part; it is our *acting*, which lies at the bottom of the language game [6]

In just this way the possibility of physically arranging colour samples to form a closed space of *n*-adic qualitative relationships lies at the bottom of our talk of colour, and founds the possibility of such talk. It gives us a way (the one Quine outlines) of satisfying condition F for colour kinds, and so a way of giving a determinate sense to the corresponding kind names, and so of determining publicly what is relevant to the truth or falsity of assertions employing such names. Less obviously, it also enables us to satisfy condition F for the kind *colour*: for something to be coloured is simply for it to be assignable, just on the basis of inspection, to a determinate location in the quality-space of colour.

IV

'But couldn't we still refer to and talk about colours, even if hues were not qualitatively related to one another?'

Well, could we? What would happen to colour-talk (not just in English, but in any natural language) if that feature of colour-experience were lacking: if, instead of colours we were presented in visual experience with an array of qualitiative determinations of light and surfaces each of which was *sui generis* in the sense of being qualitatively unrelated to each of the others in the way in which, say, yellow is qualitatively unrelated to the sound of middle C.

Let us call these *sui generis* visual qualities of light and surfaces *generic qualities*, and assume for the sake of argument (though we shall question this in a moment) that it would be possible to introduce into a

natural language terms functioning as names for such qualities. It seems clear at least that the logical grammar of such names would differ sharply, and in quite specific ways, from the logical grammar of colour names in English.

For a start, it would not be possible to predicate generic qualities of one another. The insertion of names of generic qualities into the sentence-schemata corresponding to English 'A is a reddish blue,' 'That green is yellower than that one' would be senseless (would not produce a sentence capable of embodying a true or false assertion) because, since *ex hypothesi* generic qualities are qualitatively unrelated to one another, all generic qualities would be equally unrelated to any given generic quality, as all colours are equally unlike middle C.

For similar reasons it would not be possible to characterise generic qualities in terms of hue, tonality or degree of saturation. Such characterisations presuppose membership of a common quality-space on the part of the object so characterised, but *ex hypothesi* generic qualities do not conjointly compose a quality space.

Finally, and for similar reasons, it would be impossible to bring together generic qualities under a common category term analogous to English 'colour', although we could no doubt, assuming once more the possibility of singling out generic qualities for reference, characterise them vacuously as 'qualities'. Any substantial categorisation of qualities; any, that is, which implies the exclusion of some qualities from the chosen category; presupposes the possibility of detecting some relationship between the qualities included in the category which the excluded qualities lack, and *ex hypothesi* in the case of generic qualities no such relationship would be detectable.

It follows that it would be impossible to give, for generic qualities, the sort of *identifying characterisation* that we can give of colours: the kind we give, for example, when we identify turquoise as 'the colour midway between blue and green,' or burgundy as 'a dark, purplish red'. Such a characterisation identifies a colour *intrinsically* — *qua* colour, that is — by characterising its bare *quale*, without reference to any contingent fact about its empirical circumstances of manifestation (as that boiled lobsters happen to be red, the unclouded sky blue, and so on.)

Let us call qualities for which such a characterisation is possible *descriptively identifiable qualities*. Pretty clearly generic qualities will not be descriptively identifiable. And that, perhaps, ought to suffice to raise at least the initial shadow of a worry about whether it would

be possible for different speakers to identify and reidentify generic qualities, for purposes of common reference in discourse, at all.

At first sight such worries may appear groundless. Granted that we couldn't identify generic qualities for purposes of discourse by appeal to their internal properties (they have none in the sense in which colours do), surely we could equally effectively identify them in terms of external properties; that is, in terms of the contingent facts about their circumstances of manifestation. Locke, after all, long ago accustomed us to the idea that the basic properties in terms of which we characterise all other things can themselves only be named but not characterised, but did not draw from that thought the conclusion that, in that case, characterisation *per se* is impossible.

Here, however, Locke erred; perhaps because he assumed too easily that our ordinary idea of what a property ('idea') is would pass over unchanged into his concept of a basic property ('simple idea'). Certainly if we compare generic qualities, as we have been forced to envisage them, with qualities in the ordinary sense, some striking differences emerge.

Quality names normally cover an indefinitely large range of discriminable but related phenomena. 'Red', for example, as we noticed earlier, covers an indefinitely large range of discriminable colours, related to one another, and to colours falling under other colour names, in certain definite ways in the common quality space of colour.

Precisely what we have ruled out in positing generic qualities, however, is the possibility of relationship, in a common quality space, between discriminable phenomena falling under the same quality name. If one presentation of a given generic quality is discriminable from another, then *ex hypothesi* we are dealing with two distinct generic qualities, in which case we have *a fortiori* no grounds for bringing them together under a single quality name.

So what would be involved in the recurrence of a generic quality would have to be not some mode of similarity holding between two essentially, or qualitatively, discriminable manifestations of the quality in question; but something more akin to Leibnizian identity. Nothing but their spatio-temporal co-ordinates, in other words, could distinguish one recurrence or manifestation of a given generic quality from another.

Names for generic qualities now begin to look more like proper names than like names for properties. Like 'Churchill' or 'Excalibur',

such a name picks out something which recurs and is each time identically the same. The difference is, however, that whereas we can pick out Churchill or Excalibur for purposes of reference by appeal to a variety of descriptive devices, in the case of generic qualities we have only descriptions of the form, 'the quality which manifested itself at spatial postion xyz at times $t_1, \ldots t_n$.'

What, exactly, does such a description pick out? Does it pick out anything? *Ex hypothesi*, remember, this is the only kind of description we can give of a generic quality, such entities being otherwise ineffable. Remember also that, again *ex hypothesi*, it is a merely contingent matter which generic property happens to manifest itself where and when. So when you offer such a description, what you are saying is that when you inspected xyz at various times you received an impression of something ineffable which seems to you, upon reflection, to have been identically the same ineffable something each time. You propose that we call that ineffable something, say, 'E'. What am I to make of this proposal? Could we both, from this point on, employ 'E' in discourse to name a quality? Which quality? I can attempt to find out which quality, no doubt, by myself inspecting xyz on several successive occasions. And perhaps I also receive an impression of something ineffable which seems to me upon reflection to have been identically the same ineffable something each time. But is the ineffable something I apprehend *the same* ineffable something that you apprehended? The ineffability of both somethings appears to exclude the possibility of either of us ever being in a position to answer that question in the affirmative.

E is, in effect, Wittgenstein's beetle-in-a-box by which one can 'divide through'[7]. We have common referential access to a certain spatial location (we can be sure that we are both referring to the same thing when we refer to *that*) but no common referential access to what (putatively) manifests itself there.

All the same, one might want to say, we are both inclined to say that *something* manifests itself at xyz and that (whether or not it is the same something for both of us) it is identically the same something each time. But now familiar moves derived from Wittgenstein's discussion at *Investigations* I. 2 4 3 *et. seq.* come into play. Does this inclination suffice to establish my capacity to *refer* (even solely for my own benefit, as it were) to E? Does it confer upon me the certainty that I am referring to the same thing each time I use 'E' with the intention of referring? Might not xyz now exhibit a different generic quality 'form

the one it exhibited when I originally define 'E' by appeal to what was to be apprehended at *xyz*? Might I not have overlooked the change, or misremembered how *xyz* looked originally? How could I possibly check that such an error had *not* occurred?

None of this, of course, goes to show that we could not experience the ineffable. All that it shows is that we could not differentiate one ineffable experience from another for purposes of common reference, and thus that we could not found a vocabulary of quality names upon reference to positionally locatable but otherwise ineffable experiences. But this in itself is sufficient to show that it is not, after all, an accident that colours are not, in the sense defined above, *sui generis*. No qualities we could refer to and talk about could be, in that sense, *sui generis*.

From this vantage point the sceptic's dilemma reappears in a slightly altered form. He is at liberty to say, if he likes (what could prevent him?) that there are *ineffable* experiences which differ undiscoverably from observer to observer, and we can all shake hands on that and go home. But this is not at all what he wants to say. He wants to say that *what we are referring to when we use words like 'red' and 'green'* might differ undiscoverably from observer to observer. But if he is correct about this, then we have after all no means of identifying, for purposes of common referential access, what kinds 'red' and 'green' pick out, from which it follows, by appeal to Condition F, that such names, contrary to appearances, fail to refer to anything at all.

The sceptic may still protest, however, that this must be wrong, given the intrinsic plausibility of hypotheses 1 and 2, and the apparent ease with which we can imagine the situations which those hypotheses adumbrate.

This is a not unpersuasive argument, and even if it fails to establish the truth of Claim 1 it might at least establish that of Claim 2. It is time we gave it closer consideration.

V

Both the sceptic's hypotheses work, if they work, by reconstruing the logical category of colour names; by suggesting, that is, that what we ordinarily take to be names for categories of *qualia* are in fact names for locations within complex systems of qualitative relationships. Each hypothesis adumbrates a situation in which the location which a given

array of *qualia* occupy in the quality space of colour would be held steady from observer to observer despite some radical change in the identity, from observer to observer, of the *qualia* occupying that location. In effect the sceptic is arguing that while colour names fail to satisfy Condition F if we take them as naming categories of *qualia*, they do satisfy Condition F if we take them merely as naming locations in a quality space: we can identify the *locations* in question in such a way as to permit common referential access to *them*, even if not to the *qualia* occupying them, in other words.

Let us start with hypothesis 1. It says, in effect, that there is some way of systematically transposing the hues we actually see which holds steady all qualitative relationships between hues and named categories of hues. There are several ways in which we might envisage doing this. The simplest and most obvious is to invert the spectrum of visible light. But that this will not have the desired effect is evident when we reflect that the ability of the eye to discriminate hues is not constant across the spectrum, but varies with wavelength of light and with the response curves of the various classes of colour receptors (cones) in the eye, reaching a maximum around yellow. The consequence of this variation is that the distribution of discriminatory capacity along the spectrum is asymmetric[8], which would make a spectral inversion detectable under standard discrimination tests.

Difficulties of this kind multiply when we pass from spectral colour to the surface colours produced by pigments. Here we are dealing with many more discriminable hues (on the order of 7×10^6) than are presented in spectra produced by passing light through a prism, and with 'extraspectral' colours such as pink and brown.

'Surface' colours can be displayed in many kinds of colour chart and colour solid, which exhibit the qualitative relationships which compose the qualitative space of colour. The sceptic who wishes to rest his case on hypothesis 1 must contend, in effect, that there is a way of transposing the categories of hues which compose the extensions of colour names ('green', 'red', etc.) which leaves all the qualitative relationships displayed by all such charts entirely unaffected.

Very little acquaintance with actual colour charts is needed to show that no such transposition is in fact possible. I have discussed elsewhere in some detail[9] the reasons why this is so, and shall therefore confine myself here to a brief summary of the arguments. The main difficulty is that the distribution of numbers of hues between the extensions of

different colour names is not even. As a result, what one might call the linguistic topology of the quality space of colour is assymmetric. No transposition of the sort the sceptic envisages could avoid producing the result that A would discriminate more hues within a given category than B, or that hues indiscriminable to A would be discriminable to B, or that A would detect different gradations of hue, or tonality from B in a given colour display. Another difficulty is that when we take into account brown and pink, the number of named colours on the red-yellow side of the circle of hues is greater than the number on the blue-green side. A third difficulty is that any transposition of colours under hypothesis 1 must maintain parity as regards complex predications of the '*x* is blueish green', '*x* is yellowish-orange' variety; which excludes, for one set of reasons, exchanges of primary for secondary colours, and for another set of reasons, 180° rotations of the circle of hues.

The brisk disregard for the facts of colour vision displayed in so many philosophical discussions of transposed colours is not plausibly attributable to carelessness or disrespect for facts. It is the natural consequence, evidently enough, of a familiar tissue of Cartesian assumptions. It is first taken for granted that colours are purely subjective, "inner" states, and that, as such, they stand only in contingent, or external, relationships to the behavioural phenomena, including linguistic phenomena, which bear witness to them in the public world. From these two assumptions it follows, on the one hand, that there can be no facts about *colour* worth respecting (though there may be facts about the behaviourial manifestations of colour), and on the other hand that it *must* be possible to transpose colours freely without prejudice to any empirically detectable event in the public world, provided the transposition is systematic. Both these assumptions, of course, beg the main questions at issue in the present discussion.[10]

Someone might object that these arguments, even if the obstacles they place in the path of hypothesis 1 are insuperable, only show that hypothesis 1 is hard to push through given the sort of colour vision which we contingently happen to enjoy. They don't show that there is anything *in principle* wrong with hypothesis 1, or that hypothesis 1 might not describe a genuine possibility if applied to beings with a different and simpler system of colour vision from ours. But we have already shown *ad nauseam* why such an objection is not to the sceptic's purpose. Suppose there *are* beings whose perception of colour is so

arranged that, for them, hypothesis 1 describes a genuine possibility. It follows that, for them, the collections of hues forming the extensions of the colour names in their language can be freely transposed from one location to another in the quality space of colour without any change in the structure of qualitiative relationships composing that space. It looks, perhaps, as if we might describe this situation by saying that the colour names in their language pick out, not collections of hues (on that assumption Condition F would not be satisfied) but simply locations in a quality space. But this is an illusion — for how could Condition F be satisfied on this interpretation either? If we are to exercise common referential acess to locations in a space we must possess common access to some criterion which enables us to identify each such location, in the sense of discriminating each such location from every other. Cartesian co-ordinates do just this kind of job for the case of spatial location. In the case of a *quality* space, however, the only way we have of individuating locations in the space is by noting the structural difference it makes when we exchange the positions of *qualia* relative to one another. But *ex hypothesi*. for the scepticism-prone beings the sceptic now wishes us to consider, it makes no structural difference when we exchange the positions of *qualia* relative to one another. If there is any assymmetry at all in the quality space of colour as perceived by these beings, then that assymmetry will serve to permit common referential access both to colours, in the sense of categories of colour *qualia*, and to locations in the quality space of colour. Conversely, at the point at which all scepticism-impeding assymmetry is purged from the quality space of colour it becomes impossible to refer either to colours or to locations in the quality space of colour. Both lapse simultaneously, as it were, into referential invisibility.

The answer to the objection that the assymmetries in the quality space of colour which obstruct the application of hypothesis 1 are just contingent features of our colour experience is thus simple enough. Some such assymmetry is essential to permit common referential access to colours and to locations in the quality space of colour alike. Any functioning vocabulary of colour names, since it will have to satisfy Condition F to be a functioning part of a natural language, will thus be based on some asymmetry in the quality space of colour. Any functioning vocabulary of colour terms, then — ours included — will make colours into publicly accessible objects of reference, in the sense that it

will allow speakers to communicate the qualitative character of their experiences of colour to one another in a way which is not subject to sceptical doubt of the kind associated with hypothesis 1.

<div align="center">VII</div>

However there still remains hypothesis 2. Hypothesis 2 invites us to envisage a class of visual presentations whose members are not, qualitatively speaking, colours at all. A colour-seer, presented with one of these visual presentations would say, in other words, "But that isn't at all the *sort* of thing that I mean by 'a colour'". Nevertheless, the visual presentations which compose this class are related to one another exactly as colours are related to one another.

At first sight this just looks impossible. It seems as if the relations which hold between colour *qualia* must be unique to colour *qualia* just because they hold internally. After all, what makes it possible to relate a colour *quale* to other colour *qualia* appears to be merely (*i.e.*, the same possibility as) the possibility of qualitatively modifying the *quale* in question. For example, I can start with a clear red pigment, add a trace of white to make it slightly pink, then a little more to make it slightly pinker, and so on. It is hard to see how we could separate the possibilities of qualitative modification with which a given *quale* presents us from the specific qualitative character of that *quale*, and so it is hard to see how two different *qualia* could exhibit *the same* possibilities of qualitative modification. If one changes the qualitative character of a red colour chip by painting it yellow, the possibilities of qualitative modification inherent in the redness vanish with it: adding white to yellow won't give you a colour analogous to pink, but only a paler yellow. We cannot take away *colours*, but retain or hold steady their possibilities of qualitative modification, because it is the qualitative character of a specific colour *quale* which *gives* it certain specific possibilities of qualitative modification.

It is open to the sceptic, however, to dig in his heels at this point, claiming that the difficulty we experience in grasping what his proposal would amount to in practice represents merely a psychological incapacity on our part, or something of the sort. So let us simply give him this part of the argument and see what follows.

Let us suppose, for the sake of a handy example, that what Germans see, and call *farbe*, are not colours at all, but the sceptic's homologously

related visual presentations; or in other words that when a German sees what he calls *Ein gefaerbtes Ding*, what he sees is not what you or I would call a coloured thing at all.

The sceptic's claim, now, is that the qualitative relationships in which *farbe* stand to one another are *the same relationships* as those in which colours stand to one another. No doubt the identity of the relationships in questions would be visually evident only within a linguistic community whose members were visually acquainted both with *farbe* and with colours. But still, the sceptic does seem to be committed, under hypothesis 2, to the claim that within such a community the identity of the relations constituting the quality space of *farbe* with those constituting the quality space of colour would be evident to inspection. And since our freedom to invent the world is no less unbounded than that of the sceptic, we are at liberty to invent a community of observers — call them Martians — who enjoy the required visual acces to both colours and *farbe*.

Notice, now, that *ex hypothesi* — the hypothesis in question being the sceptic's hypothesis — Martians will not be able to individuate the kind *colour*, for purposes of reference, by appeal to an order of relationships taken to be uniquely constitutive of the quality space of colour, since the only order of relationships which could satify that description no longer *is* uniquely constitutive of the quality space of colour.

On the other hand, so far as Martians are concerned, colours and *farbe* taken together do exhaust the list of things which can stand to one another in the sort of relationships which constitute the quality space of colour. So no doubt Martians will be able to individuate, by appeal to the order of relationships in question, a larger class of objects of reference — call them *visual presentations* — which will include both the class of colours and the class of *farbe*.

The sceptic is now committed under hypothesis 2 to the claim that there is a single order of relationships, which we see as uniquely constitutive of the quality space of colour, but which Martians see as constitutive of a larger quality space which includes both colours and *farbe*. But this position is unstable in ways which threaten the sceptic's entire enterprise.

To reveal the instability, we need only ask in what way Martians are supposed to be able to detect visual presentation relationships. The most natural answer for the sceptic to give is that Martians detect visual

presentation relationships exactly as we detect colour relationships (visual presentation relationships just *are* colour relationships, after all). That is, Martians simply lay visual presentation samples alongside one another and note, 'by inspection' whether they form smooth and unbroken qualitative gradations or not. But let us press this further. The sense in which the qualitative gradations which constitute one section of the quality space of colour are 'of the same kind' as the qualitative gradations which constitute other sections is simply that the entire quality space of colour can be generated by continuous qualitative modification of any of the *qualia* which conjointly compose that quality space. Would Martians be prepared to accept that this holds true for visual presentations also? If the sceptic assents to this, then he commits himself to holding that colours and *farbe*, as seen by Martians, jointly compose a single quality space common to them both. But this is surely absurd. The quality space of colour is closed and continuous. if it were the result of abstracting certain elements from a larger closed and continuous quality space perceived by Martians then both it and the quality space of *farbe* would be discontinuous; i.e., would not be quality *spaces* at all. At this point hypothesis 2 collapses, it seems to me, into the anodyne and unexceptionable hypothesis that Martians (and Germans), if they see colours, see the colours that we see.

The sceptic will doubtless wish to recoil from this conclusion, but in so doing he will succeed only in locating the opposite horn of a dilemma. His natural move is to deny that Martians will accept the second-order account offered above of what is involved in detecting visual presentation relationships. Far from it: they will insist that *farbe* are so unlike colours that there is no way in which the quality space of *farbe* could be continuous with that of colours. But to engage in second-order talk of this kind, Martians have to be able to discriminate colours and *farbe* from one another not just visually, but for purposes of reference. That means that there has to be something unique to *farbe* which enables speakers to individuate the class of *farbe* for purposes of reference, and something else, unique to colours, which enables speakers to individuate the class of colours for purposes of reference. Since we are dealing with basic sensory modalities, the unique somethings in question can only be the structures of the respective quality spaces. But hypothesis 2 commits the sceptic to the view that there is nothing about the structure of either quality space which could serve to uniquely identify the qualities which compose that quality space.

The sceptic can, if he wishes, stipulate that Martians just do have the independent referential access to colours and *farbe* which they need to have if they are to affirm the discontinuity of the quality spaces of colours and *farbe*. But if the sceptic chooses to make this move hypothesis 2 collapses once more, this time into the equally anodyne and unexceptionable thesis that Germans and Martians have access to a sensory modality to which English speakers lack access.

If this is the way things stand, then the perceptial differences between English speakers on the one hand, and Germans and Martians, on the other hand, could not but reveal themselves in discourse. If Martians really are able to differentiate *farbe* from colours for purposes of common reference, then whatever differences in the structure of the respective quality spaces permit the required individuation to get off the ground must display themselves in discourse as differences in the logical grammar of *farb* names and colour names analogous to the differences in logical grammar between names for colours and names for musical notes, such as 'C#' or 'Eb'. For only if that is so will it be possible for one Martian to check up on another Martian's identification of the kinds which the kind names 'colour' and '*farbe*' pick out; and if that is not possible colours and *farbe* alike will lapse, as far as Martians are concerned, into the referential invisibility of the ineffable.

VIII

These arguments bring us back to the fundamental issue which has concerned us here: the incoherence of Claim 1, and its consequent tendency to collapse into Claim 2. The sceptic's second hypothesis is only intelligible if it is possible for other *qualia* than colour *qualia* to stand to one another in the relationships which constitute the colour space. If that were possible, then it would be a contingent matter of fact that the qualities we see as manifesting those relationships happen to be colour qualities, just as it may be a contingent matter of fact that a light visible at a particular point in the sky is a red light. The pluralism and extentionalism characteristic of one branch of the Cartesian tradition make it evident why philosophers have been tempted to treat colour relations as contingent and propositions about colour as extensionally related to one another, even at the cost of embracing the sceptical consequences of these moves. What I have tried to show here is that such moves, however tempting, make it impossible to give any intel-

ligible account of the individuation, for purposes of common reference, of the kinds which colour names, including the name 'colour' are supposed to pick out. Any colour quale, or none, can of course manifest itself at any given point in space picked out by a set of Cartesian co-ordinates. But that precisely explains why the objects which Cartesian co-ordinates serve to individuate for purposes of reference are not colours but spatial points. The obverse of this coin is that we can individuate spatial relationships without reference to the phenomenology of colour. If the relationship between colour qualia and the structure of the quality space which they compose were similarly external, the same would be true of colour relationships. The fact that it is not is the surest guarantee we have that the conditions of reference are not mocked, and that colours are after all not private objects, but publicly referentially accessible kinds.

NOTES

* This paper has profited from comments on an earlier draft by Virgil Aldrich, Clifton McIntosh and others. It first appeared in a slightly abridged version in the *American Philosophical Quarterly*, **23**(1) (January 1986), and is republished here by kind permission of the Editor of that journal, Nicholas Rescher.

[1] Saul Kripke, 'Naming and Necessity' in Donald Davidson and Gilbert Harman, etc. *Semantics of Natural Language*, (Dordrecht: Reidel, 1972), p. 318 and *passim*.

[2] Hilary Putnam, 'The Meaning of "Meaning"' in *Mind, Language and Reality*, Philosophical Papers, vol. 2 (Cambridge: Cambridge University Press, 1975) *passim*.

[3] Gottlob Frege, *Logical Investigations*, ed. P. T Geach, tr. P. T. Geach and R. H. Stoothoff, (New Haven: Yale University Press, 1977), pp. 35—36.

[4] Putnam, *loc. cit.*, p. 245 and *passim*

[5] W. V. O. Quine, 'Natural Kinds', in *Ontological Relativity and Other Essays*, (New York and London: Columbia University Press, 1969), pp. 121—122.

[6] Ludwig Wittgenstein, *On Certainty*, (Oxford: Basil Blackwell, 1969), paragraph 204.

[7] Ludwig Wittgenstein, *Philosophical Investigations*, (New York: Macmillan, 1953, I. 293).

[8] See the diagram on p. 126 of R. L. Gregory, *Eye and Brain*, 3rd edition, (London: Weidenfeld and Nicolson, 1977), and the accompanying discussion in the text.

[9] Bernard Harrison, *Form and Content*, (Oxford: Basil Blackwell, 1973), pp. 102—114.

[10] Frank Jackson, (*Perception*, p. 36) suggests that "someone might . . . see the world in shades of grey, but, . . . have extremely good 'grey vision'; in particular, he might be able to make among the greys the same number of discriminations normal people make in the whole colour spectrum." It is difficult to know what to make of this suggestion. The difficulty for the sceptic is indeed in part that of assuring that observers make the same number of discriminations within each named colour category, but he also needs to preserve parity of judgment over a wide range of describable colour *relationships*. It is hard to see for a start, what sense Jackson's grey-seers could make of the distinction between hue, saturation and tonality, given that all they perceive is difference in tonality. Grey-seers would also — I am indebted for this reference to Clifton McIntosh — presumably give very odd responses in some of the experiments with combinations of wavelengths described by Edwin H. Land in 'Experiments in Colour Vision', *Sci. Amer.* 5, 84 (1959), see especially pp. 89—91.

JOHN GAGE

COLOUR SYSTEMS AND PERCEPTION IN
EARLY ABSTRACT PAINTING

Abstract painting still awaits its historian, and it seems clear from other
contributions to this conference that — appropriately enough in a
period of post-modernism — philosophers of art are still more con-
cerned with problems of abstracting, and of its concomitant, represent-
ing, than with the essential issues in the history of abstraction itself. It
has not proved difficult, with hindsight, to trace continuities between
representational and non-representational art; and the long careers of
several of the key figures like Kandinsky, Malevich and Mondrian, who
began with representation, have seemed to give the plotting of these
continuities some sort of validity. Kandinsky, however, in an unusually
candid autobiographical essay, gave a rather different picture of his
feelings when he at last realised that his pictures were harmed by the
presence of a recognisable subject:

A terrifying abyss of all kinds of questions, a wealth of responsibilities stretched before
me. And most important of all: What is to replace the missing object? [1]

Kandinsky's dilemma points to the importance of content in early
abstraction; but the criticism of abstract art as it developed from the
earliest years about the time of the First World War, has been very little
concerned with content. The primary as well as the secondary sources
tell, for the most part, a story of abstraction as essentially an autono-
mous, even hermetic activity; and this has enabled opponents like Lévi-
Strauss and Gombrich to suppose that what they see as the failure of
abstraction is due to its very impoverished semantic credentials.[2] As I
shall show at the close of this paper, there is a very direct way in which
one branch of early abstraction, Russian Suprematism, owed its force
to a context of debate on the fundamentals of language; but for the
moment I want to look chiefly at questions of colour in early abstrac-
tion, for colour was an area of especial semantic richness at the
beginning of this century, and it offers an aspect of content in early
abstract painting which, as I shall hope to show at least in outline, is as
complex and as resonant I as, say, the iconography of the Madonna in
the Italian Quattrocento.

191

Andrew Harrison (ed.), Philosophy and the Visual Arts, 191—200.

A good starting-point is, again, Kandinsky, whose discussion of colour in his first major publication, *On the spiritual in art* (1912) has come in for a good deal of attack, even from supporters of abstraction like Stephen Bann, who has written recently,

I would reject as utterly implausible the specific equations of form, colour and meaning propagated by Kandinsky.[3]

Yet if we compare Kandinsky's treatment of colour with that of one of his sources in the literature of the Theosophical Movement, we shall see how much more rigorous the painter is. The theosophical system in *Thought Forms* 1901, although it incorporates notions of a moral colour-space — lightness and purity as opposed to darkness and corruption — seems to be a quite arbitrary arrangement: two widely-separated classes of red, for example, are given quite antithetical connotations of 'Pure affection' and 'Avarice'. The theosophical texts are concerned to interpret colours as they are experienced by the adept in auras or 'thought-forms'; Kandinsky, on the other hand (see Figure 1), starts from what he considers to be the properties of colours themselves: their polar contrasts of warm and cool, light and dark, or

Fig. 1. The antitheses as a circle between two poles, *i.e.*, the life of colours between birth and death.
(The capital letters designate the pairs of antitheses.)
W. Kandinsky, Colour-Circle, from *On the Spiritual in Art*, 1912.

complementarity; and he articulates these into a set of antitheses which provide a tightly-interlocking armature for his meanings. The respective treatments of green are instructive: in *Thought-Forms* Besant and Leadbeater write:

Green seems always to denote adaptability; in the lowest case, when mingled with selfishness, this adaptability becomes deceit; at a later stage, when the colour becomes purer, it means rather the wish to be all things to all men, even thought it may be chiefly for the sake of becoming popular and bearing a good reputation with them; in its still higher, more delicate and more luminous aspect, it shows the divine power of sympathy.[4]

For Kandinsky, however, who had been especially attracted to green in his earlier, representational phase as a painter, it was now a product of the coming-together of the eccentric yellow and the centripetal blue, and it was thus expressive of calm, but also of boredom:

Thus pure green is to the realm of colour what the so-called bourgeoisie is to human society: it is an immobile, complacent element, limited in every respect. This green is like a fat, extremely healthy cow, lying motionless, fit only for chewing the cud, regarding the world with stupid, lacklustre eyes.[5]

The values attributed to specific colours are often very similar in the Theosophists and in Kandinsky — the spiritual blue and the earthly or intellectual yellow, for example — but only Kandinsky is prepared to argue for them according to a publicly recognisable set of principles.

Kandinsky's arrangement of colours into a polar scheme shows clearly that he was heir to earlier colour systems, and especially to those of Goethe and the Viennese psychologist Ewald Hering, whose theory of colour-perception was based on the three oppositions (opponent-colours), black-white, red-green, and blue-yellow; and the painter probably found Hering's ideas in the well-known standard psychological textbook of Wilhelm Wundt.[6] His views are thus far from arcane, 'implausible' or even very individual, for they rest in principle, if not always in detail, on a widely debated body of psychological doctrine which included effects of synaesthesia very familiar to the painter: Kandinsky's understanding of the *timbre* of the flute as light blue, for example, had been mooted in the 1870s by several psychologists and aestheticians, and was appropriated by Wundt.[7]

In *The raw and the cooked*, Lévi-Strauss argues that painting can never constitute an abstract system on a par with music since its forms and colours are necessarily rooted in nature.[8] He has clearly over-

looked the developments in chromatics and psychology to which I have
just referred; but he has also, and perhaps more surprisingly, neglected
the Enlightenment prototypes of these late nineteenth-century schemata,
notably the circular systems of the entomologists Moses Harris and
Ignaz Schiffermüller, whose dual nature is immediately clear. As part of
the great eighteenth-century enterprise of cataloguing the whole of the
natural world, Schiffermüller and Harris's scales epitomise what
Foucault has termed the *method* of Enlightenment taxonomies; but, as
their titles, *Versuch eines Farbensystems* or *The Natural system of
colours*, make clear, they also represent aspects of Foucault's *system*:
self-contained and internally-coherent schemes of colour articulation,
based upon the notion of primary and secondary characteristics, and of
contrast or harmony.[9] Although the modern Munsell and C.I.E. systems
have become more complex and more open-ended, they are no less
systematic, and as early as the second half of the nineteenth century it
had become quite in order for the popularisers of colour-theory to refer
to it in terms of a 'grammar'.[10]

I do not propose to examine here the many problems facing the
users of these very simple early schemata, and which the later develop-
ments were designed to reduce. But there is one factor which I think
has an important bearing on the role of colour as system in early
abstract painting. As Harris had already shown, the painter's applica-
tion of the principles of contrast, as presented in his *Natural system
of colours* (1776) was made very difficult by his inability to find
colorants which would exactly match ideal colours. The developing
paint-industry of the nineteenth century addressed this problem: the
Englishman George Field, for example, who was both a theorist and
a manufacturer, was careful to specify the pigments he used in his
diagrams; and by the 1880s the influential circle of contrasts published
by Ogden Rood was able to give precise pigment equivalents for com-
plementaries, and Seurat was able to set his palette with a series of
paints approximating to the colours of the solar spectrum, at least in
hue.[11]

This increasing range of colorants was of great importance in the
practical application of theory, and in particular for theories of the
affects of colours on spectators, who could now be presented with
standard, measured hues, so that dependence on language, and hence
on associations, could be reduced to a minimum. Not that technology
had yet succeeded in providing a categorically 'pure' primary colour: it

is no surprise that early abstraction, especially in Russia and Germany, sought to exert its influence on paint-manufacture, or that the most influential colour-theorist of these years, the chemist Wilhelm Ostwald, was, in the 1920s and 1930s, an important consultant to the paint industries of several countries. The Hungarian painter Vilmos Huszar, who introduced Ostwald's system into the Dutch De Stijl group in 1917, noted once again that the aspiration for 'pure' colours was still frustrated by imperfect materials.[12] Of this group, Mondrian, who perhaps more than any of its other artists had the capacity to produce work of great formal and colouristic sensitivity, continued to be vexed by the problem of finding a perfect red, and his reds, even more than his other 'primary' colours continued to be structurally complex well into the 1920s.[13] Mondrian, too, was an admirer of Ostwald's principles, and as late as 1920 he was still using the fourth 'primary' colour, green, which Ostwald had adopted from Hering, as was Huszar, and the founding father of the De Stijl group, Theo van Doesburg.[14]

The scheme of 'primary' colours was the most resonant aspect of the colour-debate among painters in these years, and the apparently straight-forward adoption of three: red, yellow and blue, plus the three 'non-colours', black, white and grey, within De Stijl was far more complex than it seems. Van Doesburg came to take a broadly phenomenological position, treating these colours as energies to be used in the dynamic articulation of two-or three-dimensional space.[15] Bart van der Leck, the painter to whom the achievement of having impressed the privileged status of red, yellow and blue on the other members of the group may be due, thought of these colours as the direct embodiment of light.[16] The architect and designer Gerrit Rietveld, whose red-blue chair of the early 1920s came to symbolize the movement as a whole, held the mistaken view that red, yellow and blue are the 'primaries' of colour vision;[17] and the painter and sculptor George Vantongerloo, although he had been briefly a follower of Ostwald, developed about 1920 a wide-ranging spiritual interpretation of colour-harmony using a mathematical analysis of wavelength in the spectrum.[18] Even Mondrian, as late as 1929, was still thinking of his colours in symbolic terms: red was more 'outward' or 'real' and blue and yellow more 'inward' or 'spiritual', in a way which relates to his early interest in Theosophy and in the theory of Goethe, which had been restated by Mondrian's friend, the Dutch Theosophist Schoenmakers in 1916. Goethe had posited two primaries, yellow and blue, but the red which

was derived from them by a process of 'augmentation' was for him the noblest and the highest colour.[19] What unites the De Stijl artists beyond all these distinctions is a belief in the importance of primariness as such, and this was clearly the legacy of the reductive and symmetrical colour-systems of the nineteenth century.

Red, yellow and blue are not, of course, the only 'primary' triad, or even the most privileged one. The much older and more universal set, black, white and red, has recently come into prominence again in anthropological studies of language, chiefly in connection with the evolution of non-European cultures, where the earliest colour-categories were those of light and dark, followed almost universally by a term for 'red'.[20] But this triad also has a long history in the Indo-Germanic languages and their cultures; as readers of Grimm's fairy-tale, *Snow White* will recall, where the heroine was compounded of these three colours.[21] In early abstract painting this set had an especially prominent place in Russia, in the first school of geometric abstraction, the Suprematism of Malevich. In an essay of 1920 Malevich divided his movement into three phases, according to the proportion of black, red and white squares introduced into its pictures. Black represented a worldly view of economy, red revolution and white pure action; and of these white and black were more important than red, and white the culmination of all.[22] Although Malevich paid a rather ambivalent tribute to colour-science, considering black and white 'to be deduced from the colour spectra';[23] and although the command of many nuances of white which informs his great series of 'white on white' paintings may have been stimulated by the revival of interest in early Russian icons, with their creams and off-whites, which often served as a surrogate for gold,[24] there can be little doubt that the place of white in the Suprematist colour-system was essentially associative and literary. Malevich's best-known statement:

The blue of the sky has been defeated by the suprematist system, has been broken through, and entered white, as the true, real conception of infinity, and thus liberated from the colour background of the sky . . . Sail forth! The white, free chasm, infinity, is before us,[25]

echoes the transcendent interpretation of white as it appears in the poetry of the Russian symbolists Belyi (whose name of course means 'white') and Blok.[26] The painter was also a friend of the poet and theorist Velimir Khlebnikov and of the linguistic scholar Roman Jakobson,

through whom the work of the burgeoning Moscow Linguistic Circle on basic phonetics must have become very familiar to him. Khlebnikov had indeed collaborated with Malevich in 1913 on the opera *Victory over the Sun*, in which one aria was composed entirely of vowels and another entirely of consonants; and the painter's austere geometric designs for the sets and costumes of this production have rightly been seen as embodying the seeds of the Suprematism which emerged two years later.[27] Both Khlebnikov and Jakobson were interested in that aspect of synaesthesia known as *audition colorée*, in which spoken sounds, particularly vowel sounds, were involuntarily associated with colours; and Jakobson, indeed, seems to be one of the very few students of language to have maintained an interest in the phenomenon. It is probably best known form one of the earliest recorded examples, Rimbaud's *Sonnet des Voyelles*, which begins:

'A noir, E blanc, I rouge, U vert, O bleu: voyelles . . .',

but by the time of the First World War it had become a major pre-occupation of experimental psychologists. In 1890 the Congrès Internationale de Psychologie Physiologique set up a committee to investigate the phenomenon, which was productive of a spate of publications, but even before that it been investigated on a statistical basis in the influential aesthetic publications of G. T. Fechner.[28]

Jakobson, who had become friendly with Malevich by 1916, may have already begun to relate infant preferences for black, white and red to the early development of speech sounds, in which 'a' (which was often associated with red in these psychological experiments) provided the basic phonetic contrast to 'w', which, according to several authorities, was associated with black.[29] In a manifesto of 1919 Khlebnikov appealed to the painters of the world to help in the establishment of a universal language, for

the task of the colour-painter is to give geometrical signs to the basic units of under-standing . . . It would be possible to have recourse to colour and express M with dark blue, W with green, B with red, Es with grey, L with white . . .[30]

Painterly and linguistic research in Russia was thus directed at the identification and expression of fundamentals, and this area of inquiry became part of the curriculum of the Soviet State Art Schools in the 1920s, a period which saw perhaps the last flowering of interest in *audition colorée*. Kandinsky, who had been engaged on drawing up

some of the teaching programmes there immediately after the Revolu-
tion, took the interest in this sort of research with him when he
returned to Germany and the Bauhaus later in the decade.[31] In Russia,
indeed, where Ostwald's colour-theories were widely adopted, it was
the psychological laboratories of late nineteenth-century Germany
which provided the models for the art-institutions of the Revolutionary
and immediately post-Revolutionary periods.[32]

We are now, I think, in a better position to interpret an extravagant
remark by the Suprematist Ivan Klyun, who, in a manifesto of 1919,
summarised the theme of this paper:

our colour-compositions are subject only to the laws of colour and not to the laws of
nature.[33]

I have suggested that early abstract artists were presented with a
number of well-articulated colour-systems which allowed them to con-
sider colour as in the nature of a language. But it is not surprising that
their use of this language should have depended upon principles of
salience and symbolism rather than on notions of mere perceptibility.
Nor is it altogether surprising — although it may be a matter of regret
— that this language of colour, which seemed around 1900 to offer the
prospect of universality, should have turned out to be so thoroughly
artificial.

University of Cambridge

NOTES

[1] *Reminiscences* (1913), in *Kandinsky: Complete Writings on Art*, ed. Lindsay and
Vergo, (London: Faber & Faber, 1982), I, p. 370.

[2] C. Lévi-Strauss, *The Raw and the Cooked* (1964), (trans. Weightman) (London:
Cape, 1970), pp. 19f., 25. E. H. Gombrich, 'The vogue for abstract art', *Meditations on
a hobby-horse*, (London: Phaidon, 1963).

[3] S. Bann, 'Abstract art — a language?', in Tate Gallery, *Towards a new art: Essays on
the background to abstract art, 1910—20*, 1980, p. 144.

[4] A. Besant and C. W. Leadbeater, *Thought-forms* (1901), (Madras: 1961), p. 20

[5] Kandinsky, *op. cit.*, note 1, p. 183.

[6] W. Wundt, *Grundzüge der physiologischen Psychologie* (1874), 5th ed., (Leipzig:
1902), II, p. 145.

[7] Kandinsky, *op. cit.*, note 0, p. 182; Wundt, *op. cit.*, p. 352nl; G. T. Fechner, *Vorschule der Aesthetik*, II (1877), (Leipzig: 1898), p. 216.

[8] Lévi-Strauss, *loc. cit.*, note 2.

[9] See M. Foucault, *Les mots et les choses*, (Paris: Gallimard, 1966), Ch. IV. The fullest account of the work of Schiffermüller and Harris is now T. Lersch, 'Von der Entomologie zur Kunsttheorie', in *De Arte et Libris: Festschrift Erasmus*, (Amsterdam: Erasmus, 1984), pp. 301ff.

[10] I am thinking especially of G. Field, *Rudiments of the painter's art; or a Grammar of Colouring*, (London: 1850); E. Guichard, *Grammar of Colour*, (Paris, 1882).

[11] Rood, *Modern Chromatics*, 1879, p. 250; W. I. Homer, 'Notes on Seurat's Palette', in N. Broude, *Seurat in Perspective*, (Englewood Cliffs: Prentice Hall, 1978), pp. 116ff.

[12] V. Huszar, 'Iets over die Farbenfibel van W. Ostwald', *De Stijl*, I, 1917, pp. 113ff.

[13] E. A. Carmean Jr., *Mondrian: the diamond compositions*, (Washington: National Gallery of Art 1979), pp. 79—83. Rood (*op. cit.*, note 11, p. 136) had found that spectral red could be matched in pigments by a glaze of carmine over vermilion.

[14] For Mondrian, see especially Composition XIII, 1920 (Bartos Coll., Seuphor 457), reproduced in colour in Cologne, Galerie Gmurzynska, *Mondrian und De Stijl*, 1979, p. 181. He does not, however, seem to use yellow and green in the same work and his yellows at this period are sometimes very greenish.

[15] See van Doesburg's texts in J. Baljeu, *Theo van Doesburg*, (New York: Macmillan, 1974), espec. pp. 160, 178.

[16] B. van der Leck, 'De Plaats van het moderne schilderen en de architectuur', *De Stijl*, I(i), 1917, in English in P. Hefting and A. Van der Woud, *Bart van der Leck, 1876—1958*, Otterlo/Amsterdam, 1976.

[17] 'Inzicht' (1928) (trans. T. M. Brown) *The Work of G. Rietveld, Architect*, (Utrecht: Bruna & Zoon, 1958), p. 160.

[18] G. Vantongerloo, *L'Art et l'Avenir*, (Brussels, 1924), especially pp. 28ff.

[19] For Mondrian, see E. Hoek in C. Blotkamp *et al.*, *De Beginjaren van De Stijl*, (Amsterdam; 1982), p. 78 and cf. P. Mondrian, 'De nieuwe beelding in de schilderkunst', *De Stijl*, I, 1918, p. 30.

[20] See especially B. Berlin and P. Kay, *Basic Color Terms*, (Berkeley: University of California Press, 1969).

[21] The fullest study of this triad in modern European languages is J. de Vries, 'Rood—wit—zwart' (1942), *Kleine Schriften*, (Berlin: 1965), pp. 35ff.

[22] K. Malevich, *Suprematism, 34 drawings* (1920) in *Essays on art*, ed. Andersen, I (Copenhagen: Borgen 1969), pp. 123—7.

[23] *Ibid.*, p. 126. See also *Suprematism as pure knowledge* (1922) in K. Malevich, *Suprematismus: die gegenstandlose Welt*, (Haftman, ed.) (Cologne: Du Mont, 1962), p. 164 and *Essays on Art*, (trans. Andersen, II) (Copenhagen: 1971), p. 126.

[24] For the icon revival in general, M. Betz, 'The icon and Russian Modernism'
Artforum, Summer 1977, pp. 38ff, and especially pp. 42—3. A. C. Birnholz, in the
fullest discussion of Malevich's white paintings, refers in passing to the white-grounded
icons: 'On the meaning of Kasimir Malevich's "White on white"', *Art International*,
XXI, 1977, pp. 14f. A further colouristic dimension to Malevich's interest in icons is
suggested by his hanging his *Black Square* at the '0—10' exhibition in Petrograd in
1915 high up across the corner of the room (photograph of installation in L. A.
Zhadova, Malevich: *Suprematism and Revolution in Russian Art, 1910—30*, (London
and New York: Thames and Hudson, 1982), Fig. 29. This was the traditional position
for domestic icons; and since this icon corner was known as the 'red corner', and the
black square was on a white ground, Malevich was here exhibiting his favourite triad of,
colours.

[25] K. Malevich, 'Non-objective creation and Suprematism' (1919), in *Essays*, cit. I, pp.
121—2.

[26] J. Peters, *Farbe-und Licht-Symbolik bei Aleksandr Blok*, (Munich: Sagner, 1981),
pp. 51, 92, 300f.

[27] For an English translation of the opera, *Drama Review*, **XV**(4), 1971, pp. 107ff.

[28] See the full bibliography in F. Mahling, 'Das Problem der "Audition colorée"', *Arch.
f. die gesamte Psychologie*, **57**, 1926. A modern assessment is in L. E. Marks, *The Unity
of the Senses*, (New York and London: Academic Press, 1978), pp. 83ff.

[29] For Jakobson's friendship with Malevich, S. Barron and M. Tuchman (eds.), *The
Avant Garde in Russia, 1910—1930 New perspectives*, (Los Angeles: Los Angeles
County Museum, distrib. by M.I.T. Press 1980), p. 18. R. Jakobson and M. Halle,
Fundamentals of Language, 2nd ed., (The Hague: Mouton 1975), p. 45n; R. Jakobson,
Child language, aphasia and phonological universals, (The Hague: Mouton 1968), pp.
82—4.

[30] V. Chlebnikov, *Werke*, trans. Urban, II (Reinbek: Rowohlt, 1972), pp. 311—5. The
best treatment of the relationships between Malevich, Khlebnikov and Jakobson is R.
Crone, 'Zum Suprematismus-Kasimir Malevič, Velimir Chlebnikov und Nikolai
Lobačevski, *Wallraf-Richartz Jahrbuch*, **XL**, 1978.

[31] W. Kandinsky, *Écrits*, ed. Sers. III, (Paris: 1975), p. 381; and cf. his programme for
the Moscow Institute of Artistic Culture (1920), in *op. cit.*, note 1, p. 460.

[32] The most impressively comprehensive programme for the experimental study of
colour in the Soviet State Art Workshops was drawn up about 1924 by N. T. Fedorov,
and has been published in an Italian translation: *Casabella*, No. 435, April 1978, pp.
59f. See also C. Hodder, *Russian Constructivism*, (New Haven and London: Yale
University Press, 1983), p. 125 and note 160.

[33] I. Klyun, 'The art of colour' (1919) in J. E. Bowlt (ed. and trans.) *Russian art of the
Avant Garde: Theory and Criticism, 1902—1934*, (New York: Viking Press 1976), pp.
142f. Cf. also Vantongerloo, *op. cit.*, note 18, pp. 22f.

JOHN CLARK

COLOUR, CULTURE AND CINEMATOGRAPHY

1. These notes arise from a concern over the extent to which the apparatus of film and television is suited to the needs of different cultures and traditions of representation. They are equally linked to policy issues raised by transcultural consumption, the reproduction of material outside the framework of its host culture and environment, alongside the practice of production for international markets.

The speculative nature of what follows necessarily involves generalisations about the history and practice of production and some overlaps in terminology, where words and phrases are drawn from different semantic fields. In particular, references to colour names are avoided, where possible, as a response to the inadequacy of language with relation to colour in colour reproduction systems.[1]

If 'colour' is a construct of human perception, then systems of colour reproduction are sites for the production of signals giving rise to colour sensations. For systems like printing, the materials and methods may vary enormously according to local conditions. For film and television, however, the same equipment, materials and processes are used internationally for production and exhibition. They both form technically unified systems. This unity is reinforced by custom and practice, international standards and the pre-eminence of a small number of equipment and material manufacturers.

2. One consequence of this seemingly holistic system is that films and tv programmes are accepted across cultural boundaries, subject only to minor visual modification. While linguistic amendments may be substantial, through sub-titling, dubbing, or the simultaneous transmission of different soundtracks, the visual components retain their original structure, except under conditions of censorship, or other editorial intervention.

Unlike literary production, which can draw on traditions and forms generated within the host culture and must be translated wholesale for consumption in other language areas, any emergent film or television culture must accomodate to the externally derived technological base

201

Andrew Harrison (ed.), Philosophy and the Visual Arts, 201—219.
© 1987 *by D. Reidel Publishing Company.*

and in doing so becomes immediately available for transcultural consumption.

This potential is an important factor in production planning and economics. The substantial resources required to ensure continuity of production can only be maintained by addressing markets that extend across cultural boundaries, whether that is the global market for North American products, the regional market of Latin America for Mexico, or Portuguese television's use of Brazilian programmes. High production costs have encouraged a tendency towards international co-financing and co-production. The restructuring of programme dissemination by satellite broadcasting is leading programme organisations to reappraise their activities.

Production for a mass audience must assume variations in audience response, however, this is underpinned by the assumption of a shared ability to read and interpret screened material. The programme maker relies on the audience behaving as competent readers.[2] Widespread audience acceptibility, however, need not indicate the successful operation of a communication process between programme maker and audience, despite the apparently rapid assimilation of variations in programme, or filmic conventions. Acceptance may conceal widespread aberrations in audience response.[3]

Transcultural consumption increases the potential for aberrant responses to particular programmes. The programme makers may accept their work is in some sense parochial, however, if programme making becomes conditional on access to international markets, then programme makers and production organisations may be expected to adapt their approach. If their response is to limit culturally autonomous variations in production, that may be to the detriment of diverse strategies and techniques developing for production as a whole.

3. Alongside films and programmes which function in direct relation to the articulation of cinematic or televisional codes, be these feature films, tv dramas, or whatever, the technology of camera/recorder/monitor systems has been adopted for many other purposes, where its characteristics as part of a cultural system of representation are of secondary importance and may be completely ignored in use. Material from, for example, surveillance cameras can be accorded the status of evidence. Its credibility has been enhanced since the advent of 'time coding' to confirm the temporal continuity of the video signal. The technical 'quality' may be quite rudimentary without effecting that

status. Once again, the presence of a competent reader is required for its success. That competence derives from the audiences' experience of all forms of screened material.

A tentative relationship might be proposed, whereby the provenance of material, according to its source, (as 'actuality', or the output of a legitimising organisation), is inversely related to the level of 'production values' (the professional attention to details in props, sets, graphics, make up etc.) deployed as the basis for articulation in cine-televisual codes.[4]

The status of colour is ambiguous. A film is 'in colour' or 'black and white'. Colour television incorporates the production of colour signals as an intrinsic function of its operation. The more rudimentary the level of cinematic or televisional organisation, the greater the charac-teristics of the material will depend on the technical characteristics of the system in use.[5]

In programming, like news or current affairs, high 'production values' in packaging and presentation deploy non-realist codes, often denoting 'authority', to emphasise the provenance of actuality material. Once the rudimentary source has been encoded within the wider system of the programme structure, it is wholly open to reinterpretation in terms of that encoding. This ambiguity need not be limited to programmes combining studio and actuality material, but cuts across all forms of production. The potential for aberrant audience response increases, especially with respect to colour and colour coding.[6]

4. What, then, is meant by a colour film, or colour television? Methods of adding a colour cast to part, or all of the image are usually distinguished from the processes of colour reproduction, which assume a relationship between the colour characteristics of the screened image with what was before the camera. Eisenstein (1940) makes this quite clear, "I advisedly say 'in colour' and not 'coloured' to preclude any association with something coloured, painted". If this statement refers to the technical characteristics of the medium, then his approach to its use is to organise 'something coloured'. He writes (1946), ". . . the master of the colour screen must intensify the group of chosen colour elements, bind them into a genuine system of colour values". A conflict emerges between the desire to manipulate colour and the 'naturalism', or 'realism' implicit in a system of technology, which seeks to 'repro-duce colour'.

The film or programme maker may, with Eisenstein, seek to develop

a 'colour system' using a technology designed to reproduce colour. Alternatively, colour production may be achieved as a function of the technology deployed, in which case its design establishes a 'colour system' for reproduction.

Films have been coloured in some way or another since the inception of cinema. At least four approaches have been used commercially to introduce colour to films based on monochrome photography. It has been estimated that 80—90% of films produced during the 1920's were coloured in some way. Although tinting, toning or hand colouring are limited in the range of hues available, such arrangements are open to organisation as 'colour systems'. Computer graphics for television, using systems like 'Paintbox', may be regarded as sophisticated equivalents of hand colouring. Though the colour signals are electronically generated, they can be coherently organised without reference to a photographic image, before being reintegrated into the wider structure of tv technology for recording or transmission.

Film or television 'in colour' may be taken to be imaging systems incorporating the reproduction of colour. Theoretically, such systems might be proposed whereby the light entering the system is exactly reproduced for the viewed image. Under these conditions, any aberrations in perception would be those of the viewing subject and would correspond to their normal perceptual experience and could be discounted. Similarly, any deviation in colour presentation would be under the complete control of the programme maker. Hunt (1970) has defined such a system as 'Spectral Colour Reproduction', where the spectral power distribution would match precisely between original and reproduction. In practice, this may neither be possible, nor desirable, depending, for example, on the scale of the screen in relation to the observers' field of view. Colour reproduction is one objective for a system, alongside the ability to achieve consistent running time, image stability etc. The objective of film and tv technology is to achieve a workable compromise between all these requirements, both in design and manufacture, alongside their use on a day to day basis.

The emergence of particular systems to prominence is a consequence of many factors beyond the scope of this discussion, however, it is important to emphasise that commercial, political and ideological factors are at least as important as the technical proficiency of any given process.[7]

An English patent for a three colour system was filed by Lee and

Turner in 1899, based on three successive frames representing records of red, green and blue. High speed projection (48 frames per second) was required to overcome colour flicker, but the materials proved mechanically unreliable. Lee and Turners' rights were acquired by Charles Urban. His collaborator patented a two colour system in 1906, which resolved the earlier problems by projecting only red and green separations. It became commercially successful as 'Kinemacolor'. Despite a technical restriction, which precluded its use in studios, Kinemacolor's demise was brought about through licencing and patent disputes during World War 1.

Coe (1981) informs us that a six hour record of the Delhi Durbar was shown from February 1912 and quotes the Pall Mall Gazette's comments on a subsequent show:—

Kinemacolor passes from triumph to triumph. After an unparalleled success with the wonderful Delhi Durbar Pictures, it enthralled a large audience last night with a no less astounding pictorial view of the making of the Panama Canal; it was received with frequent outbursts of irrepressible applause.[8]

Although the first commercially successful three colour system was introduced by Gaumont in 1912, numerous two colour systems were developed and used professionally. The diversity of colour techniques adopted has been enormous and utilised almost every theoretical basis for colour reproduction. 'Raycol', for example, was a two colour system used for a feature film in 1933. The green separation remained unfiltered on projection, while the red image remained filtered. One would expect the viewed image to range from white towards red, however, these 'Land Colour' effects display a far wider range of hues including blues.

Less diversity is evident for television, mainly because the introduction of colour was co-ordinated to conform with established monochrome broadcasting. The NTSC published technical standards for all aspects of the US system in 1954 and its derivatives, PAL and SECAM are equally comprehensive.

Despite the historical diversity of colour processes, manufacture and development is increasingly concentrated within a handful of organisations. For the cinematographer, variations between different batches of the same stock, or the choice between negative and reversal materials are more significant than the earlier choice between different technical systems.

Three colour systems, based on the principle of colour separation provide the technical base for the both film and television. The three colour signals are formed and controlled through each system using tristimulus primaries as a reference. They are a practical application of trivariance, the phenomenon, whereby three primaries may be mixed in due proportion to produce white and combinations of these primaries can produce a wide range of hues. Trivariance is equally effective in additive or subtractive configurations. The screen presentations re-unite the three colour signals in a pointillist arrangement. Colour reproduction in screen presentations is therefore doubly articulated, firstly in relation to the trivariant camera encoding, then through the pointillist interaction of the colour producing elements. This double articulation does not occur at the encoding stage, the camera is not an eye, brain or retinex.

5. Trivariance has provided a framework for colour reproduction, colour notation and theories of vision, with varying success. The emergence of a commonly applicable concept should not be mistaken for theoretical unity.

The three colour process for colour reproduction originated in printing. Le Blon's experiments in the late seventeenth and early eighteenth centuries took him from printing with seven inks, equivalent to Newton's spectral hues, to the use of three colours. Newton had made a clear distinction between contrived colour mixtures and the structure of natural light:—

Whether it (white) may be compounded of a mixture of three (primaries) taken at equal distances in the circumference (of the colour circle) I do not know, but of four or five I do not much question but it may. But these are curiosities of little or no moment to the understanding the Phaenomena of Nature. For in all whites produced by Nature, there uses to be a mixture of all sorts of rays, and by consequence a composition of all colours.[9]

This distinction remains pertinent when considering photographic colour reproduction, unless we are to accept a trivariant structure throughout visual perception. Young's Theory of Vision proposed that the colour sensitive cells of the retina responded to three colour sensations, though the first version of his work in 1802 did not specify particular primaries. Le Grande (1948) points out that:—

Throughout the nineteenth century there was almost complete confusion between the fact that stimuli were trivariant and Young's theory which gave this fact a simple

interpretation, but which was only one among many possibilities. Likewise, any con-
firmation of the trivariance, seemed, erroneously to be further support for Young's
Theory.[10]

Helmholtz' substantial reworking of Young's Theory emerged in 1852 and the following decade is a period of great importance for the development of colorimetry and colour reproduction in photography. Grassman's Laws of Colour Mixing were stated.[11] Maxwell devised a colorimeter, his 'colour box' and undertook experiments to quantify colour matches by colour mixing. Maxwell's demonstration of three colour mixing in 1861, involving the projection of three coloured slides of a tartan pattern, provided a platform for the application of colour separation in photography. Du Hauron had demonstrated viable colour printing by 1870. and numerous processes were developed by the end of the century.

Colorimetry has its own history. In 1931, the CIE adopted a standard system for colorimetry following Guild and Wright's independent experiments, which allowed a 'standard observer' to be designated.[12] The characteristics of any source can be expressed in trichromatic terms with relation to three notionally supersaturated primaries. The information can be displayed graphically, with luminance represented by the third dimension. Figure 1. is based on the 1976 CIELUV space, a revised system that displays equally noticeable colour differences as similar numerical variations.

The location of colours in a space like CIELUV expresses them as trichromatic equivalents, not the 'all sorts of rays' in Newton's natural phaenomena. The matches are 'metameric', that is to say, though the tristimulus values are equal, they do not necessarily exhibit identical spectral emittances, reflectance or transmission. If a specific colour presentation, comprising a mixture of wavelengths, is described in trivariant colour space, its metameric equivalent could conceivably be achieved by the proportional mixing of three sources, or a second more complex mixture. The reference primaries for colorimetry are notional, however, three colour systems require reference hues matched to components, which act in response to light to give colour separations. The metameric match sought for the reconstituted image is, by defini-tion, limited to three sources. The use of more complex mixtures is unavailable.

Each case, colour reproduction, colorimetry and theories of vision, employs trivariance for different ends. Colorimetry is coherent, but for

Fig. 1. Chromaticities of a set of sulphide phosphors used in tv screens, (solid line triangle, RGB). The reference primaries for PAL System 1 tv are shown by the broken line, with standard white (D65). The locus of the visual spectrum in shown with wavelengths in nanometers.[13]

theories of perception, trivariance is a phenomenon which must be accounted for in a wider framework. It is tempting to suggest that the adoption of trivariance in photochemistry and tv systems rests on the theoretical structure described in Helmholtz and Maxwell in the 1850's. Du Hauron's demonstration of photographic colour printing precedes Hering's 'Outlines of a Theory of the Light Sense', which proposes an alternative structure for colour perception.[14] The integration of tri-variance at a technical level throughout the imaging systems of film and television allow both to be considered as discrete colour systems.

6. In any imaging system, there is a potential disparity between the effective separation at the recording/encoding stage and the perfor-mance of the colour producing elements for the reconstituted image. Colour discrepancies are widespread for film. Millerson (1982) lists a

range of typical examples, through reds and oranges, yellows, blue and green cyans, greens, magentas and purples. He recommends avoiding saturated blue-greens, jade greens and purples, 'where possible'. Variations may occur at any point within a system. Figure 2 illustrates the performance of a hypothetical tv camera in relation to fifteen test colours (CIE Nos 1—14 and BBC 17).

Fig. 2. Accuracy of reproduction of a hypothetical camera. The triangle RGB gives the limits of PAL system 1.[15]

Problems emerge within the system and through the use of three colour separation. If the universe of colours can be located within a colour space like CIELUV to form a 'colour solid', then the per-

formance of a colour reproduction system may be located in relation to
it. For 'Spectral Colour Reproduction' the two colour solids would be
congruent. In other circumstances, the surface boundaries will describe
the limits of reproducibility and variations may exist within the 'volume'
of the solid. Since the purpose of the system is to reproduce colour, we
might expect the transformation to be regular and predictable, however,
it has been suggested that the transformation within the tv equivalent
would resemble badly mixed wallpaper paste, or lumpy custard. The
denser parts, representing predictable colour production, would be
surrounded by more fluid zones, where colour reproduction is unpre-
dictable or difficult to account for when an engineer intervenes to
correct the anomaly.[16]

Fig. 3. Sections of the colour solid showing TV (solid lines) and film (broken lines).[17]

A wide range of circumstances could be described where the performance of the system may be doubtful. They are likely to fall into two categories. Where a series of hues are closely related then the colour separation may be inadequate to differentiate between them, or may introduce shifts which rearrange their relationship to each other. The second category would involve colour presentations with components lying outside the colour space of the system, which will be reproduced within the system, often as a desaturated equivalent.

If standard primaries have been designated for a system, then a standard for undifferentiated (white) light must be established, both to match the sensitivity of the system to prevailing environmental conditions and to establish a match with screening conditions. Film stocks are therefore used with particular types of lighting and tv cameras are 'white balanced' in relation to light sources. Film prints are balanced for particular projector lamps and tv screens balanced to a standard white, D6500, for viewing.

The artificial light sources used as luminants display peaks and troughs in various wavelengths, just as natural sources vary according to time of day, orientation between sun, skylight and subject, and local variations in ambient conditions according to climate, topography, latitude, vegetation, pollution etc. The light may be controlled by filtering, however, the absorption or reflectance of objects under controlled illumination can give rise to unpredictable combinations of light for the camera.

The grading and balancing adjustments undertaken in production and post-production necessarily privilege certain objects, or classes of object, for example flesh tones, to the detriment of colour reproduction for other points on the screen, which must, as it were, be let go. The adjustments available in post-production effect the image as a whole, rather than specific details, except in exceptional circumstances. With edited material, colour grading must overcome the effects of after-images and perceptual effects deriving from the swift succession from one shot to another. Attention to these corrections is especially important for cinema films, where minor colour shifts between shots are very noticeable for the audience.

Film and tv systems provide an imperfect mapping of the lit subject, particularly with respect to luminance levels, white balance, colour separation and contrast. Sproson (1983) suggests a realistic goal for the

development of colour reproduction in television whereby, 'the repro-
duction has the same appearance as the original would have if the
illumination were the same as that of the reproduction'.

7. Within a system, the programme maker, cinematographer, or
engineer may intervene to amend the image at different points. Since
there is an element of unpredictability in the system, colour relations
must largely be established at the production stage. Attention to colour
control will clearly vary according to the production context, be that in
the level of human and material resources deployed, the institutional
structure of responsibilities between production staff, or the priorities
established within a genre or area of programming with regard to the
articulation of cinematic or televisional codes.

The high level of resources devoted to feature production may allow
each element to be given close attention according to the film-maker's
designs. That level of control is impossible when garnering actuality
material. In extreme situations, the equipment can effectively be run on
auto with respect to colour reproduction. For 'actuality', the colour
presentations have principally arisen as a function of the technology.
The spatial orientation of the camera, its angle of view, or framing, are
privileged before the manipulation of colour, even when colour is
singled out for attention. It is common for colour references to be
reinforced by narration, indeed verbal description is more likely to
provide colour identification and the screen colour functions only as
a cue. Any colour correction is likely to be limited to engineering
requirements, amending colour balance between material from different
sources, for example, in urgent situations, even limited attention may
not be possible.

Low level intervention in the organisation of colour components, or
its relegation by accepting pre-set co-ordinates within the technological
set up, blurs the relationship between signal and noise. A degree of
redundancy with respect to colour is introduced within the complex
signifying system established by integrating sound and image in time.
The production of screen colours may be institutionalised, either as a
result of design and manufacture, or by the criteria of staff working
without reference to the initial production conditions and pressed for
time.

The range of productions where these circumstances may arise is
increasing with the application of video equipment to many areas of
low budget production. Genres like news, documentaries and informa-

tion programming are predictable examples in broadcast contexts, while educational programmes, whether distributed by cassette, cable, or broadcasting are increasingly produced from centres with limited resources. The use of 'in house' video facilities for post-production cuts out the use of laboratories and the access that represents to concentrations of skilled technicians and facilities.

In many cases, this type of material is intended to present a reality. The ostensible subject is presented on film or video, rather than in relation to its articulation within a system of representation. Comolli (1971) quotes Serge Daney:—

(The cinema) postulates from the 'real' to the visual and from the visual to its reproduction on film, the same truth is reflected infinitely without any distortion or loss.

And in a world where 'I see' is automatically said for 'I understand' such a fantasy has probably not come about by chance.[18]

At different stages in the process of production, distribution and exhibition, the process of colour production is determined to varying degrees by the programme makers, the technology and the audience. The technical structure is constantly present, Even when exceptionally tight control is exercised by the programme makers, their influence varies at different stages in the production process. The film or programme veers in or out of control with each successive production stage.

In these circumstances, the presence of colour in film and television hovers close to a boundary indicated by Eco (1976):—

The phenomena on the lower threshold should rather be isolated as indicating the point where semiotic phenomena arise from something non-semiotic, as a sort of 'missing link' between the universe of signals and the universe of signs.[19]

8. What consequences might this have for the audience and those who, with Eisenstein, seek to incorporate a genuine system of colour values in their films and programmes at whatever level?

When discussing discrimination language for colour, Bernard Harrison (1973) suggests that:

In the universe of experience in which colour vocabularies of natural language are learned and used, well designed arrays of colour chips are extreme rarities.[20]

Given extensive viewing habits, the tv screen might be considered as a dynamic example of such an array. Consistently reproduced colour presentations may not be rarities, if we are to consider the array in its

entirety, rather than singling out individual component 'chips'. Private tv screens are rarely adjusted to test charts or standards; people watch what they prefer to see. Domestic tv sets are becoming increasingly stable, however, and variations from set standards are likely to diminish, because fewer opportunities will be available for the viewer to adjust the machine.

The array may become a consistent material presence between user and learner with respect to colour naming. If established referents for naming and discrimination are qualified by the experience of tv colour, either by the reproduction of specific referents via the screen, or the more general pattern of screen display, then the process of reproducing colour relationships and the development of colour systems will adjust to accommodate that presence.

The mis-matching of colour presentations by film and tv systems may similarly interfere with the coherent re-representation of pre-established colour systems, even though the colour terms may be verbally sustained. An audience of competent readers may be assumed to overcome such disparities. In circumstances where the audience's relationship to colour may be organised in relation to fundamentally different colour systems, potential aberrations may be anticipated.

How serious such aberrations might be is open to speculation. The development of colour systems need not be one of progressive honing or refinement, but could involve the dissolution of established correlations. Wittgenstein described the potential breakdown of a language-game with respect to colour:-

When we forget which colour this is the name of, it loses its meaning for us; that is, we are no longer able to play a particular language-game with it.[21]

If access to presentations of particular 'colour systems' is predominantly located by reference to screen presentations, perhaps by video disc, interactive video or educational tv, those systems may effectively cease to function. John Gage points out the close relationship between colour theorists and practising artists in their attempts to achieve satisfactory colorants and 'pure' colours. He emphasises, for example, the complexity of Mondrian's reds and claims that the semantic richness of early abstraction with respect to colour is 'as complex and resonant' as the iconography of the Quattrocento Madonna. The specificity of such colour presentations cannot be expected to be sustained in the transition to screen presentations.

The remit of screen colour presentations is far wider than the work of a single artist, or culture. It is potentially global. Similarly the colour systems forming the subject for colour reproduction are more extensive than those employed or developed by individual artists, however important their work may seem. Colour systems may provide a general framework for the location of colour within a particular culture or society. If screen colour is unable to respond to the detailed articulation of such systems, their effectiveness will be eroded and traditional cultural forms threatened with degradation.

In November 1983, the European Parliament considered a resolution on the establishment of a uniform technical standard for television pictures and sound within the European Community. (While this paper was being prepared for publication, the international body concerned with tv standards, the CCIR, has discussed the adoption of a standard world tv system. The Sony Corporation's High Definition TV, HDTV, was proposed for consideration and came close to adoption.) There may be sound economic, industrial and commercial arguments for standardisation in the context of extended systems of tv dissemination, but what is being standardised with respect to colour?

The ASTM standard, D-1792-82, reminds us that, 'Although colour measuring instruments have enjoyed general usage for many years, most colour matches are still evaluated by visual means'. Equipment for colour measurement may neither be coarse, nor inaccurate. It is more probable that fine colour matches are established in relation to culturally defined colour systems. The monitors for tv production, for example, are 'set up' (calibrated) in relation to standard colour bars. The signals giving rise to the colour bar display may be precisely controlled, however, the screen presentations are matched visually by the engineer or recordist. These highly engineered monitors then provide a reference for programme makers. The colour presentations are institutionally approved, rather than colorimetrically quantified.

The taxonomies of colour systems and their relationships to other signifying structures are highly variable. Individual systems may pervade the domain of colour, others may organise a limited and highly selective group of colour presentations. As a system of colour reproduction, film and television will be expected to represent all or any of these systems. It will cope with varying success. The film or programme maker who seeks to employ a particular system may find that a coarse approximation is all that is achievable.[22]

Were film and tv not mass media, vagaries and amomalies in colour
reproduction would not be particularly important outside their indus-
tries, but screen based technologies are becoming all pervasive and
screen colour a dominant presence, part of common experience.

The development of screen colour, therefore, becomes a political
issue, as well as the technological consideration, or aesthetic nicety. The
pragmatic technical development of colour reproduction systems for
film and television has hitherto rested on the expectation that specific
colour presentations will be degraded in the course of production and
dissemination. As improvements in technology improve picture control,
the issue of whose 'colour' is being presented must arise.

Understanding of colour remains less complete than the persistent-
confirmation of trivariance suggests. While the goals for the develop-
ment of screen colour and colour reproduction retain their traditional
link with the perfection of three colour reproduction, cultural con-
siderations will remain secondary. The detailed structures of colour
systems have yet to be described in colorimetric terms. Co-existent, but
contradictory accounts of colour in different disciplines point to a
condition of crisis.

The nature of that crisis for colour has yet to emerge through debate,
however, Sony's prospects for achieving global domination through the
HDTV system strengthen. The situation was encapsulated by Robin
Shenfield in the trade paper 'Broadcast': "Once the CCIR decides on
HDTV it will be virtually impossible to change its mind." [23]

NOTES

[1] ". . . adult observers can distinguish seven million colours when the three dimensions
of light are varied. Obviously each of these discriminations is not represented in
language." Lloyd (1976), p. 40.

[2] "Some of these (variations) can be considered as fertile inferences which enrich the
original message, others are mere 'aberrations'. But the term 'aberration' must be under-
stood only as a betrayal of the sender's intentions; insofar as a network of messages
acquires a sort of autonomous textual status, it is doubtful whether, from the point of
view of the text itself (as related to the contradictory format of the Semantic Space)
such a betrayal should be viewed negatively." Eco, (1976), p. 141.

[3] "When the addressee does not succeed in isolating the sender's codes, or in substitut-
ing his own ideosyncratic or group sub-codes for them, the message is received as pure
noise. Which is what frequently happens with the circulation of messages from the

centres of communicational power to the extreme subproletarian periferies of the world." *Ibid.*, p. 142.

[4] Provenance may be distinguished from 'codes of realism' for these purposes, though it may form a component of other 'realist' configurations.

[5] Apparent simplicity should not be confused with planned restraint within a production strategy, but refers to the crudity with which programme material can be slung together.

[6] The 'MEDIA EVENT' lies uncomfortably in this framework.

[7] Colour in the cinema has been studied from numerous standpoints. Branigan, *op. cit.*, provides a useful discussion of the conceptual frameworks employed by different authors.

[8] Coe, *op. cit.*

[9] 'Opticks', Prop VI, Prob II, Book 1, part 2.

[10] Le Grande, *op. cit.*, p. 208.

[11] Grassman's Laws (1853) provide the foundation of colour mixing:—

> Law 1 defines a colour C: $(C) = R(R) + G(G) + B(B)$
> Law 2 expresses the additivity of two colours:
>
> $$C3 = C1(C) + C2(C) = (R1 + R2)(R) + (G1 + G2)(G) + (B1 + B2)(B)$$
>
> Law 3 expresses the consistency of matches over a wide range of luminances:
>
> If $C1(C) = R1(R) + G1(G) + B1(G)$
>
> then $kC1(C) = kR1(R) + kG1(G) + kB1(B)$,
> where k is a numerical constant.

[12] CIE — Comite Internationale d'Eclairage. The North American standard, ASTM E308-85 states: The CIE system provides standard data and computation methods. It utilises spectrally defined colour matching functions, designated observers and spectrally defined standard illuminants for computation of tristimulus values and chromaticity co-ordinates.

[13] Sproson, *op. cit.*

[14] It is interesting that neither John Gage nor Peter Lloyd Jones find it necessary to refer to trivariance in their papers for this volume, though both writers refer to colour systems allied to Hering's proposed structure of oppositional primaries. Gage refers to the link with Goethe's theorising and identifies a complex series of relationships between these various theories and the practice of particular painters. The absence of trivariance would seem to suggest a discursive boundary between colour theories in art and colour reproduction, if we consider Gage's wideranging survey in relation to Le Grande's indication of the dominance of trivariance in other nineteenth century debates.

[15] Sproson, *op. cit.* N.B. ΔR.G.B. indicates trivariance; intensities vary to achieve tristimulance.

[16] In conversation with Terry Speke, BBC Manchester.

[17] Sproson, *op. cit.*

[18] Daney, Serge, 'Sur Salador', in 'Travail, lecture, juissance', *Cahiers du Cinema*, Issue 222.

[19] Eco, *op. cit.*, par. 0. 7. 3.

[20] Harrison, *op. cit.*, p. 11.

[21] Wittgenstein, *Phil. Inv.* 1, par. 57.

[22] Peter Lloyd Jones mentions that a structural analysis of the colour practice of Indian Ragmala painting is still awaited, but links the use of colour to a rhetorical theory that is 'more systematic than ours'. His successful appropriation of their coloration was based on matching undertaken in adverse circumstances (Munsell atlas in museums), rather than colorimetrically precise conditions. The matches and the semantic structure of the colour systems seemed to be sustained in a variety of ambient conditions. Should we infer that the fine matching establishes relationships between sets of colorants, then their location in relation to a universal colour space becomes secondary, as a basis for their successful reproduction in terms of the semantic organisation of the colour system. As a painter, Lloyd Jones can work with carefully selected colorants. One wonders whether film or television would provide the same opportunities to an Indian film or programme maker, who similarly wished to deploy that colour system.

[23] Broadcast, London, May 9, 1986.

REFERENCES

E. Branigan, 'Color and Cinema: Problems in the Writing of History', *Film Reader*, **4** (Northwestern, Ill., 1979).

B. Coe, *The History of Movie Photography* (London: Ash and Grant, 1981).

J.-L. Comolli, 'Technique et Ideologie', *Cahiers du Cinema* (in 6 parts; issues 229—235 and 241, 1971/72).

S. M. Eisenstein, 'Not Coloured, but in Colour' in: *Notes of a Film Director* (1940) (New York: Dover, 1970).

S. M. Eisenstein, 'First Letter on Colour', (Trans. Herbert Marshall) (1946) *Film Reader*, **2** 1977.

G. Millerson, *The Technique of Lighting for Television and Motion Pictures* (London: Focal Press, 1982).

D. Samuelson, *Motion Picture Camera and Lighting Equipment* (London: Focal Press, 1982).

W. N. Sproson, *Colour Science in Television and Display Systems* (Bristol: Adam Hilger, 1983).

R. W. G. Hunt, 'Objectives in Colour Reproduction', *J. Photog. Sci.*, **18**, 205—212 (1970).

Y. Le Grande, *Light, Colour and Vision* (Trans. Walsh and Hunt) (London: Chapman and Hall, 2nd, Edn., 1948).
I. Newton, *Opticks* (4th Edn., 1730) (New York: Dover, 1952).
G. Wysecki and W. S. Styles, *Color Science* (New York: Wiley, 1967).

U. Eco, *A Theory of Semiotics* (Indiana, 1976)
B. Harrison, *Form and Content* (Oxford: Blackwell, 1973).
B. Lloyd, 'Culture and Colour Coding' in *Communication and Understanding* (Vesey, Ed.) (Sussex: The Harvester Press, 1976).
L. Wittgenstein, *Philosophical Investigations* (Trans. E. Anscombe) (Oxford: Blackwell, 1958).

ASTM, Philadelphia, Pa.
European Parliament, Official Journal, Luxembourg.
Broadcast, International Thomson Publishing, London.

PETER LLOYD JONES

FORM AND MEANING IN COLOUR

COLOUR HARMONY AS VISUAL GESTALT

My contribution to this conference is both autobiographical and, at the same time, very practical. Taken together, these considerations probably disqualify it from any claim to be called philosophy. Nevertheless, there is much to be gained from real-life observation in a field that is frequently given to abstract speculation, remote from everyday reality. My topic is the way in which colour relationships are perceived in works of art as a "harmonic" unity and the way in which this unity is felt to carry a complex of feelings. I shall discuss this from the point of view of a practising painter who has also been forced to try to understand what is going on in a work of art since, for much of my life, I have been a teacher — latterly of design. Design is a discipline which is somewhat more explicit than Fine Art, not least because it is invariably carried on in teams which need to communicate with each other in words.

To remove any misunderstanding, let us look at a simple demonstration, which, although it hardly qualifies as a work of art, will make the point. As we look at the sequence of coloured fields or grounds build up before us we soon lose our grasp on their separate identities. They seem to grow or link together into that whole that is indeed greater than the sum of the parts (the famous definition of the *gestalt*.[1] This phenomenon is usually referred to using the language of music. We speak of colour "harmony". Musical analogies are further reinforced by the association of common colour names with the tones of the musical scale.

The fact that, in physics, models of the oscillation of taut strings or of columns of air share a branch of mathematics with those of the vibration of light waves, may serve to strengthen this association further. Now it is also often asserted by artists and aestheticians that colour and colour harmonies evoke (or at least suggest) various emotional states or moods. In many books on colour these notions are strung together in a suggestive way implying that the emotional effect of colour somehow arises from a musical harmony[2] which in some way

221

Andrew Harrison (ed.), Philosophy and the Visual Arts, 221—233.
© 1987 *by D. Reidel Publishing Company.*

'moves us' — a kind of 'platonic' vibration of the soul. All books on colour lay out the range of surface colours into scales of various kinds. Scales are ranges of fixed units of difference along the three variables of colour. Most of the well-known colour scales — from Munsell[3] and Ostwald[4] to the innumerable productions which emanate from the paint, printing and photographic industries — present devices whereby simple rules for the selection of a few colours from the scales automatically generates 'harmonious' colour combinations. Although they may take into account perceptual phenomena such as the contrast effects due to colour constancy, the musical analogy is rarely far away. Yet the analogy of colours with musical notes and therefore of colour harmonies with musical chords is not really very close. A musical chord involves a perceptual fusion of separate stimuli in which the 'sound' of each is lost to a great extent. Of course in colour the simultaneous presentation of separate *lights* may result in a perceptual fusion in which the individual 'colour' of each disappears but colour harmony is not this kind of phenomenon at all. The separate colours do not disappear but remain as separate percepts. It is the relationship between them that seems to us in some way a 'whole' or a *gestalt*. Colour harmony is much more like the geometrical and spatial phenomena studied over fifty years ago by the famous *gestalt* psychologists — Kohler, Koffka, Wertheimer and their followers.

Classical gestalt psychology studied the basic organisation of perceptual geometric 'wholes', 'wholes' that were "much more than the sum of their parts". Many years of ingenious experimentation eventually led to some generalisations about the conditions in which stimuli will be seen as a perceptual whole. Perceptual aggregation is more difficult when the units are far apart than when they are near; more difficult when they are different in character than when they are identical; more difficult when they are surrounded by other units than when they are isolated. Simple regularities — a common direction for instance — would tend to be extrapolated. Simple figures would tend to be visually 'closed' if incomplete. Irregular figures would be likely to be perceived as more regular or symmetrical than they really are. These generalisations are what are often called the *laws of good gestalt*.

Now close analogies with these 'laws' can be made for colour harmony — the *gestalt* in which individual colours presented together form a unity in which the 'whole is more than the sum of the parts'. Colours which are remote in colour space are less likely to be seen

as a gestalt than those nearer together. Symmetries or other simple regularities tend to be seen as wholes. (Most of the recipes for colour harmony which derive from the makers of colour scales are in fact merely variations on these two themes). Again, harmony of a given group of colours can be lost if they are surrounded by other colours. In the same way harmony can be re-established among a group of apparently discordant colours by inserting others which insist on a new dominant axis around which the others now center as deviations. Lastly, colour harmony is easier to create when colours are presented as units of identical character than when they are different — a fact that explains why most good colour harmony occurs in decorative arts and crafts where repetition of identical or closely similar units is possible. Colour harmony in figurative depictions — even in the greatest artists of colour like say Matisse, is not as rich as it is in textiles such as Persian carpets or Japanese kimonos. Colour in 'abstract' or non-figurative paintings is usually more harmonious than in figurative painting, and among abstract paintings, colour in simple geometric or hard-edge art is usually more harmonious than in informal or abstract-expressionist art.

CODING AND RECODING IN THE HARMONY OF COLOUR

Modern explanations of the gestalt phenomenon are based on insights drawn from information theory.[5] Perceptual 'wholes' can be conceived as groupings of visual information into larger units which are then recoded at a higher level. This has the benefit of reducing the amount of visual data that needs processing at any one time. Units of this kind used to be known as 'supersigns'. In the more recent jargon of computer graphics they are termed 'macros'. A macro is another name for a user-defined form or shape. It is programmed separately, given its own name and then filed. When that filename is called up the form appears 'as a whole' and it may be pushed around at will. For example, a small unit such as a door or w/c can be inserted at will and moved around an architectural plan. The architect does not need to re-draw the same form a hundred times as he might if the design was being depicted by hand. A macro can be considered as a kind of electronic 'template'.

It seems as though visual perception operates in a number of stages. The first involves checking the visual input to see if it contains any of a number of particular features such as edges, corners, slants and

gradients. These are extracted, recoded and then assembled into higher level 'macros' or templates, templates which are, it is supposed, kept in some sort of mental filestore. This is certainly how most computer 'pattern-recognition' programmes work and there are many striking similarities between these and what we know about the operation of the human visual system.[6] No-one knows of course to what extent the software of the brain is really like that of a particular pattern-recognition programme. Nevertheless, the analogy is very suggestive. The analogy has been pushed further in the construction of models of visual perception based on what are termed 'shape-grammars'. Grammars in a spoken language are rules for arranging the elements of a sentence into strings that are both 'well-formed' and at the same time, have meaning. A shape-grammar is the rules for combining elements of form into what we have called 'macros', and for combining macros into meaningful pictures or 'icons'.

There are many obvious features of mental functioning which are vastly superior to anything so far achieved by computers. Perhaps the most important is the ability of the brain to process information in unfamiliar circumstances. In contrast, pattern recognition by machine depends on presenting the computer intelligence with standardised input. For example, in the recognition of written text, letters must be presented in the correct orientation and 'normalised' to a standard size. They can then be coded as a series of points on a standard grid or matrix. This obviously makes it more difficult to read handwriting than typewritten material. Human brains can presumably generate grids at will and of course use knowledge of the world to operate more flexibily than computers.

These general insights from the information theory interpretation of *gestalt* psychology can be extended to give an account of the phenomenon of the harmony of colour. It is useful here to distinguish between 'structural' and 'metrical' information. Structural information depends on the position of elements in relation to each other. Metrical information depends on the relative amounts of elements measured on some appropriate dimension. Each can be varied independently: red or green here or there, *or*, alternatively more red, less green. Colour scales of the kind devised say by Munsell or Ostwald provide the equivalent of the grid on which patterns are projected at the input stage of pattern recognition. Colour harmonies can now be regarded as various types of redundancy or symmetry in the relationships between the location of

individual colour in the coding grid provided by the three-dimensional colour matrix. For example, complementarity is simply bi-lateral symmetry in a perceptual variable, hue, which is not open but 'closed' (conventionally represented in the colour circle). Bilateral symmetry enables the information content being transmitted to be reduced by nearly half. Similar redundancies apply to more complex symmetries involving, say brightness changes among complementary pairs. Form in colour space is read out by a decoding routine similar to that used for form in geometric space.

Artists of the Constructivist tradition use such grids as the basis for 'programmatic' decision-making. For example linear sequences or regular 'steps' in particular scales can be treated as macros leading to simple *gestalten* in colour-space which are perceived as harmonious 'wholes'. The proportions of one colour to another may be varied in order to keep the overall visual weight (the percentage of maximum saturation hue constant). By overlapping a simple gestalt in colour space on an equally simple geometric gestalt quite complex visual arrays can be contrived. Unlike the simple 'triangle' type of 'whole', these arrays are too complex to be 'understood' as a concept. But if their precise colour form cannot be perceived easily as a unity, their underlying sense of order is enough to stimulate prolonged scanning and pleasurable contemplation. The trouble it seems to me with the programmatic order of the Constructivist tradition is precisely that it is *too* balanced — not quite spicy or *piquant* enough. What is necessary to maintain our interest is not an even all-over density in the distribution of complexity (and hence predictability) but rather an irregular or *peaky* distribution, a distribution however, which seems nevertheless to be ordered by some underlying — and ultimately discernable structural principle. As in music, characteristic cadential or harmonic 'finger-prints' arise from more complex, usually unconscious, selections from the underlying scales. Of course few artists in reality use *any* of the scientific or commercial colour atlases to provide their underlying coding grid. Most contrive fragmentary versions of their own often based on studio folk-lore and tradition relating to pigments rather than to percepts.

Spectators of colour painting almost certainly do *not* interpret colour harmony by relating it to redundancy using a particular colour atlas carried in their heads as a coding grid. And yet some such mental grid seems to be essential for the decoding of structural and metrical

order. How is this achieved? How can we construct such a grid after the event when all we have is the finished percept? A fundamental problem lies in constructing an 'effective grid' that represents the largest sized units that will fit a particular pattern. The difficulty is that one has no way of knowing whether deviations from a particular regularity or rhythm are accidental — mere 'noise'. For example, suppose a particular sequence apparently involved near-complementaries. Deviations from strict complementarity could be interpreted as either deliberate decisions or, on the other hand, mere 'noise'. We can only distinguish between these two possibilities by running a further check. For example, if these deviations are themselves regularly distributed or related in size then it is probable that deliberate decision is involved. Deviation from strict complementarity is part of the message as coded. The minimum unit-size or 'grain' for the mental grid needed to capture these distinctions would be that which was just sufficiently small to catch the smallest of these deviations. These would then be treated as intended nuances rather than accidental noise. A smaller grain would simply result in wasteful repetition of redundant information. A larger grain would result in the loss of essential detail.

Doubtless, as in other aspects of perception, we can in reality 'zoom in' to expand the grid in a local region of the colour space or move a 'sliding window' of known relationships over it. Nevertheless for the purpose of the analogy the image of one simple three-dimensional grid will suffice for the present. Similar discriminations could be made about the linearity or step size of sequences in the saturation or lightness variables using effective grids generated for the purpose by similar trial-and-error routines.

We can imagine then that when he decodes a colour harmony the spectator first establishes the basic metric or 'effective grid'. He might then proceed to identify one or two dominant features — a major axis of symmetry in hue for example, or a particular sequence of regular steps in brightness. This major feature would be used as a baseline and held as a macro for subsequent judgements about other relationships. The point is that attention is of necessity selective. Only a few features can be attended to at any one time. Sequential scanning isolates these features momentarily. Those outside the focus of attention are suppressed. They become merely the 'ground' against which the salient features stand out as 'figure'. In traditional recipes for colour harmony it is usually the relationship between pairs of colours that is stressed.

However couplets are not the only combinations that take part in perceptual information processing. Concept formation presumably also involves larger groupings — triplets, quadruplets, etc, until finally *all* units are processed as one configuration. How far pattern recognition in colour involves processing serial or parallel-sequences of 1-, 2-, 3-, . . . n-gram combinations, or at what point aggregates of discrete features ('macros') are used for template matching is not known. Introspective examination of the processes of contemplative scanning suggests a continuous 'clue-guided' search involving a changing mixture of both strategies. No doubt much of the search is guided by clues from the recognition of familiar objects and their well known relationships in physical or depicted space. In totally 'abstract' works those are not available and perceptual strategies for decoding pattern in colour are likely to be highly individual. The prolonged training experienced by professional artists and designers of all kinds is aimed at developing perceptual strategies which are both more flexible and more powerful in scope and range.

ORDER, PLEASURE AND MEANING IN ART

In a work of art there are many interlocking orders. Contemplative scanning is unlimited. There is no final 'recognition' in the sense that a finite 'concept' is developed which terminates further scrutiny. The orders in a work of art are reflexive, folding back on each other again and again and thereby stimulating new pathways for attentive scanning. They are of a kind which defeats a final exit from the maze. One of Wallace Stevens most pregnant adagia states "a poem must resist the intelligence almost succesfully".[7] The pleasure we derive from scanning such orders comes from perceptual arousal. In such arousal the body-states of tension and relaxation are modulated by the flow of attentive scanning for an order that always in the end defeats us. As Berlyne[8] has pointed out (quoting an old experiment of Wundt) the optimum state for the organism is not rest but a moderate level of arousal. Pleasure attaches not only to a state of rest but lies in the movement towards it. A truly harmonious precept would quickly become boring. Herein lies the secret of great colour harmony. It stimulates, provokes, teases as well as relaxes, organises and brings to equilibrium.

It was because I was dissatisfied with the kind of limited order in the Constructivist approach that I began to study existing examples of great

colour which we find in museums everywhere. Eventually I concentrated on the harmony in certain groups of Indian Miniature paintings. Initially I had hoped to extract at least some of the selection rules — what goes together with what — by mapping the colours using a Munsell Atlas. It became obvious however that many possible orders or 'templates' could be fitted on to the data — at any rate approximately. And there was no way of knowing what counted as a 'good' fit. However, if the analysis was in this sense a failure. I did learn to pick up the combinational skills intuitively. I used an arbitrary scale of about seventy colours developed from a pool of colour samples which matched the Indian originals. I have been using these scales for over fifteen years.

During colour composition, a process of continuous shuffling or 'juggling' of sheets of colour papers goes on, sometimes for days, eventually leading to a group of twelve to fifteen which seems to me to have some kind of underlying or 'hidden' order of the types I have described above. I started out using the very simple 'nested-squares' format of Albers.[9] (Attention can be focussed on to the specifically colour-ordered information only if the geometric information is kept minimal by high symmetry.)

IMMANENT MEANING IN SYSTEMS AND SEQUENCES

Eventually, though, the problem of meaning became inescapable. While the works that I was producing were complex enough and gave me and it would seem others as well, pleasure, they still lacked something. In the end, sensation is not meaning, pleasure is not significance. Despite all the statements of well-known artists on the topic of the expressive power of colour, I had long held a sceptical view of the possibilities. There seemed to be no real evidence for the idea that individual colours or even complex combinations could transmit unambiguous meanings or clear affective states. What I could discover from the literature on psychological research (semantic differential analysis was all the rage at the time) was insubstantial and difficult to interpret. Yet the irony is that the answer was there in front of me all the time in those Indian paintings I had been studying for other, purely formal reasons.

The stories of the originals came to fascinate me more and more. One particular group was particularly haunting. These were illustrations

of Indian musical modes or *Ragas*, originally grouped into sequences called **Ragmala**. For the most part they depict narrative themes, the loves of Krishna or the aspects of Romantic love-longing in the relationships between heroes and heroines: nayik*e* and nayik*a*. Indian rhetorical theory is more systematic than ours being based on a rigorous classification of the emotions. In turn these are linked with stereotyped expressive features, symbols (birds, bees, etc.), gestures of hand and body, and colour. These conventions have been widely used over long periods of time. Moreover, emotional expression is 'built-in' to the structure of Indian classical music *a priori* since this too is based on selections from a group of expressive intervals or *srutis*.[10] Certain combinations of notes define a particular Raga not on formal grounds but on the basis of compatible expressions of feeling. 'Happy' intervals are incompatible with 'sad' ones etc. A thorough-going structuralist analysis of Indian colour practice in Ragmala painting is still awaited. It is clear however that the unknown artists of these masterpieces did not in fact stick to colour musical-interval correspondences in any strictly systematic way.[11] But in any event the sequences of paintings were meant to be 'read' together and to that extent form their own structured ensemble. I was struck by the possibility of using the narrative context of the Indian originals to give an expressive flow to more or less abstract works. By linking the story-line suggested by the titles of Indian Ragas to the perceptual game of template-matching abstract colour-orders, virtually non-figurative painting can be made to carry an emotional charge. Using the Indian convention of playing different Ragas at different times of the day as a basis — a set of more or less abstract pictures was connected into a "Book of Hours". These were shown together as an ensemble in my first one-man exhibition — "A Sequence of Ragas". The paintings were successful.[12] Many were sold and now therefore there will — unfortunately for me — be no further opportunity to see the set together.

 Since that time however all my colour compositions, however abstract, have always been inspired by some narrative theme. For example in a series of related pictures, a rather simplified allusion to the distant island seen across a wide blue sea kept on occurring. It cropped up first as a purely decorative motif. But it seemed to insist and I began to use it in various ways — in the titles of the works. In doing this I was building up, albeit unconsciously, a limited private but structured mythology. One picture was titled "She turned away from the Island

again". When it was shown together with others of the series it occasioned a good deal of speculation as to where the quotation came from. In fact, it was made up after the picture was finished as my response to the image as it presented itself to me.

CAN FORM AND MEANING IN COLOUR BE TAUGHT?

The thesis of this paper is that both the construction and subsequent perception of form in colour and the way this form carries meaning depend on the coding and de-coding of systems, systems of colour intervals and systems of differences in meaning. Obviously, semantic systems are even more complex than formal systems. Nevertheless, it is structural relationships within these systems that are the key to an understanding of abstraction and expression in colour. This is worth stressing since this view is in marked contrast to the "gestural" theories of expression which have dominated thinking about colour for so long. (It is ironical that the theory and practice of the "expressive" gesture were at their apogee in the 1950's and 60's at precisely the moment when the academic study of "marks" considered as a formal system was widely popular in the study of so-called "Basic Design".)

This systematic approach has been the basis for the programmes of teaching in the field of colour which we have developed at Kingston in the School of Three-Dimensional Design. All students do these programmes in their First Year. The exercises I shall describe are carried out over a period of twelve days. First there is a rigorous preparation in which students learn to make "grids" in the form of scales of constant interval in the three dimensions of colour. Then a personal collection of samples chosen from natural or man-made materials is colour-matched. From these colour samples students then derive a further set by a process of systematic extension and variation at constant interval. This collection is used as a pool of fixed colours which form "well-tempered" scales on which all subsequent composition is based. Working samples are kept in the form of large sheets of paper flat-painted to the appropriate colour. To largely eliminate the problem of drawing the activity of composition is carried out by a version of the "papiers decoupées" ("cut-and-paste") technique of Matisse.

Creating — and communicating — meaning in colour is the next stage in the process. We ask our students to make collaged colour compositions of an intuitive kind as their personal response to a set of

poems which they are given. For the teacher, the problem was to find a series of poems which showed an accessible set of similarities and differences so that by comparison of one with another the expressive meaning immanent in each is discovered. Over the years I have tried all sorts of poetry which had some manifest reference to colour imagery. Perhaps the most successful poet for this purpose is Wallace Stevens.[13] His poem 'Sea Surface Full of Clouds' is a series of stanzas each of identical form in which there are variations on a few repeated images of the tropical sea off the Pacific coast of Mexico. Because of the explicit nature of the contrasting themes and variations it is not difficult for students to grasp the "meaning" of each and generate a parallel series of visual images which catch the concrete references in form and colour but more importantly, match the flow of tension and relaxation in the Stevens poem. Many of these images are striking works of high quality.

The final stage of the project was devised to put all this understanding to work on a simulated design problem, a problem however which still possessed the fundamental feature of systematic structural variation in colour. We asked the students to consider the question of entrances, in this case entrances to spaces of contrasting atmosphere. I devised a hypothetical exhibition of space in a large department store which was supposed to be displaying samples from various departments — jewellery, confectionary, flowers and perfumery. Each was allocated a zone on the plan and the different zones were to be separated by decorative arches. The problem was to design these arches. Again, to simplify matters with regard to spatial design I provided the outline drawings of the arches. What the students were required to do was to decorate the arches with colours selected from their scales so that each provided an appropriate transition to the next zone with its corresponding atmosphere. It all sounds a bit artificial but it worked like a charm! Most students decided to alter the form of the arch at this stage and there seemed to be no good reason why this should be discouraged.

What all this shows is, I hope, that expression and form in the realm of colour, is like it is elsewhere, a matter of contriving a structural system which can be "read", first by its maker and then by those who contemplate the work subsequently. The structural systems of complementaries and so on which are the stuff of academic books on colour are primitive indeed but how much further it is possible to go is at this moment an open question. In particular, whether or not our understanding of the processes of abstraction in colour can be usefully

extended by analogy with the formal concepts of, for example, transformational grammar, is debatable. Some analogies in the field of three-dimensional form are very persuasive.[14] But whether or not these are sufficient to give real substance to the familiar phrases about colour as an emotional language is questionable, not least because, while the notion of deep-structure in systems other than natural languages is attractive, it is difficult to give it any operational significance. What it is that is "abstracted" when we create meaningful configurations of colours is still a mystery. However it is certain that our understanding of abstraction will not be helped by analogies with the processes of distillation nor with the expression of essences.

At this stage there are at least some useful practical lessons to be learned. The short exercise I have described here suggests that "effective" scales derived from an existing corpus of colours, whether natural or man-made, may be a better basis for composition than the more systematic theoretical scales from conventional colour atlases. Moreover, an intuitive approach to combinatorial order, an approach that is controlled by a narrative idea which constrains and modulates the flow of tension and relaxation in the artist as first spectator, appears to be a better method than a rule-bound, pre-programmed synthesis.

Unquestionably — as in the parallel case of skill in the formal devices of counterpoint in a musical fugue — an ability to discern and manipulate structural 'macros' in colour space enables artist or designer to contrive compositions that are more extended and complex than would otherwise be the case. In the end though meta-descriptions of form — for that is what abstractions are — do not provide recipes for composition. It is what is left over that is the magic bit.

School of Three-dimensional Design,
Kingston Polytechnic

NOTES AND REFERENCES

[1] For an historial account of Gestalt Psychology see: E. Boring, *Sensation and Perception in the History of Experimental Psychology* (New York: Appleton-Century-Crofts, 1942) p. 252ff.

[2] A Typical account of the supposed subjective effect of colour is: J. Itten, *The Art of Colour — The Subjective Experience and Objective Rationale of Colour* (Trans. E. van Hagen) (New York and London: Van Nostrand Reinhold, 1974).

[3] A. H. Munsell, *A Colour Notation* (Baltimore: Munsell Colour Company, 1975).
A. H. Munsell, *A Grammar of Colour* (Faber Birren, Ed.) (New York and London: Van Nostrand, 1969).

[4] W. Ostwald, *The Colour Primer — A Basic Treatise on the Colour System of William Ostwald* (Faber Birren, Ed.) (New York and London: Van Nostrand Reinhold, 1969).
W. Ostwald, *A Simple Explanation of the Ostwald Colour System* (Taylor J. Scott, Ed.) (London: Windsor and Newton, 1935).

[5] Early texts on pattern recognition which influenced my thoughts on these matters are: L. Uhr, *Pattern Recognition* (London, etc.: Prentice Hall, 1973).
J. R. Ullman, *Pattern Recognition Techniques* (London: Butterworths, 1973).
A more recent text is: S. Watanabe, *Pattern Recognition — Human and Mechanical* (New York: Wiley, 1985).

[6] A psychological approach which is congenial to computer modelling is found in: U. Neisser, *Cognitive Psychology* (New York: Appleton-Century-Crofts, 1967).
U. Neisser, *Cognition and Reality* (San Francisco: W. H. Freeman, 1976).

[7] W. Stephens, *Opus Posthumous* (New York: Alfred J. Knopf, 1957) p. 171.

[8] D. Berlyne, *Conflict, Arousal, Curiosity* (New York: McGraw-Hill, 1960).

[9] J. Albers, *The Interaction of Colour* (New Haven and London: Yale University Press, 1963) is a comprehensive account of Albers' work on colour induction effects.

[10] For a musicologist's account of structures in Indian classical music see: A. Danielou, *The Ragas of Northern Indian Music* (London: Barrie and Rockliffe, 1968).

[11] K. Ebeling, *Ragamala Painting* (Basel, Paris, New Delhi: Ravi Khumar, 1978).

[12] A note on this exhibition is published in *Art and Artists* (London, March 1970). . . .

[13] W. Stephens, *Collected Poems* (London: Faber and Faber, 1955) p. 98.

[14] H. Konig and J. Eisenberg, 'The Language of the Prairie — Frank Lloyd Wright's Prairie Houses' *Environment and Planning*, B, **8** (1981), 295—323.

ADAM MORTON

COLOUR APPEARANCES AND THE COLOUR SOLID

1. PREFACE

This paper has two distinct purposes. One of them is to make explicit some of the themes that the other essays on colour in this book have in common. And the other purpose is to make a contribution to one of those themes. Very briefly and generally, these themes are the ways colours look different to different people, and the ways in which painting and other visual arts can exploit these differences. The papers in this book by John Clark, Bernard Harrison, John Gage, Peter Lloyd-Jones, and Michael Podro connect with each other in many ways, some of which can be described in terms of questions about individual variation in colour perception. These are the connections that I hope to make explicit. In doing this I will have to straighten out some differences between the ways these writers use their terms and some apparent differences in their aims. The easiest way to do this is to develop an idea of my own. That idea is, just as briefly, that some differences between different people's perception of colour can be represented by taking people to have differing perspectives on the colour solid which is common to us all. And that one way in which paintings and the like are expressive is by imposing on the viewer's attitude to colour a different such perspective. (I described the colour solid below, and explain these perspectives via a technical notion of a colour transform.)

I write as a philosopher and not as an art theorist or art historian. What I say below about Titian, Poussin, and other painters is not meant as a contribution to the understanding of their work but as an example of what someone might say about a painting. I have no doubt that someone would have to be fairly ignorant to say some of what I say, but that does not matter for my purposes.

2. DIFFERENT PEOPLE, DIFFERENT COLOURS?

Clearly there is an enormous, probably unlimited, variety of ways in

235

Andrew Harrison (ed.), Philosophy and the Visual Arts, 235—252.
© 1987 *by D. Reidel Publishing Company.*

which people can use and react to colours. And very likely this enormous variety is based on some ways in which colour reactions are not varied, ways in which people's perception of colour is normally the same. Two ways in which colour perception can vary from one person to another should be mentioned right away, just to dismiss them. First there are actual differences of perceptual acuity: some people have defective colour vision, for example the varieties of red-green 'colour blindness' or for that matter the capacity a few people have to see further into the infra-red than is normal. And then there are simple differences of taste: different people like and loathe different colours and different combinations of colours. I am not concerned with either of these. What I am concerned with is something very ordinary which lacks an ordinary name, which I shall refer to as differences of colour appearance. I give a number of examples in Section 3 below, but I should be able to get the idea across with one example here.

I find the colour of the sky in Titian's *Bacchus and Ariadne* [PL. 5] garish and at variance with the mood of the rest of the painting. (I prefer Auerbach's commentary-painting on the Titian to the original, for this reason.) Michael Podro evidently does not agree with me. So far this is just a difference of taste. But suppose that Podro and I begin to discuss our disagreement. I will describe the sky in the Titian as having a purple tint that sets up unresolved dissonances with the colours in the rest of a painting whose general range of colour harmonies is much more sedate. Podro will explain to me why this is a naive way to see the picture, no doubt explaining both that the combination of the sky colour with the lower colours is not as tense as I see it and that the picture is meant to have more tension in it than I anticipate, anyway. And I will reply to this, and eventually we will uncover not only some irreducible differences of taste and perhaps some differences of perceptual acuity, but also the fact that some colours and combinations of colours do not *look* the same to the two of us. Perhaps blues look very different from bluish purples to me and less different to Podro. Perhaps the combination of green and even a very blue blue-purple is a striking disharmony to me and is just a run of the mill resolvable dissonance to Podro. (But perhaps not: this conversation is imaginary.) Differences of this sort would be differences in the ways colours look to the two of us, or as I shall say, differences in colour appearance.

Colours can look very different to different people. If there were no differences of colour appearance, determined in part by differences in

people's cultural and personal histories, painting — and also the colour-
ing of houses and clothes — would be a less interesting business. In fact
it is pretty clear that one of the ways in which paintings express some of
the things that they do is by showing ways in which colours can appear.
Is this not often what happens when a particular painting or a style of
painting changes ones perception of landscapes and interiors? It can be
a revelation: suddenly familiar coloured scenes look new. And one
reason that they look new is that colours and combinations of colours
do not look the same. They combine and stand out in different ways.
And it is just as clear that painting would not be possible if there were
not also definite limits to the variability of colour appearances. If
colours and combinations of colours did not look roughly the same to
all people, then no painter could have any idea what his efforts would
look like to others.

The variety of ways colours can appear, against the background of
the limits to that variety, is the basis for the expressive power of colour.
A colour style in painting, clothing, interior decoration or whatever —
which I shall take to consist of a palette or range of basic colours plus a
set of preferences among colour harmonies and patterns of distribution
of colours in space — allows some of this expressive power to be
realised. One might therefore dream of a universal colour style, one
whose vocabulary was so rich that using it one could express everything
of aesthetic importance that can be expressed by colours. John Gage, in
his article in this book, makes very clear how this dream is at work in
the writings and intentions of Kandinsky, Malevich, and other early
abstractionists. Beneath Kandinsky's mystical descriptions of the mean-
ings of particular colours there is the ambition of finding a technique
of using colour in painting, and probably elsewhere in life, given
Kandinsky's occasional allusions to clothing in *On the Spiritual in Art*,
which evokes universal spiritual meanings. Universal spiritual meanings
may not be things that bear much close analysis, but the general idea
has to be that beneath our differing individual reactions to colours
there is a level at which we all take colours in the same way, that this
level is of artistic importance, and that a style of painting or more
generally a way of using colours, could bring this level of perception
nearer to the surface. Moreover, as Gage emphasises, the theorists who
influenced Kandinsky were not so much assigning individual meanings
to individual colours as defining colour systems, descriptions of the
structural relations which govern our perception of colour as a whole.

Parts of Peter Lloyd-Jones' paper in this book can be read as con-
tinuing this tradition, in attempting to understand the expressive power
of a particular family of colour harmonies.

Kandinsky's dream contrasts with John Clark's fear. Clark's paper in
this book expresses a fear of rich colour vocabularies, such as those
made possible by film and video technology. He doubts that television
colour, rich as it is, could reproduce the specific qualities of early
abstraction, or for that matter of many historical colour styles or folk
traditions. And so he fears that its ubiquity — the fact that people see a
lot of colour on television, that in television people often have their
only experience of an organised system of colours, and that this single
colour system is becoming central in the lives of an increasing propor-
tion of the world's population — may make it increasingly hard to see
pictures, films, or the world itself except through this one colour
vocabulary. The most imprisoning vocabularies are those that are just
expressive enough to say *almost* what you need to say.

How alarmed should we be by what Clark says? How much faith can
we still have in Kandinsky's dream? There are difficult questions of fact
here, about the range of forms human colour perception can take and
its susceptibility to cultural and technological influences. But there are
questions of definition and meaning too. Let me make a start on both
with some very simple cases.

3. EXAMPLES

Here are some ways in which colours can seem different to different
people.

(a) Sunglasses: Sunglasses rarely just make the scene darker. Usually
when you look through sunglasses the colours of things change. Some-
times the effect is simple; everything is more blue or more yellow. But
often it is harder to describe, and the eeriness of the world as seen
through the glasses is partly due to the difficulty of saying to oneself
what it is that the difference consists in. Reflective and polarized glases
can be like this. But, in either case, it is undeniable that colours look
different to the person wearing them and the person without them.
There seem to be three components to the effect. First there is the
transformation of hue, the superimposition of a tint of blue, brown, or

yellow. Second there is the change of brightness, which can make colours look different, transforming oranges to brown for example. And third there are special effects, not really a single phenomenon at all, consisting of peculiar glints and metallic tinges and indescribable alterations in the feel of parts of the scene. I expect that part of this third component is very much like the second one, coming down to the effects of a complicated reduction in illumination. If the brightness is reduced in a very irregular way — irregular both in reducing different levels of illumination by different and unexpected proportions and by reducing light of different colours by different degrees — then much of what the observer expects about the effects of shadows and reflections and sources of illumination will be subverted. So inevitably things all look strange and different.

Sunglasses make the appearances of colours to a person at one time different from the appearances of colours to that same person at another time. They thus give a simple example of how colour appearances can vary.

(b) Emphases: You and I are walking through a grassy field. It is an English sort of a landscape, endless and subtle varieties of green. I remark on this to you. And you say "but look at the little flowers, the celandine and the speedwell, there's yellow and blue all about". Then suddenly for me the field is bright and variegated, *bunte*, less moving and more cheerful.

Or the opposite could occur. You say to me "how dull, just those few little flowers". And I say "don't you see how all the greens are different, the poplars are two shades by themselves, and the limes are in between the two, and just a little mist is making the further grass quite different from the grass at our feet." And then you pick up, perhaps for the first time, the force of a landscape that varies immensely within a tiny range.

In either case someone comes to see a coloured scene differently, by paying attention to a particular aspect of it. One could pay attention to a particular colour or range of colours or a particular colour harmony. Or something more subtle, but still depending on the relations between the colours before one. And it doesn't seem to be in too remote a sense of 'look' that colours look different before and after the effect of this kind of attention. The effect can mark one person's typical perception off from another's: some people pay more attention than others, and different people attend to different things.

Each of these examples is suggestive. In (a) the important point is that it is clearly particular colours that look different. I look at a blue sky without the glases and it looks, well, sky-blue. Then I put them on and it is a glimmering peculiarity, but still skyish blue. In (b) the important point is that systematic features of one's reactions to colour-in-general are exploited: which colours and which harmonies one takes as salient. There are pretty clear connections here with the way in which paintings are expressive, which I shall take up later.

Colour perception can vary in much more subtle ways from one person to another, too. Here is an extreme example.

(c) Colour constancy: I volunteer for a psychological experiment. (The point of it might be to undercut slightly Land's theory of colour, but that need not matter now.) In the experiment I watch a videotape of a scene, in which a person in a striped jumper walks around inside an artificially illuminated room and then walks outside. The camera is not recalibrated as she walks outside, and so the apparent colours of her jumper and of familiar objects outside seem crudely wrong. Then I am taken on a walk through exactly the same scenes under exactly the same lighting. Things outside look very different to me than the way they did on the videotape, but I have a mysterious inkling that the tape is not completely unrelated to what I see. I then undergo further training, the point of which is to allow me to predict what colours will appear on a videotape taken under various lighting conditions. The training succeeds, and eventually I am able to turn at will a switch in my mind which makes me see the colours about me not in terms of their relations to the overall range of wavelengths in the scene but in a more nearly absolute way. Generally when I switch myself into this way of seeing things look ugly and confusing, but occasionally the effect is startling and interesting.

This is a fantasy example based on fact. Some actual psychological experiments follow very roughly these lines, and the skills videocamera technicians have to learn are related to those the person in my example acquires. Illumination does affect colour perception in very subtle ways so that it is only via an automatic mental adjustment that colour constancy, the fact that objects do not seem to change colour when the illumination changes, is maintained. And we can to some extent bring these adjustments under conscious control. The importance of the example is the way in which it undercuts some trivializing objections to

(a) and (b). For in (c) as in (a) the same range of colours *is* clearly visible as in 'normal' experience, but it is clear that this is quite consistent with the quality of the visual experience concerned being quite different: no one could be mistaken whether or not it was his 'normal' or his 'special' colour experience he was undergoing. And in (c) as in (b) the difference is the result of something voluntary, a kind of attention which is applied to a field which is common to both the normal and the special perception. But the common field is subtly different in (c). It is now something that is not normally perceptible at all, the influx of light of various wavelengths.

It is examples (b) and (c) that are most relevant to issues about the perception of colour in paintings. (c) is particularly interesting, for it is a very attractive guess that one way in which a coloured scene is represented by means of pigments which do not exactly match those in the scene, is by exploiting the capacity of human vision to interpret colours in terms of the overall balance and pattern of wavelengths present. That is one reason, presumably, why most pictures need a frame, and sometimes a fairly wide one, for the colours to look right: the eye needs to be given a definite limit within which it can evaluate each patch of colour in terms of the overall distributions of intensity and frequency. And presumably, too, one of the sources of the expressive power of colour in paintings — the way in which they can make things look different to one — derives from subtle differences they induce in the way in which one performs these evaluations. And even when nothing this involved is going on, the (b) effect will still apply: one will see the world in terms of the colours, harmonies, and contrasts which the picture makes salient. (I take this idea further in section [5] below.)

4. THE COLOUR SOLID

These examples are meant to show some ways in which colour appearances pretty clearly do vary from one person to another, even among people with normal colour vision. But they are also chosen so as not to undermine the idea that there are ways in which colour experience does *not* vary among people with normal colour vision. The most basic feature of this lack of variation is best expressed in terms of the standard colour solid.

Very briefly, it works like this. There are a limited number of basic

ways in which colours can vary. The only ones I shall consider, though others would probably have to come into a comprehensive discussion, are the well known contrasts of hue, saturation, and lightness. As is explained in any standard work on colour, colours may be classified first as being of a certain colour character or hue, then as being more or less intensely of that colour, and finally as having a position on a scale of lightness between white and black. Thus any red and any green will contrast in hue, a red and a pink will contrast in saturation, and a bright red will contrast in lightness with a dark red. (See Clulow [1972]. The relevant chapter of Rock [1975] is very simple. See also Westphal [1984] and [1986]).

The difference between the contrasts of saturation and lightness is important, but takes some grasping. Many of the early colour theorists discussed in Gage's paper in this book (see also footnote 14 to Clark's paper) are in fact working their way towards a clear differentiation between the two. Once one has separated the three contrasts, one can represent colours as points on a three-dimensional diagram, by placing them at locations inside an asymmetrical lozenge shape with the features that (i) the vertical axis runs from pure white to pure black (ii) going around it horizontally colours vary in hue and (iii) going out from the central axis to the surface colours vary in saturation. (See the diagram.) The result is really rather marvellous: the colour solid gives a fairly simple and graspable structure which ties together both the perceived likenesses and differences of colours — and in fact it is the basis of the colour-systems used in paint manufacture, in art schools, and elsewhere — and a fair amount of what we know of the physiology of colour perception. (This is what Clark refers to as trivariance and the tristimulus analysis of colour: the fact that each colour can be obtained by mixing light of three suitably chosen wavelengths of red, blue, and green. Imagine a colour formed by projecting light of these three primaries onto a small area of a white screen. The intensity of the light from each of the three projectors can be varied. Then — ignoring some crucial facts, in particular the different sensitivity of the eye to light of different wavelengths — variations in hue are got by varying the ratios of the intensity of the three projectors while keeping the total intensity unchanged; variations in saturation are got by varying the intensity of the projector of least intensity while keeping both the ratio of the other two and the total intensity unchanged, thus in effect changing the proportion of white; and variations in lightness are got by varying the

intensity of all three projectors simultaneously while keeping their proportions unchanged.)

When someone has normal colour perception the contrasts between the colours that they see define a standard colour solid. Moreover the detailed structure of the colour solid ensures that when two people see the same colour it must look the same to them in certain respects. For example, it is not possible that what one person sees as green another might see as blue. This point is argued in detail by Bernard Harrison, both in his paper in this volume and in Harrison [1979]. As he says in that book

... the distribution of numbers of hues between the extensions of different colour names is not even. As a result, what one might call the linguistic topology of the quality space of colour is asymmetric. No transposition of the sort the sceptic [who suggests that one person sees red where another sees green] envisages could avoid producing the result that A would discriminate more hues within a given category than B, or that hues indiscriminable to A would be discriminable to B, or that A would detect different gradations of hue, or tonality from B in a given colour display. Another difficulty is that ... the number of named colours on the red-yellow side of the circle of hues is greater than the number on the blue-green side. A third difficulty is that any transposition of colours ... must maintain parity as regards complex predications of the 'x is blueish green', 'x is yellowish-orange' variety; which excludes, for one set of reasons, exchanges of primary of secondary colours, and for another set of reasons, 180° rotations of the circle of hues. (Harrison 1973, pp. 22—23)

I am convinced by this. Harrison is pointing out two asymmetries about colours. First there is a basic asymmetry in the colour solid: if you measure it in terms of just noticeable differences of colour then it is not a symmetrical double cone but bulges on one side, towards the yellows. (In fact it bulges upwards in the lightness direction as well as outwards in the saturation direction, creating a complex asymmetry.) In effect, we are better at seeing small differences of colour for some colours than others. And then superimposed on this there is a linguistic asymmetry: even given the bulginess of the colour solid the standard colour names in English and other languages do not pick out regions of the colour solid of the same shapes. As a result, the extensions of no two English colour words can be exchanged without violating some basic characteristic of one of them. So if you and I both perceive the whole range of hues, and find ourselves able to use the English colour vocabulary and the practices that go with it, then it cannot be that when you and I apply the same English colour word to an object, I am actually picking out one subset of the colour solid and you are picking

out another, which I would have taken as the extension of a quite
different colour word.

 If this is right, how should we describe the examples of the last
section? They seemed to show that two people's colour experiences
could be very different, and now we seem to see that they must be the
same. But of course that is not really what the argument shows. It only
shows one way in which two people's experience could not differ,
namely by variations on the 'when you see red I see green' pattern.

 Consider the examples again with this in mind.

(a) (sunglasses) If I am wearing glasses which change colours in a very
simple way, just by making everything a bit darker and a bit more blue,
say, then I will generally apply the same colour words to things as you
do, except perhaps for a few shades on the yellow/green/blue and red/
purple boundaries. But then people do disagree about the names of
many of these shades anyway, especially on the blue/green boundary,
and so perhaps when I wear these glasses I do actually see colours as
you do without them. But it does *not* follow from this that the exten-
sion of any colour word is exchanged with that of any other, or that the
hues that I see are not the same as those that you see, and indeed
organized in the same way. One might express this as: you and I see the
same colours but see the same scenes as slightly differently coloured.

(b) (attention) The person paying attention to colours, or some feature
of colours, does not see *different* colours to the person who is not. Reds
and greens still have just the same contrasts of hues for the two people,
just as reds and pinks have just the same contrasts of saturation and
light and dark reds just the same contrasts of lightness. *Those* features
of their colour perception are common to the two people. The features
that do distinguish the colour perception of the two people have
nothing to do with the location of colours on the colour solid. One
might express this as: they see the same colours but see them dif-
ferently.

(c) (colour constancy) Although in this example the colouration which
the subject sees a scene as having is very different from that which an
'ordinary' person would take it to have, the colouration consists of
colours all of which have definite locations on the colour solid and
which bear to each other and to the colours and ordinary person would
see the standard basic contrasts of hue, saturation, and lightness. One

might express this as: they see the same colours, but in different parts of the scene.

5. FALSE ENDING

This gives a nice comforting resolution of one form of our original worry. The colour perception of different people with normal colour vision is the same in that they see the same colours — meaning that they can apply the same contrasts of hue, saturation, and brightness — and can be different in that they can see these colours differently — meaning that given a scene different people can apply these same colours to it with different emphases and even somewhat different distributions. In this way the colours of the colour solid, identified simply by our ability to see similarities and differences between shades, are kept apart from colour appearances, the ways in which a coloured scene can look to someone. There seems to be room for everyone's conclusion in this framework: Harrison's refutation of colour-scepticism is upheld, since it rests on the link between colour words and the colours of the colour solid; the abstract possibility of a Kandinsky-style deep universal significance for colours remains, since it postulates a way of using the resources of the colour solid to represent will possible colour appearances; and different people can see colours differently, in a way that may be subject to cultural variation and inhibition as Clark suggests, since colour appearances are distinct from colours. So perhaps I should end here.

There is another reason why it might be wisest to stop now. What I have done so far in the way of clarifying the issues makes it clear that there are some quite definite theoretical and factual questions to be answered before we can know how much of Kandinsky's dream is realisable or how many of Clark's fears are real. And it is clear that they are very hard questions, too hard and too complicated for a short article. We need a full description of the range of possible colour appearances; we need to know what colour resources are needed to evoke each of them; and we need to know what the cultural conditions required for a particular colour stimulus to present a particular colour appearance are. I cannot satisfy any of these needs.

But it is not always wise to meet the big questions head on. Instead of a description of all the ways in which colours can appear to people we might try to get a grasp of some smaller class of colour appearances.

And in fact what I have said so far does give a way of describing one
class of colour appearances, which are among those provided by repre-
sentational painting. That is certainly relevant to the first of the large
needs I cannot satisfy, that of giving a description of the full range of
colour appearances, and some of the details are interesting, so I shall
spend the rest of the paper explaining it.

6. COLOUR TRANSFORMS

One could paint pictures showing some of the variation in the appear-
ance of colours in the examples I have used. The very simplest sun-
glasses cases would simply require that a standard depiction be glazed
over with a blue or green wash; more complicated sunglasses cases
would require selective use of some metallic colours. (And ideally the
picture should be enormous, and seen from close up, so that like most
sunglasses it presented no visible edges.) The examples depending on
selective attention would require a picture in which the relevant colours
were emphasised in terms of increased saturation or lightness and the
relevant contrasts were emphasised by exaggeration. And the colour
appearances involved in the colour constancy examples could be repre-
sented with pictures whose lightness and saturation were systematically
distorted from a 'natural' representation of the scene. (In this case the
edges of the picture could profitably be left visible, so that a wide
suitably coloured surround could lure the eye into making the right —
that is to say, unnatural — adjustments of brightness. But although
questions of brightness adjustments within a limited area are of central
importance for understanding how pictures work, neither I nor anyone
else knows enough about them to say anything very systematic yet.)

It might at first seem puzzling that colour appearances — which in
the early sections of this paper I carefully distinguished from colours,
that is, points or areas of the colour solid — can be described by
presenting a picture, which is after all just another array of colours. The
colours in the picture would themselves present different appearances
to different people, and would this not undo the explanatory value of
the picture? It need not. Consider a picture which represents in an
exaggerated way the colour appearances of a selective attention case.
The picture might represent the appearance of an English landscape to
someone very aware of all those greens. In it all colours except greens
would be desaturated and reduced in brightness relative to the greens,

and the further a colour is from the green area of the colour solid the more this would be done. And the greens would be exaggerated by increasing the range of brightness and saturation among them. The result would be a pretty ugly representation of the scene. But no one could look at it without having their attention drawn to all the greens and the differences and harmonies between them. And the reason for this is quite simple and general: there would be in the picture more perceivable differences among the greens than among other colours.

In this example the colours used in the picture were transformed systematically from the colours present in the scene. (More exactly, the colours of light which would be reflected from the picture under standard conditions of illumination differ systematically from the colours of the light entering the observer's eye when looking at the scene. I shall often conflate colours of things such as spots of pigment and colours of light.) Many colour appearances can be represented in this way, by transforming the full range of colours into another range, squeezing it in some regions and not in others. These transformations can be thought of quasi-mathematically as mappings of the colour solid into itself. I shall call them colour transforms.

Colour transforms are essential to painting. For the most basic fact about representative painting in colour is that the range of pigments available is always less varied than the range of colours in the scene represented. This is most evident with lightness contrasts: no range of pigments that has ever been available can reproduce literally the contrast between even a fairly dark sky and a tree or animal lit by that sky. The important point is not that the sky as painted when normally lit is not as bright as a real sky, but that the *range* of brightnesses, expressed as the ratio between the brightest colour and the least bright or even as the number of noticeable gradations of brightness, in the actual scene is never reproduced in a painting. The same happens throughout any painting: the pattern of colours used represents the pattern of colours in the scene, but not by reproducing them exactly. What is presented is the result of a colour transform. An interesting example both of how this works and of the problems it can lead to is provided by Poussin's *Worship of the Golden Calf* [PL. 12]. As Michael Podro points out, following Alberti, Poussin has represented the shining light golden colour of the calf with umbre and ochre. Gold leaf could not have been used, first because the glintiness of the gold would only be visible from some angles, but also because to have used anything like the literal

brightness of gold-in-sunlight would have undermined the transforma-
tions of lightness of the other colours in the painting. The colour
Poussin has used is a compromise: he could not have made it any
lighter without either using gold or some other reflective paint or
making it implausibly unsaturated and he could not have made it darker
without having to darken the rest of the surrounding figures, destroying
the effect of bright sunlight. (The effect is not, to my untrained eye,
completely satisfactory.)

Hue contrasts have always been easier to reproduce than lightness
contrasts, and most of the advances in pigment technology have been
directed at getting a richer variety of hues. And saturation contrasts
can be captured to the extent that one's pigments can be mixed with a
gradation of whites and greys. Largely because of these facts, most
representational ·paintings transform the colours in the scene repre-
sented by systematically reducing the lightness of all colours, and to a
lesser extent their saturations, thus projecting all the colours observed
downwards in the colour solid. (See the diagram.) The projection is not
uniform: lighter colours are reduced more than darker ones. And the
range of colours that can be used to represent black is quite small; they
are all pretty dark, though Chagall and others have got some strange
effects by representing the black of night with glowing reds and blues.
And in many pictures two different such projections are used simul-
taneously. (Just as many pictures represent space by using two or more
related linear perspectives.) Representational painting thus uses a wide
but not unlimited family of colour transforms, in all of which lightness
is reduced considerably and non-linearly (that is, greater degrees of
lightness are reduced disproportionately).

Different styles of painting use different colour transforms. Very
often the transform is characterised as much by its effects on hue as on
lightness and saturation. Thus a Rembrandt-like effect is got by not
only using a characteristic transformation of brightness and saturation
— reducing the lightness in the middle-to-low range considerably while
reducing the lightness of some middle-to-high range rather less than is
normal — but also at the same time emphasising browns and yellows in
much the way that greens were emphasised in the landscape I described
above. (One effect of using these transforms is that very bright or
reflective objects can be represented well, since even a moderately bright
colour will shine out aginst its sombre background.) Many painters with
a distinctive colour style cannot be so easily characterized. Cézanne, for

example, has an easily recognizable use of colour for which even a crude first approximation such as I gave for Rembrandt is hard to give in terms of colour transforms of the sort I am using. But that may just mean that the transform is complex. I would suggest that in Cézanne there are often two regions of the colour solid that are emphasised. Which regions varies from painting to painting, but they are nearly always such that they can be connected by lines of his favourite blues, even when these are not very prominent in the painting. In some well-known paintings (for example the landscapes with Venturi numbers 396, 762, 775) the two regions consists of one stretching from a fairly dark saturated green to a light and less saturated blue and the other containing a limited range of yellows and oranges. A Cézanne-like effect can thus be got first by projecting colours onto slightly less saturated colours and reducing a middle range of the lightness scale by much less than the upper range is reduced and then by emphasising colours in these two regions.

The tendency for colour transforms in painting to affect hue as well as saturation and lightness is not really surprising. For if a picture is to present an interesting colour appearance as well as representing a scene then it must redirect the viewer's attention to contrasts, harmonies, and particular colours which would not otherwise be salient. And the natural way to do this is to employ a range of colours which cannot be made sense of except in terms of these colours and colour combinations.

A painting makes use of a colour transform. And in using it the painting presents it, makes the transform available to the viewer. The transform then presents the viewer with a colour appearance. And this is at the root of the well known phenomenon I referred to at the beginning of this paper, that for as along as one is in the grip of a particular painting or style of painting colours look different to one. The simple reason for this is that the painting has directed ones attention to colours and harmonies in ways that I have been describing. There are other ways in which it can work, too. For there are many ways in which once one has grasped a colour transform one can apply it to ones own experience, to produce variations and alternatives.

However it is done, the viewer who has understood the colour transform underlying a painting is able to understand one way in which colours can appear. The colour appearances thus made public certainly do not exhaust the range of ways colours can look, that Kandinsky

called the "sounds" of colours. But they are an especially important family of colour appearances, for two reasons.

First, they can be communicated by pictures. The colour transformation can usually be read quite easily from the picture by someone with normal colour vision and normal visual imagination. For given a representational picture one can imagine, given the depiction of the lighting conditions, the time of day, and so on, what the actual colours would have been. The comparison between this imaginary literal representation and the picture itself then partially defines the transform. (Some more pictures in the same style would pin it down more exactly, if need be.) An appearance given by a pair of pictures — the way an actual or imagined scene is actually seen or imagined and the result of applying the transform to it — has a particularly stable and intelligible form. For it captures both the fact that the resemblances and differences that can be discerned in the actual scene *can* be discerned and the fact that some of them, those which are discernible in the transformed scene, are particularly important for the appearance in question. These appearances, then, are neither unintelligible sub-perceptual qualia nor fully conceptualised thoughts. And that is what appearances ought to be.

The second reason, related to the first, can be extracted from something Michael Podro says in his paper in this book. Podro writes

> The content of our perception of, say, a tree, involves not only a view of projection of it from a given position, it includes in its character for us . . . a sense of the other views it would yield from other position. It also includes a sense of other possible aspects we could fixate, other features we could make focal. These are parts of what Husserl termed a horizon of possibilities which an object of experience could yield. . . . Now, by contrast, let us turn to the perception of the drawing or painting of an object. What we perceive . . . *in* the drawing is a characterization or look of the object drawn and the "horizon" of that includes the belief or awareness that it could be used to show other objects, or other views of the same object or other features of the same view as salient. . . . In this way the perception of the drawing has a horizon of possibility that the object itself cannot have, and the contrary is also true.

Podro's point applies to the representation of colours as well as to the representation of objects in space. A coloured scene can be seen in many ways, with attention to many different aspects of the colours it presents. And there are correspondingly many colour appearances to be had from it. A painting representing the scene, on the other hand, has a different horizon of colour possibilities, a different range of ways

in which the colours can be seen. This range must be in some respects smaller than that of the scene itself: the painting must make it easier to grasp some colour appearances than others. If it does not it is not serving as a painting, but as an inferior substitute for the scene itself.

Colour appearances which can be represented by colour transforms of actual or possible coloured scenes are particularly important, then, since they are essentially related to one of the basic purposes of painting. That purpose is to represent by means of a picture a way in which the world can be experienced. That expressive purpose is, paradoxically, forced upon painting by the limitations of pigment. Another medium, video for example, may not be subject to such limitations. And then, as John Clark points out, its resources may threaten us with a loss.

University of Bristol

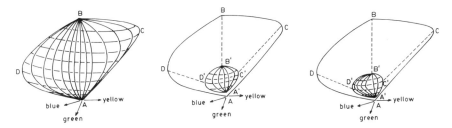

Fig. 1. Three colour solids

On the left is the standard colour solid. Note that the directions corresponding to the primaries yellow and green are marked in but that the direction corresponding to the primary red points into the page. Lightness, sometimes called brightness, increases along the vertical axis. Points on the interior of the solid represent less saturated colours, becoming more saturated as one moves away from the vertical axis. The point A represents a black, B a bright white, C a bright saturated yellow, and D a bright saturated blue. Note the asymmetry of the solid, and the resulting difference between the heights of C and D.

The middle diagram represents a colour transform which might be found in an accurate but inexpressive style of painting or system of colour reproduction. A, B, C, D are transformed to A', B', C' and D'.

The diagram on the right represents a colour transform which might be used in a style of painting which emphasised blues. Note that the transform changes the shape of the colour solid drastically. (In the text the corresponding example is of a style that emphasises greens. Blue makes the diagram clearer.)

The scale in the middle and right diagram is not meant to be exact.

REFERENCES

John E. Bowlt (with Rose-Carol Washton Long), *The Life of Kandinsky in Russian Art* (Newtonville, Mass.: Oriental Research Partners, 1980).
Frederick Culow, *Colour, Its Principles and Their Applications* (London: Fountain Press, 1972).
Bernard Harrison, *Form and Content* (Oxford: Blackwell, 1973).
Vasili Kandinski, *On the Spiritual in Art* (Translated, with a commentary in Bowlt, *op. cit.*, 1980).
Irvin Rock, *An Introduction to Perception* (New York: Macmillan, 1975).
Jonathan Westphal, 'The Compexity of Quality', *Philosophy*, **59**, 230.
Jonathan Westphal, 'White', *Mind*, **95**.

PART III

THE LIMITS OF DEPICTION

MARTIN KEMP

PERSPECTIVE AND MEANING:
ILLUSION, ALLUSION AND COLLUSION*

The approach of this paper is an odd one, in a number of ways, and I think I should begin by explaining what I am trying to do.

On one hand, the paper focuses quite closely on a specific work of art from the seventeenth century, using some of the recognisable tools of historical analysis with respect of form and content. On the other, it deals in a speculative manner with general questions of representing and seeing with special reference to space. I have two main reasons for tackling the general with close reference to the highly specific.

The first reason is that I am inherently distrustful of general theories of aesthetics, perception, signification or representation unless they can be brought to bear without strain on works of art which operate at the highest levels of complexity.

The second reason is that this approach seems to promise at least some kind of reconciliation between those who regard the representation of space in the post-Mediaeval western tradition as a symbolic form — regarding perspective as an artificial convention no more inherently truthful than other strategies of representation — and those who see the orthodox form of spatial depiction as the least arbitrary of all the ways of representing reality on the flat surface of a picture. I realise that these poles, stated baldly in this way, greatly oversimplify the interpretative complexities of the subject, but they do correspond with two recognisable tendencies — one given voice most effectively in the art-historical field of Erwin Panofsky in his *Perspective as Symbolic Form*, published in 1927 and increasingly coming back into fashion, and the other tendency finding sustained support in the writings of Ernst Gombrich, most notably in his classic *Art and Illusion*.[1]

The line of attack adopted by Panofsky and more recently by students of semiotics has accentuated the period-specific nature of perspectival representation, not only regarding it as a fruit of a particular way of painting but also interpreting it as the expression of a manner of *seeing* which is identified with a specific place at a specific time. Underpinning this approach is a philosophical stance that owes its immediate ancestry to Cassirer's doctrine of symbolic forms and ultimately leads back to Kant's ideas.[2]

255

Andrew Harrison (ed.), Philosophy and the Visual Arts, 255—268.

The form of analysis favoured by Gombrich has drawn upon psychology of perception and the theory of knowledge formulated by Karl Popper to emphasise the increasingly close match between the effects evoked by post-Mediaeval art — by the paintings of Constable for example — and our visual experience of light, colour and form in space. The development of Western naturalism becomes a systematic if not inevitable progression towards effects of illusion that our perceptual apparatus finds increasingly difficult to falsify as a compelling representation of seen forms.

As a historian researching the impact of scientific ideas, particularly optical theories, on Western art between 1400 and the late 19th century, I am chiefly concerned with a descriptive account of what happened — why, for instance, Turner transmuted Newtonian colour theories in the way he did. I cannot, however, embark upon description, selective and focussed as it inevitably is, without an implicit and I hope an increasingly explicit view of the perceptual status of the ideas and art with which I am dealing. As someone who is by inclination a synthesiser or conciliator between different stances — or perhaps simply a philosophical coward — I am prepared to acknowledge the force of both the Panofskian and Gombrichian stand-points. I think it may be possible simultaneously to rescue important elements of both theories. I intend to do this through my strategy of examining the meaning of a particular work in a highly specific historical context — playing into the Panofskian camp — while at the same time suggesting that the language of illusion does have a perceptual foundation of a non-arbitrary and even universal kind.

I hope that the specific work I have chosen will bear productively upon the questions of 'looking' at the heart of the debates about representation and suggest fresh questions that stand in the need of answers. I will, for good measure, throw in some general speculations, which will be too slippery to be regarded as a general theory but which will have to serve in lieu of one.

The example I have chosen is what may be regarded as the *reductio ad absurdum* — or, in the light of what I am about to say, the *elatio ad absurdum* — of Western perspective illusion, the dome and nave painted by the Jesuit priest, Andrea Pozzo, during the last quarter of the 17th century in the Church of Sant' Ignazio in Rome [PL. 28].[3] It is worth stressing at the outset that the context of meaning could not be more serious. Sant' Ignazio was the new church of the Collegio Romano, the great teaching organ of the Jesuit order, through which

the true message was to be transmitted to the four corners of the world. It is in such a context that perspective most necessarily functions as a 'symbolic form' and in which the claims of perspective to a broader perceptual validity will be hardest to establish.

The example provided by Pozzo is exceptionally rich, not only in its obvious terms as probably the most extreme example of large-scale illusion in the history of art, but also because the artist has left two accounts, one bearing upon the technical processes of its design and the other relating to its theological content. These accounts enable us to ask a series of questions with at least some promise of historical answers. These questions are concerned with:

1. what the artist thinks he is doing;
2. what means he has at his disposal for achieving these ends;
3. how these intentions and means relate to what he has actually done;
4. the nature of the spectator's rôle in the reading of content and form;
5. the intellectual and perceptual foundations upon which such art can function.

Arising from these questions, I hope to suggest how far we are from formulating a general theory which can handle all the extreme intricacies of what happens in the given situation of a highly sophisticated piece of illusionistic art. In the following analysis I will begin by approaching form and content successively, as Pozzo himself did. This certainly should not be taken to imply that these two factors have any real degree of autonomy, either in this particular work or in a more general sense with respect to naturalistic art and indeed with regard to nature itself. I will begin with the formal considerations.

Pozzo's *Perspectiva Pictorum et Architectorum*, published with parallel Latin and Italian texts in two parts in 1693 and 1700, provides a clear exposition of the way to design and execute illusionistic ceilings.[4] In common with those theorists who stand in line of descent from the Vignola-Danti treatise of 1584, he explains that perspectival recession may be accomplished by two main methods, the distance-point system which has the advantage of economy, and the full procedure of projection from plan and elevation on to the intersection or picture plane. For complex forms such as those of the dome, the intersection method becomes unbearably long-winded, and the distance-point method

would have served his purposes more readily [PL. 29]. Once the forms
of the dome [PL. 30] were foreshortened in a scaled preparatory study,
they could be transposed directly on to the flat ceiling erected by Pozzo
across the aperture which had originally been intended for an actual
dome. The nave illusion presented a more difficult problem, since the
vault is curved in a non-uniform manner. Pozzo's solution was to
suspend strings as a grid of squares across the nave at cornice level
[PL. 31] and to use a further long chord to the spectator's eyepoint to
project the grid on to the curved planes of the vault. The foreshortened
design, which had been divided into equivalent squares, was then
transferred unit-by-unit into the distorted squares in the vault. Plumb
lines were used to ensure that the resulting outlines achieved the optical
effect of straight elements when seen from the prime viewpoint [PL. 32]

These procedures are entirely predicated on what in recent times has
been that most derided of concepts — that of the static, monocular
spectator. Pozzo even goes so far as to place inset marble disks in the
floor of the Sant' Ignazio to guide us to the right positons. Why did he
resort to this system, when sixteenth-century and Baroque illusionistic
decorators had long since designed more flexible systems which were
less vulnerable to change of viewpoint?[5] As will become clear later, the
meaning of the work is highly relevant, but for the moment let us
concentrate on Pozzo's optical reasoning. In answer to the contem-
porary claim that multiple or softened viewpoints were preferable in
large-scale schemes of decoration, he produces three arguments: firstly
that the time-honoured practice of the 'greatest masters' has sanctioned
the use of single-point perspective; secondly, that the painter is not
obliged to make his work seem real from any possible position — an
aspiration which cannot in any case be realised — but is justified in
expecting the spectator to adopt the correct position; and thirdly, that a
multi-viewpoint system only succeeds in not looking wholly convincing
from anywhere.[6]

He then adds — and this is probably the most interesting of his points
in the present context — a corollary to the effect that the distorted
appearance of the illusion from other viewpoints [PL. 33] 'so far from
being a fault', should be regarded as manifesting the ultimate 'excellence
of the work'. This suggests, justifiably I think, that the interplay between
suspension of disbelief and awareness of the image's artificiality has an
'aesthetic' value of a high order in our enjoyment of this kind of
illusionistic performance.

His three main arguments appear on the face of it to be simple and even naive. However, like many simple arguments, they raise issues of considerable complexity, as Pozzo (who was a cleric of some sophistication) was well aware. Even if the 'greatest masters' have not so universally resorted to one-point perspective as he claimed, the ubiquitous and persistently efficacious nature of orthodox perspective in post-Renaissance Western art and in much popular imagery cannot be denied. Alternative systems of natural representation have not established themselves as viable replacements. We may notice in passing that all the advocates of the most widely-mooted alternative, curvilinear perspective, only succeed in illustrating their systems by reference to the orthodox co-ordinates of one-point perspective. The multi-viewpoint systems of Pozzo's own period do not so much posit alternative systems of vision and representation as exploit a compound series of single-point views. Pozzo's obstinate orthodoxy in theory and practice serves to highlight the central questions. Why and how does perspective work, now and in the past? What happens when perspective images are viewed from eccentric positions, and the sense of artifice supercedes that of illusion? In other words, what form or forms of collusion are required to make the image function?

A sustained campaign of stalking Pozzo's illusions *in situ* and through photographic reproduction suggests that the reading of such images is of an order of complexity which tends to undermine any unitary theory of seeing and knowing. What follows is a series of observations and related speculations which are inevitably personal, but I think that this subjective approach does have a particular area of validity and stands a fair chance of reflecting the slippery and untidy nature of the processes involved in the reading of such images.

From non-perfect viewpoints the illusion of the nave works far better as a whole or in parts than photographs from equivalent points would suggest. The readiness of our perceptual system to make the illusion function gives the spatial reading a persistence which goes against our expectation that regularity and coherence will rapidly dissolve once we move away from the prime point. The shorter lateral ends of the vault, for example, read quite well from the far ends of the central axis. Even at extremely asymmetrical viewpoints of the kind already illustrated in [PL. 33] which result in crazy configurations, the frescoes still read compellingly as three-dimensional, and the actual surface shape of the vault remains impossible to discern with any coherence. The obstinacy

with which we cling to a spatial reading of greater or lesser coherence is reflected in the sensation that the painted architecture sways in a vertiginous manner if we view it continuously while walking slowly along the central axis of the church. This effect of apparent motion — a kind of reverse parallax — becomes particularly potent the nearer we approach to the central position.

Some of the same observations apply to the dome [PL. 34]. Even if it is viewed from the choir rather than from the entrance to the nave, it retains a strongly plastic if extremely distorted configuration. However, the dome did prove more readily vulnerable than the nave illusion to changes of viewpoint. Two main possible lines of explanation occur to me. The first is that the dome is a simpler, more unitary design, with fewer broken lines of sight, and presents a greater coherence of internal rhythm. We almost certainly require fewer perceptual shots to register its overall form than the architecture on the nave ceiling. Perhaps it is this relative simplicity and coherence which renders smallish distortions more readily apparent. The second possible explanation is that the painted dome exists within a clearer frame of architectural reference within the church. The unbroken circular cornice of the aperture and regular arches of the crossing provide a spatial reading of the actual forms which rapidly competes with and supercedes the hold of the painted illusion. The setting in the nave, by contrast, is complicated by broken cornices and intruding windows. This second argument directly contradicts the experimental evidence from psychology that our reading of the perspective transformation of the external boundaries of an image (such as a frame) actually helps rather than hinders the retention of efficiency in the painted illusion. However, the experimental work relates to what we normally think of as a 'picture'; that is to say an easel painting or photographic reproduction of a relatively modest dimension which occupies a smallish part of our visual field. This consideration leads me to wonder if context and scale are not of crucial importance, to such a degree as to lead us to qualify the experimental findings. It is at this point that a comparison with the viewing of works in photographic reproduction can be particularly instructive.

Both illusions work superbly in photographs from the prime viewpoints, since the requirement of a static, monocular spectator is precisely met. But what happens when the photographs are viewed from off-centre positions? The photographic reproductions proved far less vulnerable to changing viewpoint, even if the viewing angles were of an

eccentricity impossible within the confines of the church. The dome
tends to be read coherently as a dome, though increasingly in relation
to an oval aperture [PL. 35]. The nave illusion in photographs [PL. 36]
proved remarkably resistant, with the paradoxical effect that our posi-
tion relative to the forms seemed to move in the opposite direction to
the motion of the actual viewpoint. These observations with photo-
graphs broadly conform to the experimental analyses, but the dif-
ferences from the readings *in situ* suggest that all results are specific to
their particular circumstances. Thus, when there are no overt ways in
which the fictive space within the work of art is directly tied to those
forms which describe our actual space, the perceptual system will tend
to collude with the artificial object in such a way as to displace the eye
psychologically to the correct viewpoint. In this process of collusion,
the acquired knowledge of the kind of object with which we are dealing
— e.g. a European easel painting in the post-Renaissance naturalistic
tradition or a photograph — can obviously play an important rôle, but
I do not think it is an ultimately crucial one. An essentially non-
perspectival system of representation, such as that of the Egyptians,
also requires a psychologically displaced eye if their forms are to retain
their full degree of clarity when viewed obliquely. This phenomenon
that I am calling the displaced eye is closely related to what psycholo-
gists of perception call 'constancy', though it is not quite identical to it.

On the other hand, when the fictive space is tied deliberately and
unambiguously to the forms which describe the space around us, the
painted forms exhibit a greater tendency to become swamped by the
contradictory perceptions applying to the real shapes. That this phe-
nomenon is a result of the frame of reference and not simply a quesiton
of scale or horizontal location is confirmed by Tommaso Laureti's
painted illusion on the ceiling of the Sala di Costantino in the Vatican
[PL. 37]. Laureti's architectural allegory of the triumph of the Church
over pagan idols relies upon a compelling effect of space, yet, since it is
presented as if it were as a perspective 'picture' painted on the ceiling
rather than as a fully illusionistic decoration in the Pozzo manner, it
retains its spatial independence and its resistance to shifts in viewing
position rather in the manner of an easel painting. It might be worth
speculating what would happen if we place Pozzo's illusion over a
'crazy' building in which regular forms are deliberately avoided. I
suspect that the painted illusion would retain its regularity over a much
wider range of viewpoints than it does in its present context.

These observations and speculations, subjective though they neces-
sarily are, may do something to suggest the complicated interplay of
illusion, reality, collusion, setting and circumstance, in the reading of
such images, but they do not in themselves show that we are dealing
with phenomena which are other than culturally determined. We may
be dealing with something which is no more than an unusually complex
'symbolic form' specific to a certain set of cultural preconceptions.
Pozzo himself, in his willingness to place perspective in the service of
theological meaning, provides ample evidence in support of a belief in
the period-specific nature of linear perspective.

Between the first and second parts of his *Perspectiva*, he published
his *Breve Descrizione del Disegno della Cappella di Sant' Ignazio*, which
provides a rich and relatively little-read account of how to read the
theology of the nave.[7] The essence of the meaning is that the space is
devoted to a dynamic unfolding of the missionary rôle of the Collegio
Romano in the person of its founder, Saint Ignatius, who is the radiant
centre from which the divine rays of Jesuit spirituality penetrate to the
remotest corners of the world. Ignatius, as the vehicle for the crucified
Christ's message of salvation, sends shafts of divine illumination across
the fictive space of the vault to the lower realms of the four conti-
nents. Adapting a metaphor from Dante, he shows that the true light of
Christian revelation is reflected second-hand into our space by an angel
bearing a convex mirror [PL. 38] which is inscribed with Jesuit logo.
The dynamic perspectival convergence is integral to meaning, in that
its spiritual focus — a point of infinite unknowability — becomes the
ultimate source for the physical illumination which is but a poor reflec-
tion of divine truth. That this is not to over-read the way in which
perspective serves meaning is shown in Pozzo's introductory address to
the reader in his *Perspectiva*, where he informs us that he intends 'with
a Resolution to draw all the lines thereof to that true POINT, the glory
of GOD'.[8] We should also note that when the full consequences of his
spatial illusion work against meaning, he is prepared subtly to subvert
its logic. The key figures in the celestial section of the illusion are not
foreshortened as radically as the system demands. He was understand-
ably reluctant to portray Christ and Saint Ignatius as the soles of two
pairs of feet and little else.

Such then is the specific, intentionalist reading, based on the evi-
dence of the artist's own writings. This interpretation can be located
by the historian in the more general framework of illusion, vision

and mathematics in Jesuit thought in the seventeenth century and in Baroque Catholic Europe as a whole. Pozzo's use of illusion can be aligned with a range of images which use perspective and related optical techniques as a form of natural magic to evoke awe in the spectator. It was in this context that anamorphic images, known since the early sixteenth century, really came into their own.[9] A series of optical curiosities, including the magic lantern, came to serve the dual ends of entertainment and spiritual expression. The great German Jesuit philosopher in Rome around the middle of the century, Athanasius Kircher, perfectly expresses the extraordinary compound of scientific acumen, natural magic, astrological mysticism, Neoplatonic rapture and Christian fervour which lies behind the ambitions of Pozzo and his patrons.[10] It was in this context that sacred art could become a form of theatre, expressing through illusion those spiritual truths whose presence on earth was manifested only through elusive reflections and shadows.

Pozzo's placing of illusion in the service of mystical ends should not be taken to imply that he regarded the optical means as anything other than a wholly rational system which corresponded in a direct way to the physical-cum-mathematical basis of vision. Even though the ultimate source of illumination might remain ineffable, the passage of physical light through the world is governed by infallible rules which the artist can utilise in making his illusion. An anecdote recorded in his *Perspective* stresses that he intended his illusions to possess a literal, absolute validity which permitted the painted objects to be read optically as real.

Some architects disliked my setting of the advancing columns upon corbels [in the dome], as a thing not practiced in solid structures; but a certain painter, a friend of mine, removed all their scruples by answering for me, that if at any time the corbels should be so much surcharged with the weight of the columns as to endanger their fall, he was ready to repair the damage at his own cost.[11]

This story serves to bring back to the question as to whether such images have any non-arbitrary validity in evoking the appearance of things or whether they possess only a relative and period-specific value as one of many ways of striking a visual relationship with the physical world. Was the ability of Pozzo's critics to read his painted structure in pedantically precise terms founded on nothing more than a series of visual conventions in which they were well versed?

It would be absurd to deny that we all bring a 'period eye' to bear on

the reading of such images. The particular set of visual judgments that the architect-critics brought to his image was highly specific, in that they were literate in the language of Baroque architectural design. His contemporaries in the Collegio Romano, who knew the history of the Church, would equally have brought a special understanding to their appreciation of the image; they would have appreciated its ingenious efficacy as an inexpensive and rapid way of overcoming the repeated delays which had beset the construction of an actual dome. They would also, of course, have been well placed to read Pozzo's theological references. To the modern tourist the frescoes have become, much to the irritation of an unusually acid sacristan, amusing optical diversions which can most comfortably be viewed from a prone position and which just happen to be in a church of whose name they are only dimly aware. The various processes of seeing are irredeemably directed by the interpretative expectations we bring to the paintings. But these expectations are concerned with *what* is seen — with those aspects of the image which assume significance and become specifically observed within each viewer's framework of understanding. The different focusses of attention and interpretations do not in themselves prove that the visual mechanism through which the image can potentially acquire significance is equally variable. A modern tourist may well 'understand' the dome in a manner which violates its original function. Most modern observers probably pay little attention (and may barely 'see') the group of trumpeting angels who appear simultaneously as sculptural adornments to the illusionistic architecture and as a real apparition in the space of the dome. But the tourist's ability to read the illusion at all is based on a shared and unstrained ability to grasp the fundamental visual point, namely that Pozzo has painted something which can begin to function visually as a real dome.

In reply it may be argued that the tourist remains, albeit in a debased way, an inheritor of the optical and architectural conventions pioneered by the Renaissance and Baroque designers, and that the tourist's reading of the classical columns and other features is only *relatively* unsophisticated when compared to Pozzo's critics or an architectural historian. I would not deny that recognition of the forms is a powerful element in our ability to read them spatially. Anyone totally unacquainted with such forms as ionic capitals, volutes and oval windows would have greater difficulty in reading all the individual elements of the image entirely unambiguously. We also know that orientation is im-

portant in our ability to read complex and subtle configurations. Just as it is difficult to read nuances of expression in an upsidedown face, so the tortuous groups of interlocked figures on the nave ceiling only assume full coherence when the viewer turns to read them the right way up. Recognition thus plays a fundamental rôle in resolving particularly complex passages of illusionistic description. But there remains the fundamental force of the framework of regular forms in recession which not only permits us to articulate the less lucid motifs but also allows us to perform the act of recognition at all. I should like to suggest that the architectural framework would be as spatially effective — though less artistically engaging — if it were reduced to a series of horizontal and orthogonal lines which possessed no obvious reference to recognisable forms. Such abstract demonstrations are in fact common in the earlier stages of perspectival treatises such as that by Pozzo.

I am convinced that there is a non-arbitrary aspect to our spatial reading of a certain range of clues, and that this propensity directly reflects one of the most functionally important aspects of our perceptual apparatus. I do not mean that a perspective image replicates a universal visual experience in terms of a straightforward match. Indeed, I do not believe that the process of seeing and knowing results in a unitary and matchable image as such. Rather, I mean that perspective selectively exploits a set of automatic perceptual responses which normally serve the purpose of allowing us to judge our present relationship and forecast our future relationships with the objects around us. One group of responses is dedicated to the unbelievably rapid extraction and collation of a series of spatial readings which rely upon sets of phenomena in diminution — line, scale, texture, clarity, occlusion etc. The diminutions are taken as genuinely referring to differences in spatial position rather than as the result of a systematic grading of such effects in the same plane. The effects produced by one phenomenon may assume a dominant value in such a way as to render other sets of effects irrelevant or to override contradictory and inconsistent readings in other areas. It is impossible to draw up a league table of dominant and less dominant effects which reflects the perceptual result in all circumstances. However, our response to an interlocking and consistent series of linear effects which evoke geometrical recession does often seem to have an ability in many circumstances to dominate other potentially powerful clues. This dominance is illustrated by the famous Ames room or by the related illustrations [PL. 39], in which we

automatically settle for the consistent reading of the geometrical clues, with the consequence that the relative human scales are wildly mis-read.

We may fairly suppose that the especially geometrical nature of the environment which Western urban man has made for himself pre-disposes us to place particular reliance on geometrical clues, and that other criteria may be of greater potency for observers from different cultures. However, any relative differences in weighting that may exist do not mean that any of the criteria are arbitrary in themselves or in relation to each other. Observers predisposed to a particular set of visual emphases should not prove incapable of handling major sets of clues limited to other areas. The problem in conducting what seem to be the obvious tests — the showing of perspectival and other images to peoples of widely divergent cultures — is that no observer is likely to bring to the test images a totally innocent response to artificial markings on flat surfaces. Artificial images inevitably invoke expectations of form and function. The idea of the 'primitive observer' in the sense sought after by some experimenters is a chimera — though I may add paren-thetically that some of the images used by investigators certainly show that there are 'primitive' researchers.[12]

When I argue that sets of visual clues act in a non-arbitrary manner and that a perspectival image evokes enough features of one or more of these sets so that the clues of flatness are superceded — as the result of a complex compound of automatic and conscious collusion — I am not supposing that the perspectival painting of the Pozzo kind or even the less exalted naturalism of, say, a Dutch seventeenth-century genre painter, is somehow inevitable or right or necessarily possesses a special value over other systems of representation. The impetus which leads towards perspectival painting is period-specific. Illusionistic art will only come into being when a series of mutually reinforcing con-ditions arise. The most basic of these concerns the function of the image. Only if one of the causes of its making includes the specific predicate that 'this is how such-and-such looked, looks or will look from a particular position and under particular circumstances' will artists embark on the arduous search for ever more perfect devices to achieve the suspension of our disbelief. With respect to the phases of geometrically-based illusion that were generated in Renaissance and Baroque art, we may also say that a necessary condition is that the culture should place an inherent value on mathematical procedures, not only in functional terms but also as indicative of a higher order of

knowledge. Pozzo's own brand of transcendent perspective is a particular species within a genus of art which uses proportional recession in space for ends which are simultaneously visual and philosophical.

Although his use of illusion is ultimately period-specific and indeed place-specific to a high degree, I do not think his interlocking of form and meaning, of space and significance, is essentially any different from that in any process of seeing, knowing and representing. Content and the striving for recognition are inseparably involved in all our normal acts of seeing. I do not believe that there is such a thing as meaningless seeing under any circumstances — even in the psychological laboratory. During even our lowest levels of apparently inactive vision, when we seem merely to be absorbing visual 'noise', our particular circumstances ensure that the unconscious retention of filtering mechanisms are directed towards value and significance. The processing and accessing of perceptions for the purposes of memory and representation will generally occur at higher levels of selectivity for functional significance. Furthermore, I do not believe that our memory contains a neat series of archetypal images or schemata as the minimal *formal* configurations for recall and representation, as if they existed as a series of primitive models within the mind. Nor do I believe that images of objects are stored as linguistic units. Rather, I suspect that memory contains a flexible and variously accessible amalgam of associations which are neither visual nor verbal, though embodying aspects of both of these. The functions of visual representation and systems of language is to permit the selective realisation and structuring of some of these associations in particular functional contexts. But we should not mistake these artificial realisations as direct matches for memory images. The experimental psychologists and philosophers of perception may resort to their hollow cubes and duck-rabbit illusions as much as they may like, but they should recognise that such devices stand in a highly artificial relationship to the multivalent way in which form, significance, context, expectation and memory interact in our reading of figurative paintings, no less than in our viewing of nature itself.

It is on the basis of such incompletely formed and as yet largely untested ideas that I can at the same time regard a perspectival painting like Pozzo's as reliant upon perceptual collusion in a non-arbitrary way and interpret it as entirely dependent for its particular existence on the limiting constraints of a particular set of cultural assumptions. In other words, the existence of the painted illusion as an object for perceptual

collusion is irredeemably dependent upon cultural allusion — but it is not visually arbitrary.

University of St. Andrews

NOTES

* The research on which this paper is based was part of a programme undertaken at the Institute for Advanced Study at Princeton and was financed by the Institute, the Leverhulme Trust, the British Academy and the Carnegie Trust for the Universities in Scotland.

[1] E. Panofsky, 'Die perspektive als "symbolische form"', *Vorträge der Bibliothek Warburg* (1924—5), (Leipzig/Berlin: Phaidon, 1927), pp. 258—330. E. H. Gombrich, *Art and Illusion*, (New York: Partheon Books, and London 1960), (2nd revised ed., Princeton, 1961), and more recently *The Image and the Eye*, (Oxford: Phaidon, 1982). A general review is provided by M. Kemp, 'Seeing and Signs: E. H. Gombrich in Retrospect', *Art History*, **VII**, 1984, pp. 228—43.

[2] For an outline of Panofsky's theories and his sources, see M. A. Holly, *Panofsky and the Foundations of Art History*, (Ithaca and London: Cornell University Press, 1984).

[3] Pozzo's paintings were complete by 1694. See B. Kerber, *Andrea Pozzo*, Berlin, 1971. For the background to the foundation of the Church and its design by Orazio Grassi, see E. Rinaldi, *La foundazione del Collegio Romano*, Arezzo, 1914.

[4] A. Pozzo, *Perspectiva pictorum et architectorum*, 2 vols., Rome, 1693 and 1700, translated into English, French, German and Dutch, including J. James's translation as *Rules and Examples of Perspective proper for Painters and Architects*, London 1707.

[5] For a survey of illusionistic techniques see E. Sjöstrom, *Quadratura. Studies in Italian Ceiling Painting*, (Stockholm: 1978).

[6] *Perspectiva*, text to accompany his Figure 100. [See Plate 31]

[7] A. Pozzo, *Breve descrizione del disegno della Cappella di Sant' Ignazio*, Rome 1697.

[8] *Perspective*, introductory letter to the reader.

[9] J. Baltrušaitis, *Anamorphic Art*, trs. W. J. Strachan, Cambridge, 1977, especially p. 37ff.

[10] A. Kircher, *Ars Magna Lucis et Umbrae*, Rome, 1646.

[11] *Perspectiva*, text to accompany his Figure 91. [See Plate 30]

[12] I am thinking particularly of the famous hunting scene used by W. Hudson, 'Pictorial Depth Perception in Sub-cultural Groups in Africa', *Journal of Social Psychology*, **LII**, 1960, pp. 183—208, which is visually illiterate by the standards of any pictorial tradition. For a general review of this area, see J. B. Deregowski, 'Illusion and Culture', *Illusion in Art and Nature*, (P. L. Gregory and E. H. Gombrich, Eds.) London, 1973, pp. 161—91.

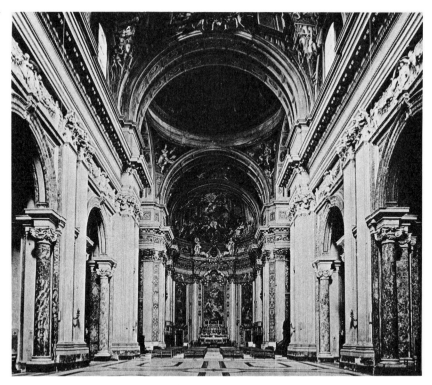

Plate 28. *Church of Sant' Ignazio*, Rome, general view of interior looking East.

Plate 29. POZZO, Andrea. *Perspective Projection of a Column and Other Architectural Elements Using the Distance-Point Method*, from the *Perspectiva Pictorum et Architectorum*, Rome, 1693—1700.

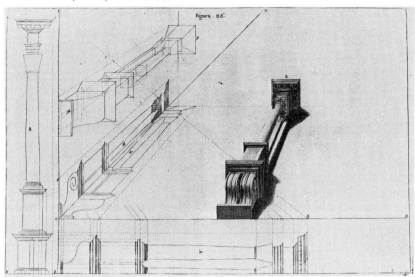

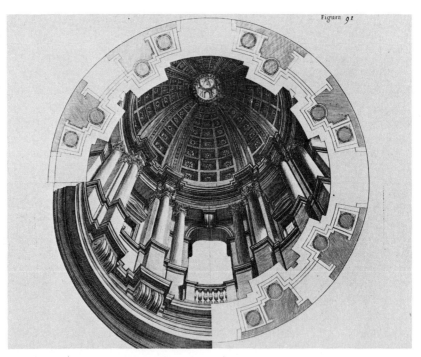

Figura 91

Plate 30. POZZO, Andrea. *Demonstration of the Scheme for the Painted Dome of Sant' Ignazio, Showing the Plan of the Drum*, from the *Perspectiva*.

Plate 31. POZZO, Andrea. *Demonstration of the Use of a Grid of Strings to Project the Illusionistic Design on to the Curved Vault of the Nave of Sant' Ignazio*, from the *Perspectiva*.

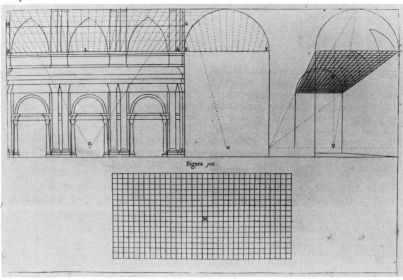

Figura 100

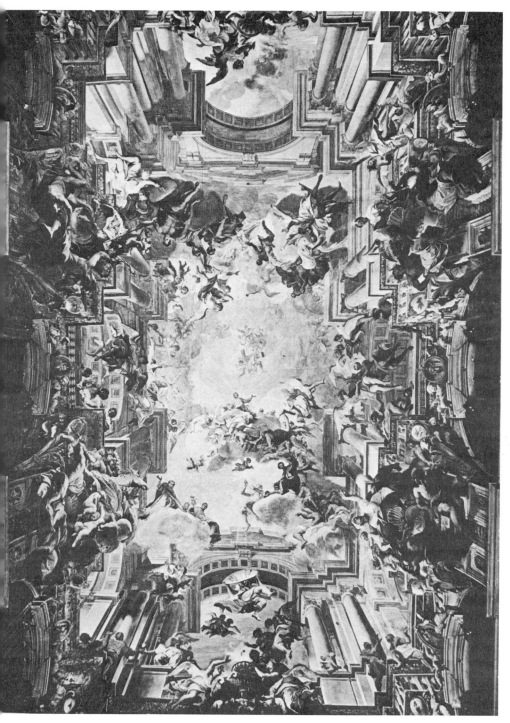

ate 32. POZZO, Andrea. *Ceiling Fresco of the Nave of Sant' Ignazio.*

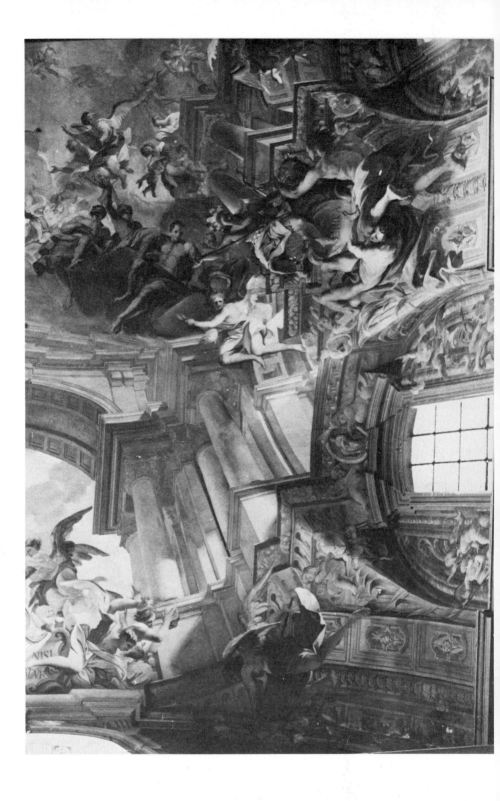

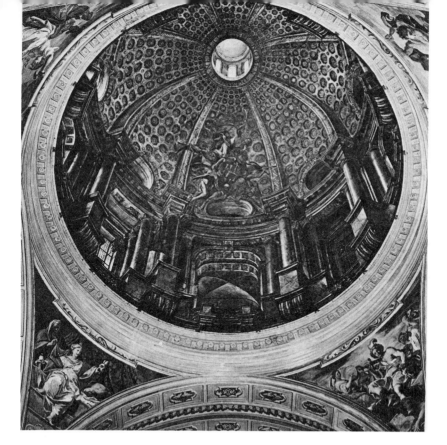

Plate 34. POZZO, Andrea. *Painted Dome of Sant' Ignazio.*

Plate 35. *Photographic Reproduction of the Dome of Sant' Ignazio. Photographed from an Off-Centre Viewpoint.*

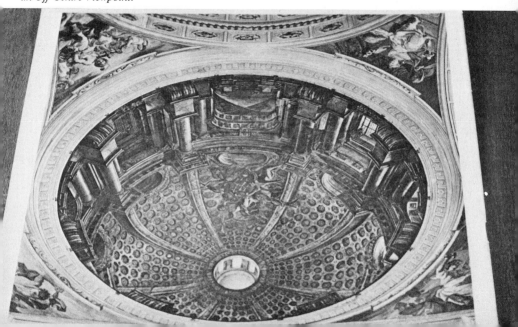

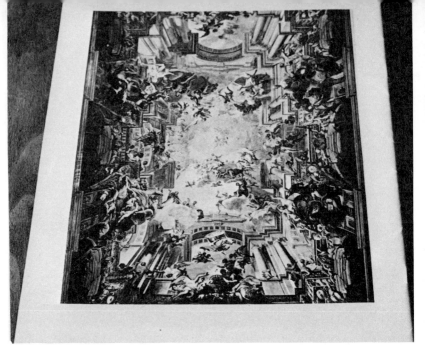

Plate 36. *Photographic Reproduction of the Nave Ceiling of Sant' Ignazio. Photographed from an Off-Centre Viewpoint.*

Plate 37. LAURETI, Tommaso. *Triumph of Christianity over Pagan Idols*, Ceiling of the Sala di Costantino, Vatican, Rome.

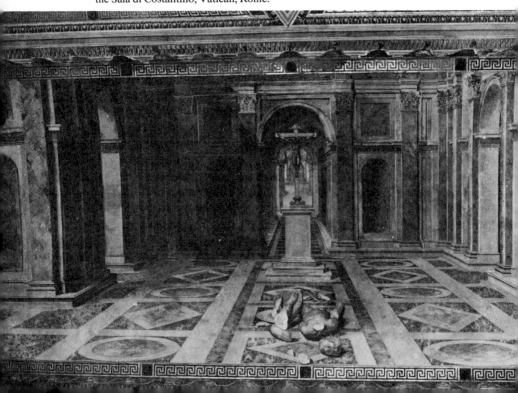

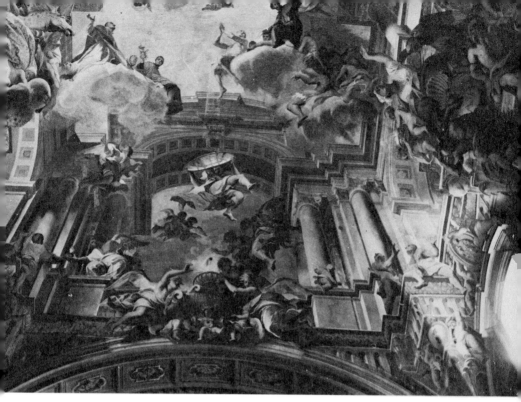

Plate 38. POZZO, Andrea. *Detail of the East End of the Vault of Sant' Ignazio Showing the Angel with a Mirror.*

Plate 39. *The Size-Distance Illusion.*

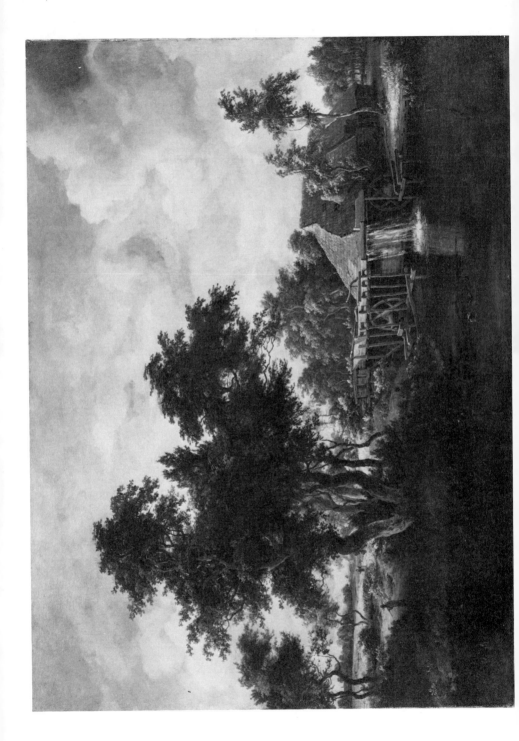

KENDALL L. WALTON

LOOKING AT PICTURES AND LOOKING AT THINGS

One way to "represent" something is to make a picture of it. Another
is to describe it or refer to it in words. Pictures are *visual* representa-
tions; words are *verbal* ones. But this difference is elusive. We *look* at
words as well as pictures; representations of both kinds are for the eyes.
How is pictorial representation more *visual* than verbal representation?

It is often said that pictorial representation is somehow "natural,"
whereas verbal representation is merely conventional. Traditional ac-
counts of this naturalness speak of resemblances between pictures and
what they picture; some even postulate illusions. A picture of a dog
looks like a dog, it is said; but the word "dog" means dog only because
there happens to be a rule or agreement or convention, in the English
language, to that effect. This may seem to accommodate the idea that
pictures are visual in a way that words are not.[1]

But resemblance theories of depiction, the most obvious formula-
tions of them at least, have run into serious difficulties. It has been
widely recognised that conventions of one sort or another have much to
do with depiction, as well as verbal languages. One cannot help being
impressed by the variety of pictorial styles, by the many *different* ways
there are of picturing a dog or a person or a building. Some have urged
that these differences amount to mere differences of "convention," that
we have many different pictorial "languages" and that the choice among
them is to some extent arbitrary. If this is so, how is it that pictorial
representation differs from verbal representation by being "natural"
rather than conventional? And what becomes of the idea that pictures
rely on resemblance in a way that words do not?

I am interested not only in the nature of depiction and how depic-
tions differ from descriptions, but also in differences among pictorial
styles, especially differences of "realism." *Realism* is a monster with
many heads, which desperately need to be untangled from each other.
Resemblance theorists have a quick if crude way of accounting for one
sort of realism, at least. Similarity has degrees, they point out, and some
kinds of pictures look more like what they portray than others do.
Realistic pictures are supposedly ones which look *very much* like what
they portray, or ones which present especially convincing illusions.

277

Andrew Harrison (ed.), Philosophy and the Visual Arts, 277—300.
© *1987 by D. Reidel Publishing Company.*

But if we are to understand picturing in terms of conventions rather than resemblance or illusion, if we regard different pictorial styles as different "languages" and resist the idea that some are more "right" or more "natural" than others, assimilating differences between Renaissance perspective painting and Impressionism and Cubism to those between English and German and Swahili, one may wonder whether there will be any room for realism. Calling a dog a "dog" is not a more or less realistic way of referring to it than is calling it a "hund." If Cubism simply amounts to a system of conventions, a language, different from that used by Vermeer, for instance, how is Vermeer's way of portraying things any more realistic than a cubist one? [2]

Most disputes about the role of resemblance in depiction and pictorial realism have been misguided, in my opinion. Theorists have looked for resemblances in the wrong place. Rather than asking about resemblances between pictures and the things they picture, we should consider resemblances between *looking* at pictures and *looking* at things. The significant similarities are to be found between the acts of perception, not between the things perceived. It is these which illuminate the sense in which depiction is more "natural" and less arbitrary than verbal representation, and which are linked to pictorial "realism," in some important senses of this extraordinarily slippery term.

To begin, I will sketch, very briefly, what I think pictures are. [3]

Pictures are props in games of make-believe. They function in many ways as dolls, hobby horses, and toy trucks do. (There are important differences too, but I will focus on the similarities now.) We can speak of the *world* of a game of dolls — in which the participants bathe and dress babies, rock them to sleep, etc. Likewise, there are worlds (fictional worlds) associated with the games viewers play with paintings.

Propositions which are "true in the world of a game" are, I will say, "*fictional.*" Some fictional truths in a game of dolls are generated by the props alone, by the dolls; others are generated by the participants, or by the props and participants together. It is fictional that there is a baby in a crib, if there is a doll in a toy crib, and it is fictional that Heidi is dressing a baby when Heidi puts doll clothes on the doll. In the game which a viewer plays with Meindert Hobbema's *The Water Mill with a Great Red Roof* [PL. 40] it is fictional that there is a mill with a red roof. This fictional truth is generated by the prop itself, but others depend on the viewer and what he does in front of the painting. It is

fictional that the viewer sees a mill with a red roof, and perhaps that he notices a peasant in the shadows of a doorway.

The world of the appreciator's game is distinct from the world of the work he is appreciating, though the two are closely related. The appreciator does not belong to the world of the work (unless it happens to be a portrait of him), but he does belong to the world of his game. Roughly, the world of the work contains only fictional truths generated by the work itself. The work of the appreciator's game contains fictional truths generated both by the work and by the appreciator, and also by the two in combination.

Novels and stories are props in games of make-believe also. What distinguishes pictures is the fact that they are props in *visual* games, reasonably rich and vivid visual games. (It is *this* that makes depiction a visual medium, unlike the novel, even though we use our eyes in both cases.) There are many visual actions which, fictionally, the spectator may perform. Fictionally the viewer of *The Water Mill with a Great Red Roof* sees a mill. It may also be fictional that he notices the woman in the doorway, that he looks for squirrels in the trees, that he examines the wood for worm holes, that he gazes casually toward the fields in the distance, and so on. A relatively rich visual game is one which allows the spectator fictionally to perform a large variety of visual actions.

Fictional truths about the viewer's visual activities are generated by his actual visual actions, by his actually looking at the picture in various ways. What makes it fictional that he notices a woman in the doorway is the fact that, in looking at the painting, he really notices that it is fictional that there is a woman in the doorway.

Moreover, it is fictional (*de re*) of his lookings at the painting, that *they* are acts of looking at a mill and its surroundings. His noticing that fictionally there is a woman in the doorway not only makes it fictional that he notices a woman in a doorway; it makes it fictional that his noticing this fact about the painting is itself an act of noticing a woman in a doorway.

I have not explained what it is for something to be fictional, to be "true-in-a-picture," or "true-in-the-world-of-a-game." For now, let me say only that there is a very close connection between what is fictional and what appreciators *imagine* to be the case. The viewer imagines that there is a mill with a red roof; he imagines himself to be seeing a mill; and he imagines his act of looking at the canvas to be an act of looking at a mill. The vividness of a visual game of make-believe is connected

with the vivacity with which spectators imagine the propositions which are fictional in the game.

My claim is that *all* representational pictures bring the viewer into a fiction, a game of make-believe, together with the people and objects which are depicted. Certain art historians — Alois Riegl and Michael Fried, for example — have taken pains to emphasize differences in the extent to which different works invite the viewer in or recognise him.[4] Certainly there are such differences. Perhaps they have to do with the degree of vivacity with which the viewer imagines himself to be in the presence of the subjects, or the extent to which he is encouraged to elaborate in imagination on his relationships to the subjects. My point now is a more basic one which concerns pictorial representation in general. It can be brought out by contrasting pictures with novels. Spectators of all pictures imagine themselves to be seeing things of the kind represented, in a way in which readers of novels do not.

Here is an objection: We can play whatever game of make-believe we like with a given prop. We could choose to play visual games with verbal texts. But surely this wouldn't transform the texts into pictures.

The answer is that we are *not* free to play any game we wish with a given prop. It would be awkward to say the least to play visual games with texts as props, and next to impossible to use them for visual games of any significant richness and vivacity.

Some things are much better suited to serve as props in games of certain kinds than others are. A tree makes a fine make-believe mast on a pirate ship. A tunnel or a watermelon would make a terrible one. A game of pirates in which to crawl through a tunnel, or to eat a water-melon is fictionally to climb a mast, is unlikely to be very rich or vivid. (What would count as fictionally swaying with the mast in the wind, or fictionally grabbing a spar to keep from falling, or fictionally scanning the horizon for merchant vessels?)

Pictures make much better props in visual games of make-believe than verbal descriptions would (given their respective semantic charac-teristics). This is because looking at pictures is analogous to looking at things, in ways in which looking at verbal descriptions is not.

The analogies in question do not hold equally for all kinds of pictures. Because of these differences, the visual games in which painted canvases of various kinds are props vary in richness and vividness, and in other important respects. This will allow us to distin-guish between pictures which are more and less "realistic." It will also

help to illuminate differences among pictorial styles which are not naturally described as differences in realism.

In what ways is looking at a picture like looking at things? I do not mean to compare the visual sensations or phenomenological experiences which viewers of pictures and observers of things enjoy. (It is not obvious how this comparison could be separated from a comparison between the visual characteristics of pictures and the visual characteristics of things. Both, it seems, would amount to comparing *how pictures look* with *how things look*.) The comparison I am interested in is between the process of investigating the "world of a picture" by inspecting the picture and the process of investigating the real world by looking at it, between visual examinations of people and landscapes in pictures and visual examinations of actual people and landscapes.

Consider a spectator examining Hobbema's *The Water Mill with a Great Red Roof*, and also a person looking at an actual scene of the kind this painting portrays, a red roofed mill near a cluster of large trees, with ducks in a pond in front of the mill and several peasants in the background. (Let us suppose that the second person is situated at a place corresponding to the point of view of the painting, i.e. that he is standing on the left bank of the river some 200 yards downstream from the mill.) What I want to compare is the process by which the viewer of the painting ascertains that fictionally there is a red roofed mill near a cluster of large trees, ducks in a pond, and so on, with the process by which the observer of the actual scene ascertains that there is actually a red roofed mill near a cluster of large trees, and ducks in a pond, etc.

Several points of analogy are obvious. The investigations are both visual ones; we use our eyes in both cases. And the two investigations yield similar kinds of information — information about visual characteristics of the world of the picture in the one case, and visual characteristics of the real world in the other. The spectator of the painting discovers the redness of the mill's roof, the size and approximate number of trees, the presences of peasants, ducks, etc., in the picture-world; the observer of the actual scene is likely to discern similar features of the real world. (More precisely, the viewer of the painting ascertains the *fictionality* of propositions whose *truth* the observer of the actual mill and its surroundings might well ascertain.) Neither viewer is very likely to learn the marital status of the (fictional or actual) peasants, or their taste in wine, or the names of their siblings,

although conceivably either might draw inferences about such matters from facial characteristics or other more obviously visual information.

A third analogy is a correspondence in the *order* in which the two observers acquire their information. A quick glance at the painting may reveal that fictionally the mill has a red roof and that there is a peasant carrying a long tool silhouetted against the bright fields. A later and longer look will reveal that the tool is a hoe and that there is a woman hidden in a dark doorway. Perhaps only after a careful and extended examination of the picture will we discover knots in the wood of the mill, subtleties of the woman's facial expression, or warts on her hand. The sequence is "realistic." The person observing the actual mill (from the point of view and in the circumstances in question) is likely to notice the red roof before noticing that the peasant's tool is a hoe, and only after that pick out knots in the wood or warts on the woman's hands.

Already we are beginning to see why it is so natural for the viewer of the painting, as he notices that fictionally there is a mill with a red roof, a woman hidden in the shadows of the doorway, knots in the wood, and so on, to imagine that he is looking at an actual mill and observing that it has a red roof, that there is a woman in the doorway, etc.

How unique are these three points of analogy? Suppose one reads a story about a red roofed mill. The reader uses his eyes, of course, to learn about the fictional mill. But much of the information he acquires about it may not be visual information. The story might tell us that the peasant was born in Haarlem and has three children, that one of her children is asleep inside the building, that she is thinking about the price of grain. And it may neglect to specify the color of the mill's roof or to mention the trees surrounding it. If it does concentrate on visual features of the scene, this information may be presented in an unlikely order. The reader might learn first of a wart on the woman's hand and only much later of the mill's prominent red roof.

Consider the opening passage from Faulkner's *The Bear*:

There was a man and a dog too this time. Two beasts, counting Old Ben, the bear, and two men, counting Boon Hogganbeck, in whom some of the same blood ran which ran in Sam Fathers, even though Boon's was a plebeian strain of it and only Sam and Old Ben and the mongrel Lion were taintless and incorruptible.

He was sixteen. For six years now he had been a man's hunter. For six years now he had heard the best of all talking. It was of the wilderness, the big woods, bigger and older than any recorded document. . . .

This passage is more visual than many in literature. Nevertheless, it is as awkward and strained to imagine one's reading it to be an instance of looking at a scene of the kind described as it is to imagine of one's crawling through a tunnel that it is an action of climbing the mast of a pirate ship. (Of course one can easily imagine, *while* reading the passage, that one is watching a party of hunters. But this is a very different matter.)

Although most stories and novels are such that reading them is not much like looking at things, in the ways we have so far considered, there can be exceptions. It is possible for a story to provide only visual information about a scene and to present it in a sequence in which an observer of the scene might actually learn it. An author might "write from life"; he might sit in front of a mill and simply record what he observes over his typewriter as he observes it. The works of Alain Robbe-Grillet come to mind. Here is the opening of his *Jealousy*:

Now the shadow of the column — the column which supports the southwest corner of the roof — divides the corresponding corner of the veranda into two equal parts. This veranda is a wide, covered gallery surrounding the house on three sides. Since its width is the same for the central portion as for the sides, the line of shadow cast by the column extends precisely to the corner of the house; but it stops there, for only the veranda flagstones are reached by the sun, which is still too high in the sky. The wooden walls of the house — that is, its front and west gable-end — are still protected from the sun by the roof (common to the house proper and the terrace). So at this moment the shadow of the outer edge of the roof coincides exactly with the right angle formed by the terrace and the two vertical surfaces of the corner of the house.
 Now A . . . has come into the bedroom by the inside door opening onto the central hallway. . . .[5]

Investigating the world of *this* story by reading it will be much like learning about an actual mill by looking at it, in the respects I have mentioned so far.

But there are other correspondences between looking at pictures and looking at the world which are much more difficult to duplicate in a verbal medium.

Some have to do with why it is that we make discoveries in the order that we do. It is because the red roof in the painting is more obvious, more striking visually, than the knot in the wood that it is likely to be noticed first. This might well be true of the actual scene, of course. But if, in reading a story, one learns that fictionally a mill has a red roof before learning fictional truths about a knot in the wood, one does so

because of the order in which the sentences of the story occur, not because the red roof springs from the pages and forces itself on our attention. Detecting the knot does not require a closer examination of the text than detecting the red roof does. One just reads the sentences as they come.

Also, of course, the viewer of the painting, like the spectator of life, has some choice about what he looks at when. If a story is read in the normal manner, from the beginning to the end, the reader makes no similar decisions; the order of his discoveries is determined by the author.

We see, again, how it is much easier to imagine one's examination of the picture to be an examination of a real mill than to imagine this of one's reading of a story, even a story "written from life" in the manner of Robbe-Grillet. Being struck by the prominent red patch on the canvas from which one learns that fictionally the mill has a red roof, is much more naturally imagined to be an instance of being struck by the red roof of a (real) mill, than is methodically reading on in a story. Searching deliberately for marks on the canvas which would portray squirrels in the trees is more naturally imagined to be looking deliberately for (actual) squirrels, than is perusing sentences in a text in the order the *author* chose, even if, as it happens, one learns thereby that fictionally there are squirrels in trees.

There is a certain openendedness to the task of visually investigating our (real-world) surroundings. There seems always more to be learned about things by examining them more closely or more carefully. Likewise, one can continue more or less indefinitely discovering fictional truths in Hobbema's painting: details about the grain of the wood, the expressions on the peasants' faces, the precise dimensions of the building and the pond in front of it. But there is a definite limit to what fictional truths can be learned from a description (though one may always continue reflecting on and digesting what he has learned). One can *finish* reading a novel, but there is no such thing as completing the task of examining a painting or that of visually investigating the real world. One does not stop to *contemplate* a text, as one does a picture. One simply reads each sentence, and goes on to the next, and the next until one comes to the end.

This point is not as clear cut as it may first appear. There are limits

to how closely we can look at a picture, and to our powers of dis-
crimination. These can be extended by the use of magnifying glasses
and microscopes, in theory indefinitely, perhaps. But the "information"
in pictures often runs out even before optical instruments come into
play. The image dissolves into blobs of paint or black dots, and it
becomes clear that closer looks will not reveal anything more about the
fictional world.[6] (This happens sooner for pictures of some kinds —
tapestries, mosaics — than for others.) It is significant that approxi-
mately when we see that the information is running out we no longer
see the picture as a picture, we no longer see a mill or a bowl of fruit or
a person in it. As long as one examines a picture in a *normal* manner,
seeing it as a picture, one does not exhaust the fictional truths which it
generates. No ordinary examination of Hobbema's painting will reveal
all of the fictional truths that can be extracted from it; there is always
more to be found. In this respect looking at the picture *in the usual
manner* is like looking at life.

The openendedness of the task of "reading" pictures is related to the
fact that the experience of *seeing as* or *seeing in* — the experience, for
instance, of seeing a red-roofed mill in a design — is not a momentary
occurrence but a continuous state. One continues to see a mill in a
picture for a period of short or long duration. But there seems to be no
comparable continuous state connected with descriptions. Does one see
an inscription of the word "elephant" as meaning elephant for thirty
seconds, or for five minutes? It may be true throughout a period of
thirty seconds or five minutes that one takes this word token to have
that meaning, but doing so is not a *perceptual* state and need not
involve seeing the inscription throughout the period. One does per-
ceptually recognize the word and grasp its meaning, but this is a
momentary occurrence (or possibly two momentary occurrences), not a
continuous state, even if the recognition or grasping comes only with
difficulty. My point is not that the state of seeing a picture as a man is
one of constantly discovering new fictional truths. Rather it is the
constant *possibility* of making new discoveries which sustains the state.

The openendedness of examinations of pictures is connected with
Goodman's claim that pictures necessarily belong to "dense" symbol
systems. I don't think Goodman is right about this. A system of
mosaics, for instance, might fail to be dense but be pictorial nonethe-
less. But pictorial systems do tend to be dense *"up to a point"* at least,

a point which is frequently beyond the limits of discrimination when pictures are examined in the normal manner. And this fact contributes to the openendedness of pictorial investigations.

The important point is that we can now see *why* pictorial systems are dense, insofar as they are. Density contributes to a significant analogy between visual investigations of picture worlds and visual investigations of the real world, and so to the ease with which the former are imagined to be the latter.

Another significant analogy between examining the world of a picture and examining, visually, the real world concerns what is easy to ascertain and what difficult, and what mistakes the investigator is susceptible to.[7] In these respects also examinations of both of these kinds contrast sharply with readers' investigations of the worlds of verbal representations.

In estimating the height of a tree by looking at it, small errors are more likely than large ones. It is easier to mistake an 85 foot tall tree for an 85.0001 foot tree, than for one which is merely 35 feet tall. This holds for picture-trees as well as for real ones. Smaller mistakes in estimating the height of trees in Hobbema's painting are more likely than larger ones.

The reverse is often true for trees in stories. The numerals "3" and "8" are readily mistaken for each other. An inattentive reader might easily take an 85 foot tall (fictional) tree to be merely 35 feet high. This enormous mistake is much *more* likely than many smaller ones. The reader is not very likely to suppose that the tree in the story is 85.0001 feet high rather than a mere 85 feet high, since "85" and "85.0001" are easily distinguishable.

It is relatively easy to confuse a *house* in a story with a *horse* or a *hearse*, a *cat* with a *cot*, a *madam* with a *madman*, *intellectuality* with *ineffectuality*, *taxis* with *taxes*, and so on. But when we examine either the real world by looking at it, or picture worlds, houses are more apt to be mistaken for barns or woodsheds than for hearses or horses, cats are harder to distinguish from puppies than from cots, etc.

The mistakes perceivers are susceptible to correspond to similarities among things themselves. Things which are hard to discriminate perceptually are things which really are similar to each other in some respect. An 85 foot tree resembles one which is 85.0001 feet more closely than it does a 35 foot tree. Houses are more like barns and

woodsheds than like horses or hearses. In fact, the degree of similarity explains the likelihood of confusion. It is *because* 85 and 85.0001 foot trees are very similar that they are difficult to distinguish.

So there are substantial correlations between difficulty of discrimination, when we look at the real world, and similarities among things. In *this* sense we can be said to perceive things as they really are. Pictorial representations largely preserve these correlations.

But descriptions scramble the real similarity relations. Houses are not much like horses or hearses. The difficulty of distinguishing a house from a horse in a story has nothing to do with similarities between the house and horses; it is due to similarities between the *words* used to describe them. So we think of the words as getting between us and what we are reading about, in a way in which pictorial representations do not. The words block our view of the objects. No wonder that it is so much easier to imagine, vividly, of one's investigation of a picture that it is a visual examination of the world, than to imagine this of one's reading of a story.

We now have the tools to understand a couple of possible representational systems mentioned by Richard Wollheim:

> . . . we could imagine a painting of a landscape in which, say, the colours were reversed so that every object — tree, river, rocks — was depicted in the complementary of its real colour: or we could imagine, could we not?, an even more radical reconstruction of the scene, in which it was first fragmented into various sections and these sections were then totally rearranged without respect for the look of the landscape, according to a formula? And in both cases it seems as though there is nothing in the . . . view [that representation is a kind of code or convention] that could relieve us from classifying such pictures as representations. Yet ordinarily we should not be willing to concede that this is what they were, since it is only by means of an inference, or as the result of a 'derivation', that we are able to go from the drawing to what it is said to depict. There is no longer any question of seeing the latter in the former. We have now not a picture that we look at, but a puzzle that we unravel.[8]

I agree that if "reading" a representation is an inferential process of the kind described, if one must first ascertain the relevant features of the representation and then figure out, according to a formula, what fictional truths are generated, the representation is not functioning as a picture for us. Normally the viewer of Hobbema's mill-scape just looks and sees that fictionally there is a mill with a red roof near a grove of trees. If we could not do this more or less automatically, if we had to invoke explicitly the relevant rules of perspective and so forth, the canvas would not be a picture for us.

Fig. 1a. Normal; Witch on Right.

The reason, I would add, is that the process of figuring out on the basis of features of the two dimensional pattern and with the aid of a formula, that fictionally there is a red-roofed mill, etc., can hardly be imagined vividly to be an instance of looking (at the real world) and noticing a red-roofed mill, etc.

What about Wollheim's examples? Is it *impossible* that the representation with its colors reversed, or the systematically scrambled one, should be *pictures*? I suspect that with sufficient practice we could become so familiar with these systems and so adept at "reading" representations in them, that we wouldn't have to figure out what fictional truths are generated, but could just look and see. If we did Wollheim, apparently, would be willing to call the representations pictures.

But I am suspicious. The ability to read representations automatically is clearly not sufficient for their being pictures; we read words automatically, after all.

Fig. 1b. Scrambled; Witch on Right.

Consider a scrambled system whereby the parts of pictures in some normal system are rearranged according to the following schema:

Normal				Scrambled		
1	2	3		6	4	2
4	5	6		5	3	1

Figure 1b is the scrambled version of the normal picture, 1a. Understood in their own systems, they generate the same fictional truths — the "world of the picture" is the same in both cases. Each depicts a tree in the center of the scene and a witch on the far right. Since the Scrambled System is foreign to us, we have to do some calculating to figure out what is going on in Figure 1b. We understand 1a much more readily.

Fig. 2a. Scrambled; Witch on Right.

But suppose that after long experience with both representational systems we develop the ability to "read" pictures of both kinds automatically. There still will be important differences in the processes of investigating them. The scrambling drastically alters the ease or difficulty with which various fictional truths are ascertained, even for observers equally fluent in the two systems. A viewer practiced in reading pictures in the Scrambled System could presumably tell at a glance that the witch in 1b is not near the centre of the scene, not above the tree, but is far to one side or the other. (If she were in the centre her portrayal on the picture surface would be in one of the two rectangular areas indicated in Figure 1b, and it obviously is not). But it is not so easy even for the practiced viewer to tell *which* side of the scene she is on, whether she is far to the left or far to the right — whether she is coming or going. In 2a she is on the right. In Figure 2b she is on the left. These two pictures are not readily distinguishable.

Fig. 2b. Scrambled; Witch on Left.

Contrast the ordinary, unscrambled versions of these pictures: Figures 3a and 3b. In 3b the witch is approaching on the far left; 3a shows her far to the right on her way to other mischief. It is easy to tell which is which.

Examining the worlds of ordinary pictures like these is clearly more like looking at the real world than is examining the worlds of the scrambled ones, even for a viewer thoroughly fluent in the Scrambled System. When in real life would one notice quickly that a witch is *either* far to the right or far to the left, and not be able to tell which without looking much more closely?

I do not suggest that the scrambled pictures are not pictures. Looking at them is, in many *other* respects, like looking at the world, and they do function as props in visual games of make-believe which are *reasonably* rich and vivid. Certainly each of their six segments qualifies as a picture. Nevertheless, the differences between them and their unscrambled cousins are important. We might characterize them as differences in degrees of 'realism'.

Fig. 3a. Normal; Witch on Right.

(Incidentally, the scrambled system has every right to be regarded as *dense*, in Goodman's sense, both syntactically and semantically, if the unscrambled one is, and is just as replete. Goodman's account of pictures fails to distinguish between them.)[9]

Wollheim's scrambled system is not just an academic exercise. Various artists have employed what amount to scramblings in their work, most obviously the Cubists,[10] although the principles on which their scramblings are based are typically very unsystematic and much more complex than those employed in our artificial example. Often viewers have to divine the system by which the pieces are arranged from the picture itself. Another example is Paul Citroën's photograph, *Metropolis* (1923) [PL. 44] Flashbacks and flash-forwards in film have similar consequences.

We see more clearly now how serious a mistake it is to regard Cubism, for instance, as just a *different* system from others, one with different conventions which we must get used to. It is a system which

Fig. 3b. Normal; Witch on Left.

affects substantially the nature of the visual games in which the works function as props, quite apart from our familiarity with it. The difference I have described bears out the familiar characterization of Cubism as a more intellectual, less visual pictorial style, compared to earlier ones.[11]

We are now in a position to assess the significance of many other features of pictorial styles. In general, I suggest that we look at the nature of the visual games of make-believe works in various styles allow or encourage. (When the games encouraged by certain pictures are reasonably described as richer or more vivid than those encouraged by others we may comfortably speak of differences of "realism." But there are important variations among visual games which are not easily characterised in terms of richness or vividness. Our understanding of manners of depiction should go beyond explaining judgments of realism.)

Consider what I will call the *Sloppy Style* of depiction. Figure 4 is in this style. It would be uncharitable and a little boorish to insist that the walls of the house-in-the-picture are crooked and don't quite reach the ground, and that the structure is listing dangerously to one side. True, the lines of the sketch are not straight and don't connect with each other as they would in a precise architectural drawing. But this *is* Sloppy Style, after all, and lines in Sloppy Style are *expected* to be sloppy. Their sloppiness is not to be read into the fictional world portrayed, but to be accepted as inevitable in that style regardless of what is being portrayed. It is reasonable to allow that fictionally the house is a normal one with normally straight walls which do connect with the ground, etc., notwithstanding the sloppiness of the portrayal.

How does this picture differ from a precise architectural drawing? Neither portrays a house as about to fall down. But there are important differences between the visual games of make-believe we can play with the two drawings. The person who looks at either of them fictionally looks at a house. But nothing which the viewer of the Sloppy Style sketch might do is easily imagined to be looking carefully to see just how straight the walls are. One will not, fictionally, examine the house

Fig. 4. House in Sloppy Style.

closely to see how well made it is. For once we see that it is in Sloppy Style, we realize that further investigation of the lines of the drawing will not reveal fictional truths about details of the house's construction. The person who looks at a more precise drawing of a house, however, might very well fictionally engage in a close scrutiny of the house's construction. A more precise drawing will probably admit of visual games of make-believe which are richer in some respects than ones we might play with the Sloppy Style sketch.

Paul Klee's *Mountains in Winter* [PL. 43] is of an opposite kind. Here the lines are straight, but the mountains aren't. We can reasonably take for granted, I suggest, that fictionally the mountains are rough and ragged, as befits all self-respecting mountains. We might call this *Smooth Style*.

Similar observations can be made about the idealized shapes of Cubist works. Is it fictional that a person has an angular head, if the picture uses angular shapes to portray it? Not if the angularity is thought of as being simply a feature of the style, whatever is being portrayed. Picasso's *Portrait of Daniel Henry Kahnweiler* (1910) [PL. 21] does not portray Kahnweiler as exotically deformed. But our visual game of make-believe is severely limited in certain ways. There will be no such thing as fictionally gazing fondly at the gentle curve of his brow, or fictionally being slightly intimidated by his aggressive, prominent chin.

Let's consider a more involved example. Some pictures portray very explicitly the play of light on the surfaces of objects, rendering shadows and reflections in great detail. Vermeer's works do, and so do many photographs. Other pictures concentrate on the shapes, positions, colors, and textures of objects, while ignoring how light is reflected from them. These include outline drawings and assorted ancient, "primitive," and twentieth century works. Vermeer's *Girl Reading Letter Near Window* (1657) [PL. 42] will serve as an example of the first kind. The second kind of picture is illustrated by Matisse's *The Red Room* (1911, MOMA) [PL. 41] in which the solid, homogeneously coloured table cloth and wall are portrayed by solid coloured, homogeneous stretches of canvas, ignoring shadows, differing angles of the incidence of light on different parts of the table cloth, etc.

What exactly does this difference amount to? Shall we say that the Vermeer contains "information" of certain kinds which the Matisse

lacks? Perhaps, but this difference is not as great as might first appear. It would probably not be fair to say that whereas the Vermeer generates fictional truths about the play of light, the Matisse does not. It is clear that the main illumination in the Matisse comes from the large window on the left. (The window is open, it is large, and since the scene is a daytime one we shouldn't expect there to be any other significant sources of illumination.) So it is reasonable to infer, for example, that (fictionally) the vase casts a shadow on the table in the direction away from the window. The fact that Matisse did not use a darker patch of paint to portray the shadow, as Vermeer would have, can be construed as a characteristic of the style in which his picture is painted, which does not indicate the absence of a shadow in the depicted scene.[12] (This is not to deny the aesthetic importance of the absence of explicitly portrayed shadows and reflections, however; this feature of the work's style contributes significantly, even profoundly, to the expressive character of the painting. But neither the supposition that it is fictional that there are no shadows nor the supposition that it is not fictional that there are shadows is required to explain the contribution. It can be understood to derive from the truncation of spectators' games of make-believe, which I will describe shortly.)

The Red Room does, then, generate some fictional truths about the play of light. It does not generate as detailed or specific ones as we find in the Vermeer, to be sure; the Vermeer contains *more* "information" about the light and shadow than the Matisse does. But a more interesting and important difference between the two works has to do not with what fictional truths are generated, but with the manner in which they are generated, and the effect that *that* has on our visual games of make-believe.

It is only by virtue of generating fictional truths about the position of the window, the position and shapes of the vase and other objects on the table, etc., that the Matisse generates fictional truths about shadows and reflections. Fictionally there is a shadow *because* it is fictional that there is a vase on the table, a window on the left, etc. The Vermeer generates such fictional truths more directly.

Fictional truths about the positions and shapes of objects are in some cases generated more directly in the Matisse than in the Vermeer. Vermeer uses reflections and shadows to indicate the folds of the draperies, for instance, and also textures of surfaces. It is fictional that the draperies fall in such-and-such manner because it is fictional that light it reflected from various parts of them in a certain way.

In short, there are certain relations of dependency among the fictional truths generated by these works, and the dependencies run in opposite directions in the two cases. In the Matisse, fictional truths about the play of light depend on fictional truths about three-dimensional objects. In the Vermeer fictional truths about three-dimensional objects depend, to a considerable extent, on fictional truths about the play of light.[13]

There is a corresponding difference in how we learn fictional truths of the two kinds. Fictional truths about the play of light enable the spectator of the Vermeer to ascertain fictional truths about the spatial configuration of objects. But the viewer of the Matisse must base such judgments on other things — most obviously on lines in the painting indicating the edges of objects. Our access to the world of the Vermeer corresponds more closely to the access perceivers have to the real world. In real life reflections and shadows have a lot to do with our judgments of spatial properties of three-dimensional objects. It is easily understood that, fictionally, we perceive the topography of the drapes by perceiving the patterns of light and shadow on them.

But one might reasonably allow that it is fictional, in our game with the Matisse as well, that our perception of the attitudes of objects are dependent on our perception of light and shade. This fictional truth derives from a general principle to the effect that a fictional world is to be regarded as normal, as similar to the real one, in the absence of explicit indications to the contrary.

The difference that does obtain between the two pictures comes out most dramatically when the observer investigates the perceptual cues underlying his perception of fictional truths about three-dimensional objects. The viewer of the Vermeer inevitably imagines himself to be probing the grounds of his judgments about objects of the kind represented. Fictionally, he notices that certain reflections and shadows are important cues. But the viewer of the Matisse who embarks on similar reflections is soon forced out of the game of make-believe. It may be fictional that shadows and reflections serve him as cues, but nothing he docs is naturally imagined to be investigating and discovering these cues. Examining the *actual* cues underlying his awareness of *fictional* truths about three-dimensional objects is not, for these cues do not include fictional truths about light and shadow.

The visual games one plays with the Matisse are thus attenuated, in a way in which the visual games one plays with the Vermeer are not.

Often in real life we pay no attention to shadows and reflections; we

concentrate on the spatial configuration of three dimensional objects, not even noticing the perceptual cues on which our judgments of these matters are based. In contemplating the Vermeer we may also fail to notice fictional truths about the play of light which serve as cues for our perception of fictional truths about three-dimensional objects. When this is so, is our experience no different from that of the viewer of Matisse's painting? In both cases we simply look and see that, fictionally, objects are arranged in certain ways, thereby fictionally looking at objects and seeing how they are arranged; the mechanics of the process by which we tell, it may seem, are not part of the experience.

I believe that a vague realization of the possibility of, fictionally, probing the cues underlying one's perceptions of three dimensional objects is present in one's experience of the Vermeer and significantly colors it, even if one pays no attention to the portrayal of light and shadow. This realisation, the realisation of the potential richness of his visual game of make-believe, is an important part of what makes so vivid the viewer's imaginings, of his viewings, that they are observations of the real world.

Many other aspects of pictorial representations can, I believe, be illuminated by examining spectators' visual games of make-believe. It would be interesting to look at various kinds of perspective in this light; at pictures which do and ones which do not conform to what Gombrich calls the eye-withness principle in its negative aspect: "[T]he artist must not include in his image anything the eye-witness could not have seen *from a particular point at a particular moment*";[14] at pictures in which foreground and background are in equally sharp focus, in contrast to ones in which one or the other is blurred; at the use in film of slow motion, wide screens, bird's eye views, etc.; at depictions of things which we don't or can't see in real life for one reason or another: microscopic organisms, foetuses in the womb, drops of falling water frozen in a photograph, patterns of thermal or ultraviolet radiation, sounds and smells, etc. The significance of these various features of representational styles can be traced, in large measure, to the consequences they have for viewers' perceptual games of make-believe.

University of Michigan

NOTES

¹ An alternative suggested by Richard Wollheim and others, is based on the idea that we see a picture of a dog as a dog, or that we see a dog in it. This requires an explanation of what seeing as or seeing in amounts to. I would suggest that the relevant notion of seeing as or seeing in is to be understood in terms of visual games of make-believe.

² There are intimations in Panofsky of the view that differences of pictorial styles are mere differences of convention. According to Michael Podro, Panofsky's paper. 'Die Perspektive als "Symbolische Form"',

> Takes the perspective construction developed in the Renaissance and argues . . . that is has no unique authority as a way of organising the depiction of spatial relations, that it is simply part of one particular culture and has the same status as other modes of spatial depiction developed within other cultures. (Michael Podro, *The Critical Historians of Art* (New Haven: Yale University Press, 1982), p. 186.)

Nelson Goodman denies realism any place at all in pictures or pictorial styles themselves. Realism, he claims, is just a matter of habituation, of how familiar we happen to be with the conventions of a given pictorial symbol system. Pictures which we judge more realistic than others are merely ones in symbol systems which we gave learned to 'read' more fluently. (Nelson Goodman, *Languages of Art* (Indianapolis: Bobbs-Merrill; Sussex: Harvester, 1963), p. 34—39.)

³ I have presented my account of depiction in much more detail in a series of papers including 'Pictures and Make-Believe' (*The Philosophical Review*, 1973), 'Fearing Fictions' (*The Journal of Philosophy*, 1978), and in others mentioned in the latter. The present sketch of my account will not be very adequate, I am afraid, for those who aren't familiar with these papers.

⁴ See Alois Riegl, *Holländisches Gruppenporträt* (1902); and Podro's discussion of it in *The Critical Historians of Art*, pp. 81—95; also Michael Fried, *Absorption and Theatricality: Painting and Beholder in the Age of Diderot*, (Berkeley: University of California Press, 1980.)

⁵ Alain Robbe-Grillet, *Two Novels by Robbe-Grillet: Jealousy and in the Labyrinth*, translated by Richard Howard (New York: Grove Press Inc., 1965).

⁶ In some cases we can see the blobs before seeing the limit approaching. But the reverse is not likely.

⁷ I consider this point more thoroughly in 'Transparent Pictures: On the Nature of Photographic Realism;' *Critical Inquiry* (December, 1984).

⁸ Richard Wollheim, 'On Drawing an Object', in *On Art and Mind*, (Cambridge MA Harvard University Press, 1974), p. 25.

⁹ The scrambled system differs however from the ordinary one with respect to what Kent Bach calls 'continuous correlation', and what Elliott Sober calls 'perspicuity', cf. Bach, 'Part of What a Picture Is?', *British Journal of Aesthetics* (1970), and Sober, *Simplicity*, (Oxford: The University Press, 1975).

[10] "[Picasso] presents us here [in Desmoiselles d'Agignon] with a female form dismembered and reassembled in a way that allows us to see the back and front at the same time, a device that became a keystone of Cubism". (Roland Penrose, 'In Praise of Illusion', in R. L. Gregory and E. H. Gombrich, *Illusion in Nature and Art*, (London: Duckworth, 1973), pp. 248—249.

[11] "[Cubism] is the art of painting new structures out of elements borrowed not from the reality of sight, but from the reality of insight". (Guillaume Apollinaire, The Cubist Painters: *Aesthetic Meditions*, tr. Lionel Abel, (New York: 1949).

[12] There is room for doubt about this construal of the Matisse. But many ordinary line drawings are obviously to be construed in this way, it seems to me, and they can serve to illustrate my point. It is fictional, in many line drawings, there there are shadows and reflections, even if the drawing does not explicitly portray them.

[13] Which work is thought to correspond best to the way the world is may depend on one's metaphysical theory. A phenomenalist might pick the Vermeer; a materialist the Matisse. My present concern is with how pictures relate not to how the world is or is thought to be, but to how we perceive it.

[14] E. H. Gombrich, 'Standards of Truth: The Arrested Image and the Moving Eye', *Critical Inquiry*, 7(2) (Winter 1980), p. 246. (My emphasis.)

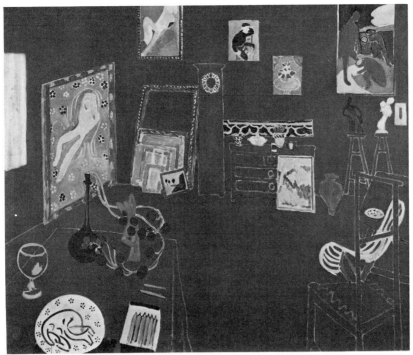

Plate 41. MATISSE, Henri. *The Red Studio*, 1911. Oil on canvas 181.25 × 240 cm. Collection: Museum of Modern Art, New York.
© DACS

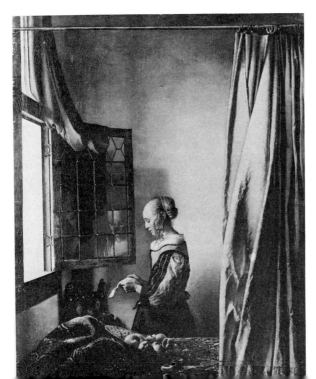

Plate 42. VERMEER van DELFT, Jan. *Woman Reading Letter by Window.* Reproduced by permission of Staatliche **Kunstsammlungen,** Dresden.

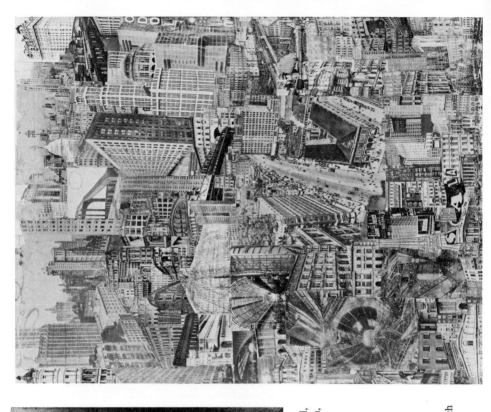

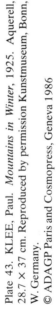

Plate 43. KLEE, Paul. *Mountains in Winter*, 1925. Aquerell, 28.7 × 37 cm. Reproduced by permission Kunstmuseum, Bonn, W. Germany.

© ADAGP Paris and Cosmopress, Geneva 1986

Plate 44. CITROËN, Paul. *Metropolis*. Photo montage. Reproduced by permission Kunsthistorisch Instituut der Rijksuniversiteit, Leiden.

© DACS

JOHN FISHER

SOME NEW PROBLEMS IN PERSPECTIVE*

The title of this paper is a shameless pun. It plays on the polysemy of 'in perspective.' The essay attempts to put into perspective some problems which for the most part are generated by the new technologies which constantly spawn new candidates for artforms. (Of course, getting something in perspective is a curious metaphor for seeing it correctly. Perspectival techniques intentionally deceive. They don't show things as they are. Indeed, using this miscegenetic metaphor is part both of the shamelessness and of the strategy of the paper.) There is a sense, it can be argued, in which there are no new problems in perspective. The problem of perspective for the Brunelleschi, to Alberti, to Vasari, to Leonardo: the representation of deep dimensionality in perception, the illusion of three dimensions produced on a two dimensional surface. And the old problem has always had two prongs; how to produce the illusion, and how to explain it.

Both the production and the explanation of perspective have produced some standard-form enigmas which can easily be discovered in the literature, where some standard-form solutions have become almost canonical. There may be some problems which I seemingly suggest are new, particularly when I discuss holography as an example of the arts of the new technologies. It may very well be that suggestion of novelty is mistaken, but the alleged newness is not the point of this paper. The problems are, and should it be that they are the same old problems disguising themselves in contemporary costumes, I trust that a look at new arts will at least enhance our understanding of certain philosophical issues which have always been hovering about the old.

I shall briefly couch these issues in three pairs of notions which, if not radically disjunctive, at least seem to be at deep odds with each other, and have separated otherwise benign and friendly philosophers into bellicose adversaries. I shall call these pairs (a) perception and the world, (b) convention and nature, and (c) image and object. Philosophers yawn. We know most of these as safe-houses for vagrant and ill-thought-out concepts. They are for the most part, if not Gothic, at least somewhat Nordic notions, and philosophy today, in its headlong

303

Andrew Harrison (ed.), Philosophy and the Visual Arts, 303—316.

flight from foundations, prefers lying on deconstructed beaches, wiggling its toes in the sand, coping rather than knowing, waiting for the next pragmatic wave which shall wash it into a happy oblivion. Before that moment arrives, I want to take one more look at some of the old puzzles in the light of the new arts, not pretending for a moment to explore sweepingly concepts like nature, or the world, or object (I am both intellectually and constitutionally inadequate to that task), but looking only at those aspects which apply most cogently to some old problems in the newer arts, such as holography. The tension between the world and what we perceive is as old as philosophy itself. What is finally real? Is our world given or made, and how is it related to perception? We are all aware how, especially beginning with Kant, and with his interpreters, such as Fichte, philosophers were genuinely puzzled by our seeing things 'out there' when the perceptual process is rooted 'in here' in eye and brain. Schopenhauer's answer, perhaps anticipating Helmholtz, was that you follow the light rays back to the point where they diverge. We perceive some sort of optical stimulations; we don't perceive objects. Objects are at best only the causes of perception. Illusion is mistaken perception. The up and down history of such views can best be seen in the conflicting worldmakings of the psychologists of art (although one should note that the worldmakings of philosophers like Goodman[1] and Wolterstorff[2] are of a different sort). I suppose that the majority of philosophers today deny that there is a 'problem' in talking about perception and the world. The alleged problem leans heavily on sense data theories for its legitimacy, and sense data theories are largely out of vogue. From Austin on, most philosophers who concern themselves with the issue seem to have given themselves enthusiastically to discrediting such theories. Nevertheless, the world which we perceive does not always coincide with the world in which we believe, and puzzling about why this is the case is the inescapable legacy of taking the phenomenon of illusion seriously.

Consider the distortion (which can readily be demonstrated by photography) which results from viewing a painting from an acute angle. The distortion can be extensive, yet in a crowded museum, when the press of the crowd forces us to view from a wide side angle, we don't seem to sense any distortion at all. Is there some apparatus functioning in us, or some schemata being employed whereby our perception somehow 'corrects' the impressions given? It surely isn't deliberate or even conscious. If interpretive, is it something learned or

invented? One of Helmholtz's 'unconscious inferences?' Is it natural or conventional?

Conventionalists have had much the better of the disputes about interpretation in literary theory. Only a very courageous few take up the cause of 'right' interpretations. It is much easier to follow the parade of reader-response theorists and make the reader the creator of meaning. In the visual arts the scene is somewhat more balanced. How do you explain illusions due to linear perspective? Optical and physiologically based theories treat linear perspective as natural. Gombrich's familiar works, while not wholly clear on this point, surely are strongly in that direction — at least until he began reading Goodman. Of course, the supposition that such theories work effectively all the time is refuted in practice. An annoyed Kenneth Clark once wrote,

Clearly scientific perspective is not a basis for naturalism, and the fact that it continued to be taught in school by professors who have long forgotten its purpose to pupils who will never apply its laws is an example of the inherent Platonism of all academic teaching.[3]

Even those committed to the theoretical soundness of linear perspective have always admitted to the variance that exists between the canons and the practice of the rules. Pictures drawn in strict compliance with the rules do simply look wrong. Among the dozens of treatises on perspective published in London at the beginning of the nineteenth century, the most elegant is that of Richard Brown, who complained of the lack of any easy and practical scientific work on perspective,

... for the figures and the objects by which most writers on Perspective have ilustrated their rules have been uninteresting and such as seldom occur in practice.[4]

Nothing wrong with the theory: The trouble is with the examples. The geometrical theory is correct. It cannot be based on conventions emerging from cultural or psychological patterning. On the other hand, followers of Herbert Read readily accepted the mere conventionality of the derivations of fifteenth century perspectival theories. Linear perspective was just one way, the scientific way, of describing space. But the effort to find a scientific, optically acceptable theory has little to do with art, where brain, not eye, is said to be the organ most involved. Gibson, himself a nonconventionalist, fumed at all these hassles about convention and nature. The questions to which these answers are proffered are ridiculous:

They come from the simple-minded conclusion that because a picture is flat and the retinal image is a picture that deliverances of the retina to the brain are depthless.[5]

One reason why Gibson is so impatient with the enduring philosophical questions is that he has irreconcilably separated the optics of physics and the optics of vision, which he calls ecological optics. The eye is evolved to detect immediately the invariances which other theories choose to handle in terms of some kind of process or structuring. The eye gets information directly; the kind of information which a person living in this three dimensional world finds most useful. There is a structuring in the perception of pictures, but the pictures do the structuring. They show how things look by structuring light so that it conveys information isomorphic with what we receive from the actual scene; not perfectly, of course (that's how the puzzles arise), or else there would never have been any problems of picture perception. Light can convey information because it is not merely a stimulus, but a structure.

Without doubt, explaining representational art in terms of information is regnant today. That acute observer of American art, Harold Rosenberg, once noted, with some acerbity,

Pictures that copy appearances have been an obsession of American art since the early draftsmen of the exploring expeditions. Current conceptions of art as 'information' reinforce the obsession.[6]

Indeed we may well be obsessed with 'information.' If so, it should be expected that some at least minimally adequate theory of information is in place in aesthetics. Strangely, not only the literature but the standard reference works ignore it. In the analysis of a new art which follows, one which leans on an undeniably unsophisticated notion of information, it will be obvious that the negligence continues. I shall at best only use analogies, allowing something like 'data' to function as an admittedly unilluminating synonym, and make no pretence, in so brief a work, of getting beyond that unpropitious device.

After an initial disclaimer about perspective and the focus of this essay it has twiddled with the notion for too long. So now to get holograms into perspective, to fit them to the philosophic and artistic context of the occasion, I propose to consider holograms not as the tools of the engineer, nor as the wacky, and kitchy, fun and games they sometimes truly are, but as candidates for artworks. To perceive holography as art demands an adventurous spirit as well as a good eye. If

we succeed, some of the problems in perspective may be a little closer
to resolution.

From the beginnings of the modern era of aesthetics, theoreticians
have displayed an almost perverse fixation on open concepts. The fear
has been that some tomorrow a new medium or an innovative genre
might embarrass us by making us alter our definitions or recast our
criteria. The worrisome minefield has, of course, produced a few loud
pops, but I doubt that there has been any real structural damage to
theories and hardly any casualties to theorists. What have these new
explosions been? Concrete poetry? Serial music? Found art? Lost art?
Minimal art? Maximal art? Full frontal abstract neoplasticism? Or what
Harold Rosenberg used to call "demilitarized zone vanguardism?" We
remember with amusement George Dickie's concerns about a work
called "High Energy Bar," which most people now think was only a
saloon on the north side of Chicago.

So much for the alleged missiles poised to interdict the closing of any
concept, or to intimidate any foundational tendencies. Regaling against
the terrors of the shades, the largely empty threats against theory, is by
no means an argument against the notion that new candidates for the
arts emerge out of the maelstrom of rampant technological advances
and the restlessness of creative imaginations. I treat holography with
neither awe nor disdain. There are enough people who treat it with
either pious solemnity or niggardly contempt. I have no prophesies to
make. As an art form, holography may not get very far. It hasn't gotten
very far yet. It may blossom into a significant and accepted artform.
One thing is clear; it does address interesting problems of aesthetic
theory, and more importantly, by making us focus on some facets of the
experience of art which are often neglected, it can contribute to the
clarification of some concepts.

Few people, I suppose, thought seriously about holograms and art
before Salvador Dali commissioned holographic revisions of some of
his works in 1977. (Few people, as a matter of fact, thought seriously
about holograms as artworks after Dali's holographic revision.) Holo-
graphy remained kitchy, and whatever artistry was there was latent,
expressed in junk jewelry and magazine covers. Most of the interest in
holography was still expressed by engineers and physicists. Those who
claimed the status of artist tended to come from the other artistic
disciplines; photography, the plastic arts, film, some from theater and
dance. We are probably experiencing now for the first time holo-

graphers who are not transplants from other areas of the arts. Most of these are only faintly interested in what fascinated the earlier holographers; naked illusion, particularly the illusion of deep dimensionality. Today they talk about the enrichment of latent formal possibilities, and they often work in mixed media. Because of the quirkiness of the illusionary tricks of the earlier experimenters, their efforts are not always met with objectivity. Too many people remember and like to quote Hilton Kramer's remarks in the New York Times a decade ago:

[i]t is . . . a gadget culture, strictly concerned with and immensely pleased by its bag of illusionistic tricks, and completely mindless about what, if any, expressive possibility may lie hidden in its technological resources. . . . It is difficult to know which is more repugnant: the abysmal level of taste, or the awful air of solemnity which supports it.

Although the optical theory behind holography was hardly new, the lack of a requisite technology prevented the creation of true holograms before the late 1940s. Somewhat like the history of photography, it took the arrival of a sophisticated technology before anyone thought of holography as an artform.

That is not difficult to understand, for even today one must admit that a hologram is a very puzzling entity. It is easier to speak of holography than of the hologram. Holography is a process, rather simple in principle, which captures and encodes on film information about the light waves reflected from an object. When this special film is properly illuminated, light waves identical with the ones coming from the original object are reproduced, and the observer sees what appears to be the object, dramatically, in three dimensions, without the aid of any further optical equipment, and without the restrictive conditions which other depth-producing experiences demand (single-eyed vision, fixed station point, etc.).

The use of photographic film, dark rooms, and the like, might suggest some similarity between photography and holography. The analogy would be very misleading. While artifactually films, holograms are not at all like photographs. In photography there is an image on the film. There is no object image on a holographic film, which shows at best only some very fine lines. Indeed the process requires no camera, not even a lens to focus; the film is quite simply bathed in light. None of the procedural steps necessary to produce a photograph are involved. What happens when the appropriate light, corresponding to the original beam, floods the film as it is observed is that a new set of rays, creating interference patterns identical with the original emerge. If that is not

sufficient to convince that holograms are not photographs, one has only to make the following experiment: Cut a photograph in half and you have two pieces, each showing half of the original picture. Cut a hologram in half and each half wholly reconstructs the original object, although from a slightly different point of view. If cut in half again, each piece, once more, in its own way, reconstructs the original object. What holograms do is wholly (holo = whole, gram = message) reconstruct objects, not in or on an artifact, but in the visual experience of the observer. Where is that? The illusion that there is an object there, in three dimensional space, is overwhelming. The attendant delight has contributed much to the success of holography today. Wölfflin was undoubtedly correct: The eye enjoys overcoming difficulties. In photography the eye alone can reject the illusion. There is no way for the eye to reject the holographic illusion. One may (sometimes with great reluctance) reject it by another sense, such as the tactile, or by reason (I know that the frame is only one inch thick; it cannot contain a full sized telephone.) but not by vision alone. In fact, moving the eyepoint slightly tends to confirm the existence of the purported three dimensional object.

Such observations dramatise once and for all that we have in a hologram something unlike any other work of visual art. Produced on the principle of wavefront reconstruction, holograms raise special questions about classification and evaluation, about perception and the art experience, as well as the artwork itself, if indeed we have here a legitimate candidate for such a title.

It would be irresponsible in such brief remarks about a medium, especially a non-standard medium, to try to postulate a definition of artwork, and to provide the necessary defence. Uncorking such an ancient bottle has to be done under ideal conditions, allowing plenty of time to let it breathe. Suffice it to say that I have no problems with the notion of an aesthetic object. Any object can function as an aesthetic object, so a hologram, or a log in the fire, or a blank canvas, or a black hole can serve as an aesthetic object, but clearly not all aesthetic objects can be called artworks. The difference on sheer intuitive grounds seems to be intentional, a position that even that maligned enemy of intention Monroe Beardsley began to move toward, yet never quite reached, in his later writings, saying things like, "I now think I overstated the disadvantages of employing as my most general concept one defined intentionally." In simplest terms I am treating an aesthetic object as a member of a subset of perceptual objects delineated by their suscepti-

bility to critical statements and productive of a special kind of experi-
ence, and works of art as members of a subset of aesthetic objects
delineated by their being intended to be generative of that experience
and of critical discussion.

To discuss the nature of that experience, aesthetic experience, at this
point would take us too far from holograms. When you combine
'experience,' which Whitehead said was the slipperiest term in philos-
ophy, and 'aesthetic,' which is perhaps the least understood, you can
expect nothing but trouble. I am not convinced, however, that to
replace 'aesthetic experience' with 'the experience of art,' as Dickie does
in a recent issue of the *British Journal of Aesthetics*, and thus unite
Beardsley's and Goodman's in one friendly, bland aesthetic theory,
differing only in minor details like whether the experience of art is
cognitive or not, is to soundly, and I almost think wilfully, miss the
point.

By these admittedly simplistic and presumptive criteria holograms
can function, as any artifact can, as aesthetic objects. Furthermore,
some holograms can function as artworks. The problem is how we
observers are to handle them. Now that is not a unique problem. We
are obliged to ask that question in every medium, in every artform, in
every contact with an artwork, although in most cases our response is
so habituated that we are not even aware of a problem. Only when we
for the first time encounter something which does not fit our acclimated
responses, our accepted interpretive schemata, such as the music of
George Crumb, or the paintings of Jackson Pollock, or the novels of
James Joyce, do we consciously ask ourselves, how do we handle this
aesthetically?

How we handle presupposes that we have answered the question,
what do we have here? In the visual arts there is unexceptionally an
artifact, a canvas, a paper, a stone, some material, some sensory bearer
of perceptual signs which are images, not necessarily representational,
but exemplifying, referring, even if they are only self-referential. But
holograms don't fit, because the artifact is a set of coded signs which,
while material, are perceptually unrecognisable unless we are provided
with the more or less specific performance conditions of reconstruction.
The closest thing we might imagine is painting with pigments which are
visible only under conditions of non-natural lighting, light of a partic-
ular wavelength, such as ultraviolet, for instance. The comparison
collapses, however, when we realize that this kind of painting produces
a visible two dimensional object spatially locatable on the surface of the

artifact in ways which are in principle no different from ordinary white light painting.

To facilitate the constructive consideration of holograms as artworks let me sort out by example some different categories of holograms which have been advanced as works of art. Considering first content, holograms have been created of natural objects, like flowers, of imaginary objects, such as cubistic constructions, and of totally non objective abstract designs. Considering the image, these may be virtual, that is, appear to be behind the picture plane, real, that is, appear to be in front of the picture frame, or, in the case of the non-representational hologram, be only colour areas, vertically or horizontally parallactic, changing radically in hue and intensity with changes in station point.

Now I think that each of these is capable of generating an experience of an aesthetic nature (and again, I am not at all concerned here with the analysis of that experience). They can function as aesthetic objects. As is often the case, information about intentions is largely privileged. That need not be significant. They can be taken as intentionally generated and intended to be generative of aesthetic responses. (I am sometimes told that the trouble with this kind of thinking about artworks is that we may not have in a given case knowledge about intentions and therefore we may not know, indeed cannot know whether something is an artwork or not. I think that all of that is correct, but I do not find it a defect in the notion of an artwork to admit that there are many instances in which we do not know whether an artifact is an artwork or not. If the artifact is an aesthetic object and we have reason to suspect that it was created to produce aesthetic responses in observers we may, indeed we should, take it as an artwork. This is one of a host of interpretive acts which cannot be ignored.)

What follows cannot be discussed in terms of experience because aesthetic experience does not require an artwork. The consequence of taking a hologram as an artwork is that the critical process is now possible. Works of art by their intentional nature become open to critical discourse. Evaluations are paradigm cases of critical discourse.

Surely we cannot evaluate holograms as we would paintings or photographs or items of graphic design. What is it that we value? Consider (a) the object, (b) the technical skill of production, (c) the artifact, (d) the image. If you ask why not (e) the experience, the answer is that the concern is not in ranking experiences, but in determining what generates the experience.

(a) The object. Can a flower as the holographic object be better than

an abstraction? Surely the formalists exaggerated when they insisted that it mattered not a straw whether the crucifixion sculpture was of Jesus Christ or John Smith, but no convincing argument has even been offered that an English landscape is in itself better than a portrait, or a painting of a bowl of fruit better than that of a cathedral, or that any randomly chosen abstraction is better than any randomly chosen representational work. A work of visual art may be more interesting because of the nature of its object, but we do not evaluate it aesthetically on the basis of object criteria.

(b) The technical skill of production. This may be impressive, but that may have a high rating due to our unfamiliarity with the information involved, or by the curious but familiar criterion that the harder it is to make something the better it is aesthetically. It obviously took more skill to make holograms on the old sandboxes needed for stability in making sharp holograms than on the modern hydraulic tables, but the fast moving technologies, the pulsed lasers, the higher speed films, and so on both made it easier and at the same time infinitely more challenging to the artist. There is no way to correlate the requisite technology and the value. There are some Steichen photographs dated in the 1920s which have marvellous artistic qualities not often found in photographs produced with the advanced technologies of today.

(c) The artifact. Clearly in holography the artifact is not what is being evaluated. The artifact is a set of mysterious signs which must be decoded. A great deal of the decoding is, of course, embedded in the technology of the reproduction of the interference patterns. It is not at all like the way we decode the signs given in the symbols of our natural language. The artifact in holography is a piece of film aesthetically worthless until the precise lighting conditions corresponding to the conditions of making are reproduced.

(d) The image. Images are not material objects, nor are they subjective states. They are locatable in space. They obey the descriptive laws of the optics of physical science. They are not artifacts, nor are they experience. How can we talk critically about them? At last something concrete begins to emerge from the warren of questions and disclaimers. We are familiar with at least one other artform in which a similar kind of semiotic exists, but it is not in the visual arts. In listening to recorded stereo music we use an artifact, a grooved or compact disc or a magnetic tape upon which is encoded all the information necessary to produce the sounds of the original live performance. All

we need is the equipment to decode the information held within the material artifact; a stereo sound system. Now by comparison the holographic requirements are quite simple. They consist only of an appropriate light source, a laser beam or some other source of coherent light, a simple white light from as near to a point source as possible. Given that, the decoding takes place, the artwork happens.

I find this analogy with full dimensional sound reproduction rewarding. The same questions are raised; how do we achieve the dimensionality, and, given the phenomenon, what is it that we are talking about when we make critical, that is, aesthetic statements? The composer? The work itself (whatever that is)? The skill of the engineer? No: The sound. Where is it? When you wear stereo earphones you might say it isn't anywhere, or that it is everywhere, or perceived to be at the very centre of the skull. Is it real? In a good recording it corresponds very closely to what the microphones 'heard.' Two wavefronts, each differing slightly from the other in phase and amplitude, produce a sound which is located exactly where the microphones were placed, and that sound is reproduced in my experience when I listen under optimum conditions. One can, of course, locate by instruments exactly where the reproduced sound is focussed, just as one can with instruments locate where the holographic image is located. One can in a derivative way rerecord that sound by placing a microphone at that focus, just as one can photograph a holographic image by focussing a camera on the real or virtual image in space.

Of course, in listening to a Mozart quartet we do make judgments about the composer, as well as judgments about the relative merits of compact disc recording, and inevitably comparisons of our technological systems for reproducing sounds. Nevertheless it is the perception of the sound that counts. Watching a quartet on an oscilloscope won't do, nor will reading a score, nor perusing the specifications in a brochure. Composers, performers, technicians, and specifications may find their way into our critical evaluations, but resting on these would disqualify one from being a genuine perceiver of music.

If we admire the thing represented we retreat into an indefensible object-prejudice. If we admire the technology we may as well be physicists, or engineers (who, incidentally, use holograms for the most precise measurements and reconstructions. The best holographic equipment is not found in fine arts departments at universities, but in engineering departments).

It is difficult to imagine anyone admiring the holographic artifact, as difficult as imagining music lovers admiring a phonographic disc. It just isn't an art object. It is on the image that aesthetic determination must be founded, and we all know that what we bring to the image contributes to the determination of the character of our judgments. If the schemata are those of illusionist verisimilitude we restrict ourselves to the judgments of classical naturalism, which, of course, can be very powerful. The anecdotal stories provided by Pliny and the fictional Duris of Samos portray Hellenic painting so natural that one can hear the breathing and smell the sweat of the struggling warrior. That's quite a different reading of an image than that of the formalist, or the social realist, or the disinterested attitude theorist, or the Marxist, or a moralistic romantic like Ruskin.

Any sighted person who understands and can listen critically to recorded music can grasp and evaluate holograms as artworks. Some holograms do not pass the test because they are utterly incapable of generating even the most moderate aesthetic response. It is not my purpose to sort out the artworks from those that are not, nor to prescribe the specific conditions of excellence, but rather to point to the initial, pivotal question. In simplest terms, to determine what it is that we have in a hologram. I have tried, by way of analogy, to show that. Technology has made the artworld no longer the domain of sure and firm-set objects. In a way, it seems, holograms are a generalisation of the Macbeth problem:

Is this a dagger which I see before me
The handle toward my hand? Come, let me clutch thee:—
I have thee not, and yet I see thee still.
Art thou not, fatal vision, sensible
To feeling as to sight? Or art thou but
A dagger of the mind, a false creation,
Proceeding from the heat-oppressed brain?

Yet a little reflection will show that the problems are quite dissimilar. If Banquo or Fleance had remained we know that they would not have seen Macbeth's dagger. It was not a general or public illusion. In the quintessential illusion, a hologram, what is perceived is convincing, not just to one troubled or one imaginative mind, but to all observers of normal vision at a specific station point. The holographic illusion is not one of perceptual ambiguity, such as the duck/rabbit, or figure/ground,

or the paradoxical, impossible-figure illusions are. These all, if Gombrich is right, are readings, they are inferred, not immediately perceived. By the time we are conscious of them they are already interpreted, even though we quarrel whether the interpretation is conventional or not.

Holograms are illusions which insist that something exists in space in the total absence of any object at all, and they are not private. (That allows us to retain sanity in the face of the ultimate deception.) They differ from illusionist painting because in perspectival painting there is an object, a two dimensional flat surface, yet not construed as flat, but communicating a significant sense of depth. Even in *trompe l'oeil* painting, deception is only modest. We rarely mistake the painting for reality. And they differ from motion pictures, which involve projected images, because the image is on a material base, a screen. Remove the screen and you remove the image. The image in holographic phenomena floats in empty space.

Image art today is found pure only in holography. The image is not Macbeth's projection of guilt, nor any other private state. On the contrary, it is something public enough, perceptual enough, and possessed enough of the appropriate properties that it can be considered as a candidate for an artwork.

It may seem odd, perhaps, or at least anachronistic, to make much of a new illusionism at a time when representation seems finally to have been emancipated from illusion and mimesis. That some kind of equivalence exists between naturalistic representation and what it depicts is not exactly where the philosophy of art is today. And it seems a curious timing which intrudes a technology-based naturalism into an artworld still showing its enthrallment with those historical movements which forced us to accept the flattening of space. What makes holography contemporary, in spite of these observations, is that, in addition to its sophisticated technology, it presents a way of producing and ordering information by means of a way of coding new to the visual arts, by which it produces what earlier perspectival systems accomplished with far less convincingness and power, and far more theoretical difficulties.

Temple University

NOTES

* Research for this paper was aided by a Faculty Summer Research Fellowship from Temple University.

[1] N. Goodman, *Ways of Worldmaking*, (Indianapolis-Cambridge: Hackett Publishing Company; Sussex: Harvester, 1978)

[2] N. Wolterstorff, *Works and Worlds of Art*, (Oxford: Oxford University Press, 1980).

[3] K. Clark, *Landscape into Art*, (London: Phaidon Press, 1976), p. 44.

[4] R. Brown, *The Principles of Perspective*, (London 1815, vii).

[5] M. A. Hagen, *The Perception of Pictures* (New York: Academic Press, 1980, xvii).

[6] H. Rosenberg, *Art on the Edge*, (Chicago and London: University of Chicago Press, Ltd, 1970), p. 244.

ANTONIA PHILLIPS

THE LIMITS OF PORTRAYAL*

> Hayman, the painter, though but an ordinary artist,
> had some humour. . . . Mendes, the Jew poet, sat to
> him for his picture, but requested he would not put it
> in his show-room, as he wished to keep the matter a
> secret. However, as Hayman had but little business
> in portraits, he could not afford to let his new work
> remain in obscurity, so out it went with the few others
> that he had to display. A new picture being a rarity in
> Hayman's room, the first friend that came in took
> notice of it and asked whose portrait it was?
> "Mendes". "Good heavens!" said the friend, you are
> wonderfully out of luck here. It has not a trait of his
> countenance." "Why, to tell you the truth," said the
> painter, "he desired *it might not be known*."[1]

There are three central demands which an adequate analysis of the
concept of a portrait must satisfy. First, the widespread belief that a
reasonably successful portrait presents a likeness of its subject must be
accounted for. Second, an analysis must explain how it is that portraits
come to represent the individual they do and no other. And third, not
every picture of which we may want to say *both* that it is of someone
and that it is a likeness of them should come out as counting as a
portrait. The second and third constraints overlap in involving the
notion of a model as distinct from a subject or sitter, and both concern
the problem of explaining what it is for an individual to be the subject
of a picture.

Throughout this paper I shall be dealing only with pictures of real
individuals, and so only with what I take to be the basic case: portraits
of actual, rather than fictional or mythical, people. I shall say something
more about each of these constraints, but before I can do so, I need to
introduce — and I mean 'introduce', no proper discussion can be
undertaken here — two distinctions, each yielding a principle of clas-
sification for pictures of objects at the juncture of which, I shall argue,
the concept of portrayal is to be located.

317

Andrew Harrison (ed.), Philosophy and the Visual Arts, 317—341.
© 1987 *by D. Reidel Publishing Company.*

1

In the theory of language a distinction is made between what is con-
veyed by a remark and what the speaker had in mind in making it. This
distinction is reflected at a colloquial level in our distinguishing two
senses in which a remark may be about a particular object. On the one
hand, having a particular object in mind, a speaker may make a remark
which is not intended to convey anything which depends upon his
audience being able to identify the object he is thinking of. Thus a
speaker might say "One of the stewards has disappeared" with a par-
ticular person in mind whose identity is nevertheless not part of what
he intends to convey to his audience in making the remark. By contrast,
a speaker may make a remark about an object intending his audience to
identify it as the object about which he is saying something, so that it is
an essential part of what he intends to convey by his remark that it is
about some object to be identified by his audience. So, for example, the
speaker might say "Briggs, the chief steward, has disappeared", intend-
ing his audience to think of the relevant person.

 There is a parallel distinction to be drawn among pictures of which it
is true to say that there is something they are of, and, correspondingly,
there are two senses of the sentence "This is a picture of a", where 'a' is
a singular term.[2] In the theory of pictorial representation, unlike the
theory of language, the difference between the two senses has tended to
be obscured or disregarded. A picture which is of a particular object
does not necessarily represent that object. It is not true, in other words,
that wherever there is a relation of *of*-ness between picture and object,
there is *representational relation* too. Obviously, I am not making a
claim about how the word 'represents' happens to be, or is rightly used
in English within discourse about pictures; but I am making a sugges-
tion towards the clarification of the concept of pictorial representation,
a suggestion which is not theoretically neutral. My general line could be
summarised, very roughly, by saying that a picture represents an in-
dividual only if the artist intended to get the audience to think of that
individual as the object the picture is of. This formulation brings out the
point that the concept of Individual Representation (as I shall call it)
is subject to the same well-known unclarities as beset the concept
of thinking of a particular object, and *de re* propositional attitudes
generally.

 In the case of language the difference between the two senses in

which a remark may be about an object can — very roughly — be seen to be a matter of whether the audience is intended to know which thing the speaker has in mind in making his remark, and whether what is conveyed depends upon the audience identifying the relevant object, whether understanding requires identification. The difference between the senses in which a picture may be of an object can be seen in a similar light, but with an important qualification.

When the artist intends spectators to identify the object his picture is of, this may be understood in a strong and a weak sense, and it is important to bear this in mind for what follows. (This distinction between a strong and a weak sense should arouse suspicions about how far the analogy between language and pictures can be pursued.) The strong sense applies to cases where the artist intends his picture for spectators who will identify the object his picture is of, and in such cases understanding the picture will require 'uptake', just as in the linguistic example mentioned earlier. Now, there are pictures whose function depends upon spectators actually identifying the objects they are of, pictures which require 'uptake' to be understood. The most striking examples are the political cartoons and caricatures we encounter daily in the press. In some cases one cannot understand what the picture represents — for example, what it represents the protagonists as doing — unless one has identified the person or persons it is of. Most commonly, however, one simply fails to get the joke — think of the cover pictures of *Private Eye*: even the best ones are completely pointless to someone who fails to make the right identifications. Many religious paintings fall into the same category to the extent that a spectator who fails to make the intended identifications is bound to miss much of what the work conveys — he will not understand the story or drama of the scene represented, for example. There are portraits, too, whose iconographical elements are unintelligible to someone who has not identified the subject. The fact that pictures of objects are intended to have functions and convey meanings which require the spectator to identify the relevant object certainly calls for explanation.

The weaker sense in which the artist may intend spectators to identify the object his picture is of applies to cases where the artist does not require 'uptake' — actual identification — for his picture to be understood, but merely intends to make it possible for spectators to know which object his picture is of. In this case the picture is not intended only for spectators who can and will identify the object;

indeed, pictures which require actual identification are special cases. The more typical case will involve intended identification in the weaker sense and it is this sense which plays a rôle in defining what it is for a picture to *represent* an individual.

When is it right to regard a picture of a particular object as representing that object? Only, I suggest, when the picture was produced with the intention (among many other intentions, of course) to make it possible for spectators to know which thing the picture is of. Clearly, producing a picture with this intention means that the artist must endeavour to provide spectators with some means of identifying the individual his picture is of, and I will mention some of the ways he can do this in a moment. Is there any reason why we should accept such a condition on the representation of individuals? Here I can mention only a very general reason for acceptance, namely that the condition would be a unifying principle, for, *mutatis mutandis*, it applies to the notional sense of 'represents' equally. Surely, and here I appeal to pre-theoretical intuitions, a picture can be said to be a representation of a man, or horse or tree — to be a man-depiction, horse- or tree-depiction — only if the fact that it is is a fact spectators are intended to be able to gather from looking at the picture.[3] Are there not limits to what spectators are willing to accept as a picture representing a man, or horse, or landscape? And do these limits not also act as a restraint on what an artist intending to represent a man or horse can rationally produce as a picture of a man or horse? An affirmative answer to these questions does not force us to regard these limits as fixed or absolute. Indeed, a moment's reflection makes it overwhelmingly clear that the limits are very flexible — the history of painting is full of examples of artists consciously pressing against the currently accepted limits, and of audiences (rather more slowly) seeing the point of such pressure.

Whether a given picture of an individual *a* represents *a* depends on the entirely factual question of whether the artist had the intention I have claimed is necessary. The facts, of course, may not be accessible to us, or we may have only the picture itself to go on, and it may not entirely resolve the issue. But even if the picture was produced with the intention of making it possible for spectators to identify the relevant individual, the artist may have failed to realise this intention. Thus a commissioned portrait may be rejected because it so little resembles the sitter that no-one can tell it is of that person; or a painter may be asked to add iconographical detail, a cardinal's hat or a lion to a picture of St

Jerome to facilitate identification. Nonetheless, successful realisation does not mean that *anyone*, however remote from the spatio-temporal circumstances of a picture's production, could tell who the picture is of, and the fact that we do not know, and probably will never know, who are the subjects of countless portraits does not necessarily mean that the artists failed to render their subjects identifiable. Some ways open to the artist of rendering individuals identifiable are more longlasting than others, and so how far into posterity the represented individual will remain identifiable, *in the way intended by the artist*, by future spectators will depend, among other factors, on the particular way chosen, and the particular way chosen will in turn be related to the kind of picture it is, for whom it was painted, what its function or placement was to be, how public or how private, and so on. Generally speaking, written identification of a person on the picture surface is more long-lasting a way of ensuring that he is identifiable than, say, relying on knowledge of what he looked like.

There are various ways in which the object the picture is of can be identified, but if a picture is an individual representation, then there must be some way of identifying the relevant object *which the artist intended the spectator to follow*. I shall call this the 'intended route' to the object. The fact that there is in a given case some way or other of identifying the individual the picture is of does not entail that the picture is an individual representation, any more than the fact that a picture is an individual representation entails that there cannot be a way of identifying the object the picture is of which was unintended. Some of the ways historians identify the object are not ways intended by the artist — historians often rely on information which the artist could not have had, or which spectators could not be expected to have. Sometimes historians rely on written records, official or private — e.g. inventories, or Vasari's writings; sometimes they rely on the existence of other *bona fide* portraits to identify a figure in a fresco. Gisela Richter mentions as being relevant to the identification of the portrayed individual such facts as the number of copies preserved, and the site at which the statue or relief was discovered.[4] But the strongest kind of argument or evidence the historian can provide for counting a picture as an individual representation would be, I suggest, a reconstruction of the way the artist intended the object his picture is of. to be identified, with all that this implies about the reconstruction of the artist's intentions, his expectations of the audience, the audience's knowledge and

how the artist draws upon it — in short, all that is implied about what can be called the artist-audience community. (The linguistic analogy here is with the pragmatics of the speaker's reference.)

Different ways of identifying represented objects exploit various kinds of knowledge, and several types of identificatory 'routes' from picture to object can be distinguished according to what kind of knowledge is intended to be drawn upon. All I can do here is mention some of these different ways, leaving many interesting and difficult questions for another occasion.

I distinguish types of route from picture to object by the kind of knowledge they exploit, but it must not be thought that each individual representation must exploit a single kind of knowledge, or that the route the artist intended to be followed in a given case must fall squarely into one or other type of route. On the contrary, it is far more common for the intended route to exploit several kinds of knowledge. There may be over-determination, when the audience is provided with more than one sufficient route; such over-determination will have the effect of bringing more people into the potential audience by drawing different people into the net according to the different knowledge they possess. Usually, however, there is a single intended route and it relies on several kinds of knowledge, without any one strand in the route being by itself enough to secure identification, but taken together they are intended to suffice.

The first, and most obvious, way for an artist to render an individual identifiable in a picture is to write his name, or some identifying description or clue, on the picture. Many examples are in the nature of captions, as when names, or mottoes, quotations or slogans commonly associated with the represented individual are inscribed either on the picture surface, or on the frame, or the pedestal of a statue. Rather different are cases where the inscription is not so much a caption as an element of the picture's depictive content: when for example, a name is inscribed on a depicted scroll, or on the binding of a depicted book. Until we have a better understanding of how these cases differ, we might as well group them together as 'identification by inscription'.[5]

The second type of route from picture to object, which I call identification by symbolism, is one that is deeply rooted in pictorial traditions and conventions, in that the way of identifying the represented object exploits knowledge that a Ø-depiction is or has been used to stand for an individual, knowledge without which a spectator could not know

which individual the picture represents. The spectator requires some specific item of knowledge relating the Ø-depiction and the individual. Whenever a Ø-depiction symbolically stands for *or picks out* an individual *a*, the spectator is intended to draw upon knowledge of the form: 'a Ø-depiction stands for (or denotes, or means that this is) *a*' and upon this basis and from what he sees in the picture, namely a Ø, to infer that the picture, or relevant part of it, represents *a*. Such inferences, culturally embedded as they are, may be highly internalised by members of the community or civilisation in which the pictorial symbol is used; they will be heavily context-dependent as well.

The form in which these items of knowledge are expressed has been left deliberately vague. It would be nice if identification by symbolism was always of the simple form: a Ø-depiction stands for *a*, so that it can be said to be a symbol representing *a*, in the way that, for example, a lamb-depiction or a sheaf-of-corn-depiction in some contexts can stand for Christ directly enough for us to quite naturally say that they represent Christ.[6] But in fact this kind of case is relatively rare: the relation between a symbol and the individual it identifies is not commonly as like the relation between an individual and his name as it appears to be in the case of the lamb for Christ. By far the largest group in the category of symbolic identification is one in which emblems, and the so-called Attributes, are exploited. Emblems are typically objects traditionally or iconographically associated with individuals, usually derivatively from stories about them, historical or legendary. Because of this, I think, emblems have more than a purely identificatory function, and are often also illustrative of the nature and activities of the individual whose emblem they are, and this means that they are not mere analogues of the more primitive device of the depicted inscribed scroll or label — the emblem is not such an *ad hoc* device as that.

The third type of route to the object represented is one that involves identification by description and *prima facie* it works like this. A description 'something Ø' is intended to be derived from or yielded by the depictive content of the picture, where this means that the spectator is intended to see something Ø in the picture; what he sees in the picture 'triggers' his antecedent knowledge that *a* is the Ø, and so he infers that the Ø in the picture represents *a*. Because of obvious parallels with reference by description, the characterisation of this type of route from picture to object will be fraught with similar problems, and so what I have to say about it will be rough-and-ready.

In using this type of route, the artist will exploit beliefs about, or beliefs about what has been believed about, the object he intends to represent in his attempt to make that object identifiable by spectators. If it is possible for a speaker to refer to an object using a definite description which is not true of it, and if this possibility holds equally in the case of pictorial representation, then the beliefs the artist exploits need not be true. But true or false, they must be commonly held, or commonly known to have been held, because otherwise there can be no reasonable expectation on the artist's part that his reference to an individual will be picked up by spectators. The representation of Biblical themes and stories provides countless examples of pictures representing people and events which are identifiable by description by an audience familiar with the Scriptures and/or familiar with the illustration of the Scriptures. So, for example, a spectator believing that Jesus carried his cross and wore a crown of thorns, or the spectator who merely believes that people have believed this of Jesus, can easily identify the man he sees in the picture, who bears a cross, etc. Moses can be identified in a picture by means of the description 'the man who caused the sea to divide' because it is widely known that he was said to have done that deed, even if it were the case that no-one now believes that he did such a thing.

Iconographical studies are replete with identifications by description, but not all of them are intended by the artist as routes to the represented object — historians make identifications by description independently of what the artist may have intended. But if the historian is reconstructing an intended route which involves descriptive identification, he will be attributing to the artist quite complex intentions. Consider as an illustration a specific problem of identification discussed by Panofsky.[7] The case concerns a painting depicting 'a handsome young woman with a sword in her left hand, and in her right a charger on which rests the head of a beheaded man'. Is this a picture of Judith or of Salome? The scriptures confirm either identification equally, at the price, of course, of not being able to account for either the charger or the sword. Assuming, with Panofsky, that the artist was not merely muddled, how are we to settle the issue? Panofsky settles it by appealing on the one hand to the discovery of a practice, albeit small, of depicting Judith with a charger instead of a sack, a practice existing where the painting was produced, and on the other to the fact that there is no practice or precedent for representing Salome with a sword.

Supposing Panofsky is right about the facts of the case, the icono-graphical question is settled because the facts make it reasonable for the historian to attribute to the painter the otherwise unusual intention of representing Judith with a charger, while not making it reasonable to attribute an intention of representing Salome with a sword. The same facts — the existence of the practice and precedent of Judith with a charger — also make it reasonable for the artist to intend to make Judith identifiable in spite of the charger, because it is reasonable for him to expect his audience to identify Judith: he, like the historian, draws on a practice which spectators participate in. Indeed, the exis-tence of the practice only makes the historian's attributions of intention reasonable because it makes the having of those intentions reasonable on the part of the artist. It is no wonder then that historians are so much concerned with the reconstruction of the circumstances, social and artistic, surrounding the activity and production of artists, for it is bound to throw light on what intentions particular artists could have had in particular circumstances — could have had with the hope of realising them.

The fourth and last type of route from picture to object I will mention is one about which there will be more to say in connection with portrayal. It exploits the knowledge involved in the recognition by sight of individuals. We recognise people, places, animals and things countless times in the world, and also in pictures, in what we see in pictures. It is with the recognition of individuals that we shall be concerned here, where this means that the recognitional capacities are directed upon particular objects, rather than upon properties or kinds. How the two cases of recognition are related, whether the knowledge involved in recognising an individual and in recognising an instance of a property are of the same sort, are not questions we need to pursue here. When an artist intends that the object his picture represents be identified by recognition, he will invoke such knowledge of the object's appearance as would enable a perceiver to identify it (i.e. the actual object) when he encountered it.[8] If the intended route to the object in a given picture is one exploiting such recognitional knowledge alone, then only those spectators possessing that knowledge will be able to tell who the represented individual is in the way intended by the artist. We count a disposition to identify an object as recognition only when the object upon which it is directed is the very same object as gave rise to that disposition. In such cases, and they should be regarded as the standard

ones, we speak also of knowledge: recognition is a form of memory. It is to be able to tell on the basis of how a present object appears, that one is seeing (hearing, smelling, touching) a previously encountered object. The ability is not immune to error: one's disposition to identify Mrs. Thatcher can be led astray by her look-alike. In such a case the perceiver's recognitional capacity concerning Mrs. Thatcher is activated by the wrong object — wrong in the sense that it is not the object that gave rise to that capacity, i.e. it is not Mrs. Thatcher — and so recognition has not taken place. The perceiver's disposition to identify a lady who looks very like Mrs. Thatcher as Mrs. Thatcher does not in such a case issue in his knowing who the lady he sees is.

Because recognitional capacities can be activated by a 'wrong' object (this will not, of course, be a widespread phenomenon — think of the consequences), presumably because it strikes the perceiver as like the 'right' object, I shall speak of recognitional *knowledge* as distinct from recognitional *capacities*. Recognitional knowledge is exercised only when a recognitional capacity or disposition is activated by the same individual as was the causal/perceptual origin of that capacity.

This distinction means that if an artist intends to get spectators to identify the individual his picture represents by recognition, he will intend his picture to be such as to activate recognitional capacities *concerning that individual*: he will invoke such knowledge of what the individual looks like as would be acquired from encounters with it and which would enable its re-identification at a later date. If the artist succeeds in realising his intention the represented individual will be recognised by spectators possessing the requisite knowledge, who will thereby come to know whom his picture is of. But it will also be a possibility that, as a consequence of successful realisation, seeing the picture will trigger recognitional capacities concerning some individual other than the represented individual, but in this case no identification will have taken place, because no recognition will have occurred. This is a possibility because if the artist has succeeded in producing a picture in which the represented individual is recognised, he may also have produced a picture which will activate recognitional capacities concerning someone who looks like the represented individual. The connection between recognition and likeness is very important to the account of portrayal I shall be proposing.

Recognitional capacities vary in respect of longevity, sturdiness against change and dependence upon context. An object may be

recognised solely on the basis of how it appears, but frequently we draw upon other, non-visual sorts of information, not all of which need have been gathered in encounters with the object. Either way the object is recognised as something or other, and what it is recognised as will vary from perceiver to perceiver. Recognitional capacities are typically associated with bodies of information — sets of descriptions — which a perceiver connects with the object. So when an artist intends to render an individual identifiable in his picture by recognition, he may have in mind some specific description which he wants spectators to recognise the represented individual as (Mrs. Thatcher as Prime Minister); often, however, the artist is not concerned with, and does not care to determine the descriptions under which spectators recognise the represented individual.[2] His concern will be to get spectators with the relevant recognitional knowledge to come to know which individual his picture is of by recognising him in the picture, without caring what they recognise him as, so long as it is enough to secure identification.

So far, then, we have at our disposal a distinction among pictures of objects between those that are individual representations and those that are not. But there is a second distinction we need to make, without which even a provisional taxonomy for pictures of objects would be inadequate. This further distinction cuts across the distinction between types of route from picture to object, and has a different but overlapping range of application: it applies both to individual representations and to pictures of objects which are not individual representations.

This second distinction sorts pictures of objects according to whether there is a perceived resemblance or likeness between the picture and what the picture is of. More will be said about this notion of likeness as we go along, but for the present I want to take it as primitive and conceive it like this: for x to be like y is just for x to seem to a perceiver A, or strike A as like or similar to y. A's being struck by a likeness in this sense will not mean that he believes that there is some objective likeness between the two items, nor does he have to know in what respect the two items strike him as being alike. The notion of likeness I want to invoke does not, strictly speaking, hold between picture and object, although I will continue to use this misleading form of expression in order to avoid excessive circumlocution. When I say that a picture may strike a perceiver as like the object it is of, what I mean is this: what a spectator sees in a picture may strike him as like the object the picture is of. We are dealing, in other words, with a three-place

intentional relation of some kind, holding between a perceiver, what he sees in a picture and some object. This notion of likeness admits of degree: a picture of Churchill, for instance, will not strike each spectator as like Churchill to an equal degree, and to what degree it does seem like Churchill will depend on both facts about the picture and facts about the spectator.[9] A final point: attributions of likeness between picture and object of this sort quite clearly occur within the scope of representation and so this notion of likeness is quite useless when it comes to analysing what it is for a picture to represent or depict something or other — to have depictive content.

<div align="center">2</div>

Returning at last to the three constraints on an account of portrayal listed at the outset, the question to which we must now address ourselves is whether likeness (in the sense just defined) may be necessary for a picture to *portray* an individual. Clearly, on the view I have sketched of what it is for pictures to be representations of individuals, perceived likeness between picture and object is not necessary for a picture to be an Individual Representation of that object. But intuitive reflection upon the notion of a portrait suggests that portrayal does require likeness, and that we seem to have expectations of portraits which involve the perception of likeness. Insufficient resemblance to the sitter is a frequent cause for complaint in the case of portraits — it is, for example, a ready explanation of a man's disappointment when, having commissioned a portrait of his wife, he finds that no one who knows her is able to tell that the picture is of her without the help of extraneous information, such as a label or his say-so. The fact that Henry VIII, in his pursuit of a suitable wife, saw fit to send Holbein hither and thither across Europe to take portraits of several candidates, including the Duchess of Milan and Anne of Cleves, is incomprehensible if he had no expectation of the portraits enabling him to assess the appearance of those ladies, given that he had failed to arrange to meet them personally.

Portraits, at least when successful, seem like their subjects in a way that appears to transcend what might be loosely termed 'generic' likeness. *Prima facie*, the way in which we may be struck by how like the man a portrait of Churchill is does not seem to be reducible to our

being struck by how like a man of the same type as Churchill the picture seems. The peculiar thing about a good portrait is that we seem to see the person in the picture, rather than that we seem to see someone like that person in the picture (of course, we do that too). There appears to be a special intimacy between a person and his portrait: so much so, indeed, that not only can we apparently recognise Churchill, say, in a portrait of him, but we can also *acquire* an ability to recognise him in life from seeing a portrait of him; moreover, we value those pictures of people we know in which we do recognise them, in part because our sense that we are seeing them in the picture is thus strengthened, because they carry greater conviction. Pictures which have these effects (effects which are relative to the perceiver, of course) include pictures that are not in fact portraits, but even so we may, and often do, value them as well, for exactly the same reason. Our valuing pictures in which we recognise someone is not, however, simply a matter of the picture being sufficiently like the person that it triggers our recognitional capacity concerning that person: imagine discovering that a picture of a loved one which you had been treasuring for years because it was so like them is not in fact a picture of that person at all, but of someone else — the picture would instantly lose whatever value it previously had for you. At least, we can say that we value pictures which activate recognitional capacities only if it is true that we recognise the person in the picture. Seeing a portrait of a person is in some respects the next best thing to seeing the person himself. So, when Henry VIII wished to know that Anne of Cleves looked like, given that he could not actually meet her, he made arrangements which would enable him to see a portrait of her instead.[10]

If we consider the history of the painted portrait in Europe since the Renaissance, and the development of portraiture in antiquity, if we think of the countless family portraits, and portraits of Kings and Queens, Prime Ministers and Heads of Colleges, it is natural to suppose that recognition, by those spectators who have or had recognitional capacities concerning the individual portrayed, is a criterion of success in a portrait — *qua* portrait, and not necessarily *qua* work of art. It is a criterion of success precisely because it is at the point (which is variable) at which a picture of Churchill activates recognitional capacities spectators may have concerning the man that the picture can be said to have captured a likeness of Churchill. Encouraged by these apparent connections between likeness, portrayal and recognition, my

aim will be to attempt to capture both the element of likeness and the element of 'individuality' — the way portraits are meant to transcend what I have called 'generic' likeness — by appealing to the notion of recognition.

How will recognition be of use in trying to get a purchase on the notion of likeness? It helps because if looking at a picture of Churchill activates a spectator's recognitional capacity concerning Churchill, then what the spectator sees in the picture seems to him, strikes him as, like Churchill. Equally, when the picture which activates the spectator's recognitional capacity concerning Churchill is not in fact a picture of Churchill at all, but a picture of a Churchill look-alike, it will have seemed to the spectator like Churchill. In this case, of course, there will be no recognition, but only the triggering of a recognitional capacity. So an intention to render an object *a* recognisable in a picture is *ipso facto* an intention to produce a picture in which a spectator who possesses the requisite knowledge will see something which will strike him as like *a*. But the converse is not true. There can be, for example pictures of objects such that what is seen in the picture may strike someone as like the objects they are of, without those objects being of a kind regarding which human beings as a matter of fact have recognitional capacities (*qua* individuals, that is): things like apples, roses, billiard balls, gold-fish, sparrows. So one might find oneself watching a person draw some artichokes on a dish, and remark upon how the artichokes in the picture are like the actual artichokes, without there being any question of recognising those self-same artichokes. There can be, also, pictures of people such that what can be seen in the picture may, in similar circumstances, seem to the spectator like the person the picture is of without it being the case that that person is recognisable in the picture — when, for example, that person is shown from a peculiar angle, from behind, in a strange position. An individual is not recognisable, in life or in pictures, from just any point of view or in any guise. So although perceived likeness does not imply recognisability, recognition implies perceived likeness.

The second constraint on an account of portrayal — that it explains how it is that portraits come to represent the particular individual they do, and no other — concerns the distinction between a sitter for a portrait and a model. The standard portrait-taking situation involves the subject sitting for his portrait, whether it is painted, sculpted, drawn or

photographed. This was not always standard: portraiture in its early phases, both in Antiquity and in Renaissance Europe, often had a commemorative function, so that portraits were frequently made post-humously. Sometimes an artist will employ a model to pose in place of the actual subject for portrayal, when, for instance, the subject is very busy or very grand. Certainly this was a common practice when it came to painting the body of the subject, as distinct from the face.

An adequate account of portrayal must therefore be able to deal with the following case. An artist wishes to paint a portrait of a man named John, who is unfortunately too busy to give the painter enough sittings. Suppose John has an identical twin, and that the artist prevails upon him to sit in John's stead. The resulting picture, let's suppose, looks equally like John and his twin; both have participated in the picture's production in similar ways, that is, by posing for the artist. Yet the picture is a portrait of John and not his twin, even though we might want to say that it is also in some other sense a picture of the twin. This case is simply a more extreme version of the sort of case in which an artist uses a model for the figure of, say, Pontius Pilate in a painting of Christ being brought before Pilate. Whether or not we want to count Pilate as portrayed in such a picture (and it is my belief that we don't), it is certainly the case that Pilate, and not the model, is part of what the picture conveys, despite the model's rôle in the picture's production. Now, it might be thought that the fact that the model is not part of what the picture conveys is merely a consequence of there being, as in this case, some other individual who *is*; but this would be a mistake, for reasons which bring me to the third constraint.[11]

Within the activity which at its widest is one of drawing, painting, sculpting *from life*, there is a narrower practice of using models in the study of human anatomy and the human figure. As a result of this practice there are many drawings which are of some individual, the model, but which are not Individual Representations of the model, nor do they seem to be portraits either. A sketch made by Rembrandt of Saskia does not automatically count as a portrait of her, not even if it happens to look just like her. Art students produce pictures of the models provided for them in Life classes, but these pictures, even when good likenesses, are not necessarily, indeed are quite rarely, regarded as portraits.

To some extent these remarks reflect usage of the expression 'por-

trait'; obviously, when we do and when we do not naturally use this expression is not necessarily significant, but in this case something like a general principle can be discerned at work.

There is a different point about usage of the expression 'portrait' which it is as well to mention and set aside, since it obscures the important distinction between a sitter or subject and a model. There is what might be called a *compositional* use of the term, and in this usage it alludes to or indicates what is now the most common, the standard motif for a portrait: a single figure, seated or standing, half or full-length, full or three-quarter face. In fact this type of portrait motif is a fairly late development in the case of Renaissance portraiture, and becomes commonplace only as the portrait emerges as a genre in its own right. The net effect of the emergence of this portrait-motif is that it can be adopted for pictures which may not be intended as portraits; it becomes, in other words, simply a motif. This means that it can be a mistake to assume, when confronted with a picture showing a man as if in a standard portrait, that the picture is in fact a portrait of someone. Unfortunately, this compositional use of the term has gained a wide currency, with the consequence that linguistic usage is an unreliable guide to the concept of portrayal.

So we have two kinds of case involving models: cases where we want to say a picture portrays some individual other than the model; and cases where, although the picture is of a single person, *viz* the model, nonetheless it is not said to be a portrait. Together the two kinds of case sharply constrain an account of what it is for a picture to be a portrait of someone; together the two kinds of case constitute what I shall call the sitter-model problem.

3

If we treat portrayal as a species of individual representation, the sitter-model problem will be taken care of. Accordingly, a picture will be a portrait of some individual only if the artist intended that individual to be identifiable by spectators as the individual the picture is of. In the examples just outlined, the picture is a portrait of John and not his twin because it is John whom the artist intended spectators to identify as the person the picture is of. In the second case, the picture of Saskia is not a portrait of Saskia if Rembrandt did not intend spectators to be able to identify Saskia in the picture.

So much for the sitter-model problem.

4

The more difficult part of the task of defining portrayal, assuming now that it falls under the concept of Individual Representation, is that of saying what is special or distinctive about portrayal, what differentiates it from other sorts of individual representation. It is here that the notion of likeness, or rather, recognition, has a part to play. Reflecting on the various types of route from picture to object which the audience may be intended to follow in identifying the individual represented, one might be tempted to think that portraits, like many caricatures and cartoons, are intended to invoke recognitional knowledge in the intended route to the object, and that this is what is distinctive of portrayal. Accordingly, consider the following proposal:

A picture P is a portrait of an individual a if and only if

(i) the artist intended to make it possible for spectators to identify a in P (this concerns P's status as an individual representation)

AND

(ii) the artist intended spectators to identify a in P by recognising a in P. (This is the route to the object the spectator is intended to follow.)

But there is a problem. The difficulty lies with the second condition: for although portraits are individual representations and so are aimed at or intended to be 'consumed' by an audience able to tell, in one way or another, who the represented individual is — the artist intends his subject to be identifiable in the weaker of the two senses distinguished earlier — it just does not seem to be true that portraits are aimed exclusively at spectators who are able to recognise the relevant individual. I am not suggesting that there are no portraits where the portrayed person is intended to be identifiable solely by recognition, only that it is not a necessary condition: portraits can be, and indeed often are, aimed at an audience which includes people lacking the relevant recognitional knowledge — witness the customary use of portraits in the arrangement of diplomatic marriages in the past, or their use in assisting people in acquiring recognitional capacities in political campaigning or in searching for missing persons, criminals, etc.[12] Moreover, a natural explanation of the development and persis-

tence of the use of inscriptions, labels, emblems, identificatory clues and symbols, and so on, would be that portraits are not intended only for spectators possessing the requisite recognitional knowledge.

But quite apart from this difficulty with condition (ii) there is what is to my mind a deeper problem with the idea of invoking recognition as a necessary element of the intended means of identification. An intention to render an individual recognisable in a picture introduces a strong element of competence: the artist must have skills sufficient for him to entertain a reasonable expectation of realising that intention, and, more crucially for us now, when this intention operates on portrayal under the aegis of the intention to render an individual *identifiable* by spectators, it introduces an even stronger element of achievement. The artist must achieve recognisability if he is to realise his intention to render the portrayed individual identifiable, even when, as is quite commonplace, there is some alternative route to the object. Recognisability, on the current proposal, must be achieved if the picture is to be successful *qua* individual representation; and this means that, mysteriously, portraits are a kind of individual representation which is unsuccessful when it fails to be a likeness good enough to engage recognitional knowledge. But in fact many unsuccessful portraits — unsuccessful because not good enough likenesses — remain successful individual representations in spite of that. In addition, such a strong element of achievement is not compatible with either the historical development of portraiture, or the variety of pictures which we are inclined pre-theoretically to accept as *bona fide* portraits — these includes successes, failures (in respect of individual likeness) and also, when portraiture is practised as an art, deviant or untypical cases. (I shall say more about the latter in a moment.)

It seems to be wrong, then, to define portrayal as that species of Individual Representation which invokes recognition as the means of identification. We must give up the idea that recognition is necessarily involved in portrayal as its intended route to the object. But we can still maintain both that portraits, like all individual representations, are intended to provide spectators with an identifying route to the object, and that, when successful, they activate recognitional capacities in appropriately equipped spectators. We can do so because there is no reason to continue to think that the twin elements of identification and likeness must be as closely tied together as has been supposed sofar. Recalling my claim that portrayal lies at the juncture of two principles of

classification for pictures of objects, condition (ii) can be understood as reflecting the fact that we regard portraits, at least when successful, as falling on the side wherein there is a perceived likeness between picture and object. This might seem at first glance too great a restriction on portrayal — think of some of Picasso's or Matisse's, or Bacon's portraits — but in fact, as we'll see, it is not: considerable leeway in the appearance of portraits is allowed for, without this undermining our ability to tell at a glance whether a picture is likely to be a portrait or not.

In what follows I elaborate and qualify this proposal, without attempting to complete an analysis.

The independence of the two conditions needs to be stressed: just as there are pictures of objects which satisfy condition (i) but not condition (ii), so there are pictures of objects satisfying (ii) but not (i). Examples of the first sort are, obviously, individual representations that are not portraits — most representations of biblical characters, for example. When we identify a woman in a picture as Salome, we are not struck by a likeness (or the lack of a likeness) between the woman we see in the picture and Salome, since we know nothing of what Salome looked like, and cannot recognise her. Examples of the second sort are to be found among pictures whose objects, a person for instance, have been drawn from life and are recognisable in the picture but served merely as models — in such cases we may be struck by a likeness between model and figure in the picture. Returning to our previous examples, an artist intending to represent Pilate may have produced a picture in which his model happens to be recognised (by his friends, say) but without this having come about as a result of intending the model to be *identifiable* in the picture. The crucial point is that pictures which are the outcome of an activity of drawing from life can be such that they seem enough like their objects to activate recognitional capacities regarding those objects.

Condition (ii) is intended to specify the intention of the artist by describing its *result*: what it says is that the artist must have a certain intention, and this intention must be such that the result or outcome of its successful realisation will be a picture such that spectators with recognitional knowledge of *a* are likely to recognise *a* in the picture, other things being equal.[14] Nothing has been said about the artist's thoughts or conscious aims, but something has been said about the result of what he does when he embarks on making a portrait. In the definition itself, what follows the expression 'the artist intended *P* to be

such that' in condition (ii) describes the picture and not the artist's thoughts. This will not seem puzzling if one bears in mind that the making of pictures is an activity, and is to a large extent governed by the conception of a desired end product, a conception which may, of course, suffer alteration and articulation as that activity is prolonged over time. The making of a portrait is a specific form of picture-making, engagement in which constrains what the artist does and produces, but there are many ways of going about it.

Just now I said that condition (ii) has nothing to do with intended identification, and this might be thought to be an exaggeration for the sake of a contrast. Is not recognition always *potentially* a way of identifying the portrayed individual? For, given the successful realisation of the intention contained in condition (ii), spectators with the appropriate recognitional capacity will be able to tell who the picture is of. This is undeniable, but it is to the credit of the proposed account of portrayal that it has this consequence — that the two conditions together potentially gather two sets of spectators able to identify the portrayed individual: those possessing the relevant recognitional capacity, and those possessing whatever knowledge is exploited in the intended route. (The two sets may, of course, overlap if it is recognitional knowledge that is exploited in the intended route.) But there is nothing inconsistent in this with my claim that condition (ii) has nothing to do with the *intended route* to the object. The important point is that two ways in which the notion of recognition can figure in portrayal are distinguishable: recognitional knowledge may be invoked as part of the intended route to the object; and recognitional capacities may be activated as a result, as a byproduct, of the artist successfully producing the kind of picture a portrait standardly is, namely likeness of the sitter.

The difference between the two ways in which recognition operates in portrayal shows up when one considers a situation where recognitional capacities concerning the 'wrong' individual — i.e. someone other than the sitter — are activated by seeing a portrait. In cases where recognition is invoked as the intended means of identification, the envisaged situation affects the realisation of the artist's intentions, because the *sitter* is not identified at all. By contrast, if the same situation obtains in cases where recognition is not part of the intended route to the sitter, the artist's intentions are untouched. Confusion which would undermine the intention in condition (i) need not undermine condition (ii): for instance when the sitter and the individual

concerning whom a recognitional capacity is inappropriately activated happen to look alike, as in the case of twins. (The same confusion would be likely in life as well.)

The fact that recognisability can be the result of an artist's engagement in the activity of drawing from life, in both cases independently of any intention to render that individual identifiable, presents the tantalising possibility that a degree of unification might be achievable if we could — and I don't know how one might set about it — define a notion of likeness between pictures and objects general enough to span both portrayal and drawing from life, and which carries recognisability in its wake, provided certain other conditions are satisfied. If we had a definition of such an over-arching concept of a picture's being like a particular object, it might then be possible to reformulate my condition (ii) in terms of it, while dropping its present reference to recognisability. Whether in the limited context of an account of portrayal this would be preferable is unclear — it would not follow, for instance, that all talk of recognition could be dropped. For quite apart from the way recognitional knowledge can be invoked as part of the intended route to the represented individual, there appear to be two features of the concept of a portrait I have not yet drawn attention to. These two features I take to be at the level of data, and possibly the best explanation of them would have to appeal to human recognitional capacities.

The first feature is a limitation on what kind of object can be portrayed: we do not treat pictures of objects belonging to kinds regarding which we as human beings do not, as it happens, have long-term (individual) recognitional capacities as portraits of those objects. We do not commonly speak of portraits of apples, a brace of pheasant, a vase of chrysanthemums, or of tins of Campbell's Soup. The second feature is a restriction on how one can depict an object that is being portrayed: we seem to expect a portrait of an object (of a kind regarding which we do have long-term recognitional capacities — people, buildings, ships, thoroughbred horses) to depict or show that object in a way in which it may be recognised in the picture. And so one cannot portray a man anyhow; a speaking likeness of him cannot be caught from any distance, or from any angle or point of view. The proposed account has the consequence that there is both a limitation on what kinds of thing may be portrayed, and a restriction on how, under what aspect, or in what guise a thing may be depicted when it is portrayed. There would be a welcome relativity to the actual range of human

recognitional capacities, such that, were that range to alter, because of
genetic or environmental factors, perhaps, then the range of portrayable
kinds of thing would likewise change.

Speculative as the suggestion of an over-arching notion of likeness
between picture and object is, its interest for us now lies in the way it
throws some light upon the connection between portrayal and drawing
from life. Portrayal, I have claimed, lies at the juncture of the two
principles of classification for pictures of object discussed earlier, and
the two conditions are intended to reflect this. Another way of putting
the point would be to see portrayal as the offspring of the union of a
practice of Individual Representation and of a capacity for achieving a
high degree of pictorial verisimilitude (competence). This way of look-
ing at portrayal reflects at a conceptual level the historical evolution of
portraiture. Both in Antiquity and in the Renaissance, for example,
portraiture emerged only when there existed skills and techniques such
that the attempt to create in individual likeness of a man or woman
could be contemplated. This suggests a connection between the distinct
concepts of a portrayal and drawing from life.[15] The connection is this.
The practice of drawing from life is indispensable to the development
of the very skills essential to the achievement of a level of likeness high
enough to foster the development of a practice of portraiture. It is no
accident that portrayal lies at the juncture of the two principles of
classification for pictures of objects.

Portraits vary widely both in respect of how like their sitters they
seem to perceivers and with respect of what sort of features of an
individual's appearance they make salient. This variation is not simply
due to the artist's competence, or lack of it; it may be due to factors
affecting the production of a portrait other than the seeking of an
individualised likeness — factors having to do with period and in-
dividual style, composition, medium, for example. In some cases it
might even look as though the artist has sacrificed the requirement of
likeness almost completely to these other demands. In others, for
instance in the case of many Cubist pictures, it looks highly question-
able whether we can speak of portrayal at all.

The painting of Francis Bacon provides examples of how style and
formal concerns can impinge upon the seeking of an individualised
likeness, and yet he does paint portraits. In an interview in *The Times*
(15.9.83), Bacon was asked: "When you do portraits, are you attempt-
ing to unlock feelings about the sitter?" — the question was presumably

motivated by the fact that many people fail to see how Bacon's figures look like *anyone*, let alone the sitter. And Bacon replied: "No. No. I am really working for the form. I am hoping that the form will become a likeness. People say my work is deformed. But it is certainly not deformed for the sake of deformity. I am always hoping to deform into reality." The painter's hopes are certainly realised in, for example, 'Three studies for a portrait — 1982' in which Mick Jagger is easily recognised despite the distortions of Bacon's style. (Jagger is identifiable by recognition alone, without the aid of title or clue.)

Distortion is much exploited in caricature, and on my account many caricatures will count as portraits. It is often thought that what is mystifying — paradoxical even — about caricature is: How can pictures patently so unlike their subjects also be so like them? But the mystery is rather: how is it that we can recognise individuals in such a variety of pictorial modes? The fact that we do, seemingly on an amazingly slim basis in many cases, means that the perception of likeness between what is seen in a picture and some individual cannot be shackled to some conception of naturalism or realism, least of all in the form of an attempt to explain what naturalism is in terms of the perception of likeness. A symptom of the freedom of the perception of likeness from a picture's being a naturalistic one is the fact that there are pictures in which an individual is recognisable but from which it would be very unlikely that one could acquire a recognitional capacity vis-à-vis that person. In Bacon's portrait, Jagger is easily recognised, yet it is not the sort of picture one would hand round (in reproduction) if one were trying to find Jagger in a place where he was not well-known — one would not go round asking: "Have you seen this man?"

If Jagger's portrait by Bacon can be regarded as a successful portrait — if both the intentions I have required are realised — it must not be thought to be a typical instance of a successful portrait. Portraiture at its highest artistic level can avail itself of any slack there is between the realisation of each of the two intentions it requires — in how the balance between the two intentions is weighted — but it can only do so against the background of a wider practice of a more prosaic form of portrayal. (This is another reason in favour of catering for the requirements of identifiability and likeness with separate conditions.)

And finally, it is implicit in much of what I have said about portrayal that the artist's intentions are supposed to be *de re*, and that looking at portraits can put the spectator in a cognitive relation with the portrayed

individual, that his thoughts can reach beyond the picture to that
individual. We generally assume that portraits, at least successful ones,
can be a source of knowledge and information about the individual
portrayed, and that recognitional capacities can be acquired from
successful and standard portraits. Whether there is a connection be-
tween some pictures and some objects analogous to the connection
many philosophers believe to hold between some of a person's beliefs
and thoughts and some objects is a difficult question I have tried to
clear a path to, but the issues thereby raised must await results from
investigations in other areas of philosophy, chiefly the philosophy of
language.

London

NOTES

* This paper is formed from two chapters of a book, *Pictures and Object*, still in draft,
and so the discussion here is inevitably much condensed, particularly in Part 1. Many
people have been generous with their comments over the years, and I am especially
grateful to Gareth Evans, Christopher Peacocke, Michael Podro, John Nash, Galen
Strawson, Richard Wollheim and Chaim Tannenbaum.

[1] *Oxford Book of Literary Anecdotes*, ed. James Sutherland, (Oxford: Oxford Uni-
versity Press, 1975), p. 98.

[2] Not all pictures of a man, say, are such that there is some man whom they are of.
Thus there are senses of the sentence "This is a picture of a man", which may loosely
speaking, be called *relational*: those senses implying the existence of a man the picture
is of. By contrast, there are senses of that sentence which carry no existential commit-
ment, are content-giving, i.e. say something about what can be seen in the picture,
namely a man, and these senses I will call *notional*. This relational/notional distinction
applies equally to the sentence "This represents a man"; as I use the expression
'depicts', the sentence "This depicts a man" or "This is a man-depiction" is always
notional, i.e. content-giving. The two senses of the sentence "This is a picture of *a*" I am
distinguishing can both be regarded, in the loose terminology here, as *relational* senses
of the sentence.

[3] How is 'what can be gathered from looking at the picture' to be construed? Very
generously, so that the spectator can be said to gather facts about one particular picture
with the help of knowledge about pictures in general (i.e. other pictures), or can do his
gathering slowly, with effort, perhaps with several viewings as when, for instance,
initially a spectator cannot make out the man in the picture, then gradually begins to
find him — first he spots an eye, then a nose, and so on, until the man is 'pieced
together'. Something like this process occurs with Cubist pictures, or more recently,
with some of Auerbach's paintings.

[4] G. M. A. Richter, *The Portraits of the Greeks*, (Oxford: Phaidon Press, 1965).

[5] For a discussion of some interesting cases, see Michel Foucault, *Ceci n'est pas une pipe*, trans. and ed. by James Harkness, (University of California Press, 1983).

[6] It might be objected that it is unnatural to speak of representation here: the sacrificial lamb may stand for Christ, and doubtless gets spectators to think of Christ, but it does not represent Christ — how could a *lamb*-depiction represent a man? Ordinary usage, however, cannot settle this issue; indeed it is not one that can be settled pre-theoretically, and different theories of pictorial representation will deliver different answers. It may be that the resistance to the idea that the lamb *represents* Christ arises in part because such symbols are quite rare, and partly because there are other less abstruse, less conventional ways of representing particular men. We do not encounter the same resistance to the idea, for instance, when it comes to the symbolic (allegorical) representation of properties and concepts, such as sainthood, justice, peace, gentility, and so on.

[7] 'Iconography and Iconology' in E. Panofsky, *Meaning in the Visual Arts*, (Harmondsworth: Penguin, 1970).

[8] For a discussion of identification by recognition, see Gareth Evans, *The Varieties of Reference*, (Oxford: Oxford University Press, 1982), Chapter 8.

[9] A picture, for example, may be more or less like Churchill relative to the response it tends to (and may have been intended to) elicit from spectators; or, a spectator's response to the picture may vary from not seeing any likeness at all, to being very struck by one, and this variation might be traceable entirely to facts about the spectator.

[10] Henry VIII could have done something else, given what he wanted to know. He could have sent a writer to see Anne, and bring back a detailed description of her physical appearance, etc; or he could have requested that a look-alike be found — a lady whose looks were remarkably like Anne's — who could have been presented to him by proxy. A portrait, however, was the natural solution to his problem.

[11] Two individuals could both be represented by the same figure in a painting, but, I think, they would have to be identified by different routes. In Raphael's School of Athens, for instance, the figure representing Plato was for some time thought also to portray Leonardo (in fact the evidence is now discredited), but the ways of identifying each represented individual were different in type.

[12] There is a sense in which portraits invoking recognition as the sole means of identifying the subject may now be regarded as the purest, the ideal form of portraiture, even though they are by no means typical.

[13] But see below for a qualification.

[14] It is a consequence of the successful realization of condition (ii) that seeing P may also activate recognitional capacities concerning some individual b other than a when a and b happen to look alike. See my remarks earlier about identification by recognition.

[15] The two concepts are distinct in that not all drawings from life are portraits and not all portraits are drawn from life.

BIBLIOGRAPHY OF WORKS CITED

MONOGRAPHS

Albers, J., *The Interaction of Colour* (New Haven & London: Yale University Press, 1963).

Alberti, *On Painting and on Sculpture*, ed. and trans. C. Grayson (London: Phaidon Press, 1971).

Alpers, Svetlana, *The Art of Describing: Dutch Art in the Seventeenth Century* (London: John Murray in association with the University of Chicago Press, 1983).

Anderson, T., *Malevich* (Amsterdam: Stedelijk Museum, 1970).

Apollinaire, Guillaume, *The Cubist Painters: Aesthetic Meditatons*, tr. Lionel Abel (New York: Wittenborn Schultz, 1949)

Aristotle, *Poetics* and *Rhetoric* (with Demetrius on Style & Longinus on the Sublime & Herace's Art of Poetry) trans. Thomas Twining with an Introduction by T. A. Moxon (London; Dent, New York, Dutton, Everyman Library, 1955).

Arnheim, R., *Art and Visual Perception* (Los Angeles: Faber, 1966).

Baljeu, J., *Theo van Doesburg* (New York: Macmillan, 1974).

Baltrušaitis, J., *Anamorphic Art*, trans. W. J. Strachan (Cambridge: C.U.P., 1977).

Bann, S., *Towards a New Art: Essays on the Background to Abstract Art, 1910–1920* (London, Tate Gallery, 1980).

Barr, Alfred J. Jr., *Cubism and Abstract Art* (New York: Museum of Modern Art, 1936).

Baxandall, Michael, *Giotto and the Orators* (Oxford: Oxford Warburg Studies, Oxford University Press, 1971).

Baxandall, Michael, *Patterns of Intention: On the Historical Explanation of Pictures* (New Haven and London: Yale University Press, 1985).

Bell, C., *Art* (London, 1914).

Bergson, H., *Creative Evolution* (London: Macmillan, 1960).

Berlin, B. and Kay, P., *Basic Color Terms* (Berkeley: University of California Press, 1969).

Berlyne, D., *Conflict, Arousal, Curiosity* (New York: McGraw Hill, 1960).

Besant, A. & Leadbeater, C. W., *Thought-forms* (1901), (Madras: 1961) (also pub. Theosophical Publishing Society, New York, J. Lane, 1905).

Blunt, A., *The Paintings of Nicolas Poussin, a Critical Catalogue* (London: 1969), No. 26.

Blunt, A., *Nicolas Poussin* (London and New York: Phaidon Press, 1967).

Blunt, A., *The Drawings of Poussin* (New Haven and London: Yale University Press, 1979).

343

Andrew Harrison (ed.), Philosophy and the Visual Arts, 343–351.
© *1987 by D. Reidel Publishing Company.*

Boring, E., *Sensation and Perception in the History of Experimental Psychology* (New York: Appleton-Century-Crofts, 1942).
Bowlt, John E. with Washton Long, Rose-Carol, *The Life of Kandinsky in Russian Art* (Newtonville, Mass.: Oriental Research Partners, 1980).
Brown, R., *The Principles of Perspective* (London: 1815).

Cardinal, Roger, *Expressionism* (London: Paladin Books, 1984).
Carmean, E. A. Jr., *Mondrian: The Diamond Compositions* (Washington: National Gallery of Art, 1979).
Cheney, S., *Expressionism in Art* (New York: Tudor, 1934).
Clark, K., *Landscape into Art* (London: Phaidon Press, 1976).
Clulow, Frederick, *Colour, Its Principles and Their Applications* (London, Fountain Press, 1972).
Coe, B., *The History of Movie Photography* (London: Ash and Grant, 1981).
Compton, Michael, *New Art* (London: Tate Gallery Publications, 1983).

Danielou, A., *The Ragas of Northern Indian Music* (London: Barrie and Rockliffe, 1968).
Descartes, *Philosophical Writings*, trans./ed. Anscombe and Geach (Edinburgh: Nelson, 1954).

Ebeling, K., *Ragamala Painting* (Basel, Paris, N. Delhi: Ravi Khumar, 1978).
Eco, U., *A Theory of Semiotics* (Bloomington: Indiana University Press, 1979).

Fechner, G. T., *Vorschule der Aesthetik*, II (1877) (Leipzig: 1898).
Field, G., *Rudiments of the Painter's Art: Or a Grammar of Colouring* (London: 1850).
Foucault, Michel, with illustrations and letters by René Magritte, *Ceci n'est pas une pipe*, trans./ed. by James Harkness (Berkeley: University of California Press, 1983).
Foucault, Michel, *Les mots et les choses* (Paris: Gallimard, 1966).
Frege, Gottlob, *Logical Investigations*, ed. P. T. Geach, trans. P. T. Geach & R. H. Stoothoff (New Haven: Yale University Press, 1977).
Fried, Michael, *Absorption and Theatricality: Painting and Beholder in the Age of Diderot* (Berkeley: University of California Press, 1980).
Fried, Michael, *Three American Painters* (Harvard: Harvard University Press, 1965).
Fry, Roger, *Flemish Art* (London: Chatto and Windus, 1927).
Fuller, Peter, *The Naked Artist* (London, Writers and Readers, 1983).

Gamwell, L., *Cubist Criticism* (Ann Arbor: UMI Research Press, 1980).
Gilot, F. & Lake, C., *Life with Picasso* (London: Nelson, 1965).
Gombrich, E. H., *Art and Illusion: A Study in the Psychology of Pictorial Representation*, 2nd ed. (London: Phaidon Press, 1962).
Gombrich, E. H., *Meditations on a Hobby Horse and Other Essays on the Theory of Art* (London: Phaidon Press, 1964).
Gombrich, E. H., *Art and Illusion* (New York: Parthenon Books, and London, 1960) (2nd revised ed., Princeton, 1961), and more recently *The Image and the Eye* (Oxford: Phaidon Press, 1982).

Goodman, Nelson, *Languages of Art* (Indianapolis: Hackett Publishing Co., 1976) and (Indianapolis: Bobbs-Merrill and Sussex: Harvester, 1963).

Goodman, Nelson, *Ways of Worldmaking* (Indianapolis-Cambridge: Hackett Publishing Company and Sussex: Harvester, 1978).

Gosling, N., *Paris 1900—14: The Miraculous Years* (London: Weidenfeld, 1978).

Greenberg, Clement, *Art and Culture* (Boston Massachusetts: Beacon, 1961).

Gregory, R. L., *Eye and Brain*, 3rd edition (London: Weidenfeld and Nicolson, 1977).

Guichard, E., *Grammar of Colour* (Paris: 1882).

Guilbaut, Serge, *How New York Sold the Idea of Modern Art: Abstract Expressionism, Freedom and the Cold War*, trans. A. Goldhammer (Chicago: University of Chicago Press, 1983).

Hagen, M. A., *The Perception of Pictures* (New York: Academic Press, 1960).

Hanslick, E., *The Beautiful in Music*, trans. G. Cohen (New York: Liberal Arts Press, 1957).

Harrison, Andrew, *Making and Thinking: A Study of Intelligent Activities* (Sussex: Harvester Press, 1978).

Harrison, Bernard, *Form and Content* (Oxford: Blackwell, 1973).

Haskell, Francis, *Patrons and Painters* (London: Chatto and Windus, 1963).

Hegel, G. W. F., *Aesthetics*, trans. T. M. Knox (Oxford: Clarendon Press, 1975).

Hegel, G. W. F., *The Phenomenology of Spirit*, trans. A. V. Miller (Oxford: Clarendon Press, 1979).

Heidegger, Martin, *Being and Time*, trans. John Macquarrie & Edward Robinson (Oxford: Basil Blackwell, 1967).

Hepburn, R. W., *Wonder: And Other Essays* (Edinburgh: Edinburgh University Press, 1984).

Hintikka, Jaakko, *The Intensions of Intentionality and Other New Models for Modalities* (Dordrecht: Reidel, 1975).

Hodder, C., *Russian Constructivism* (New Haven and London: Yale University Press, 1983).

Holly, M. A., *Panofsky and the Foundations of Art History* (Ithaca and London: Cornell University Press, 1984).

Itten, J., *The Art of Colour — The Subjective Experience and Objective Rationale of Colour*, trans. E. Van Hagen (New York and London: Reinhold Van Nostrand, 1974).

Jakobson, R. and M. Halle, *Fundamentals of Language*, 2nd ed. (The Hague: Mouton, 1975).

Jakobson, R., *Child Language, Aphasia and Phonological Universals* (The Hague: Mouton, 1968).

Jameson, Fredrick, *Formations of Pleasure* (London: Routledge and Kegan Paul, 1983).

Kan, Diana, *The HOW and WHY of Chinese Painting* (New York: Van Nostrand Reinhold Company, 1974).

Kandinsky, Wassily, *Concerning the Spiritual Art* (1912), trans. M. T. H. Sadler (New York: Dover Publications Inc., 1977).

Kandinsky: Complete Writings on Art, ed. Kenneth Lindsay and Peter Vergo (London: Faber and Faber/Boston: G. K. Hall, 1982).

Kerber, Bernard, *Andrea Pozzo* (Berlin: de Gruyter, 1971).

Kircher, A.: *Ars Magna Lucis et Umbrae* (Rome: 1646).

Klee, Paul, *The Thinking Eye*, trans. Ralph Manheim (London: Percy Lund, Humphries & Co. Ltd., 1961).

Kramer, Hilton, *The Art of the Avant Garde* (London: Secker, 1956).

Kwo Da-Wei, *Chinese Brushwork* (Montclair: Allanheld & Schram and London; George Prior, 1981).

Le Grande, Y., *Light, Colour and Vision*, trans. Walsh and Hunt, 2nd ed. (London: Chapman and Hall, 1968).

Lévi-Strauss, C., *The Raw and the Cooked* (1964), trans. Weightman (London: Cape, 1970).

Lyons, William, *Emotion* (Cambridge: Cambridge University Press, 1980).

Malevich, K., *Essays on Art*, trans. Glewacki-Pries & McMillan, ed. T. Anderson (Copenhagen: Borgen, 1968).

Marks, L. E., *The Unity of the Senses* (New York & London: Academic Press, 1978).

Marx, Karl, *Early Texts*, trans./ed./David McClellan (Oxford: Basil Blackwell, 1972).

Merleau-Ponty, Maurice, *The Phenomenology of Perception*, trans. Colin Smith (London: Routledge and Kegan Paul, 1974).

Merleau-Ponty, Maurice, *The Primacy of Perception*, ed. James Edie (Evanston: Northwestern University Press, 1964).

Morris, George L. K., *American Abstract Artists* (New York: Weyhe's Bookstore, 1939).

Munsell, A. H., *A Colour Notation* (Baltimore: Munsell Colour Company, 1975).

Munsell, A. H., *A Grammar of Colour*, ed. Faber Birren (New York and London, 1969).

Neisser, U., *Cognition and Reality* (San Francisco; W. H. Freeman, 1976).

Neisser, U., *Cognitive Psychology* (New York; Appleton-Century-Crofts, 1967).

Newton, Isaac, *Opticks*, 1730, 4 ed. (reprint, New York; Dover, 1952).

Osborne, H., *Abstraction and Artifice in Twentieth Century Art* (Oxford: Clarendon Press, 1979).

Ostwald, W., *The Colour Primer — A Basic Treatise on the Colour System of Wilhelm Ostwald*, ed. Faber Birren (New York and London: Reinhold Van Nostrand, 1969).

Ostwald, W., *A Simple Explanation of the Ostwald Colour System*, ed. Taylor J. Scott (London: Windsor and Newton, 1935).

Panofsky, E., *Meaning and the Visual Arts* (Harmondsworth: Penguin, 1970).

Peters, J., *Farbe- und Licht-Symbolik bei Aleksandr Blok* (Munich: Sagner, 1981).

Pleynet, Marcelin, *Painting and System*, trans. S. M. Godfrey (Chicago: University of Chicago Press, 1984).

Podro, Michael, *The Critical Historians of Art* (New Haven: Yale University Press, 1982).

Pozzo, A., *Breve descrizione del disegno della Cappella di Sant' Ignazio* (Rome: 1687).
Pozzo, A., *Perspectiva pictorum et architectorum*, 2 vols. (Rome: 1693 and 1700), trans. into English, French, German and Dutch, including J. James's trans. as *Rules and Examples of Perspective Proper for Painters and Architects* (London: 1707).

Rabelais, *Gargantua and Pantagruel* (Harmondsworth: Penguin, 1955).
Rinaldi, E., *La fondazione del Collegio Romano* (Arezzo: 1914).
Rock, Irvin, *An Introduction to Perception* (New York: Macmillan, 1975).
Rood, *Modern Chromatics*, 1879. (reprinted, New York: Van Nostrand Reinhold Co., 1973).
Rorty, R., *The Consequences of Pragmatism* (Sussex: Harvester Press, 1984).

Samuelson, D., *Motion Picture Camera and Lighting Equipment* (London: Focal Press, 1977).
Sartre, Jean-Paul, *Nausea* (London: Penguin, 1965).
Schapiro, Meyer, *Modern Art* (New York: George Braziller, 1978).
Schopenhauer, F., *The World as Will and Idea*, trans. R. B. Haldane and J. Kemp (London: Kegan Paul, Trench, Traubner, 1907).
Scruton, Roger, *The Aesthetic Understanding* (Manchester, Carcanet Press, 1983).
Scruton, Roger, *Art and Imagination* (London: Methuen, 1974).
Sjöstrom, Ingrid, *Quadratura: Studies in Italian Ceiling Painting* (Stockholm: Almqvist and Wiksell International, 1978).
Sproson, W. N., *Colour Science in Television and Display Systems* (Bristol: Adam Hilger, 1983).
Sterne, Laurence, *The Life and Opinions of Tristram Shandy, Gentleman*, ed. Ian Campbell Ross (Oxford: Clarendon Press, 1983).
Stevens, W., *Collected Poems* (London: Faber and Faber, 1955).
Stevens, W., *Opus Posthumous* (New York: Alfred J. Knopf, 1957).

Tao Tsui, *Spirit of the Brush*, trans. Shio Sakanishi (London: John Murray, 1948).
Taylor, R. L., *Beyond Art* (Sussex: Harvester Press, 1981).
Tilghman, B. R., *But Is It Art?: The Value of Art and the Temptation of Theory* (Oxford: Basil Blackwell, 1984).

Uhr, L., *Pattern Recognition* (London etc: Prentice Hall, 1973).
Ullman, J. R., *Pattern Recognition Techniques* (London: Butterworths, 1973).

Vantongerloo, G., *L'Art et l'Avenir* (Brussels: 1924).
Vysecki, G. and Styles, W. S., *Color Science* (New York: Wiley, 1967).

Watanabe, S., *Pattern Recognition — Human and Mechanical* (New York: Wiley, 1985). 1985).
Wilenski, R. H., *The Modern Movement in Art* (London: Faber, 1927).
Wittgenstein, Ludwig, *Notebooks 1914—1916*, ed. C. H. von Wright & G. E. M. Anscombe, trans. Anscombe (Oxford: Basil Blackwell, 1961).
Wittgenstein, Ludwig, *Philosophical Investigations* (Oxford: Blackwell, 1952) and (New York: Macmillan, 1953).

Wittgenstein, Ludwig, *Philosophical Investigations*, trans. Anscombe (Oxford: Black-well, 1958).
Wittgenstein, Ludwig, *On Certainty* (Oxford: Basil Blackwell, 1969).
Wölfflin, M., *Renaissance and Baroque*, trans. K. Simon (London: Fontana Library, 1964).
Wölfflin, M., *On Art and Mind* (Cambridge, Mass.: Harvard University Press, 1974).
Wollheim, Richard, *Art and Its Objects*, 2nd ed. (Cambridge: Cambridge University Press, 1980).
Wolterstorff, N., *Works and Worlds of Art* (Oxford: Oxford University Press, 1980).
Wundt, W., *Grundzüge der physiologischen Psychologie* (1874) 5th ed. (Leipzig: 1902).

Zhadova, L. A., *Malevich: Suprematism and Revolution in Russian Art, 1910—30* (London and New York: Thames and Hudson, 1982).
Ziff, Paul, *J. M. Hanson* (Ithaca: Cornell University Press, 1962).
Ziff, Paul, *Understanding Understanding* (Ithaca: Cornell University Press, 1972).
Ziff, Paul, *Antiaesthetics* (Dordrecht: D. Reidel, 1984).

COLLECTIONS

Barron, S. and Tuchman, M. (eds.), *The Avant Garde in Russia, 1910—1930*: New perspectives (Los Angeles: Los Angeles County Museum; Cambridge Mass. distrib. by M.I.T. Press, 1980).
Bowlt, J. E., *Russian Art of the Avant Garde: Theory and Criticism 1902–1934* (New York: Viking Press, 1976).
Broude, N., *Seurat in Perspective* (Englewood Cliffs: Prentice Hall, 1978).

Chipp, H. B., *Theories of Modern Art* (Berkeley: University of California Press, 1968).

Davidson, D. and Harmon, G. (ed.), *Semantics of Natural Language* (Dordrecht: Reidel, 1972).

Frascina, F. (ed.), *Pollock and After* (London: Harper and Row, 1985).

Gleizes, A. and Metzinger, J., *Cubism in Modern Artist on Art*, ed. R. L. Herbert (New Jersey: Prentice Hall, 1965).
Gregory, R. L. and Gombrich, E. H. (ed.), *Illusion in Nature and Art* (London: Duckworth, 1973).

Haftman (ed.), *Suprematismus: die gegenstandlose Welt* (Cologne: DuMont, 1962).
Hardwick, E. (intro), *A Susan Sontag Reader* (Harmondsworth: Penguin, 1983).
Harrison, C. and Orton, F. (eds.), *Modernism, Criticism, Realism* (London: Harper and Row, 1984).
Herbert, R. L., *Modern Artists on Art* (New Jersey: Prentice Hall, 1964).

Millerson, G., *The Technique of Lighting for Television and Motion Pictures* (London, Focal Press, 1982).

Osborne, Harold (ed.), *Aesthetics* (Oxford: Oxford University Press, 1972).

Standos, Nikos (ed.), *Concepts of Modern Art* (London: Thames & Hudson, 1981).
Sutherland, James (ed.), *Oxford Book of Literary Anecdotes* (Oxford: Oxford University Press, 1975).

Vesey, G. (ed.), *Communication and Understanding* (Hassocks: Harvester, 1976).

PAPERS

Bach, 'Part of What a Picture Is?', *British Journal of Aesthetics* (1970).
Bann, S., 'Abstract art — a language?', in Tate Gallery, *Towards a New Art: Essays on the Background to Abstract Art, 1910–20*, 1980, p. 144.
Beckman, Max, Lecture *Meine Theorie in der Malerie,* given at the New Burlington Gallery, London in 1938. (In Chipp, 1968)
Birnholz, A. C., 'On the meaning of Kasimir Malevich's "White on white"', *Art International*, XXI, 1977, pp. 14f.
Branigan, E., *Color and Cinema: Problems in the Writing of History*, Film Reader 4, Northwestern, Ill. (1979).

Carrington, Tim, 'Why Modern Art May Never Become Old Masterpieces', in *The Wall Street Journal*, January 19, 1985.
Comolli, J-L., 'Technique et Ideologie', *Cahiers du Cinema* (in six parts, issues 229–235 and 241), 1971–72.
Crowther, Paul, 'Art and Autonomy', *British Journal of Aesthetics*, Vol. 21 (Winter, 1981).
Crowther, Paul, 'Barnett Newman and the Sublime' in the *Oxford Art Journal*, Vol. 7, No. 2 (1985), pp. 52–58.
Crowther, Paul, 'The Experience of Art: Some Problems and Possibilities of Hermeneutic Analysis', *Philosophy and Phenomenological Research*, Vol. XLIII, March 1983, pp. 347–362.

Deregowski, J. B., 'Illusion and Culture' (in Gregory and Gombrich, 1973, pp. 161–91).
de Vries, J., 'Rood-wit-zwart' (1942), *Kleine Schriften* (Berlin: 1965), pp. 35ff.

Eisenstein, S. M. (1940), 'Not Coloured, but in Colour', in *Notes of a Film Director*, Dover, 1970.
Eisenstein, S. M. (1946), 'First Letter in Colour' (trans. Herbert Marshall) in *Film Reader 2*, 1977.
Elliot, R. K., 'Aesthetic Theory and the Experience of Art' (in Harold Osborne, 1972), pp. 145–57.

Gabo, Naum, 'Sculpture: Carving and construction in space' (1937) (in Chipp, 1968).
Gleizes & Metzinger, 'On Cubism' (in Herbert, 1964).
Gombrich, E. H., 'Standards of Truth: The Arrested Image and the Moving Eye', *Critical Inquiry*, Vol. 7, No. 2 (Winter, 1930).

Gombrich, E. H., 'The vogue for abstract art', *Meditations on a Hobby Horse* (London: Phaidon, 1963).

Harrison, Andrew, Review of Alper's *The Art of Describing in Art International*, Vol. XXVII/1 (Jan-Mar. 1984), pp. 52—55.

Hoek, E., in C. Blotkamp et al., *De Beginjaren van De Stijl* (Amsterdam: 1982), p. 78 for Mondrian and cf. P. Mondrian, 'De nieuwe beelding in de schilderkunst', *De Stijl*, I. 1918, p. 30.

Homer, W. I., 'Notes on Seurat's palette' (in Broude, 1978).

Hudson, W., 'Pictorial Depth Perception in Sub-Cultural Groups in Africa', *Journal of Social Psychology*, LII, 1960, pp. 183—208.

Hunt, R. W. G. (1970), 'Objectives in Colour Reproduction', *J. Photog. Sci.* 18, 205—212.

Huszar, V., 'Iets over die Farbenfibel van W. Ostwald', *De Stijl* I, 1917, pp. 113ff.

Imdahl, Max, ' "Kreide und Seide" zur Verlage "Fiction and Reality in Painting" ', in *Funktionen des Fiktiven, Poetik und Hermeneutik* Vol. X (Munich: Wilhelm Fink Verlag, 1983), pp. 359—363.

Kandinsky, Wassily (1914), 'On the Spiritual in Art', trans. with a commentary (in Bowlt, 1980).

Kemp, M., 'Seeing and Signs: E. H. Gombrich in Retrospect', *Art History*, VII, 1984, pp. 228—43.

Klyun, I., 'The Art of Colour', 1919 (in Bowlt, 1976), p. 318 and *passim*.

Konig, H. and Eisberg, J., 'The Language of the Prairie — Frank Lloyd Wright's Prairie Houses', in *Environment and Planning* B, 8, 1981, pp. 295—323.

Kripke, Saul, 'Naming and Necessity' (in Davidson and Harman, 1972).

Land, Edwin H., 'Experiments in Colour Vision', *Sc. Amer.* 5, 84 (1959).

Lewis, M., 'Hintikka on Cubism', *British Journal of Aesthetics*, 1980.

Lloyd, B., 'Culture and Colour Coding', in *Communication and Understanding*, Vesey (Ed.).

Lynton, Norbert, 'Expressionism' (in N. Standos, 1981).

Lyotard, J-F., 'The Sublime and the Avant-Garde', *Art Forum*, April 1984.

Malevich, K., 'Non-objective creation and Suprematism', in *Essays, cit*, I, 1919, pp. 121—2.

Malevich, K., 'Suprematism, 34 drawings (1920), in *Essays on Art*, trans. Andersen, I.

Malevich, K., See also 'Suprematism as pure knowledge' (1922) in K. Malevich, *Suprematismus: die gegenstandlose Welt*, ed. Haftman (Cologne: Du Mont, 1962), p. 164 and *Essays on Art, ibid.*, p. 126.

Malevich, K., 'Suprematism' (in Chipp), *ibid.*, pp. 341—346.

Merleau-Ponty, M., 'Eye and Mind', in *The Primacy of Perception*, ed. James Edie (Evanston: Northwestern University Press, 1964).

Mondrian, Piet, 'Natural Reality and Abstract Reality' (1919) (in Chipp), *Theories of Modern Art*, pp. 321—323.

Motherwell, Robert, 'The Modern Painter's World', Dyn. VI, 1944 (see Frascina, 1985), p. 111.

Newman, **Barnett**, 'The Sublime is Now', *Tigers Eye*, No. 1, October 1947, p. 551. (in Chipp, 1968)

Panofsky, E., 'Die Perspektive als "Symbolische Form"', *Vorträge der Bibliothek Warburg* (1924—5) (Leipzig/Berlin: Phaidon, 1927).
Panofsky, E., 'Iconography and Iconology', *Meaning in the Visual Arts*.
Peetz, Dieter, 'Some current philosophical theories of pictorial representation', *The British Journal of Aesthetics*, Summer 1987.
Penrose, Roland, 'In Praise of Illusion' (in Gregory and Gombrich, 1973), pp. 248—249.
Podro, Michael, 'Auerbach as Printmaker', in *Print Quarterly*, Vol. II, No. 4 (December 1985), pp. 283—298.
Podro, Michael, 'Fiction and Reality in *Painting*', *Burlington Magazine*, Vol. CXXIV, No. 947 (February 1982), 'Funktionen des Fiktiven, Poetik und Hermeneutik', Vol. X (Munich: Wilhelm Fink Verlag, 1983), pp. 225—298.
Putnam, Hilary, 'The Meaning of "Meaning"', in *Mind, Language and Reality, Philosophical Papers*, vol. 2 (Cambridge: Cambridge University Press, 1975) *passim*.

Quine, W. V. O., 'Natural Kinds', in *Ontological Relativity and Other Essays* (New York and London: Columbia University Press, 1969), pp. 121—122.

Raynal, M., 'Conception et Vision', in *Gil Blas*, 1912.

Sibley, F. N., 'Is art an open concept? An unsettled question', *Proceedings of the IVth International Congress of Aesthetics*, Athens, 1960.
Sontag, Susan, 'The Aesthetics of Silence', 1967, Hardwick (1983).

van der Leck, B., 'De Plaats van het moderne schilderen en de architectuur', *De Stijl*, I, i, 1917, in English in P. **Hefting & A.** van der Woud, *Bart van der Leck, 1876–1958*, Otterlo/Amsterdam, 1976.

Walton, Kendall L., 'Categories of Art', *Philosophical Review*, Vol. 79, 1971, pp. 334—376.
Walton, Kendall L., 'Fearing Fictions', *The Journal of Philosophy*, 1978.
Walton, Kendall L., 'Pictures and Make Believe', *Philosophical Review*, Vol. 82, 1973, pp. 283—319.
Walton, Kendall L., 'Transparent Pictures: On the Nature of Photographic Realism', *Critical Inquiry*, December, 1984.
Weitz, M., 'The Role of Theory in Aesthetics', *Journal of Art and Art Criticism*, 1956.
Westphal, Jonathan, 'The Complexity of Quality', *Philosophy*, Vol. 59, 1984, p. 230.
Westphal, Jonathan, 'White', *Mind*, Vol. 95, 1986.
Wollheim, Richard, 'On Drawing an Object' (in Wollheim, 1974).
Wollheim, Richard, 'Talk with Bryan Magee 'Philosophy and the Arts' in Magee, B. (ed.), *Modern British Philosophy* (London: Secker & Warburg, 1971), Ch. 11.

INDEX

353

INDEX

Blunt, Anthony, 21 n
Boring, E., 232
Bowlt, John E., 252 n
Branigan, E., 217 n, 218 n
Braque, Georges, 77, 83, 85—89, 90, 92
British Academy, 268 n
Brown, Richard, 305, 316 n
Broude, N., 199 n
Brunelleschi, Filipo, 303
brushwork, 12, 31, 40

calligraphic qualities, 67, 74
Caravaggio, Michelangelo da, 12
Cardinal, Roger, 33, 34, 36, 49 n
Carmean, E. A. Jr., 199 n
Carnegie Trust for the Universities in Scotland, 268 n
Caro, Anthony, x n
Carrington, Tim, 166
Cartesian: self, 65; tradition, implications for scepticism about colour, 187—188
Cassiano del Pozzo, 7
Cassirer, Ernst, 255
cause, transcendental to what is pictured see values
causal coherence of appearances, 110, 114, 117
causes of perceptions, 109
Cézanne, Paul, 66, 78, 80, 112—113, 248, 249
Chagall, Marc, 248
Chardin, Jean Siméon, 75 n, 164
Chebnikov, V., 200 n
Cheney, Sheldon, 93, 95 n
Ch'i, 'one breath' performance, 164
Church of Sant' Ignazio, Rome, 256—268
Citroën, Paul, Metropolis, 291
Clark, John, 235—238, 242, 245, 251
Clark, Kenneth, 305, 316 n
Clemente, F., 30, 32
Clulow, Fredrick, 242, 252 n
Coe, B., 205, 218 n
cognitive processes in language and in art, 57—74 colorants, 194, 214, 218 n
Collegio Romano, 262, 264

colour, ix, 44—46; appearance, 235—351; atlases, 218 n, 225, 232; blindness, 170, 236; grading, 211; harmony, 221—223; hue, tonality, saturation, 173, 175, 241; as language, 76, 231—232; local, 105; meaning and expressive power of, 76, 241, 228—232; names, words for, 170—198, 201, 243—245, see also kinds; primary colours, 194—197, 206; relationships, 221; reproductive systems for colour in film and television, 201—216, 238, 251; colour solid, 175, 181, 208, 210, 235—251; space, 175—188, 211, 232; colour systems in art theory, 191—198, 204; see also trivariance and tristimulus
Comité Internationale d'Eclairage (C.I.E.) system 194, 207, 217 n
Comolli, J-L., 213, 218 n
Compton, Michael, 49 n
conceptual art, 125
Condillac, 81
Constable, John, 112, 256
constancy in perception, 261
Constructivists, 125; tradition, 225, 227
conventions: and nature, 303; of representation, 5
Courbet, 80; colour harmony in, 80 The Atelier, 80
crafts and decorative arts, 223
Cranach, Nicholas, 37
Crowther, Paul, 46, 49 n, 50 n, 76 n
Crumb, George, 310
Cubism, 31, 36, 77—94, 113—114, 125, 278, 292—293, 300 n, 311, 338
curvilinear perspective, 259

Dadaists, 124
Dali, Salvador, 307
dance, viii, 39, 49n, 52
Daney, Serge, 213
Dante, Alighieri, 262
deductive structure, 117
De Kooning, 38
depictive content, 328
Deregowski, J. B., 268 n

ROYAL INSTITUTE OF PHILOSOPHY CONFERENCE VOLUMES
published by D. Reidel Publishing Company

1979: **LAW, MORALITY AND RIGHTS**. Edited by M. A. STEWART.
1981: **SPACE, TIME AND CAUSALITY**. Edited by RICHARD SWINBURNE.
1983: **PHILOSOPHY, ITS HISTORY AND HISTORIOGRAPHY**. Edited by A. J. HOLLAND.